Imperial Rome and Christian Triumph

Oxford History of Art

Jaś Elsner is Lecturer in the history of art at the Courtauld Institute in London. He is author of *Art and the Roman Viewer* (1995), and editor of *Art and Text in Roman Culture* (1996), *The Cultures of Collecting* (1994) and *Reflections of Nero* (1994), and he has written scholarly articles on subjects ranging from pilgrimage to collecting, Graeco-Roman art and literature to Byzantine Iconoclasm. He is married with two children and lives in London.

Oxford History of Art

Imperial Rome and Christian Triumph

The Art of the Roman Empire AD 100–450

Jaś Elsner

Oxford New York

OXFORD UNIVERSITY PRESS

1998

FOR SILVIA, MAIA AND JAN

Oxford University Press, Great Clarendon Street, Oxford OX2 6DP

Oxford New York
Athens Auckland Bangkok Bogota Bombay
Buenos Aires Calcutta Cape Town Dar es Salaam
Delhi Florence Hong Kong Istanbul Karachi
Kuala Lumpur Madras Madrid Melbourne
Mexico City Nairobi Paris Singapore
Taipei Tokyo Toronto Warsaw
and associated companies in Berlin Ibadan

Oxford is a trade mark of Oxford University Press

First published 1998 by Oxford University Press

British Library Cataloguing in Publication Data
Data available

Library of Congress Cataloging in Publication Data
Data available
0–19–284201–3 Pbk
0–19–284265–X Hb

10 9 8 7 6 5 4 3 2 1

Picture Research by Elisabeth Agate
Designed by Esterson Lackersteen
Printed in Hong Kong
on acid-free paper by
C&C Offset Printing Co., Ltd.

Contents

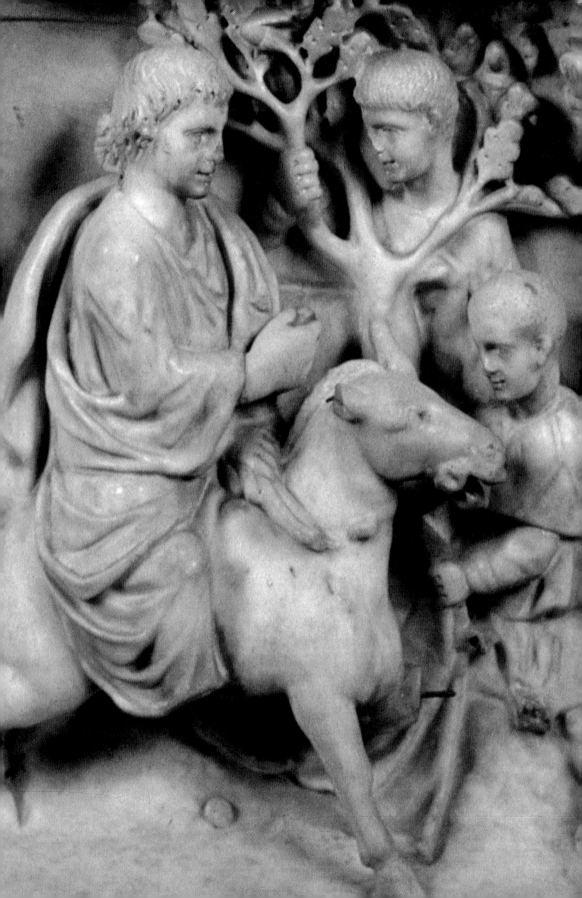

Preface

In keeping with the aims of the *Oxford History of Art*, this book attempts to provide a new and accessible approach to the arts of the Roman empire from AD 100–450, that is, in the periods known as the 'Second Sophistic' and 'Late Antiquity'. I explain the reasons for choosing these dates, as well as my method and aims, in the first chapter. As a discussion of Graeco-Roman art, the book may be read in conjunction with the two other books on Greek and Roman art in this series—*Archaic and Classical Greek Art* (by Robin Osborne) and *Hellenistic and early Roman Art* (by Mary Beard and John Henderson) —as well as Janet Delaine's book on Roman architecture. But this volume can also be treated as an introduction to the origins of Christian art in its Roman cultural context.

The avid reader of timelines may wonder why that included in this volume seems perversely detailed. There are (at least) two ways to write a general book of this sort: one might take a chronological approach— treating the period in chapters which examine decades, centuries, or dynasties—or a thematic one, in which each chapter focuses on a separate issue, and attempts to treat the entire period in what is called a synchronic manner. Although I had originally proposed to write a chronological book, I decided after much thought that what I wished to say was best suited to a synchronic and thematic discussion. In order that the reader who is new to Roman art should not feel stranded on an isthmus of unfamiliar history in the midst of a sea of incomprehension, I have attempted to provide a rather detailed timeline to help with at least some matters of chronological orientation and historical context.

I have tried as much as possible to relate my general discussion to the specific images I have chosen to illustrate—which means that these particular objects have to do a good deal of 'work' as historical documents. The format of a series like this forces one to be extremely selective about choosing illustrations: I have been allowed fewer than 150 pictures of the thousands of surviving objects from three and a half centuries of art in the Roman empire, each of which has a fair claim to be included. My selection has been governed in part by a (surely unsuccessful) attempt to be 'objective' about what are the key images surviving from the era under discussion, in part by my own particular convictions and subjective interests, and in part by what I believed my readers would themselves expect from a book on this period—so that it

Detail of 130

might be reasonably representative of what are currently regarded as the main (dare one say it still, the canonical) objects. But I would find it hard to disagree with someone who objected that the selection was tilted to public and especially imperial art at the expense of smaller and more private objects, or that architecture has been presented as little more than a setting for works of art. Likewise, for reasons of space and expense, I have had to be very restrictive about the quantity of diagrams and reconstructions of monuments which have not survived (or have survived in very fragmentary condition) but are known from the archaeological record.

This book is underpinned by the firm conviction that Graeco-Roman writings about art (for which our period is in fact the golden age) are as important to an understanding of the reception and cultural context of images as the surviving objects themselves. I have tried to be wide-ranging in my quotations from all kinds of ancient sources, and have usually used readily available translations (often altering them in the sometimes conflicting interests of greater accessibility and accuracy). One interesting problem is that the Romans themselves rarely thought about art or described it in the ways employed by a modern book, like this one, which puts pictures next to their discussion or analysis. While many Roman portraits, for example, were labelled with the name of the subject—as well as, more rarely, the names of the artist and the dedicator (something like a modern picture caption or shortish museum label, see **19**, for example), works of art were often discussed and written about in their absence. Ancient critics and historians have left us a rich legacy of *ekphraseis*, or descriptions of art, whose rhetorical elegance at their best is perhaps a better account of the effects of art, and especially of naturalism, than any analyses written since. But in using these descriptions, by the likes of writers such as Lucian or Philostratus, for the purposes of modern art history, I have to confess to a certain uneasiness. The closer one feels one has come to defining how images worked in any particular aspect of their Graeco-Roman cultural and historical context, the further one fears one has departed from the ways the ancients themselves enjoyed and reflected upon their art.

From what I have said already, it will be obvious that this account aims to examine the ways Roman and early Christian images worked in their cultural and social context. In particular, I have sought to explore some aspects of how art both reflected and contributed to social construction, as well as how it functioned as a marker for different kinds of personal identity—social, provincial, religious. This means that I have focused primarily on the role of images within cultural history. There is a price to pay for this kind of approach: inevitably, it allows relatively little scope for discussion of the aesthetics of Roman art, or the specific developments of style, form, and tech-

nique over a period of 350 years, or the special nature (even the philosophical basis) of naturalism—the particular visual convention which came to an end in the early middle ages. I do not believe that these are insignificant issues. But it is true that they have broadly dominated general discussions of Roman art in the past, and so—at this point—a more strictly cultural-historical approach has much to recommend it.

There are many debts acquired in writing a book. Above all, this project was inspired by my students at the Courtauld Institute—BA, MA, and PhD—whose questions have relentlessly goaded me into thinking again about the usual assumptions and stories we are told about Roman and early Christian art. Two recent seminars in London have enabled me to examine a number of key artefacts in the British Museum in the company of some expert critical companions: these were David Buckton's informal 'hands-on' series of meetings to look at late-antique and Byzantine objects, and the student seminars organized by Emmanuele Curti, Jeremy Tanner, and Ute Wartenberg, as well as myself, among the Townley marbles of the British Museum. I have learnt much from these encounters and from all who took part. At a late stage, the award of a Hugh Last Fellowship by the British School at Rome, enabled me to test much of my text before the silent but potent jury of the objects and buildings in Rome it discusses. The success of my time in Rome owes much to the heroic efforts of Maria Pia Malvezzi, secretary of the British School, who relentlessly pursued the authorities on my behalf to give me access to buildings and objects not currently on public view. I would like to thank my Courtauld colleagues, Robin Cormack, Paul Crossley, and John Lowden, for their support over the years, their comments on my work, their encouragement in reading early drafts. In the hunt for photographs, I am most grateful to George Galavaris, Herbert Kessler, Tim Potter, Bert Smith, and John Wilkes. Two friends, especially, have given me the benefit of copious and detailed notes on virtually every page of a chaotic manuscript: they've put me through a purgatory of re-writing and re-thinking, and only one day will Chris Kelly and Robin Osborne be forgiven! But the book is profoundly better for their efforts.

Three people have conspired to give me the time to make the writing possible and simultaneously to deprive me of any spare moments in which to write: whenever, with the aid of Silvia, my wife, I closed the door and turned the computer on, Maia, my two-year-old daughter, found a way to get in and turn upside down what I was typing. And when my son, Jan, was born, just a week after the completion of the typescript but with many of the captions and the timeline still to write (let alone the process of proof-reading and checking), all hell did its best to break loose! So, I shall dedicate what I have written to them. Maybe one day they will forgive me.

<div align="right">J. E.</div>

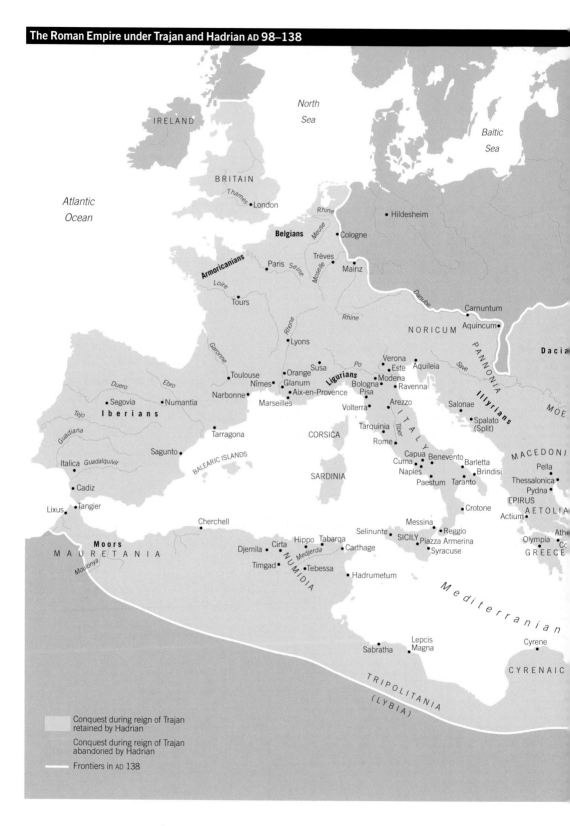

IRELAND

North Sea

Baltic Sea

BRITAIN

Thames • London

Atlantic Ocean

Rhine

• Hildesheim

Belgians

Meuse

• Cologne

Trèves

Armoricanians

Paris Seine

Moselle

Mainz

Loire

Tours

Rhine

Danube

Carnuntum

NORICUM Aquincum •

PANNONIA

Dacia

Rhône

• Lyons

Verona

Este • Aquileia

Save

Garonne

Susa

Po

• Toulouse • Orange

Duero

Ebro

Nîmes • Glanum

Ligurians

Modena

Illyrians

MOE

Narbonne •

Aix-en-Provence

Bologna •

Pisa • Ravenna

Salonae

• Segovia • Numantia

Marseilles

Volterra •

Arezzo

• Spalato

Tejo

Iberians

ITALY

Tiber

(Split)

Guadiana

Tarragona

CORSICA

Tarquinia •

Rome •

MACEDONI

Sagunto •

BALEARIC ISLANDS

Capua

Pella

Italica Guadalquivir

SARDINIA

Cuma • Benevento Barletta

Naples • Brindisi

Thessalonica •

• Cadiz

Paestum Taranto

Pydna •

EPIRUS

Lixus • Tangier

• Crotone

Actium •

AETOLIA

Messina

Ath

Cherchell

Reggio

Olympia •

Co

Moors

Selinunte • SICILY Piazza Armerina

GREECE

MAURETANIA

Djemila •

Hippo Tabarqa

Cirta •

• Carthage

Syracuse

Medjerda

Mouiorya

Timgad •

NUMIDIA

Tebessa

Selinunte

• Hadrumetum

Lepcis

Cyrene

Magna

Mediterranean

Sabratha •

CYRENAIC

TRIPOLITANIA

(LYBIA)

Conquest during reign of Trajan retained by Hadrian

Conquest during reign of Trajan abandoned by Hadrian

Frontiers in AD 138

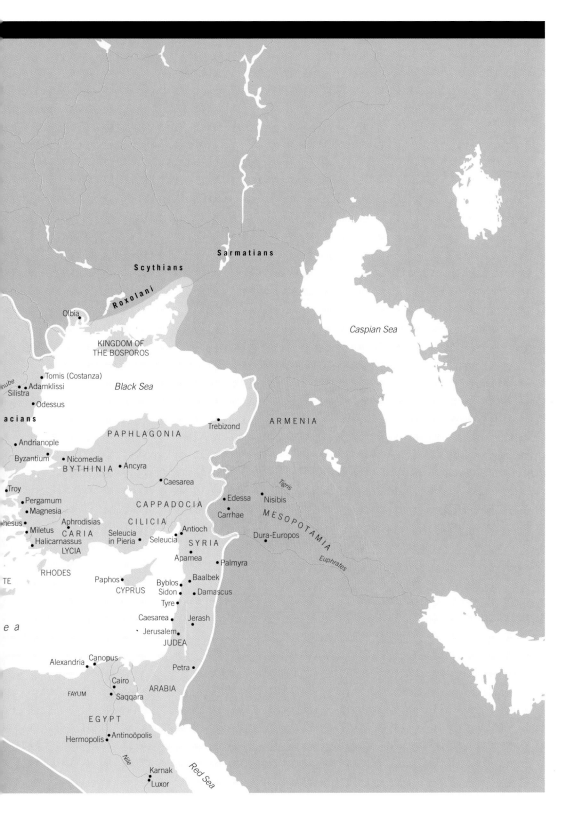

Scythians

Sarmatians

Roxolani

Olbia

KINGDOM OF
THE BOSPOROS

Caspian Sea

Tomis (Costanza)

Danube
Adamklissi
Silistra
Odessus

Black Sea

acians

Trebizond

ARMENIA

Andrianople

PAPHLAGONIA

Byzantium
Nicomedia
Ancyra

BYTHINIA

Caesarea

Troy
Pergamum
Magnesia

CAPPADOCIA

Edessa
Nisibis

Tigris

Carrhae

MESOPOTAMIA

hesus
Aphrodisias
Miletus
CARIA
Halicarnassus
LYCIA

CILICIA

Antioch

Seleucia
in Pieria
Seleucia

SYRIA

Dura-Europos

Apamea

RHODES

Palmyra

Euphrates

TE

Paphos

Baalbek
Byblos
Sidon
Damascus
Tyre

CYPRUS

e a

Caesarea
Jerash

Jerusalem

JUDEA

Alexandria
Canopus

Petra

Cairo

ARABIA

FAYUM
Saqqara

EGYPT

Hermopolis
Antinoöpolis

Nile

Karnak
Luxor

Red Sea

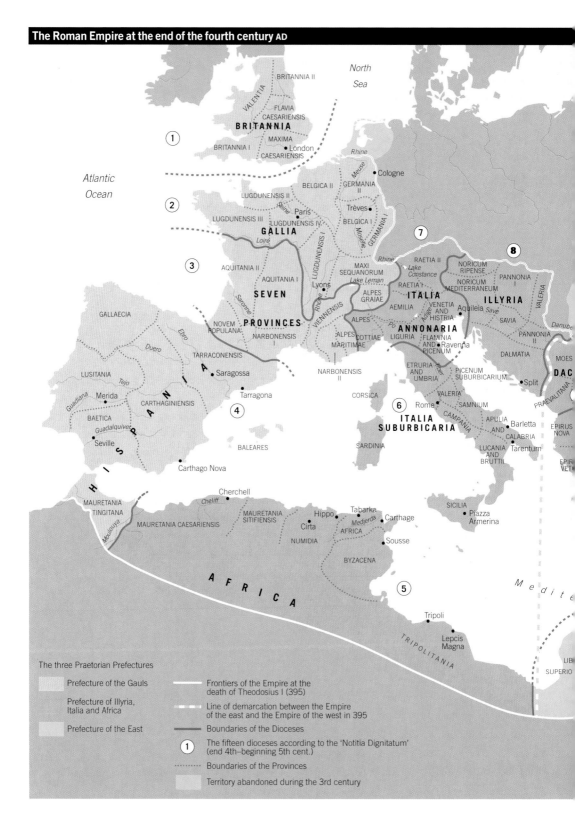

The Roman Empire at the end of the fourth century AD

North
Sea

BRITANNIA II

VALENTIA

FLAVIA
CAESARIENSIS

BRITANNIA

① MAXIMA
BRITANNIA I CAESARIENSIS • London

Atlantic
Ocean

Rhine

Meuse • Cologne

BELGICA II : GERMANIA
II
LUGDUNENSIS II

② Seine • Paris Trèves •
LUGDUNENSIS III LUGDUNENSIS IV BELGICA I

GALLIA Loire

Rhine

⑦

RAETIA II NORICUM
RIPENSE
PANNONIA
I
Lake
Constance NORICUM
MEDITERRANEUM

⑧

③ AQUITANIA II MAXI
SEQUANORUM
Lake Leman
AQUITANIA I Lyons RAETIA I
SEVEN ALPES
GRAIAE
ITALIA
ILLYRIA
VALERIA

GALLAECIA
NOVEM
POPULANA **PROVINCES**
NARBONENSIS
I
Garonne VIENNENSIS AEMILIA VENETIA Aquileia Save
AND
HISTRIA
ANNONARIA
SAVIA
PANNONIA
II

Ebro
ALPES
Rhône
ALPES
COTTIAE
MARITIMAE
Po
LIGURIA FLAMINIA
AND
PICENUM • Ravenna
DALMATIA

Danube

Duero
TARRACONENSIS
NARBONENSIS
II
ETRURIA
AND
UMBRIA
Tiber
PICENUM
SUBURBICARIUM • Split
MOES

LUSITANIA
Tejo
CARTHAGINIENSIS • Saragossa
CORSICA
VALERIA DAC

Guadiana Merida
④ • Tarragona
⑥ Rome • SAMNIUM PRAEVALITANA

BAETICA
Guadalquivir
• Seville
CAMPANIA
APULIA
AND • Barletta
EPIRUS
NOVA

BALEARES
SARDINIA
ITALIA
SUBURBICARIA
CALABRIA
LUCANIA • Tarentum
AND
BRUTTIL

• Carthago Nova
EPIR
VET

Cherchell
Cheliff • SICILIA
MAURETANIA
TINGITANA
MAURETANIA
SITIFIENSIS
Hippo • Tabarka • Piazza
Armerina

Cirta • • Carthage
Medjerda
MAURETANIA CAESARIENSIS AFRICA

Moulouya
NUMIDIA • Sousse

BYZACENA

Medite

⑤

A F R I C A

• Tripoli

TRIPOLITANA
Lepcis
Magna
LIB

SUPERIO

The three Praetorian Prefectures

Prefecture of the Gauls
Frontiers of the Empire at the
death of Theodosius I (395)

Prefecture of Illyria,
Italia and Africa
Line of demarcation between the Empire
of the east and the Empire of the west in 395

Prefecture of the East
Boundaries of the Dioceses

① The fifteen dioceses according to the 'Notitia Dignitatum'
(end 4th–beginning 5th cent.)

Boundaries of the Provinces

Territory abandoned during the 3rd century

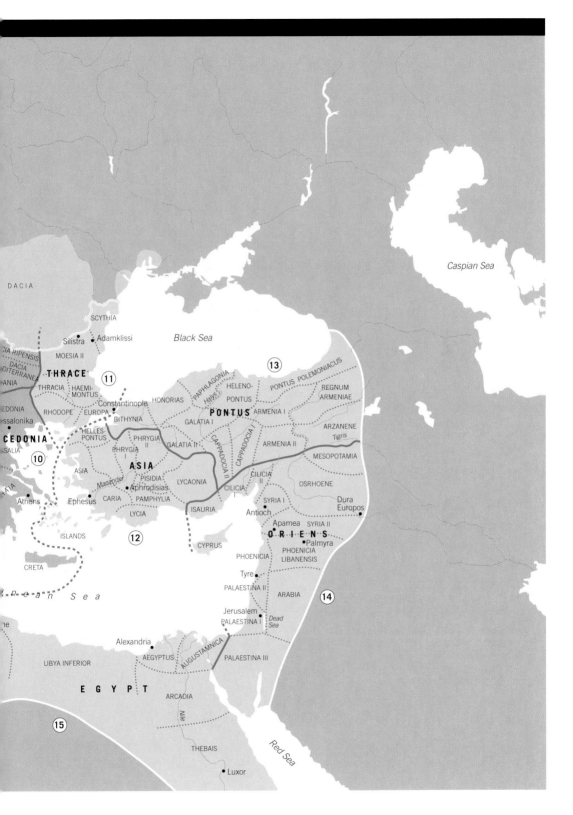

DACIA

SCYTHIA

Black Sea

Caspian Sea

Silistra • Adamklissi

MOESIA II

CIA RIPENSIS

DACIA
DITERRANEA

ANIA

THRACE (11)

THRACIA HAEMI-
MONTUS

EDONIA

RHODOPE EUROPA

ssalonika

HONORIAS

Constantinople

BITHYNIA

CEDONIA (10)

HELLES
PONTUS

PHRYGIA
II

PHRYGIA
I

GALATIA I

GALATIA II

PAPHLAGONIA

Halys

HELENO-
PONTUS

PONTUS

ARMENIA I

(13)

PONTUS POLEMONIACUS

REGNUM
ARMENIAE

ARZANENE

Tigris

SALIA

ASIA

ASIA

PISIDIA

Maeander

• Aphrodisias

LYCAONIA

CAPPADOCIA I

CAPPADOCIA II

ARMENIA II

MESOPOTAMIA

Athens •

Ephesus •

CARIA

PAMPHYLIA

CILICIA
II

OSRHOENE

CILICIA
I

Dura
Europos •

ISLANDS

(12)

LYCIA

ISAURIA

CYPRUS

Antioch •

SYRIA I

Apamea

SYRIA II

ORIENS

• Palmyra

an Sea

CRETA

PHOENICIA

PHOENICIA
LIBANENSIS

Tyre •

PALAESTINA II

ARABIA

(14)

e

Jerusalem •

PALAESTINA I

Dead
Sea

Alexandria •

AUGUSTAMNICA

LIBYA INFERIOR

AEGYPTUS

PALAESTINA III

EGYPT

ARCADIA

(15)

Nile

THEBAIS

Red Sea

• Luxor

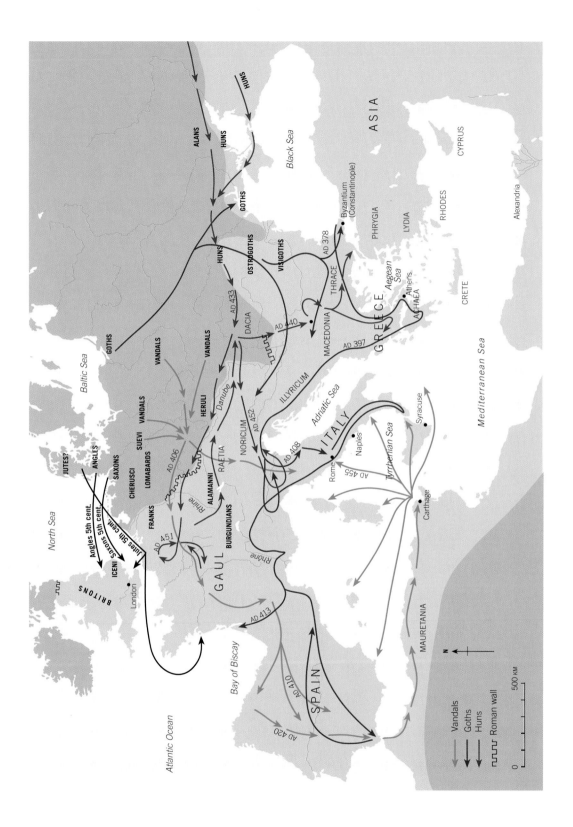

This map shows the west- and southward advances of the Germanic tribes and the Huns in the fourth and fifth centuries. However, the impression given of the empire's collapse under relentless barbarian assault is misleading: many of the Germanic tribes became rapidly Romanized or assimi- lated into Roman culture and sovereignty, while others conquered and ruled over populations which continued for some time to live according to Roman patterns.

Introduction

1

The scope of this book: redefining the present by rewriting the past

This book is about the arts of the Roman world from the height of the Roman empire in the second century AD (under a series of famous 'good' emperors like Trajan and Hadrian, Antoninus Pius and Marcus Aurelius) to the fully established Christian empire of the fifth century. It explores Roman art in what have traditionally been seen as three phases of Roman history: the triumphant second century (famously described by Edward Gibbon as 'the period in the history of the world during which the condition of the human race was most happy and prosperous'); the so-called 'crisis' of the third century when military, economic, and social turmoil is represented as creating the conditions for a radical transformation of Roman culture; and the empire of Constantine and his successors, when a new religion and highly innovative modes of cultural life came to redefine the Roman world. We confront the arts of Rome in their moment of maximum stability as mature exemplars (visual as well as social) of the classical tradition, and in a period of change, whose results would inform the arts and culture of the Byzantine and western middle ages for over a thousand years.

It may seem strange, on the face of it, for a book about the history of art in the Roman empire to begin in what appears to be the middle of the story—in the second century AD. After all, this is more than a century after the imperial system had been established by Augustus following his great victory over Mark Antony at the battle of Actium in 31 BC. In fact, most books on Roman art tackle the periods of the Republic and the Empire, finishing conveniently with the alleged end of paganism and the affirmation of Christianity under Constantine in the early years of the fourth century AD. To end the story with the coming of Christianity ignores the fact that the post-Constantinian empire saw itself as entirely continuous with its pagan ancestor: Constantine's visual image-makers incorporated sculptures from the reigns of his distinguished second-century predecessors, Trajan, Hadrian, and Marcus Aurelius in his arch in Rome [1], while the emperors Theodosius (378–95) and Arcadius (383–408) erected columns in Constantinople carved with spiral friezes showing their illustrious

Detail of 73

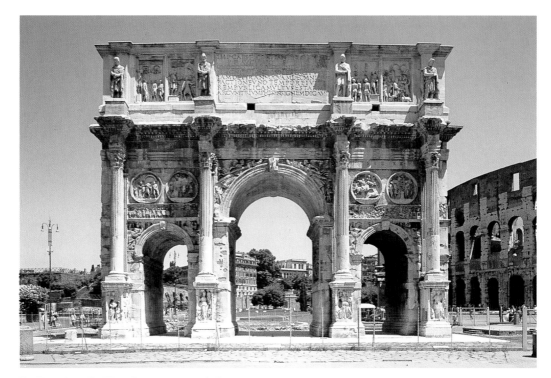

The Arch of Constantine, erected on the Via Triumphalis in Rome, in honour of Constantine's victory over Maxentius in AD 312 and of his *decennalia,* or tenth anniversary as emperor, in AD 315.

Of the visible sculpture, the reliefs in the top storey, on either side of the inscription, come from a monument made for Marcus Aurelius in the late 170s. The statues on the upper level, representing Dacian prisoners, probably come originally from the forum of Trajan and date from the second decade of the second century AD. The roundels in the middle tier above the smaller bays come from a monument erected under Hadrian from the 130s. The remaining sculpture— the spandrels over the arches, the bases of the columns at ground level and the friezes above the smaller bays— is Constantinian.

victories, following the model of the famous Roman columns set up in memory of Trajan and Marcus Aurelius (see **36, 37**). At what is usually regarded as the beginning of the story, Republican and early imperial Rome have much in common with the Hellenistic Greek world whose monarchies, established in the eastern Mediterranean, Rome conquered throughout the second and first centuries BC. The story of early Roman art is most interestingly told as a portion of the complex tale of Hellenistic art: it is a narrative of indigenous Italian forms giving way to imperial and cosmopolitan styles which proclaimed dominance over multicultural societies, and a tale of the sometimes burdened, and sometimes playful, inheritance of the previously formed classical Greek artistic canon.

This book begins by asking the question of what is most interesting about Roman art from the end rather than the beginning. If the origins of Roman art lie in the confrontation of the indigenous Italian arts with those of Greece, the end lies in one of the signal transformations in all of world art: the end of Classical antiquity and the rise of Christian culture. This period, known as late antiquity (which lasted from the early third to, at least, the mid-fifth century AD), brought profound changes in social, political, and personal relationships, in the formation of organized Christianity (not only as a religion but also as a dominant cultural system), in the reformulation of attitudes to the family, to sexuality, to the body itself. These transformations were not imposed upon the Roman world but were created by it and within it:

they were made possible by the reinterpretation of history and myth-ology in a completely new, Christian, framework. The very adaptation of so many aspects of Roman culture to the demands of a Christian *mentalité*, was itself an imperialist project on the part of Christianity as the new official religion of the Roman state. Although the transformation of culture on almost every level (and not least in the realm of art and architecture) counts as one of the truly radical breaks in world history, it did not necessarily seem so at the time. In many ways, I will argue, the history of Roman culture had already prepared the ground for the process of unprecedented internal self-transformation.

My thesis is that the dynamics that motivated the great cultural changes of late antiquity already existed within Roman culture, which had long been willing to redefine its present by freely reinterpreting its past. The transformation in culture which brought Roman paganism (by which I mean here also its social, religious, and economic structures, as well as its forms of visual and architectural representation) to an end, is a process whose success was anticipated by earlier changes in Roman culture. One of the persistent cultural features of the Roman world was its ability to reinvent itself while preserving a rhetoric of continuity. The present could be radically transformed above all by rewriting the past so that the new patterns of the present appeared as a seamless development from the past. Roman historians, from Livy in the age of Augustus to Cassius Dio in the third century and the Church historian Eusebius in the fourth, were among the prime masters of this art.

A famous example of this double strategy, whereby the political and social realities of the present are fundamentally changed while the myth-history of the past is spectacularly redefined, was the moment when Augustus transformed the established forms and rituals of the Republic into the new model of a monarchy. While constantly affirming continuity with the Republic, which he claimed to be restoring, Augustus set about creating an entirely new structure of rule. All the complex politics of the formation of an imperial system were bolstered by a pervasive cultural programme (in the visual arts and in literature) which redefined Rome's history in terms of the mythology of Augustus' family (reaching back to Aeneas, the legendary ancestor of the Roman people) and which reconceptualized Rome's relations with the Greek world, whose Hellenistic monarchies formed Augustus' model for an empire dominated by a single ruler.

However, Augustus' establishment of what is known as the *principate* (since the system was dominated by the single figure of the *princeps*, or emperor) was only the first of a series of such changes whose culmination would be Constantine's espousal of Christianity. This book opens with the second great transformation of Roman culture in the imperial era—the phenomenon known to history (for so

it was named by its first historian, the third-century Greek writer Philostratus) as the *Second Sophistic*. In this period—less in fact an era with specific dates at either end than a new cultural outlook which took hold of the empire gradually from the second half of the first century AD and rose to its zenith in the second and early third centuries— Rome again profoundly redefined its past. The late Republic and early Empire had affirmed a strongly Italic, Roman identity against the pervasive influence of all kinds of Greek luxuries and debaucheries (at least this had been the rhetorical position of aristocratic Romans, writers, and governors). But as shaped in the Second Sophistic, the Roman world became much more directly philhellenic in attitude, culture, and education: it became Graeco-Roman. That is, where earlier Roman imperial attitudes had affirmed a political and moral superiority over other nations and especially Greece, the Second Sophistic created a more integrated and holistic cultural system based largely on Greek educational values and on shared Graeco-Roman mythology.

Consider these famous lines from Vergil's *Aeneid* (VI. 847–53), written in the second half of the first century BC under Augustus:

> Let others better mould the running mass
> Of metals, and inform the breathing brass,
> And soften into flesh a marble face;
> Plead better at the bar; describe the skies,
> And when the stars descend, and when they rise.
> But Rome! 'tis thine alone, with awful sway,
> To rule mankind, and make the world obey:
> Disposing peace and war thy own majestic way.
> To tame the proud, the fettered slave to free,
> These are imperial arts, and worthy thee.

This passage (rendered here in John Dryden's translation), with its appropriation of the arts of government to the Romans and its relegation of the other arts—less important to an imperial conqueror, like rhetoric, sculpture, and astronomy—to 'others' (which means primarily to the Greeks), could not have been written in the Second Sophistic. It marks a sentiment of Roman-centred imperial snobbery which was quite simply out of date by the middle of the second century AD.

Compare the contemporary responses to the emperor Nero's infatuation with all things Greek in the sixties AD, which was ahead of its time and was roundly vilified as a perfect example of every sort of moral, sexual, and personal iniquity, with those to the greater (if perhaps less flamboyant) hellenophilia of Hadrian—emperor from AD 117–38, less than 60 years after Nero's fall. While Nero was damned for his Greekness, Hadrian was praised. Yet the latter not only spent years in the Greek-speaking provinces of the empire (longer in fact than Nero) and pioneered an impressive programme of investment and

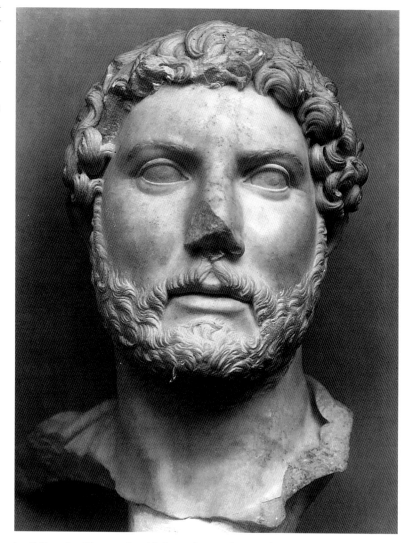

2

Marble portrait of Hadrian from Rome, made after AD 117.

Like Augustus before him, Hadrian (who acceded to the purple aged 41 and reigned for 21 years) hardly ages in the portrait-types which survive of him, even those designed and carved relatively close to his death. This example, broken at the neck, preserves the upper folds of a military mantle about the shoulders. The visual rhetoric of the bearded philosopher king was thus set effectively against the traditional military intimations of the victorious general.

building in Greece itself, but changed significantly such important aspects of his representation as the imperial portrait—which had always been clean-shaven in the Roman Republican style, but was now bearded in emulation of the Greek philosopher king [**2**]. Increasingly, literature throughout the Roman world came to be written in Greek and education came to be offered by Greek teachers of rhetoric, called sophists, travelling through the empire. One of Hadrian's successors as emperor, Marcus Aurelius, even composed philosophical meditations, writing in Greek.

Art not only reflected the changing values of the Second Sophistic, it was also an agent of change. Images gave popular currency to new, philhellenic, styles (like Hadrian's beard) and to new forms of material culture which had previously been unfamiliar. On a much less elevated social level than imperial portraiture, burial practices changed from the

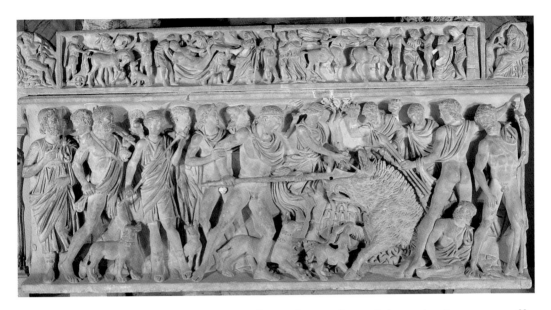

3

Marble sarcophagus from Rome with the myth of Meleager, *c.* AD 180. One of nearly 200 extant examples of this theme from Greek mythology.

In the centre, Meleager is about to kill the Calydonian Boar, surrounded by other huntsmen. Atalanta, with whom Meleager fell in love, is depicted twice—behind him and immediately in front of him, attacking the boar. Unlike the male hunters, who are for the most part nude, she is draped and wears boots. On the lid, Meleager's dead body is carried back home in solemn procession, while his mother Althaea commits suicide (on the far right).

traditional Roman form of cremation to inhumation in a stone coffin called a sarcophagus. These sarcophagi came to be carved not only with family portraits (as had earlier Roman grave reliefs) but also with scenes from Greek mythology, such as the confrontation of Meleager and Atalanta with the Calydonian Boar [3]. Both on an imperial and on a private level, in the most public images of the emperor's portrait and in the most personal themes chosen for one's tomb, there was a persistent affirmation of a *Greek* cultural past and ancestry for Roman subjects from all over the empire. Art, in propagating these themes and myths, often to a barely literate audience of viewers, had a prime function in spreading cultural identity and defining change.

One of the conspicuous achievements of the Second Sophistic was the empire's reformulation as a culturally integrated whole. The peoples of the entire empire, from Britain and Spain to Egypt and Syria, shared not only a single currency, an economy, an army, and a government, but also an ideology of common Graeco-Roman myths, of public rituals (such as the games), and of religious practices (including the cult of the emperor). In the early third century, the emperor Caracalla extended the rights and privileges of Roman citizenship to all the free inhabitants of the empire. And throughout the third century the position of emperor was largely occupied by men from the distant provinces (for instance, Africa, Palestine, Syria, Illyria) and even from very lowly social backgrounds: if we believe the Christian apologist, Lactantius, the emperor Diocletian appears to have been the son of an ex-slave (and whatever the truth of this, his father was certainly of relatively low rank). There was great religious tolerance of local diversity, except in the case of those few religions which were themselves anti-pluralist and refused to tolerate the worship of any

gods but their own—Christianity, Judaism, and other monotheistic sects, like Manichaeism, being the classic examples. There was also a great deal of travel through the empire (for military, economic, educational, religious, and touristic reasons) bringing the spread of a number of formerly localized cults to a very wide area. In the third century AD, for instance, the worship of Mithras (originally an Iranian deity from outside the Roman empire's sphere of influence) is found in its Roman form scattered from Hadrian's Wall and London to Rome and Ostia, from Germany to Spain, from Gaul to Dura Europos in Syria. Indeed it was the very universalism of the Second Sophistic—its tendency to spread a common culture of education, expectations, religion—which would serve to help prepare the empire for its rather surprising takeover by the adherents of one very specific religious cult which combined claims for universal salvation with a profound understanding of the power of education through literacy.

If the empire could experience profound change during an era of relative political stability and social coherence, it is not surprising that—in response to crisis—the Roman world should again be willing to embrace fundamental transformation. For example, in the 280s and 290s, Diocletian (284–305) radically reorganized the military, economic, and administrative structure of the empire into a 'tetrarchy' or college of four joint emperors who, acting together, could best resist the terrible threats of barbarian invasion and internal turmoil that had nearly overthrown the state in the previous 50 years. This change, in many ways as significant as Augustus' original transformation of the Republic into an empire, was presented as a revival of the traditional religion and culture of Rome—with Diocletian and his senior co-emperor, Maximian, presented as embodiments of Jupiter and Hercules.

Likewise, in the fourth century, Constantine, who became one of the tetrarchs after 306, reconquered the whole empire, placed it under his sole dominion and reformulated it (building on many of Diocletian's innovations) in what was to become a Christian mould. Between 313, when Constantine legalized Christianity (a religion severely persecuted only a decade earlier by Diocletian) and 391 when Theodosius banned sacrifice, the central sacred rite of every form of ancient paganism, the Roman empire underwent remarkable changes in its religious life and identity. The espousal of Christianity precipitated a still more significant break with the past than even the Second Sophistic's affirmation of a Greek cultural heritage for the whole Roman world. The pluralist polytheism of literally dozens of mutually tolerant religions was replaced by a single exclusive initiate cult, to which—by roughly the sixth century AD—it became virtually impossible not to belong, if one wished to get on in the world. The relatively loose structure of imperial provinces, governors, and cults which had controlled the empire gave way to a system underpinned by a universal

Church which combined authority with a strongly coherent belief system at its core. Ultimately, the *political*, *cultural*, and *geographic* sense of Graeco-Roman identity associated with being a Roman citizen in the period of the Second Sophistic was transformed into a *religious* identity which focused on Christianity as being the deepest mark of belonging to the Roman world.

The process was complex and slow. The visual arts were not only one of the areas where change (in style, form, subject matter, iconography, even the types of objects produced) was most visible and pronounced; they were also a key agent in transmitting the meanings of the empire's new Christian identity to its subjects. Once again, the Roman empire changed its present by rewriting its past. The origins of the new Christian dispensation for the Roman world were to be traced jointly in the imperial pagan past and in the Old Testament (Jewish) scriptures of a small religious sect whose Hebrew writings had been entirely unknown to the vast majority of Roman citizens during the long history of the empire. The present, a Christian present, was rewritten in terms of a Jewish past (told in the books of the Greek translation of the Hebrew Bible, known as the Septuagint); and to these supremely important narratives, access was permitted through rituals of initiation like Baptism, through a religious education in a whole new sacred mythology and through the visual images which juxtaposed Christian and Old Testament themes. A new method, called 'typological exegesis', was developed for understanding the connections of past and present. The copious writings and commentaries of the Church Fathers (themselves drawing on rhetorical and philosophical methods of argument going back to Plato and Aristotle) created ways of tying Christian events, like the Crucifixion and sacrifice of Jesus, to their Old Testament foreshadowings or prototypes—for instance, Abraham's attempt to sacrifice Isaac, his only son [4]. The results of such complex typological connections were transmitted directly and fluently to (often illiterate) Christian believers in works of art and in sermons.

Continuity and change

The traditional picture of Roman history in our period is one of cardinal change. The principate of Trajan (AD 98–117) marked the last and highest point of Roman military expansion, with the triumphant conquest of Dacia in the wars of 101–2 and 105–6 (celebrated repeatedly in works of art like Trajan's column, his victory monument at Adamklissi, and other relief scuptures in Rome [36, 53, 84], and the extension of Roman military control far into Armenia and Parthia in the east. By contrast, Hadrian's reign (117–38) saw a shift from a policy of conquest to the manning of boundaries as defensive barriers, most potently visualized by the building of Hadrian's Wall. The essentially defensive,

4

The sacrifice of Isaac, fresco from the Via Latina Catacomb, cubiculum C, Rome, painted c. AD 320.

Abraham raises his sword to slay his son, according to the text in Genesis 22. 1–14. Above left, the hand of God has been lost. Beside Abraham is a sacrificial altar with burning wood and the ram which God has provided to be killed in Isaac's place. Below is an extra textual addition of a servant with a donkey. Abraham's willingness to sacrifice his only son came to be seen as a typological foreshadowing of God's willingness to sacrifice Jesus in order to save the world.

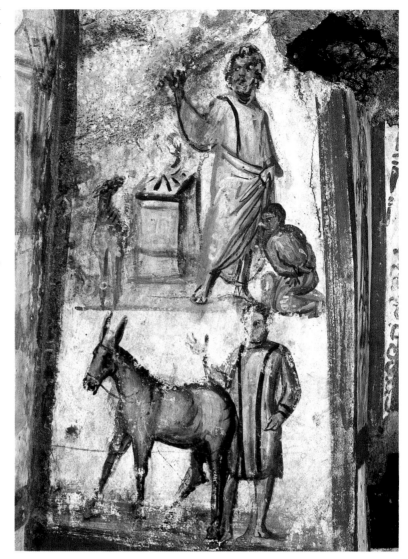

rather than aggressive, nature of late-Roman warfare became the norm as early as the last quarter of the second century, when Marcus Aurelius was forced to fight a series of northern wars in the 170s against various nomadic barbarian tribes (celebrated in the sculpted reliefs of his column in Rome [**37**]). The movements of the barbarians from Asia into central and northern Europe, and their attempts to infiltrate the empire in search of booty or settlement, were a continual factor from the late second century. But in the fourth century, the arrival of the Huns at the Danube in 376 exerted a decisive pressure on the tribes settled around the empire's northern borders to move west and south. The resulting invasions into the territories of the Roman state would ultimately overwhelm the empire in the west. In the first half of the fifth century, the Vandals would take control of North Africa, the

Visigoths would invade Spain, and a series of tribes—not least the Goths and the Huns—made repeated incursions into Italy.

Against such pressure, it is not surprising that the fabled force of Roman arms occasionally gave way. Certainly, it is hard to compare Trajan's spectacular victories in Dacia and Parthia with the defeat of the emperor Valerian by the Sassanid successors of the Parthians in AD 260, the fall of the emperor Valens and the massacre of his army by the Goths at Adrianople in 378, and the sack of Rome by Alaric the Goth in 410, without thinking of decline. Yet we should remember that in the glory days of the late Republic, Crassus, the Roman governor of Syria, had suffered a terrible defeat by the Parthians at Carrhae in 55 BC, while in AD 7, during the later years of Augustus, the general Varus along with three entire legions had been slaughtered in a battle in the German forests. One of the great successes of late-Roman military policy was the integration of Romanized (and often Christianized) barbarians not only into the army but even into the highest offices of the state—for instance, the pagan Frankish general Arbogast and the Christian Vandal regent Stilicho, both of whom held power in the later fourth and early fifth centuries.

The dynamics behind the story of radical change depend especially on the notion of a third-century crisis between AD 235 and 284, marked by a rapid turnover of emperors, virtually continual warfare (internal and external), as well as the collapse of the silver currency and the government's recourse to exactions in kind. This crisis has been seen as providing the impetus for the fundamental military, administrative, financial, and religious reforms under Diocletian (284–305) and Constantine (306–37). Yet this emphasis—for all its persuasiveness in charting the passage from antiquity to the 'Dark Ages'—may be profoundly misleading. In part, we are dependent on sources, largely written for and about the imperial court, which inevitably but perhaps unjustifiably see emperors and other 'major players' as the centre and the motivators of the action. But were the emperors the main agents of change? Certainly rulers (and their tax collectors) are seldom irrelevant to their subjects, but they may have bulked far smaller in the daily lives of the empire's populations than our sources would like us to imagine. On many of the great estates and in the empire's metropolitan centres (especially in the east), it may be that the primary impression—apart from the news of particular, temporary, crises—was one of resplendent continuity with the hallowed past. The traditional patterns of education, the strength of archetypally Roman social rituals (such as the baths, the amphitheatre, and the banquet) and not least the functions of the arts themselves, speak of manifold and deep continuities, despite the apparently objective nature of change.

Change may, in effect, be more *our* perception, reading the surviving entrails of the empire from the outside (as it were), than the

perception of those who lived at the time. Many social changes—and not just those that took place in the period of the Second Sophistic— were imperceptible and their impact was slow. In the arena of the arts, it is striking that once one has eschewed a conventional stylistic account in favour of a thematic analysis of images according to their social and cultural functions, the evidence points towards very deep continuities. From the end of the third century, the patterns of patrician patronage, the culture of wealthy villas and their decoration, the lavish accoutrements of the dinner table, the continuing adornment of cities with impressive new buildings (especially churches)—all this seems to have been virtually unaffected by military or economic crisis. Imperial art continued to propagate all the time-honoured forms of public display through images—bronze and marble statuary, state reliefs and dedications, columns and triumphal arches—well into the fifth century. Private art preserved the pre-Christian culture of Second Sophistic Hellenism in its visual narratives and its iconography well beyond the end of the fifth century. Far from fading into the twilight of the Dark Ages, Roman architecture—whose most important surviving monument in our period was Hadrian's Pantheon in Rome—would continue its exploration of domes, vaults, and space into the building of Christian churches. The culmination of this process, in the sixth century, would be perhaps the greatest of all Roman buildings— Justinian's monumental church of St Sophia in Constantinople.

The role of the visual in Roman culture

> *spectatum veniunt, veniunt spectentur ut ipsae*
> Ovid, *Ars Amatoria* I.99

In several significant ways, the Roman world was a *visual* culture. It was a society of public rituals—religious (both pagan sacrifice and the Christian liturgy), social (for example, the gladiatorial displays, chariot races, and the animal fights of the amphitheatre), and intellectual (as in the great public rhetorical debates between sophists, doctors, and other kinds of academics, sometimes conducted in the presence of the emperor himself). These rituals were intensely visual: the audience or congregation went both to watch and to be seen (as the poet Ovid wrote of women going to the theatre in his *Ars Amatoria*). It was a culture whose fictions, in the form of romantic novels, emphasized the vivid portrayal of other countries, of described pictures, of the processes of looking and being looked at. It was a civilization which theorized the visual more intensely than at any other time in antiquity— especially through the literary descriptions (*ekphraseis*) of works of art, paintings, and sculptures, in writers like Lucian (in the second century), the elder and younger Philostratus (in the third), and Callistratus (perhaps in the fourth).

With the vast majority of the empire's inhabitants illiterate and often unable to speak the dominant languages of the élite, which were Greek in the east and Latin in the west, the most direct way of communicating was through images. People learnt about their emperor—who he was, what he looked like, the attributes of his power—through his portrait on coins which circulated on all social levels throughout the empire, in paintings and in the statues which occupied prime positions not only in civic and public space but also in the temples of the centre and the provinces, especially the temples of the imperial cult. Such images, confronting the empire's subjects in every mode of their social, economic, and religious lives helped to construct a symbolic unity out of the diverse peoples who comprised the Roman world by focusing their sense of hierarchy on a supreme individual. When an emperor died, his heirs might laud his images as those of a god—proclaiming a continuity of succession and erecting temples in his honour. When an emperor was overthrown, his images were often violently eradicated in a *damnatio memoriae*, an abolition of his very memory, which informed the populace graphically and compellingly of the change in political authority at the top.

However, the role of images in the spread of political information was, before the coming of Christianity, in many ways dependent on their role in religion. People knew their gods *through* the statues which depicted them, with a statue's particular attributes in a specific site often marking a local myth or ritual variation of a more general sacred cult. Ancient polytheism was not a religion of written scriptures and doctrines, under the structure of a hierarchical and organized Church. It was an immensely varied series of local cults, myths, and rites, administered by local communities and often hereditary priesthoods. It was eclectic and diverse, largely pluralist, and tolerant. Images and myths provided the main forms of 'theology' in the ancient world— giving worshippers the means to recognize and think about their gods. When pilgrims went to a temple to receive an oracle or a cure through a dream, for instance, it was through his appearance that they would know the god, and by the brightness of the deity's face or the sternness of his countenance that they would interpret his divine message.

With the coming of Christianity, the role of art in religion changed radically, though it did not lose its central importance. The Christian God, unlike His pagan predecessors, was known not through graven images but through a sacred scripture. That body of texts—not only the Bible in the early period, but a great range of what are now known as apocrypha, gradually excluded from the Orthodox scriptures, together with a plethora of commentaries written about the scriptures by various theologians and bishops—was not accessible at first hand, except to the literate few. The sacred texts had to be expounded through sermons, heard directly by congregations, and through

images, seen directly by worshippers. The spread of Christianity, not only its presentation of the Ministry of Jesus and his apostles but the theological linking of those stories with the Old Testament narratives which were seen as precursors to the events of the Gospels, was facilitated by, indeed was to some extent dependent on, images. This was to occasion some concern in the Church's hierarchy, since art necessarily simplified, often misinterpreted, and sometimes falsified the complex tenets of the Faith.

On a more social level, it was through public buildings (the baths, the arena, the market place, the gymnasium) that a distinctively Roman way of life was propagated in the cities of the empire from Asia Minor and Syria to Spain, from Africa to Gaul. The rituals of cultivated Roman living—of bathing, of dining, of gladiatorial fighting and animal slaughter in the arena, of public and private sacrifice—were systematically displayed in the villas and houses of the élite. The magnificently decorated mosaic floors surviving from every province and the lavish silverware which adorned the dinner-tables of the wealthy amply attest the power of images in reinforcing these quintessentially Roman modes of civic life. Art and architecture made possible the rituals of Roman daily life, images naturalized the appropriateness of that life through repeated representation; together those rituals and images formed a potent means of 'Romanization'—of bringing the still ethnically, linguistically, and culturally diverse communities around the Mediterranean into a single imperial polity. While some of these rituals, notably public sacrifice, were brought to an end by the coming of Christianity, most—such as the élite symposium or the games—continued through late antiquity and were actively propagated by the imperial government in Christian times.

One way to build a coherent cultural background, to bind the peoples of the empire together, was to emphasize a shared cultural heritage based on the classical myths and literature of Greece (and to some extent of Rome itself). This was a particular achievement of the Second Sophistic, and on the visual level it is one way to explain the presence of so many mythological representations of themes like Narcissus, Dido and Aeneas, Meleager and Atalanta. They formed a loose cultural identity for the citizens of the empire which could knit together the villa-owner in Britain with his contemporaries in Antioch, Carthage, or Cyprus. Later, Christianity—as a religion of initiation and repeated participation in sacred ceremonial and mysteries—would form a still closer ideological narrative to construct a shared identity and bind the peoples of the empire together; but even in the first centuries after Constantine's conversion, many Christian Romans still asserted their Hellenic identity by surrounding themselves with the images of the literary and mythical canon. In a sense, before the advent of Christianity, such mythological images defined the loose

combination of the secular and sacred modes of polytheistic living; after the conversion of Constantine, they came to define the secular world by contrast with the sacred, Christian, world—until that secular culture was (after our period) finally all but eliminated.

The bulk of our images come from the milieu of the upper or governing classes, who could afford the luxury of possessing art, and depict their ways of life as they wanted to be seen. Art represents the world not as it was, but as those who paid for or produced it wished the world to be. Slavery, that (to us) cruel but fundamental pivot of the ancient economy, is depicted in art [**17**, **60**, **66**] not as it was (from the slave's viewpoint) but as it was seen (from the master's). Women, whose position was central both to social life (whether as wives or as prostitutes) and to the ancient economy of inheritance, were also widely depicted—but inevitably from the predominant male point of view. There is very little by way of an independent female voice in ancient Roman culture, whether pagan or Christian; but there was always a strong mythological, imperial, religious, and familial assertion of the normative images of womanhood in its prime roles as goddess, empress, priestess, and mother. With the coming of Christianity, many of the forms of normative womanhood would change—from wife, priestess, and goddess to holy virgin, martyr, and above all the Virgin Mother of God.

Finally, just as our images are limited as a portrait of their world by the ideologies of those who commissioned, made, and viewed them, so our access to antiquity is limited not just by our own presuppositions, but by the history of attitudes, archaeology, and taste leading up to us. Many things—often the prime masterpieces of ancient art—have been lost, whether by neglect, by deliberate destruction (of a pagan god's statue by Christians, for instance) or by the greed of later owners (as when Pope Urban VIII plundered the bronze beams of the Pantheon's portico in the 1620s to provide metal for cannons and for the altar canopy designed by Bernini for St Peter's). We necessarily write our history looking not at antiquity as it was, but at the visual, archaeological, and literary fragments which survive. Sometimes these are rich, as in the personal correspondence between Marcus Aurelius and his tutor of rhetoric, Fronto, or in the surviving imperial sculpture in Rome, and give what appears to be a precise and accurate picture of the reality (though we should always be wary of generalizing from too much detail—we have relatively little of Marcus' equally prolific correspondence with anyone else); sometimes the remains are poor, as in the case of ancient painting from our period, and leave us only the scope for the most sketchy of accounts.

The changing nature of Roman art and the art-historical problem of style

This book explores the way art both reflected and helped precipitate the cultural changes of the Roman world. Moving from a period of political stability to one of greater uncertainty, from the supreme self-confidence of the imperial establishment during the Second Sophistic to the religious conversion of late antiquity, we will observe the functions, forms and transformations in visual images—in their uses, their appearance, and their scope. One, perhaps surprising, element in the story—given the tremendous changes in the period—is how much, especially in the imagery and social functions of art, proclaimed continuity. The stylistic and thematic eclecticism, the veneration for the classical arts of the past, and even many pervasive visual motifs (from the arena to pagan mythology, from hunting to the illustration of literary themes)—all these characteristics of second-century art are equally true of the arts of the Christian fourth and fifth centuries, despite the changes of meaning and emphasis which some of these motifs underwent.

Usually the story of Roman art in late antiquity is told as the narrative of a radical transformation in the *forms* and *style* of visual images. The period with which this book opens produced some of the greatest and most influential masterpieces of naturalistic sculpture which have survived from antiquity. It was by such magnificent marble statues as the Apollo Belvedere (probably made in the first third of the second century AD [5], or the Capitoline Venus (dating also from the mid-second century) that the Renaissance's love affair with naturalism was inspired. The Apollo Belvedere, probably a copy of a bronze original by Leochares of the fourth century BC, was one of the most celebrated and influential of all Classical sculptures during the Renaissance. After its discovery (sometime in the later fifteenth century), it found its way by 1509 into the papal collections, where it remained one of the prize exhibits in the Belvedere courtyard of the Vatican. It was through such images that the history of the rise of classical naturalism has been written. There were other supremely skilful variations on and creative copies of great sculptures made by Greek artists, like Leochares or Praxiteles, in the fifth and fourth centuries BC. Likewise our period saw the creation of some of the most magnificent 'baroque' sculptures of the Roman period—for instance, the Farnese Hercules [114], itself a version of a famous statue by the fourth-century Greek artist Lysippus, or the Farnese Bull [121] (both from the early third century AD, and found in the Baths of Caracalla in Rome)—spectacular carvings which played with the full scope of naturalistic imagery, extending its limits to flamboyant and 'mannerist' effect.

Yet, by the fourth century AD, the outstanding classical heritage of the arts which imitated nature and created an impression of lifelike

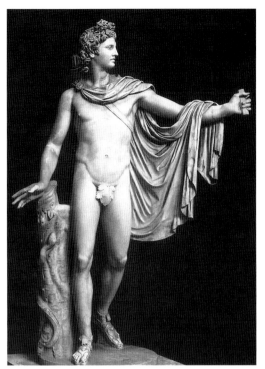

5

Marble statue of Apollo, from the first half of the second century AD, known as the 'Apollo Belvedere'.

Left: The statue as restored in the 1530s, with the addition of the right forearm, the left hand, and the fig-leaf. Such resorations—often highly fanciful and sometimes constituting downright forgeries—were frequent in the antiquities market of the Renaissance and Grand Tour. *Right*: The statue as restored after the Second World War, with most of the non-antique accretions (except the fig-leaf) removed. Whether the modern concern to return such marbles to their 'authentic' form constitutes an improvement is, and will remain, a moot point.

realism began to be replaced by non-naturalistic modes of representation. For example, compare the roundel of the emperor Hadrian sacrificing to the goddess Diana [**6**], originally carved for a public monument in the AD 130s (about the same time as the Apollo Belvedere) and later incorporated in the Arch of Constantine, with the bas-relief frieze of the emperor Constantine addressing the Roman people from the rostra in the Roman forum, sculpted for the Arch of Constantine nearly 200 years later [**7**]. Both scenes are symmetrical compositions, but note the spacial illusionism of the Hadrianic tondo with its clear marking of foreground and background figures (Hadrian—whose face was later recut—on the viewer's right-hand side, stands in front of the statue of Diana with a cloaked attendant behind him to the right). The draperies of the figures on the tondo fall naturalistically about their bodies giving an illusion of volume and mass, of limbs and space. The plinth of the cult statue, which is placed in the open in front of a tree, is itself offset at an angle, giving an impression of perspective which is reinforced by the disposition of the figures.

By contrast, the Constantinian *adlocutio* (or address to the populace) has eschewed all the visual conventions of illusionistic space and perspectival naturalism so elegantly embodied by the roundel. Background is indicated simply by placing a row of equal-sized heads above the foreground figures, who stand in a line with little hint of naturalistic poise or posture. Draperies, far from exposing the forms of

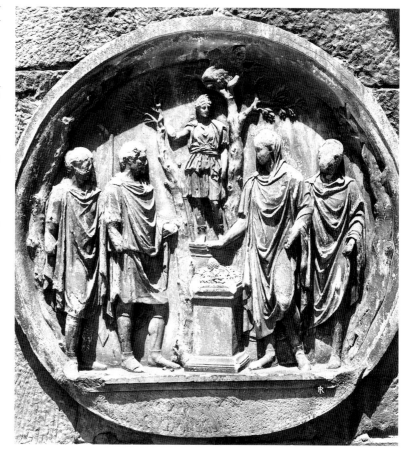

One of eight marble roundels depicting Hadrian hunting, executed in the 130s and subsequently incorporated into the Arch of Constantine.

The series of eight combines a celebration of hunting (an activity for which Hadrian was famous) with a focus on piety and the careful rendering of a rustic setting. Four of the eight scenes depict the act of sacrifice at an altar before the statue of a deity. In this relief (from the south side of the Arch of Constantine), Hadrian, the first figure on the right-hand side, pours a libation to the goddess Diana.

the bodies beneath them, are rendered as drill lines incised into the flat surface: they stand as a sign for clothing but they neither imitate real dress, nor emphasize the physical volumes of the bodies they clothe. There is no sense of perspective, just a flat surface with the most important figures clustered on the raised podium around the emperor, who stands beneath two banners at the centre. In the Hadrianic tondo, the statue is obviously a statue—differentiated in scale from the other figures and placed on a plinth. By contrast, the two seated figures to either side of the rostra in the *adlocutio* relief are not obviously different from the other figures, yet they represent not human figures but *statues* of Constantine's deified predecessors, Hadrian and Marcus Aurelius. The fact that the three highest figures in the relief are Constantine (had his head survived) and the two deceased emperors, works to make the political point that Constantine is their successor, even their embodiment. Both reliefs were displayed together as part of the same monument during the Constantinian period (and thereafter), as the Hadrianic tondo was incorporated into the decoration of the Arch of Constantine in Rome. The tondo (one of eight), with Hadrian's head recut to resemble Constantine or his father Constantius Chlorus, as

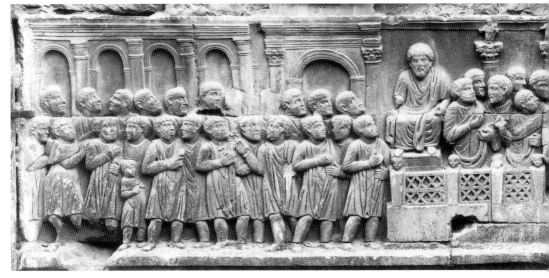

Adlocutio relief, *c*.315, from the Arch of Constantine, showing the emperor addressing the people.

This image is famous for its intimations of late-antique style, including centralizing symmetry, the frontality of the emperor, the stacking of figures, the elimination of illusionism in depicting space. The setting is the Roman forum. Constantine speaks from the rostra. Behind are the five columns of Diocletian's *decennial* monument, of AD 303, crowned with statues of the four tetrarchs and Jupiter in the centre (beneath whom Constantine stands). To the right is the Arch of Septimius Severus (erected in 203); to the left, the arcades of the Basilica Julia and the single bay of the Arch of Tiberius, both now lost.

well as other sculptures from monuments of Marcus Aurelius and Trajan, became part of a complex visual politics designed to legitimate Constantine in relation to the great emperors of the second century.

The arts of the late third and the fourth centuries—not only political images like those on the Arch of Constantine, but also (perhaps especially) the sacred arts—were the crucible in which the more 'abstract' forms of medieval image-making were created. The great variety in the visual forms of the arts in late antiquity make our period simultaneously the ancestor of medieval and Byzantine art on the one hand, and of the Renaissance (which replaced and rejected medieval styles of image-making) on the other. Indeed, the juxtaposition of styles in the reliefs of the Arch of Constantine proved a principal basis for the Renaissance's formulation of artistic 'decline' in late antiquity in the writings of Raphael and Vasari. One of our difficulties as students of the period is that we approach it, inevitably, with preconceptions formulated by the kinds of more recent art we ourselves may enjoy: medieval 'symbolism', Renaissance and post-Renaissance 'naturalism', modernist 'abstraction' and 'expressionism', post-modernist 'eclecticism'. One of the riches of the Roman imperial art explored here is that not only did it have elements of all these qualities, but it is in many ways their direct ancestor.

The stylistic challenge of the juxtapositions of the reliefs on the Arch of Constantine has led scholars in a search through the history of Roman art to explain how and when the Classical conventions governing representations like the Hadrianic tondo gave way to the proto-medievalism of the Constantinian frieze. In many ways the history of late-Roman art has become a quest for the first moment of decline. Among the candidates have been the arts of the Severan period (193–235), those of the Antonine dynasty (in particular, reliefs

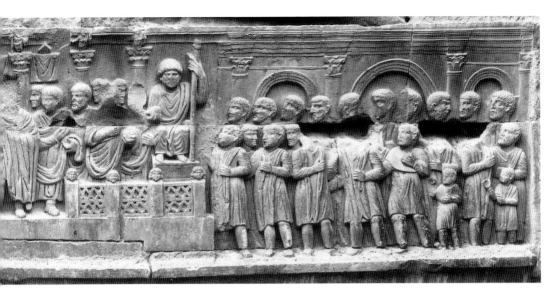

and sarcophagi from the reigns of Marcus Aurelius, 161–80, and Commodus, 180–92), and even earlier art from the lower classes, like the remarkable Trajanic circus relief from Ostia [**14**]. The overwhelming burden of this stylistic story has been a narrative of incremental decline, leading to radical change. It has married perfectly with the traditional and oversimplified historical picture of crisis in the third century followed by the end of Classical antiquity and the onset of the Christian middle ages. Both history and art history have insisted on change, and both have seen formal structure (whether the stylistic forms of images or the administrative ordering of the empire) as responses to a social and stylistic crisis.

However, to examine the visual material with such a strong emphasis on stylistic change has led to a number of errors, or at least overexaggerations. First, the transformation from the illusionistic arts of the second century (and before) to the symbolic arts of late antiquity has invariably been represented as 'decline': decline from the hard-won naturalism of Greek classicism into hierarchic images that no longer imitate what they represent but rather gesture toward their meaning as signs or symbols; decline from the elegant illusionistic evocation of space and perspective in the Hadrianic tondi to the flat surfaces, the stacked, ill-proportioned, and schematically realized figures of the Constantinian friezes. Yet 'decline' is a modern value judgement (specifically a post-Renaissance posture) revealing a particular strand of modern prejudice (or 'taste')—it certainly does not reflect how the Roman world saw its image-making at the time. On the contrary, the designers of the Arch of Constantine appear to have been quite happy to juxtapose images which are stylistically contrasting, even jarring, to modern eyes. Second, while it is true that the Constantinian *adlocutio* relief was an affirmation of an hierarchic and ritualized vision of

empire (looking back in visual terms beyond the relatively abstract arts of the tetrarchs as far as the frontal portrayals of the emperor on the column of Marcus Aurelius and in Severan times [23]), it is impossible to demonstrate that any apparent break in visual forms was dependent on any simple or wholesale change in social structures. True, the whole period from the later second century to the fifth was one in which very profound changes took place; but it was a slow and incremental process lasting several centuries.

Third, the selection of objects for stylistic comparison is always dangerously arbitrary. Had the designers of the Arch of Constantine chosen a different series of second- and fourth-century objects for their juxtapositions, the Arch would have occasioned far less scandal in later centuries. Take, for instance, one of the two *decursio* scenes from the base of the column dedicated by the co-emperors Marcus Aurelius and Lucius Verus in AD 161 to the memory of their deified predecessor Antoninus Pius [8]. Although its small figures are rendered realistically enough, this sculpture—which represents one of the rituals at Antoninus' funeral and deification—ignores the classicizing illusions of perspective and space characteristic of most contemporary sculpture in order to give a rather more schematic rendering of a sacred ceremony. The galloping figures and the standard-bearers around whom the horsemen ride are seen, as a composition, from above (a bird's eye

8

Marble pedestal of the Column of Antoninus Pius, erected in his memory in Rome in AD 161.

The four faces of the pedestal show a scene of imperial apotheosis [13], two virtually identical images of the funerary *decursio* ceremony (one of which is shown here), and a dedicatory inscription. The *decursio* scenes represent a ritual of anti-clockwise circling by mounted cavalry of a group of praetorians with two carrying military standards in the centre

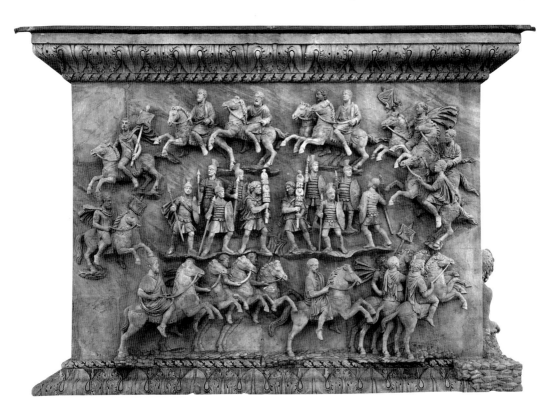

Porphyry sarcophagus of Helena, from her mausoleum on the Via Labicana in Rome, *c.* AD 325.

Despite its use to house the remains of Constantine's sainted mother (died *c.* 329), whose pilgrimage to the Holy Land in 327 led by the end of the fourth century to the legend that she had discovered the True Cross on which Christ had been crucified, this sarcophagus displays no overtly Christian decoration. Its military subject matter, showing Romans in triumph over barbarians, suggests it may originally have been intended for a male member of the imperial house.

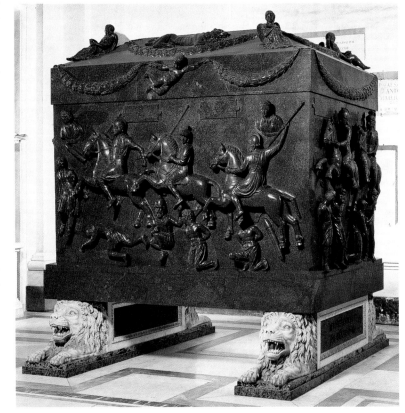

view, as it were), but each figure is carved as if we were looking at it from ground level. The sense of encirclement is achieved, not by illusionism, but by the stacking of rows of figures. There is a fundamental discrepancy (from the naturalistic point of view) between the compositional arrangement—which demands that we be shown only the tops of the riders' heads, since we are looking down from a height—and the depiction of the figures, which would suggest that all three rows should be shown in a single plane. Compare this scene with the fourth-century porphyry sarcophagus of St Helena, mother of Constantine, discovered in the remains of her mausoleum in Rome and depicting the triumph of Roman soldiers over barbarians [**9**]. Despite the fact that it was much restored in the eighteenth century, the sculpture of this object—with its realistic figures but non-illusionistic spatial and perspectival field—is close to the spirit of the Antonine column base. Even the military subject matter and the penchant for stacking rows of figures against an undetermined background is similar in both sculptures. Had carvings like these been juxtaposed on the Arch of Constantine, we might never have imagined them to be over 150 years apart. Beside other, much more coherently naturalistic, Antonine works—including the famous relief of imperial apotheosis carved for the very same column base from the very same block of stone possibly

10

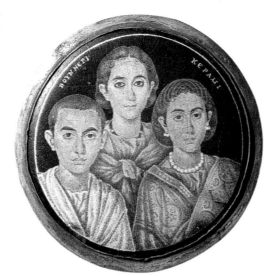

Gold-glass medallion, perhaps from Alexandria, dated anywhere between the early third and the mid-fifth centuries AD.

This family group of a mother, in a richly embroidered robe and jewels, with her son and daughter, bears the inscription BOUNNERI KERAMI. This may be an artist's signature or the name of the family represented.

by the very same artists [**13**]—the *decursio* panel looks decidedly out of place, if one uses purely stylistic critera for judgement. Beside the *adlocutio* relief of the Arch of Constantine, the sarcophagus of Helena looks intensely classicizing. Clearly there was a great deal more stylistic variation within the arts of any particular moment in our period—even in objects produced specifically for the imperial centre at Rome—than any straightforward stylistic comparisons of single objects will allow.

Another approach to the arts of late antiquity—that espoused traditionally by historians of early Christian and Byzantine art—has been to see them teleologically, with the visual changes as part of a wider cultural process which led naturally to the triumph of Christianity and Christian art. To some extent, of course, this is valid as a retrospective way of looking at the material: by (say) the eighth century AD pretty well all pagan themes and naturalistic forms had been extirpated from the canon of visual production. However, the triumph of Christianity (indeed, even its very theological definition) was too haphazard and uncertain, at least in the fourth century, for any attempt to eradicate classicism. Indeed, well beyond our period—into the sixth and seventh centuries—there was a flourishing production of pagan imagery and naturalistic styles on the textiles and silverware used not only by isolated pagan groups in the peripheries of the empire, but even by the imperial Christian court at Constantinople. Also, as we shall see, it was not just Christian art, but also the arts of other mystical or initiate sects in the period before Constantine's legalization of Christianity which encouraged increasing (non-naturalistic) symbolism; and it was pre-Christian imperial art—the art of the tetrarchic emperors of the late third century AD—which imposed the first systematically simplified and schematized forms on the visual propaganda of the Roman world.

My own approach in this book, signalled by choosing the dates with which it starts and ends, is twofold. First, I reject the notion of decline. There are obvious changes between AD 100 and 450 in the styles and techniques used for art, as well as in the kinds of objects produced (for example, late antiquity saw a rise and rapid development in the art of high-quality ivory carving). But there are also profound continuities between the visual productions of the pagan and Christian empires, as the following chapters will show. Take, for example, the beautiful gold-glass medallion from Brescia, which could have been made at any point in our period—its transfixing naturalism gestures towards the second century, while its technique is more typical of objects from the fourth [10]. Perhaps from Alexandria, since its inscription is in the Alexandrian dialect of Greek, it probably found its way early to Italy—at any rate, it was incorporated there in the seventh century in a cere-monial, jewelled, cross. Whenever it was made, and for the duration of its use in antiquity, the imagery of this gem speaks of the continuity and values of family life, of the wealth and patronage of aristocratic élites, of the high value placed on exquisite workmanship from the second century to the fifth.

Second, I have ignored the historiographic divide (virtually a wall of non-communication) between those who write about 'late-antique art' from the point of view of the Classical heritage and those who write about 'early Christian art' from the stance of its medieval and Byzantine inheritance. While the dichotomy is understandable—given the different trainings and expectations with which its upholders were educated—it is, quite simply, false. There was a multiplicity of cultures in the world of the later Roman empire which—far from being exclusive—saw themselves (especially after the legalization of Christianity) as part of a single political entity. The arts of that world were inextricably interrelated. If I have one overriding aim, it is to show how early Christian art was fully part of late antiquity, how—for all its special features—it developed out of, and reacted to, the public and private, religious and secular, visual culture of the later Roman empire.

Part I

Images and Power

A Visual Culture

2

Only very rarely does art function as a documentary description of an actual event (although much of the specialist literature on Roman art is concerned with inferring such events from works of art on the grounds that images may be documentary). Whether one looks at images in the most public of official contexts, like imperial ceremonial, or in the more private—at least, the less official—spheres of daily life, in neither case are we concerned with accurate records of actuality. Rather, art in both the public and private spheres serves as a way of celebrating familiar institutions or rituals—whether these be visiting the baths or the circus in the context of ordinary Romans' lives or the great ceremonies of *largitio*, *adventus*, and so forth in the diary of imperial activity. The representation of such rituals helped to elevate these activities from repeated mundane actions into better performances constitutive of what it meant to be a citizen of the Roman empire. The rituals of Roman life—perhaps even more in the private than in the public sphere—served, more than any other factor, to define what it was to be quintessentially *Roman*. To be a Roman was to do the kinds of things repeatedly represented in Roman art: to dine in a particular manner, to make sacrifice, to go to the baths, the arena and the amphitheatre, to participate as an audience in the official ceremonial events in one's city over which the emperor, or his representative, presided.

The rituals, institutions, and activities in which images were used, or which works of art memorialized, relate to a specific yet dynamic space in cultural experience. They helped to establish—indeed to construct—the identities of Roman citizens on all social levels from emperors to freedmen, from wealthy benefactors to slave girls, in what might be called the space between self and the world. Even in the private house, certain areas were less than 'private' in our sense of the word: areas which were open to the view and even the entry of guests (some perhaps uninvited) and clients.[1] In such 'private' areas, many of the most fundamental Roman social rituals—sacrificial libation, salutation of a patron by his clients, the entertainment of chosen guests at the dinner-table—took place.

The visual arts as a means of defining identity filled (in many ways, created) the social environment in which Romans lived—from some

(if not all) the rooms of their houses to the public spaces of urban life. This was particularly the case in the cities, but was also true of the rural villas and retreats favoured by the élite. In the public and visual space between self and the world, images not only helped to establish the terms on which a collective social identity and subjectivity might be defined. They were also used to announce someone's status within that system, to negotiate issues of ethnicity, class, and gender, to promote a person or family or group (even a city) beyond local confines into the broader cultural ambience of the Roman empire.

Despite some significant changes over the period which this book covers, a focus on the presence of images in Roman culture indicates great continuities. The style of imperial ceremonial (and its representations) may have changed between AD 100 and 450, but the basic ceremonies and the basic rationale behind them (of providing a format where the emperor might be seen by his people) remained remarkably similar. Likewise, in the private sphere, aristocratic Romans continued most of the rituals of daily life from the pagan period into the Christian era, with particular exceptions of course in the realm of religion. But where private libations may have largely given way to going to church by the fifth century, the games and chariot racing (for example) continued to enjoy unabated popularity in the cities, despite some severe condemnation of such frivolities from the Church Fathers. It is these fundamental continuities of identity, ritual activity, and social meaning that an overzealous concentration on stylistic and cultural change tends to obscure.

Art in state ceremonial

The official ceremonials of Roman culture were spectacular. They employed works of art—statues, lavishly embroidered robes, painted banners—not simply as decoration, but also as an essential ingredient of the action. Art could be used to evoke the grandeur of the imperial past, the glorious extent of the empire in the present, the dignity of the great Roman institutions. One striking feature of continuity from the pagan Roman empire of Augustus and his successors to the Christian empire of Constantine and Theodosius the Great, was an emphasis on state ceremonial and grandiose ritual as a way of defining hierarchy and monarchic power. We cannot understand the official art of the Roman state—its most public monuments and celebrations of the emperor— without due regard to the significance of this art as perhaps the prime factor in creating the aura of an august imperial presence.

In this section, I use a number of contemporary and first-hand accounts to evoke the pervasiveness of the visual in the culture of the Roman state. Take the remarkable description of the apotheosis of the emperor Pertinax in AD 193, written by a participant in the event, the Roman senator and historian, Cassius Dio:

Upon establishing himself in power, Septimius Severus erected a shrine to Pertinax, and commanded that his name should be mentioned at the close of all prayers and all oaths; he also ordered that a golden image of Pertinax be carried into the Circus on a car drawn by elephants, and that three gilded thrones be borne into the other amphitheatres in his honour. His funeral, in spite of the time that had elapsed since his death, was carried out as follows. In the Roman Forum a wooden platform was constructed hard by the marble rostra, upon which was set a shrine, without walls, but surrounded by columns, cunningly wrought of ivory and gold. In it there was placed a bier of the same materials, surrounded by heads of both land and sea animals and adorned with coverlets of purple and gold. Upon this rested the effigy of Pertinax in wax, laid out in triumphal garb; and a comely youth was keeping the flies away from it with peacock feathers, as though it were really a person sleeping. While the body lay there in state, Severus as well as we senators and our wives approached, wearing mourning; the women sat in the porticoes, and we men under the open sky. After this there moved past, first, images of all the famous Romans of old, then choruses of boys and men, singing a dirge-like hymn to Pertinax; there followed all the subject nations, represented by bronze figures attired in native dress, and the guilds of the City itself—those of the lictors, the scribes, the heralds, and all the rest. Then came images of other men who had been distinguished for some exploit, or invention or manner of life. Behind these were the cavalry and infantry in armour, the race-horses, and all the funeral offerings that the emperor and we (senators) and our wives, the more distinguished knights, and communities, and the corporations of the City, had sent. Following them came an altar gilded all over and adorned with ivory and gems of India. . . . At the Campus Martius a pyre had been built in the form of a tower having three stories and adorned with ivory and gold as well as a number of statues, while on its summit was placed a gilded chariot that Pertinax had been wont to drive in. Inside this pyre funeral offerings were cast and the bier was placed in it, and then Severus and the relatives of Pertinax kissed the effigy. The emperor then ascended a tribunal while we, the senate, except the magistrates, took our places on wooden stands in order to view the ceremonies both safely and conveniently. The magistrates and equestrian order, arrayed in a manner befitting their station, and likewise the cavalry and the infantry, passed in and out around the pyre performing intricate evolutions, both those of peace and those of war. At last the consuls applied fire to the structure, and when this had been done, an eagle flew aloft from it. Thus was Pertinax made immortal.[2]

This is a rare, if perhaps slightly ironic, account of one of the great official ceremonies of the Roman state, the apotheosis of a deceased emperor. For the art historian, what is immediately striking are the number of images which perform key functions in the rituals—giving the whole ceremony a potent visual force to which Dio was sensitive. From the procession of a golden image of the dead emperor into the Circus Maximus and the use of a splendidly attired wax effigy of Pertinax 'as if it were really a person sleeping', to the statues representing the famous Romans of the past, the images of distinguished men

and the bronzes signifying the provinces, the whole ritual is composed of works of art. The Roman state, in its present geographic extent (through the bronze figures of the provinces) and in its past as personified by the portraits of great men, comes to be visually evoked and embodied by images. Dio repeatedly emphasizes the sumptuous materials and colours: ivory and gold were the traditional materials of cult statues and thus very suited to an event in which a man will be turned into a god; purple and gold were the imperial colours.

Of course this is not in any sense a text about images. Its very significance comes from the fact that Dio has no particular interest in art for its own sake; he just gives it its proper place in the complex and impressive dynamics of imperial ceremonial. Images do not simply decorate the activities; rather, they constitute a central part of the ritual. Crucially, Pertinax himself can only exist through his representations—whether as wax effigy or golden statue (as later, he would be present as a god in a series of divine statues). But the Roman state as a meaningful and historical institution—its glorious men of the past and its conquered provinces—is also made present through images, as well as through the assembled orders of senators, knights, cavalry, infantry, guilds, and City corporations. Images are thus not merely passive representations or adornments. They are active. They are paraded, displayed, and even burnt in a fire which will transform the wax effigy of Pertinax into the living presence of a deity—as well as consuming the pyre with its statues and the emperor's gilded chariot.

Art too could capture the splendour of this kind of ceremony. A late-antique ivory now in the British Museum, the right-hand leaf of a diptych, depicts an apotheosis with striking similarities to Dio's description [11]. The bottom part of the ivory shows the statue of the bearded dignitary about to be deified, enthroned in an *aedicula* with a gabled roof. The image is being drawn, like the golden statue of Pertinax, by a troop of elephants. Behind this scene (and probably some distance away, the distance from the Circus Maximus and the Forum to the Campus Martius in Dio's account) is the pyre: a triple-storeyed tower surmounted with a *quadriga* driven by the naked effigy of a man. The eagles fly aloft to the left and, above, the bearded figure from the elephant carriage is made immortal—carried by personifications of the winds to be welcomed by the company of heaven beyond the arc of the zodiac.[3] While the ivory's restricted visual form requires it to dispense with Dio's serried ranks of Romans of all classes, it captures effectively the combination of solemn ritual with distracted—even informal—participants in the elephant drivers, who appear to be chatting. Like Dio's description, much of the visual emphasis in the ivory is devoted to *images*—the figure on the car drawn by elephants and the *quadriga* on the funeral pyre. These images were not just decorations or records, but were the crucial constituents of the ceremony.

11

Ivory leaf from a diptych of about AD 400, showing a scene of apotheosis, probably from Rome.

The monogram in the scroll on the top has been deciphered to read SYMMACHORUM, making it likely that this ivory was cut to commemorate the death of the great pagan aristocrat, Symmachus, in 402.

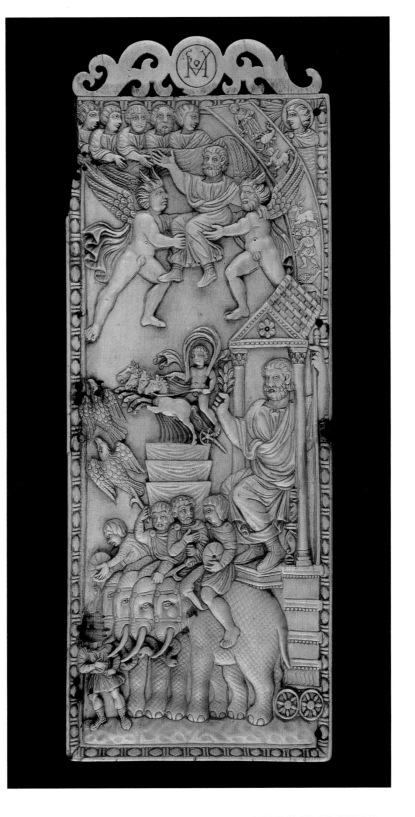

We do not know whose deification the ivory depicts—it may be that of an emperor (Julian the Apostate, emperor 361–3, has been suggested) or of a powerful pagan aristocrat like Symmachus, who died in 402, as is implied by the monogram at the top. Likewise, we do not know for what purpose the ivory was carved: whether it was commemorative or more actively proselytizing of a key pagan custom in a time when paganism was under threat.

While apotheosis was perhaps the central ceremony in the public exaltation of the office of emperor, marking the moment when the deceased holder of that office became a god, it was far from representing the only use of images in state ritual. The marshalling of art to address an audience was of particular importance in impressing not only the populace of the empire, but also its barbarian enemies. This is pointedly expressed in a surviving fragment from the third-century Athenian historian P. Herennius Dexippus.[4] Describing an embassy to the emperor Aurelian by the Juthungi, an invading barbarian tribe whom Aurelian had chased out of Italy, defeated, and driven back across the Danube in AD 270, Dexippus writes:

[Aurelian] arranged his army as if for battle, in order to strike terror into the enemy. When the troops were well drawn up, he mounted a tall platform, standing high above the ground, resplendent in purple. The army was arrayed on either side of the emperor in crescent formation. Beside him stood the military commanders, all mounted on horses. Behind the emperor were gathered the standards of the army—the golden eagles, the imperial images, the army lists emblazoned in letters of gold—all of these mounted on silver lances. Only when all was arranged in this way, did Aurelian give the order for the embassy of the Juthungi to approach. Stupefied by the sight, they remained for a long time in silence.[5]

Allowing for the patriotic tone and a somewhat imaginative touch (it is most unlikely that Dexippus, though a contemporary of these events in AD 270, was actually present), this passage stresses the care and importance given to public ritual in impressing foreigners. Again art forms a central weapon in the armoury of display. Here, not in the official state context of an imperial funeral at the capital city, but in the realm of military and diplomatic activity surrounding the person of the emperor, images—especially the statues which proclaimed the imperial lineage as well as the gilded standards which paraded Roman conquest and military might—and the royal colours of gold and purple, were essential. This description is the textual counterpart to many imperial 'icons', such as the reliefs depicting Marcus Aurelius in his official public and military capacities which, though carved about 100 years before Aurelian's audience with the Juthungi, were reused some 40 years after Aurelian's death (in 275) on the Arch of Constantine.

A number of these reliefs show the emperor, at key moments of his

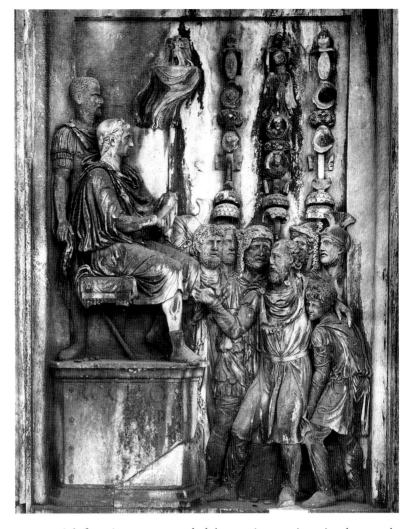

Marble relief of Marcus Aurelius administering justice to barbarian prisoners. One of eight panels made in the 170s for a lost monument in Rome and subsequently incorporated into the Arch of Constantine.

ceremonial functions, surrounded by an impressive visual panoply of standards bearing eagles, imperial tondi, and insiginia, or flags. Take, for instance, the panel of Marcus (whose head was probably replaced by that of Constantine in the fourth century, and restored in the eighteenth century) administering justice to a pair of conquered barbarians, an old man leaning on a younger one in the lower right-hand side of the relief [12]. Like Aurelian in the passage from Dexippus, Marcus is raised on a platform above the throng of Roman soldiers and the foreign ambassadors. In the background of the image are four standards, perhaps like those mounted on silver-plated lances in Dexippus' account, of which the one closest to the enthroned emperor carries a banner and is topped with a winged victory, while the third one along from the emperor contains tondi bearing the imperial likeness.

The most famous description of the emperor in a public ceremony

comes from the writings of the great fourth-century historian Ammianus Marcellinus. In his history, Ammianus gave what must rank as one of the great purple passages of late Roman literature to an account of the *adventus* into Rome of the emperor Constantius II on 28 April 357:

He himself sat alone upon a golden car in the resplendent blaze of various precious stones, whose mingled glitter seemed to form a sort of second daylight. And behind the manifold others that preceded him he was surrounded by dragons woven out of purple thread and bound to the golden and jewelled tops of spears, with wide mouths open to the breeze and hence hissing as if roused by anger, and leaving their tails winding in the wind. And there marched on either side twin lines of infantrymen with shields and crests gleaming with glittering light, clad in shining mail; and scattered among them were the full-armoured cavalry, all masked, furnished with protecting breastplates and girt with iron belts, so that you might have supposed them statues polished by the hand of Praxiteles, not men. . . . And, as if his neck were in a vice, he kept the gaze of his eyes straight ahead, and turned his face neither to the right nor to the left. Like a graven image of a man, he neither allowed his head to shake when the wheel of the carriage jolted, nor was he at any time seen to spit, wipe or rub his nose, or to move his hands.[6]

In its extraordinary elevation of both imperial figure and bodyguard into works of art—'a graven image' and 'statues polished by Praxiteles' —Ammianus' remarkable description conveys the centrality of art as a model to be imitated even by reality, in the ceremonial extravagance of the late Roman state. Likewise, in looking at the roughly contemporary apotheosis ivory, one is at first unable to tell whether the bearded figure in the elephant car is a real person or his image. Only the visual narrative of the pyre, the ascending eagles and the apotheosis of the man's soul into the heavens, makes it clear that the bearded figure in the foreground must be the statue of the figure carried aloft at the top. The ivory, just like Ammianus' text and Dio's, dramatizes the elision of imperial dignitary and statue which late antiquity had brought about. By the time of Ammianus, the attempt to remove the imperial presence from the natural world into a supernatural majesty of jewelled and gilded artifice led to a still more concentrated evocation of monarchy through stylized images. Though Ammianus was not present himself at Constantius' *adventus* in 357, he did witness the entry of Theodosius into Rome some 30 years later in June 389. It is likely that this account of Constantius, laced with references to earlier literature, is a literary construct rather than a description of actuality, just as the *adventus* was a ritualized and rehearsed visual construct of official ceremonial rather than a spontaneous event. Indeed it may be Ammianus' idealized literary summation of a large number of imperial entries witnessed over a long career in the emperor's service.

This text glitters with the visual: its constant emphasis is on

light, colour, the splendour and pomp of the procession. Brilliantly, Ammianus transforms the dragon-like banners into real dragons, hissing with purple fury around the jewelled presence of the emperor. Constantius himself is no longer a mere man. He is presented as an effigy—like the bearded figure on the elephant chariot in the apotheosis ivory. It is as if developments in the ceremonial role of emperor have moved his status beyond being the director of proceedings, for instance Septimius Severus in Dio's account of Pertinax's deification, to being the divine statue itself. There is a movement in the three descriptions we have examined from the emperor as actor in the case of Severus, to the emperor as human being elevated by ceremonial in the case of Aurelian to the emperor as work of art, as sacredly charged object within ritual, in the case of Constantius. Historians of the fourth century attributed these changes to the emperor Diocletian (AD 284–305) whom Aurelius Victor, for instance, writing after 360, accused of being 'the first to covet, in addition to a gold-brocaded robe, an abundance of silk, purple and jewels for his sandals . . . to have himself called "lord" in public, and "adored" and addressed as a god'.[7] However, the quotation from Dexippus shows that the movement towards the emperor as ceremonial centre and virtual effigy was already well under way before Diocletian assumed the purple.[8] For an early fourth-century visual realization of the theme of imperial *adventus*, see the scene from the top tier of the south-west pillar of Galerius' arch in Salonica [**87**], where the emperor—isolated in his carriage drawn by two chargers and surrounded by cavalry—enters a town, perhaps Salonica itself, dwarfing the inhabitants, who greet the imperial party with enthusiasm.

Art in civic life

The rituals of imperial appearance in public not only involved images but were also commemorated and conceptualized through images. For example, the four sides of the pedestal of the column set up to honour the emperor Antoninus Pius (138–61) after his deification by his successors Marcus Aurelius and Lucius Verus, were decorated with an inscription and three scenes recording the imperial apotheosis—the two *decursio* panels which represent the kinds of 'intricate evolutions' performed by the cavalry, which Dio described in the case of Pertinax [**8**] and the scene of the emperor and his wife Faustina ascending to heaven [**13**]. Likewise, the great rituals of public imperial action—sacrifice, war, the offering of money to the populace, administering justice, and so forth—were, as we shall see in Chapter 3, replicated through state-sponsored reliefs on highly visible monuments and were thus elevated into icons of monarchic authority.

The same visual elevation of rituals or institutionalized activities is visible in private art. It would be risky to describe images of the games,

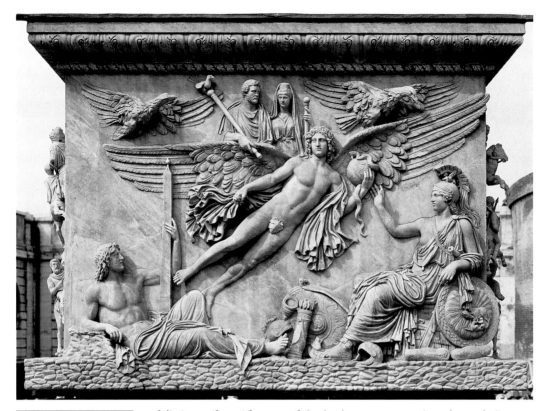

13

Marble relief of the apotheosis of Antoninus Pius and his empress Faustina, from the pedestal of the column of Antoninus in Rome, AD 161.

The emperor (bearing an eagle-crowned sceptre) and his wife ascend to heaven accompanied by eagles and carried by a winged *genius*. Below are personifications of the Campus Martius (where the ceremony of imperial apotheosis took place) as a reclining male holding an obelisk, and of Rome, as a female wearing a helmet and leaning on a shield with a carving of Romulus and Remus suckled by the wolf.

of dining, of sacrifice, or of the baths as representing the real circumstances of private life. More often they represent idealizations of frequent and hence ritualized activities, circumstances where the private citizen appeared in a public or at least social world, which could be recognized as familiar by the commissioner of the work of art and by his or her circle of acquaintances. Ultimately such ritualized occasions and their images were systems of symbols which evoked a sense of Roman identity, even a position within the social hierarchy—for their participants and viewers.[9] For example, a funerary relief from the first half of the second century AD, perhaps from Ostia, the port of Rome, very probably commemorates a freedman who had risen to being a circus official or possibly a charioteer [**14**].[10] The man stands to the left, holding hands with his wife (who probably died before him, since she is depicted as a statue on a base). His way of life is represented in the main body of the relief with its scene of a charioteer racing around the circus. Here the ritual of public entertainment, the activity of chariot racing which every Roman from every part of the empire would have recognized, is turned into a personal memorial of the deceased—a commemoration which marks his public identity beside the more private record of affection between man and wife.

The relief employs a number of techniques to elevate its subject beyond mere happenstance into a more permanent celebration of a life.

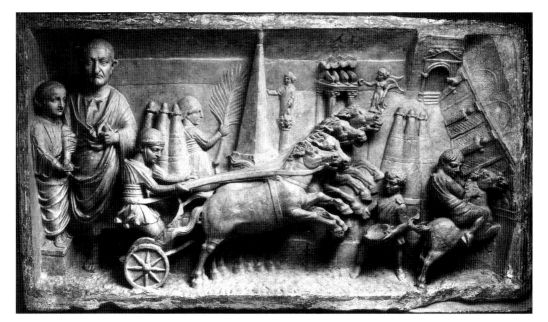

Interestingly, despite its Trajanic or early Hadrianic date, this sculpture eschews every 'rule' of naturalistic proportion (the deceased man being carved to a larger scale than any other figure, including his wife), spatial illusionism, and even temporal differentiation (so that the charioteer is depicted twice, first racing and then—immediately—displaying the palm of victory which was the prize for winning the race). Alongside this rupture of the norms of naturalism, goes an elision of persons and images, similar to (but much earlier than) what we have already seen in the apotheosis ivory and Ammianus' account of Constantius. The deceased man holds the hand of his wife although she is a statue. The circus, perhaps a depiction of the Circus Maximus in Rome, is full of art-works—the central obelisk, honorific columns with statues on their tops, the herms along the row of columns by the entrance gate to the right. Both the 'real people' here (and it may be that the charioteer represents the dead man in earlier days) and the statues are realized sculpturally in much the same way, their distinction broken down, like the 'norms' of illusionism and of time, by their coexistence in the omnivorous space of death. Yet, by gazing frontally out of the space of his funerary relief into the world of the spectator (a feature which became common in late-antique art), the dead man summons us too, as viewers, to contemplate his fate, which will one day be our own.

The circus relief uses a culturally central theme of mass popularity and leisure in order to define the identity of its deceased subject, probably a freedman relatively low on the social scale. Works of art portraying themes from the same cluster of cultural symbols—the hunting of animals, the games in the amphitheatre, chariot racing, and so forth—were chosen to adorn the possessions, and thus mark the identities, of

people spanning the entire social spectrum. Numerous aristocratic villas from the second century to the fourth and fifth, from Gaul to Africa, from Syria and Cyprus to Italy and Spain, display fine floor mosaics with such themes. Impressive chariot-racing mosaics from wealthy villas have been discovered, for example, in North Africa, Sicily [**67**], Gerona, Lyons, and Italy.[11]

In a number of late-antique ivory diptychs, the games become a means to define the relations of the great aristocrats who donated and paid for these entertainments with the populace for whom they were

provided. The fragmentary early fifth-century Lampadiorum leaf, now in Brescia, shows chariot racing in the circus presided over by a high official, presumably the senator Lampadius himself [**15**].[12] In larger scale than the dignitaries who accompany him (they may be his sons), and bearing a sceptre topped by imperial busts, the great man watches the action below, and is himself on display to both the implied circus audience and the viewer of the ivory. This kind of image, showing not just the aristocrats it celebrates, but also the entertainments which these noblemen offered to the populace, is an iconic portrayal of a relationship. It exalts the dignitaries portrayed, *euergetes* or public benefactors, in a position of power as statue-like objects of the gaze: they preside over the games as the ultimate visual goal not only of the Roman populace which watched the actual events, but also of the viewers of the diptychs.[13] The very stylization of images, like the Lampadiorum leaf, marks a relationship of hierarchy: the presiding figures (framed by a niche, and isolated in a box behind elaborate parapets) adopt the static grandeur of the 'graven image' by contrast with the more naturalistic sense of movement, depth, and perspectivally rendered action in the arena below. The isolated aristocrats, raised to the iconic status of Ammianus' Constantius II, seem to exist in a different sphere from the games they have donated, the populace which would have watched them, or the viewers who look at these plaques.

In both these cases—whether the depiction of freedmen or the highly prized issue of commemorative ivories by the supreme aristocracy—the same symbols, relating to fundamental institutions of leisure and social rituals of mass entertainment, came to define the identities of their commissioners. In reflecting the world of public life, and in representing its subjects' involvement in that world, art proved a fundamental means for identifying, constructing, and negotiating individuals' places in the hierarchy of Roman society. The games are by no means the only example of such social self-definition through images. The portrayal of sacrifice, for example, or the representation of visiting the baths, were equally means of establishing civic or religious identity through images of social ritual. And, like the circus, such images could be used to represent Romans on every social level. By evoking ritualized activities in different spheres of cultural experience —religion or the world of women and the household, for example, by contrast with the circus—the choice of different sets of visual symbols could offer somewhat different nuances in self-definition and identity.

In an early third-century funerary altar, the deceased—probably a retired centurion in the Roman army and thus not of very elevated social rank—is portrayed pouring a sacrificial libation over an altar laden with fruit [**16**].[14] The man's military background is announced not only by his clothing (tunic, boots, sword, and the centurion's rod, which he carries in his right hand) but also by the Roman standards

Marble altar of unknown
provenance, c. AD 205.

The main body of the altar
shows a full-length portrait of
a man in military (marching
rather than fighting) dress,
pouring a libation at an altar.
In the pediment above is an
eagle flanked by masks.

which decorate the two pilasters that frame the scene and by the eagle
in the pediment. The standards carry praetorian eagles as well as
crowns and imperial portraits similar to those visible on the standards
in the panel of Marcus Aurelius administering justice [12]. The subject
of this altar, probably a veteran by the time it was put up, affirms his
identity by his military paraphernalia and by his pious action of
sacrifice. Thus his life is summed up visually by two of the great insti-
tutions of the Roman world—its army and its religious system. There
is a poignancy in his act of libation being portrayed on a monument
which was itself an altar, where similar offerings would have been made
by his descendants and those who held his memory dear. One might
almost say that the iconography of his monument was an injunction to
his kin about *how* he should be remembered.

Women too figured in the establishment of identity through
images. The back panel of the lid of the Projecta casket, one of the
grandest surviving masterpieces of fourth-century domestic silver,
depicts two groups of an adult woman, a girl and a youth arriving at the
baths [17].[15] The lady of the house appears to be the central figure of

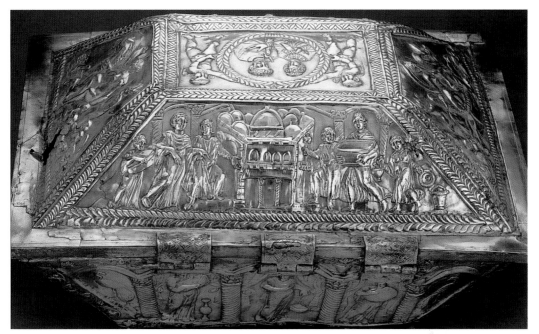

Scene from the back panel
of the lid of the Projecta
casket, hammered silver, with
some gilding, engraving, and
stippling, from Rome, fourth
century AD.

The imagery of this panel
shows a lady and her
attendants visiting the
baths. Behind is an arcade
of alternately round and
pointed arches which spring
from spirally fluted columns
with Corinthian capitals.

the left-hand group, while the other figures—a veritable retinue of
attendants, again shown smaller than the main figure—guide her way
or bring the necessary accoutrements of her toilet. The iconography of
this scene, with its strongly female emphasis, fits well with the rest of
the imagery of the casket, which includes the Toilet of Venus with
attendant nereids and the lady of the house at her toilet with attendant
servants. It may even be that the casket itself (perhaps a wedding gift to
Projecta and her husband Secundus, who appear to be portrayed on the
top of the lid, and are both named and commended to Christ in the
inscription) was used to carry toilet implements, like the oval and
rectangular caskets depicted in the scene.

In evoking the world of élite women through the rituals of the toilet
and the baths, the casket is placed (as an implement of the toilet) at
the centre of Projecta's identity. Not only is she defined by the inscrip-
tion in the context of her husband, Secundus, and her god, Christ, as a
wealthy woman who cares for her appearance—for the principal theme
of the iconography is Projecta's preparations for display in the world of
men, but the casket itself (and thus its donor, if it was a wedding gift) is
made crucial to this self-fashioning of Projecta as the beautiful wife.
While the centurion's sacrificial altar, like the circus relief from Ostia
or the Lampadiorum plaque, showed its subject on public display
enacting a ritualized duty, Projecta's casket goes further: it dramatizes
the very process of adorning oneself for public display. The casket not
only projects an identity for Projecta, it also shows the process of con-
structing that identity, of preparing the self which will interact with
the world.

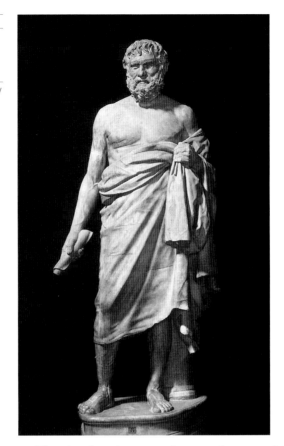

The visual environment between home and the world—that space
in which the citizen was on display, where the rituals of everyday life
and civic existence took place—was itself filled with images. Roman
cities were full of honorific portraits often set up at public expense
to celebrate a local dignitary, to offer thanks to a great civic benefactor,
or to glorify the emperor. Such statues, which included famous figures
from the past like Homer or the Greek philosophers [**18**], as well as
distinguished men and women like Plancia Magna, a wealthy bene-
factress and patron of the early second century AD at Perge in
Asia Minor [**19**], were a necessary and ubiquitous element in the urban
landscape of the empire. In the second century, when the sophists—
professional orators and teachers of rhetoric—were among the
empire's foremost celebrities, performing feats of oratorical virtuosity
in public contests often held in the presence of the emperor himself, we
find much rhetorical play being made of whether a sophist has been
voted a statue by a city (a sign of popularity), and of the relationship be-
tween an orator and his image.[16] The fact that such images entered the
literary imagination is itself a sign of how much prestige they con-
ferred.

These public images were not simply static decorations. Just as the

carrying of statues and other images in processions proved a prime element in imperial ceremonial at Rome, so some of the most significant religious events in the urban life of the empire involved the repeated carrying of images along a predetermined public route. An inscription from Ephesus in Asia Minor from the early second century records a bequest made to the city by one Caius Vibius Salutaris.[17] This bequest not only provided for the distribution of money but also for the dedication to the goddess Artemis of 31 statues, mainly of silver but one of solid gold. These—which included representations of Artemis herself, the Roman emperor Trajan, his empress Plotina, the Roman Senate and Equestrian Order as well as the tribes and city of the Ephesians—were to be paraded through the heart of the city from the temple of Artemis to the theatre and back again at intervals of roughly a

19

Marble portrait statue of Plancia Magna, from a display wall to the south of the main gate dedicated by Plancia Magna at Perge in Asia Minor, c. AD 121.

Dressed as a priestess in chiton and himation, with the himation pulled over her head and wearing the (now rather chipped) priestly diadem of the imperial cult, this statue is over 2m high. The inscription affirms Plancia's position as high priestess of the imperial cult.

fortnight during festivals and sacred days. This ritual of the frequently repeated public procession of statues vividly brings to life a culture of images in which the sacred identity of the city of Ephesus, its myths and its place within the wider Roman state were represented, remembered, and re-enacted.

The Salutaris procession was hardly unique: other similar rituals occurred in Ephesus itself and in every city in the empire. What is perhaps most striking about image-processions, be they an imperial apotheosis or a civic ritual, is that they mark most effectively the dynamic space where images had their greatest power in antiquity: that fluid, public space between home and the world. In this space, where an individual's self-identity met with the images, views, and representations of others, art acted as a means of negotiation, self-affirmation, even (in the case of iconoclasm) of attack. Since even the space of a private house was in some senses open to public visitation, even much 'private' art belongs to this crucial public domain of self-projection and identity formation. The identities concerned were not only personal (an emperor or a Plancia Magna or a deceased centurion) or familial (as in the casket of Secundus and Projecta, and the diptych commemorating the Lampadii family), but they could involve a whole city (as in the case of Ephesus in Salutaris' inscription) or even the whole empire (in the images of the provinces in Pertinax's funeral). The culture of images in the Roman world was thus extraordinarily versatile and significant: it performed fundamental symbolic and social work in helping individuals make sense of themselves and of the world; and it provided a vivid and potent means for visualizing the huge extent and diversity of an empire in a world without modern levels of literacy or means of communication.

Art inside the Roman house

No marker of identity was more profound, in the world inhabited by the Roman élite, than the 'private' house. In the words of a letter written by Sidonius Apollinaris, a wealthy aristocrat from Gaul who served both as prefect of the city of Rome and, later, as Bishop of Auvergne in the second half of the fifth century AD, a house 'is not so much your property as the property of your friends. . . . It feeds your guests with feasts and you with guests. Its lay-out charms the eye of the beholder.'[18] In effect, repeating a Roman literary assumption that identifies house and self, which goes back in Latin culture to the poems of Horace in the age of Augustus and the letters of Cicero in the late Republic, Sidonius conjures a timeless image of the home as an ideal enclave, where the owner's learning and good taste may be fostered amidst the congenial company of close friends. In many ways, it is a myth of the home which modern culture has inherited.

The house was thus the most intimate of Roman public spaces; and

it too was filled with images. It was here—in an arena crucially open to outsiders at key moments of social obligation (like the morning salutation of patrons by their clients, or the long and luxurious procedure of dinner)—that antiquity's rituals of privacy were performed. The elite house was highly decorated with paintings on walls and ceilings as well as mosaics on the floors.[19] The essayist Lucian, writing in the Greek-speaking east during the second century AD, speaks of the ceiling as the 'face' of a house—'its reserved modelling, its flawless decoration, the refined symmetry of its gilding' being 'lavish, but only in such degree as would suffice a modest and beautiful woman to set off her beauty'.[20] 'The rest of the decoration', he continues, '—the frescoes on the walls, the beauty of their colours, and the beauty, exactitude and truth of each detail—might well be compared with the face of spring and with a flowery field, except that those things fade and wither and change and cast their beauty, while this is spring eternal, field unfading, bloom undying.'[21] While this is all rather high-flown rhetoric, it evokes well the colourful richness of decor in the élite home.

The images within the house—many of which seem to allude explicitly to the theatre—provided a visual backdrop for the performance of private life. But they also drew attention to the careful fabrication of identity which both constituted the Roman house and which the house was itself helping to construct. Domestic paintings and mosaics staged their mythical or genre subjects as if they might be pantomimes or charades, played out by the home's owners. For instance, the subject matter of many scenes, like Venus at her toilet [64], emulated the activities of daily life—such as the cosmetic rituals of the ladies of the house. And often images cast a witty eye in the direction of the public world outside the home.

The early fourth-century villa at Piazza Armerina in central Sicily boasts a huge extent of mosaic floors depicting images of wealthy pastimes like hunting, fishing, and dining, as well as a chariot race in the Circus Maximus in Rome (depicted obelisk and all [67]). The villa's images elevate its owner's aristocratic pretensions by referring to distant Rome, and to the procurement of animals for the games in faraway India or Africa. But they also set these grand desires within the potential irony of their visual embrace: Rome was little more than a dream on the remoter estates of Sicily in a century when even the emperors rarely visited the city. The scenes which allude to the metropolis may be no more than empty images. The villa performs its *romanitas* through art by the iconographic staging of the empire's centre and its boundaries. But at the same time, it parodies this very construction of identity by displaying a mock circus (obelisk and all) with images of children racing in chariots pulled by kitchen fowl [20], or cupids doing the honours of hunting against domestic animals. These scenes are much more than simply humorous asides on

20

Fantasy chariot race, detail from a floor mosaic from the Villa at Piazza Armerina, Sicily, first quarter of the fourth century AD.

Two chariots pulled by birds (the teams are pigeons and flamingos) compete in a mock circus, complete with an obelisk. The charioteers and other figures, including the official offering a palm to the winner at the bottom right, are children.

the serious themes of the villa's grandest floors. They cast the aspirations evoked by the villa's allusions to the public sphere within a frame which earths grand illusions as but the games of children. The commentary, by one set of the villa's images on another, makes explicit the fact that its portrayal of a cultural identity—the very setting for its owner's most private persona—is but an elegant construction.

Roman art in the domestic sphere was particularly adept at these highly complex portrayals—deconstructive celebrations—of private and civic life. The images of the house created an environment where the visitor was encouraged to be self-conscious about his or her identity and position within the house—about the view, about the fact that viewers were themselves being observed, about social status and desire. The surviving houses of Pompeii and Herculaneum (preserved by the eruption of Vesuvius in AD 79)—through their architectural disposition in favour of specific viewpoints and their disposal of statues, paintings, gardens in relation to the view—construct a complex relationship between viewers (whether visitors, inhabitants, or owners) and the house itself.[22] A number of floor mosaics found in houses throughout the empire, as well as other household objects like terracottas, represent apotropaic images (sometimes with verbal tags) which threaten the viewer—even as he or she looks into a house—warding off the evil eye.[23] The material accoutrements (plates, goblets, glasses) of that most important of all social rituals to take place in the domestic context —that of the banquet—frequently depicted the business of eating and drinking, and even of catching the game and preparing the meat [**65**], often with a certain ironic commentary.[24]

One of the most sumptuous glass objects to survive from the fourth-century AD dining room is the Lycurgus cup [**21**].[25] Carved with the skills of a jeweller from a thick-walled plate of glass, the cup depicts the legendary king Lycurgus who wronged Dionysus, the god of wine, and was throttled by vines when the god took his revenge. The imagery of Dionysus' vengeance is a barbed joke at the expense of the cup's user, given that the object's main function was for holding wine at drinking parties. But the cup plays on its functions not only in its thematic content, but also in the very material from which it is made. Its glass is opaque green in reflected light but becomes translucent red in transmitted light. The effects of this kind of super-clever prestige object are best described by the second-century AD novelist, Achilles Tatius, writing of a crystal drinking-bowl used at Tyre on the feast day of Dionysus:

Long coils of grapevine seemed to grow from the bowl itself. Their clusters hung at random on all sides. When the bowl was empty the carved grapes were green and immature, but as you filled it with wine, the clusters slowly grew darker, and the grapes ripened. Dionysus was carved near the grapes like a farmer who would tend their growth with wine.[26]

Cage-cup from the fourth century AD, depicting Dionysus, accompanied by his entourage of a satyr, a panther, and Pan taking revenge on Lycurgus; provenance unknown.

The thick base of mould-blown glass was cut back, and undercut, with spectacular virtuosity and fire-polished to a highly glossy finish. This page shows the cup's jade-green colour in reflected daylight, with a satyr throwing a stone and—to the lower right—the Maenad Ambrosia, whom Lycurgus had attacked. The facing page shows the cup's wine-red colour in transmitted light, with Lycurgus pinioned by the wine-shoots which will ultimately throttle him.

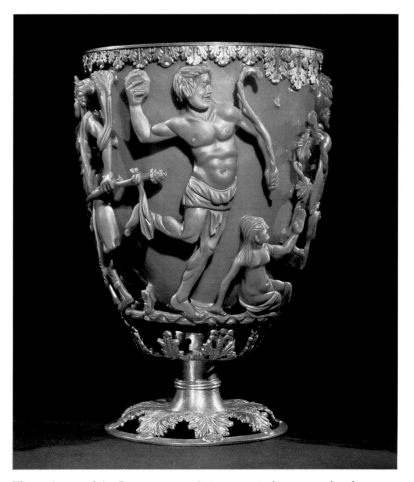

The colours of the Lycurgus cup bring to mind green and red grapes, white and red wine, ripe and unripe vines; Dionysus—stretching out his thyrsus—is both the farmer of the grapes and the slayer of Lycurgus.

The finest ancient account of the sheer complexity of the Roman house as a stage for the negotiation of cultural identity is Petronius' *Satyrica*, a brilliant satirical novel probably written during the reign of Nero in the AD 60s. It is a difficult text to use, because its intricate, rippling, ironies mean the reader is never quite sure to what extent any passage is a spoof. In the section dealing with a dinner party at the house of the millionaire freedman Trimalchio, we are introduced into a topsy-turvy picture of the Roman house at its most public and ceremonial. The works of art described are multiple, and they are constantly made to play on the identities of Trimalchio, the host, and Encolpius, Petronius' anti-hero, who is one of the guests. In the vestibule is a painting of a dog so life-like that Encolpius falls over in fear, and a series of paintings showing the life of Trimalchio which—in an outrageously over-the-top gesture—take us from his beginnings as a slave to

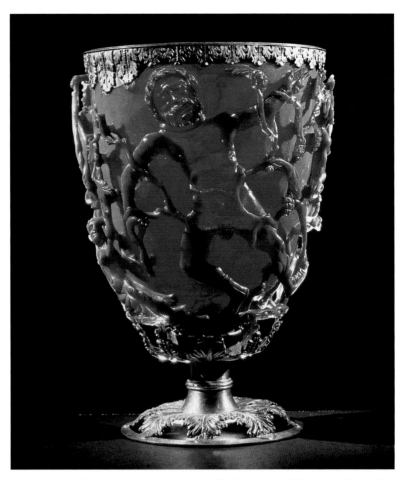

a virtual apotheosis in the company of Minerva and Mercury (*Satyrica*, section 29). The excess which defines Trimalchio as a *nouveau riche* is repeatedly expressed in material objects from his silver chamber pot (27) and tooth-pick (33) to his gold jewellery (32), the gold and silver coins which he uses instead of counters to play draughts (33), and the silver plate which his slaves sweep away along with all the rubbish (34). Amidst the exquisitely designed courses of dinner, most of which are served in disguise (for instance as a zodiac, 35 and 39) in order to appear radically different from what they actually are, Trimalchio produces a silver skeleton (such as appear relatively frequently in Roman dining decorations, in fact)[27] and sings (34):

> Man's life, alas! is but a span,
> So let us live it while we can.
> We'll be like this when dead.[28]

The theme of death as expressed in art, with its potential undermining and ironizing of the dinner party's living participants—reiterated in Trimalchio's obsession with passing time (26), in the paintings of

apotheosis in the vestibule, in the zodiac dinner, and in the silver skeleton—climaxes in Trimalchio's long disquisition about the form and decoration of his tomb (71). In the end, one is left wondering if Trimalchio's feast is not a kind of wake, celebrating the living deaths not only of the host but also of his guests. Of course, this text is a satire, and its use of objects is carefully orchestrated for effects simultaneously humorous and biting; but the Roman house was at least susceptible to the kinds of complex and undermining impressions so well portrayed by Petronius.

Change and continuity

This chapter has explored the presence of images in Roman life, the ways in which images recorded and represented social rituals, the manner by which they helped to construct identity. The effect has been to emphasize remarkable continuities in the power of the visual on every level from state ceremonial to the private house. To some extent, this strong sense of continuity is dependent on the fact that social and civic rituals are usually archaizing—even when they change, those changes are presented as being traditional and non-disruptive. In this sense, the traditional patterns of Roman life from the second century to the fifth, as well as the traditional images and texts in which these patterns were represented, disguised the kinds of changes which would ultimately define the difference between antiquity and the middle ages. In the first, deeply conservative, part of Sidonius Apollinaris' letter from the late fifth century (whose ethos and style, as well as the house it describes, could belong at almost any stage in the preceding three centuries), there is a telling reference—alongside the villa's colonnades and baths—to a chapel. While so many aspects of the cultural environment may have seemed static since time immemorial, the uses of the traditional leisure Sidonius extols had changed fundamentally. He suggests that the domestic retreat, whose description would be recognized by Horace or Cicero, should be spent with 'your tongue devoting itself to heavenly praises, your mind intent on heavenly thoughts, your right hand busy with heavenly offerings'.[29]

What took place within the Roman world over the period this book covers, was a slow but incremental reinterpretation of the culture inherited from the past, which was ultimately to transform it radically. By the end of the fifth century, imperial images (like those in the Salutaris procession or the effigies described by Dio) had ceased to be made. Instead, emperors put up their mosaic portraits in the interiors of churches, and conducted their public ceremonial beneath the protection of processional icons and miracle-working relics. With the dissolution of urban culture in the seventh century, many of the public rituals (baths, amphitheatre, circus), which had defined civic life for more than a millennium, died quietly and ceased to be represented in

art. As already implied by Sidonius Apollinaris, many of the most potent symbols of cultivated private life in the Roman world would become gradually subsumed into a Christian religious dispensation. In effect, from this perspective, the fifth century remained perhaps the last great period of continuity with the Classical past.

Art and Imperial Power

3

Power is very rarely limited to the pure exercise of brute force. We have already seen how the Roman state bolstered its authority and legitimacy with the trappings of ceremonial—cloaking the actualities of power beneath a display of wealth, the sanction of tradition, and the spectacle of insuperable resources. Sometimes, as in the precarious third century (when Aurelian met the embassy of Juthungi), the trappings of power concealed its absence in reality as much as they proclaimed the implicit might of the emperor. Power is, then, a far more complex and mysterious quality than any apparently simple manifestation of it would appear. It is as much a matter of impression, of theatre, of persuading those over whom authority is wielded to collude in their subjugation. Insofar as power is a matter of presentation, its cultural currency in antiquity (and still today) was the creation, manipulation, and display of images. In the propagation of the imperial office, at any rate, art was power.

The usage of works of art to create the image of power at any one time (a propaganda strategy which a state may more or less determine), is broadly dependent on the ways art is viewed and perceived in a society. Over these, the state has little control, although it may attempt to foster and to discourage certain attitudes, depending on its interests. That is to say, power—in the deeper sense not of a particular exercise of authority but of the *means* by which authority may at a particular time be most persuasively exercised—is knowledge. It is the control of, and access to, knowledge, and it is the sophisticated understanding of the most effective methods by which a culture's shared assumptions and expectations may best be communicated.

While the Roman emperors were attempting to propagate themselves (or their dynasty or indeed their very office) through art, they needed also to be aware of changes in cultural expectations. Our period is one of great change on precisely this level—the transformation of the empire's self-image in the Second Sophistic and its further reformulation into a Christian dominion. In the face of these changes, the imperial image proved a most effective visual mode of necessary (if sometimes subtle) transformation and at the same time strong affirmation of apparently unchanging continuity. The challenge for imperial

images, on this level, was to unite seamlessly these utterly contradict-ory needs—simultaneously the message of changeless tradition and the assimilation of profound cultural change. It is a tribute to the real excellence of Roman image-makers, both as artists and as propagand-ists, that this apparently impossible brief was so successfully accom-plished for so long a period. Right up to the early fifth century, high-quality imperial images in a great tradition explicitly reaching back to Augustus were being produced and used even when the empire had rejected a great number of the religious, administrative, and social tenets by which its earlier incarnations had lived.

The animate image and the symbolic unity of the empire

You know that in all the banks, booths, shops and taverns, gables, porches and windows, anywhere and everywhere, there are portraits of you exposed to pub-lic view, badly painted for the most part or carved in a plain, not to say worth-less, artistic style. Still, all the same, your likeness, however unlike you, never meets my eyes when I am out without making me part my lips in a smile and dream of you.

(Marcus Cornelius Fronto writing to Marcus Aurelius, *c*. AD 148)[1]

Since an emperor cannot be present to all persons, it is necessary to set up the statue of the emperor in law courts, market places, public assemblies, and theatres. In every place, in fact, in which an official acts, the imperial effigy must be present, so that the emperor may thus confirm what takes place. For the emperor is only a human being, and he cannot be present everywhere.

(Severian of Gabala, *On the Creation of the World* 5.5, *c*. AD 400)

The images of the emperor and his family were ubiquitous. For all the element of flattery in the comments of Cornelius Fronto, tutor in rhetoric to Marcus Aurelius (then the heir to the imperial throne), his letter to his pupil expresses vividly the visual domination of the Roman urban environment by the imperial image. And Bishop Severian's sermon from the dawn of the fifth century indicates that the situation had hardly changed 250 years later, at least in regard to official public venues. The emperor appeared on coins, in statues, in paintings throughout the cities of the empire, prominent not only in the great civic or religious buildings but also in much more humble shops and inns. Whether expert or incompetent in workmanship, images of an emperor adopted a recognizable form. They created a portrait-type (like coins of the Queen of England today) whose instances at least resembled each other sufficiently for their viewers to imagine they rep-resented a single individual—even if their model (the emperor him-self) might not always have been recognizable from them. This portrait-type was spread through the Roman world, symbolically pro-claiming the unity of the empire beneath the charismatic presence of its god-like monarch.[2] Even in Christian times, when the divinity of

Painted tondo of Septimius Severus (AD 145–211) and his family, tempera on wood, from Egypt, *c.* AD 200.

A relatively crude image (compared with some very sophisticated marble portraits from the Severan era), this painting continued to be displayed after Severus' death since the face of his son Geta was erased after his murder in 211. All three male figures hold sceptres; Severus and Caracalla are crowned with golden wreaths. Unlike the ageless portraiture of Hadrian, for instance, this image emphasizes the generations of imperial rule: Severus is grey-haired by contrast with his wife and children.

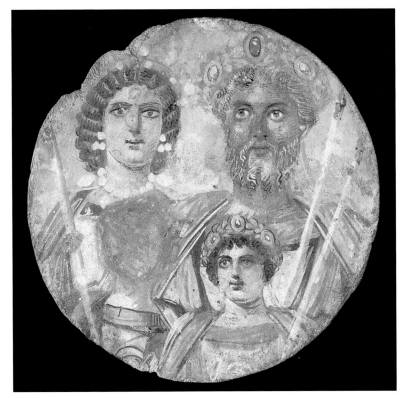

the emperor was firmly rejected by the theologians, Severian of Gabala would justify the need for omnipresent imperial images by virtue of the emperor's humanity. The imperial portrait—much more than being an actual likeness of the emperor—was a sign for who the emperor was and for the unified empire's good fortune during his reign.

For the average citizen living in a city in the provinces, or in Italy for that matter, changes in the disposition of official images of emperors and other important figures in public places were a key way of learning about changes in the power politics at the top, and about the dynamics of succession. An emperor who died peacefully and was succeeded by his designated heir (like Hadrian, Antoninus Pius, or Marcus Aurelius) would be consecrated a god, while an emperor who was overthrown and killed (a Nero, Commodus, or Elagabalus) was often subjected to *damnatio memoriae*—official condemnation of his memory—in which his images and inscriptions were systematically destroyed. For example, when the emperor Caracalla (sole ruler AD 211–17) had his brother and co-emperor Geta murdered in 211, claiming to have done this in self-defence, Geta's image and his name in public inscriptions throughout the state were eradicated. In a painted tondo from Egypt, showing the imperial family of Septimius Severus, his wife Julia Domna and their two sons, Geta and Caracalla, the face of Geta was simply eliminated [22]. In the panel from the Arch of the Argentarii, in

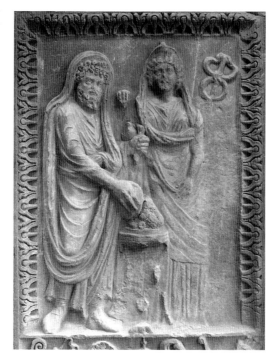

Marble relief panel of Septimius Severus, accompanied by his empress Julia Domna, pouring a libation. From the Arch of the Argentarii, a gate erected by a guild of silversmiths or bankers in the Forum Boarium (the cattle market) in Rome, AD 204.

Both figures are veiled and frontal; the empty space on the right-hand side once held an image of their son, Geta, which was removed after his death and *damnatio memoriae* in 211.

the Forum Boarium at Rome, showing Severus as Pontifex Maximus sacrificing to the Penates, the emperor is accompanied by his wife and—to the right—an empty space from which the relief portrait of Geta has been gouged out [**23**].

The virulence of the rhetoric of *damnatio* is well illustrated by a law included in the *Theodosian Code*, prescribing the destruction of the images of the palace eunuch Eutropius who, after being advanced as far as the Consulship in 399, fell from imperial favour and was beheaded in the same year:

All his statues, all his images, in bronze as well as in marble, in pigments, or in whatever material is suitable for portraiture, we order to be destroyed in all cities and towns, both in private and in public places, in order that the stigma of our age, so to speak, may not pollute the sight of those who look at such images.[3]

Such action does not efface the destroyed one from public memory: it is obvious in the tondo that Geta's features once occupied the destroyed space. Rather, it marks an almost magical assault—a mark of permanent and sacred disapprobation—on the memory of the damned figure, in this instance Geta, whereby the extinction of his every portrayal in this world is an attack even on his state after death in the other world.

Even in Christian times, the imperial image was venerated as a substitute for the emperor: it stood magically for his divine presence when he himself was absent. In the words of St Basil (*c.* AD 330–79):

The image of the emperor is also called the emperor, yet there are not two emperors. Power is not divided nor is glory separated. Just as he who rules us is one power, so the homage he receives from us is one, not multiple, for the honour given to the image is transferred to the prototype.[4]

This sense that the emperor's portrait was almost animate with his presence meant that iconoclasm, like the destruction of Geta's statues and inscriptions, carried a forceful charge. In AD 387, the citizens of Antioch rejected the imposition of a new tax by the emperor Theodosius I (378–95) by rioting which rapidly got out of hand and resulted in the destruction of the imperial images—both wooden panel pictures and bronze statues.[5] This was taken by the emperor as a sign of open insurrection, and his vengeance was terrible. The perpetrators (or at least some scapegoats) were swiftly identified and put to the sword. The city itself, the greatest Roman metropolis in the Middle East, was stripped of its metropolitan status as one of the empire's great capitals and brutally deprived of its privileges. As the Antiochene orator, Libanius, put it in a plea of mitigation to Theodosius:

Our city has changed entirely—to be more accurate, it is not a city at all. The theatre there is shut; so is the race course. No bridegroom takes his bride back home, no torch is lit for marriage, no marriage song is sung. All the flutes and pipes and songs have left us. There is no jest, no witticism, no drinking party. Absolutely nothing can be seen that is conducive to pleasure and enjoyment. The classes of rhetoric have melted away; so have the elementary classes. There is no one to teach and no one to learn. There is the pallor of illness, the voice of the invalid, the mind of bewilderment.[6]

Such was the picture of the city in the face of the emperor's displeasure at the public destruction of his images.

Underlying the violence which occasionally erupted against imperial images, and against those who attacked them, is the deep sense of divine charisma immanent in such objects. The statue of the emperor served as a place of asylum, like sanctuary in a medieval church. Even in Christian times, the emperors promulgated laws affirming this right, as in the case of this decree issued by Valentinian, Theodosius, and Arcadius on 6 July 386, one year before the Antioch riots:

We suffer those persons who have taken refuge at the statues of the emperors, either for the purpose of avoiding danger, or of creating ill will, neither to be taken away by anyone before the tenth day nor to go away of their own accord; provided that, if they had definite reasons for which they had to flee to the statues of the emperors, they shall be protected by law and the statutes. . . .[7]

It was before the imperial likeness, as before the statues of the gods, that slaves could be set free.[8] In the pagan imperial cult, images of the emperor—even the living emperor—were appeased with a variety of rituals including sacrifice, they were carried in civic processions and

24

Bronze coin of Caracalla,
struck at Side in Pamphylia.

The obverse has the imperial
portrait; the reverse (shown
here) has Ares contemplating
a bust of the emperor set on
a column.

they even presided over mystery rites.[9] The statue of Hadrian from the room dedicated to the imperial cult in the sanctuary of Asclepius in Pergamon is an impressive surviving example of the emperor worshipped as a god [**131**]. Hadrian, over two metres high and carved in fine white marble, stands in divine nudity with his military cloak and armour signalling his temporal might. The statue, whose inscribed base proclaims its subject as 'the god Hadrian', was set up in the late 120s or early 130s when Hadrian was still alive, as part of the emperor's magnificent refurbishment of the whole sanctuary.[10]

To behave incorrectly before a statue imbued with this kind of sanctity, or even to bring a coin with the imperial image on it into an inappropriate place, was dangerous. In fact, Cassius Dio reports the following story about an image of his contemporary, the early third-century emperor Caracalla [**24**]:

A young knight carried a coin bearing his image into a brothel, and informers reported it; for this the knight was at the time imprisoned to await execution, but later was released as the emperor died in the meantime.[11]

In the early Christian *Acts of Paul and Thecla*, an apocryphal hagiography first composed in the second century AD, the saintly virgin Thecla repels the advances of the pagan Alexander. Pushing him away, she throws to the ground his golden crown which bore the image of Caesar (perhaps this resembled the triumphal crown with imperial busts worn by the tetrarch from Romuliana, see **30**). For this, Thecla is exposed to the beasts in the arena with a plaque around her neck which reads: 'Thecla, the sacrilegious violator of the gods, who dashed the imperial crown to the ground from the head of Alexander, who wished to treat her impurely'.[12]

Imperial self-promotion

To know the emperor's image was in a very concrete sense to know the empire. It gave access (through viewing and through ritual) to the holy presence of the living god, or in Christian times to the chosen representative of God, under whose protection the civilized world had been placed. It was the imperial image which constituted that access for the vast majority of the empire's citizens. Throughout the period which this book covers, such statues—more or less realistic, more or less idealizing, more or less hieratic—were produced to fulfil this function. The late fourth- or early fifth-century idealising head of an emperor found in Istanbul [**25**]—perhaps Valentinian II (375–92), Arcadius (383–408), or Honorius (393–423)—is one of the last surviving examples of the great tradition of imperial statues, which had thrived even during the rapid turnover of emperors during the third century, for instance in the remarkable portrait of Trajan Decius (249–51) from the Capitoline Museum in Rome [**26**].

Marble head of an emperor of the Theodosian dynasty from Constantinople, late fourth or early fifth century AD.

The head, slightly over life-size, is worked so as to be inserted into a statue. Judging from its archaeological findspot—at Beyazit in modern Istanbul, just outside ancient Constantinople's Forum Tauri—the statue was probably one of those set up in the forum.

These images communicated subtle political messages. Many emperors—including vulnerable rulers whose power was dependent on the assertion of relations with their predecessors—tended to resemble those predecessors. In the case of the Istanbul bust (given the absence, admittedly, of much surviving visual comparanda or an inscription) we cannot tell which of several lesser emperors in the circle of Theodosius the Great the image actually represents.[13] It clearly resembles the type established by court artists to represent Theodosius, which may be seen in the central portrait of his silver Missorium of 388 (see **56**). The portrait of Decius, with his heavily creased face, cropped military hairstyle, and mournful eyes, is both a copy of, and a model for, other soldier emperors from the time of the empire's direst crisis.[14] He closely resembles the portrait of his immediate predecessor, Philip the Arab (244–9, who was killed in civil war, just as Decius was killed fighting the Goths) and more broadly another mature emperor, Maximinus Thrax (235–8), who was murdered by the army. Later military emperors like Aurelian (270–5) and Probus (276–82) would resemble this type, which has been seen as ultimately dependent on the later images of Caracalla.[15] On the other hand, a strong emperor like Septimius Severus (193–211) who had taken the throne by force, might seek to bolster his legitimacy by being represented in the mould of his distinguished predecessors. In the case of Severus, not only did his

Marble portrait bust, probably
representing the emperor
Trajan Decius, *c.* AD 250. The
tips of the nose and ears, the
upper lip, and much of the
neck are restorations.

image resemble that of Marcus Aurelius, but he had himself and his
dynasty adopted retrospectively into the Antonine family.

By contrast, the propaganda of imperial portraiture was also used to
distance an emperor from those whom he succeeded where changes or
novelties in representation might suggest innovations in imperial style
or attitude. Hadrian (117–38) espoused a public rhetoric of modesty so
ostentatious that he did not inscribe his own name on any of what his
biographer describes as the 'infinite' public works he constructed in
Rome, save only the temple of his deified adoptive father, Trajan.[16] Yet,
in his portraiture—for example the magnificient head found in 1941 in
Rome [2] or the statue from Pergamon [131] or his coins [27]—he
broke with earlier tradition. Trajan (98–117), in both coins and statues
[28], was portrayed clean-shaven with his hair arranged in the manner
of Augustus; he was still the noble republican general, the emperor as
ideal citizen. Hadrian, by contrast, is bearded in the Greek style;

27

Silver coin of Hadrian, struck in Asia Minor.

The obverse shows the bearded profile portrait of the emperor. The reverse is **44**.

28

Gold coin of Trajan, struck in Rome.

The obverse shows the clean-shaven profile portrait of the emperor in laurel crown and cuirass. The reverse is **41**.

whether in military dress, in toga, or as nude divinity, he is always the mature philosopher, the cultivated lover of Greek culture and art.[17] This change speaks of a very specific politics of image propagation where Hadrian's statues presented him as *different* from Trajan and his other imperial predecessors, while his building projects (at any rate in Rome) affirmed a strong rhetoric of continuity.

The new bearded type of the emperor caught the mood of the times. It defined the emperor within the transformed Roman culture of the Second Sophistic as not just Roman but as a figure with more universal resonance: he was now cultural guide—even philosopher—to his state, as well as general, monarch, and god. The bearded type was to be the norm for imperial portraiture for nearly two centuries, with the beard changing from the flowing locks of the philosopher in the second and early third century (for example in the portraits of Marcus Aurelius and Commodus, e.g. **50** and **132**) to the more clipped military stubble of the soldier emperors (like Trajan Decius).

When Diocletian established the tetrarchy after ascending to the purple in 284 and putting an end to the years of instability, the new imperial tetrad was portrayed as a harmonious group of virtually indistinguishable icons—hardly individuals at all. In the famous group of embracing tetrarchs now embedded in the south-west corner of San Marco in Venice (and brought there in the middle ages from Constantinople [**29**]), the four emperors—carved in porphyry, an extremely hard and rare stone only quarried in Egypt, which had the value of being purple, the imperial colour—are indistinguishable, except that the emperor on the left in each pair (the more active one, since he embraces his partner with his right arm) is bearded. Here the beard is used to distinguish the senior partners in the tetrarchy, the Augusti, while the clean-shaven figures are the junior emperors, the Caesars. A recently discovered porphyry head of a tetrarch from Romuliana in modern Serbia [**30**]—the birth- and burial-place of Galerius (293–311)—is also beardless, showing the emperor in a triumphal crown adorned with imperial busts.[18] It is likely that the statue portrays Galerius as Caesar after his victory over the Persians in AD 297/8 and before he replaced Diocletian as Augustus in the east in 305.

It was only Constantine, portrayed on his arch in Rome as the new Trajan (see **53**), who finally broke the bearded precedent after his victory over Maxentius in 312. In his earliest portraits, for instance the coins struck after the date of his proclamation as successor to his father Constantius in 306 and his elevation to the rank of Augustus in 307, Constantine resembles the other tetrarchs—with schematic features and cropped beard [**31**]. But in his later portraits—such as the recut heads of Trajan and Hadrian on the reliefs of the Arch of Constantine [**6, 53**] or his colossal statue in Rome [**32**]—he is the archetypal Roman general of the distant imperial past, a new Augustus, a new Trajan.[19]

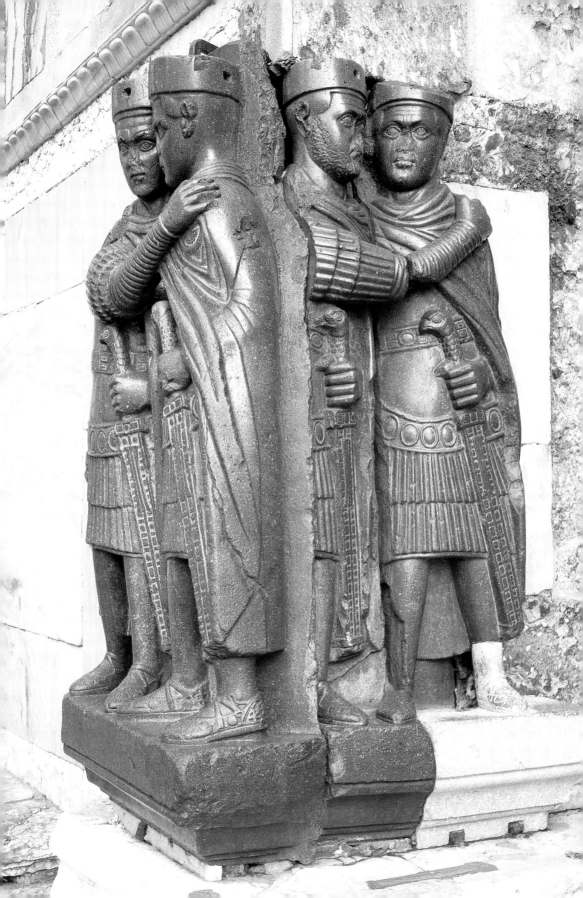

29

Porphyry group of the tetrarchs, carved about AD 300 and moved after 1204 from the Philadelphion in Constantinople to the south façade of the cathedral of San Marco in Venice.

The four emperors are probably the members of the first tetrarchy (293–305), namely the senior emperors Diocletian and Maximian (bearded) and their juniors, Constantius Chlorus and Galerius (clean-shaven). These figures, carved in deep relief, stand on a bracket which may originally have extended from the base of a porphyry column. They were probably taken to Constantinople from elsewhere in the east after the city's refoundation by Constantine in AD 330.

The colossal marble head was part of a huge seated statue of the conqueror placed in the Basilica Nova [**33**], a grand addition to the Roman Forum originally constructed by Maxentius but taken over, somewhat remodelled, and rededicated by Constantine. The clean-shaven, classicizing portraiture of the Christian emperors, such as the Istanbul bust [**25**], was their assertion of the religious and dynastic link back to Constantine as the new Augustus, the founder of the Christian empire. The last pagan emperor of the fourth century, Julian the Apostate (sole emperor 361–3), briefly revived the philosopher's beard as a formal signal of his revival of paganism and repudiation of Christianity.

Continuity and change

From the delicate politics surrounding the imperial image, it is clear that issues of continuity and change were central to the self-promotion of imperial art. This is nowhere more clear than in the architectural embellishment of the city of Rome under successive emperors. A key problem for imperial builders was the need to make a new and grandiose statement while at the same time not veering to the excessive. Too extravagant an architectural, visual, or topographic gesture (like Nero's colossus or Domus Aurea) could meet with virulent polemical condemnation.[20] None the less, for an emperor not to build in a manner worthy of his office was inviting a mediocre reputation in perpetuity. Squaring this circle—the demand to be ever more

30

Monumental porphyry head of a tetrarch, from the south-eastern baths, Romuliana (modern Gamzigrad in Serbia), *c.* AD 300.

Found in 1993, this crowned head (35 cm high) and a hand holding an orb (excavated in 1972) come from a statue likely to represent Galerius. The crown is adorned with three gems and four busts, which probably signify the four members of the tetrarchy. It is possible that all the porphyry sculptures made for the tetrarchs were carved in Egypt, where the stone was quarried and then exported around the empire. The porphyry images are generally from imperial capitals or residences specifically associated with tetrarchic emperors.

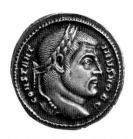

31

Gold coin of Constantine, *c.* AD 306–7.

The obverse shows the bearded profile portrait of the emperor when he was still a member of the tetrarchy, with laurel crown.

32

Colossal marble head of Constantine (2.6 m high) from what was once a 9 m seated statue erected in the west apse of the Basilica Nova in the Roman Forum, *c.* AD 315–30.

The statue was *acrolithic*, that is, with head, chest, arms and legs fashioned from white marble and with drapery of bronze.

dramatically innovative while never too outrageously exceeding the bounds of traditional decorum—is one of the most persistent features of the imperial office (and not only in matters of art and architecture).

Any imperial intervention in the visual environment—however conservative or radical—was a sign of continuity. It expressed the current emperor's affirmation of a tradition of constructing and restoring public buildings, and of setting up honorific statues and paintings, which went back to the Republic. After Augustus' great programme of visual innovation at the dawn of the Principate,[21] the acts of public building and dedicating images became a particular prerogative of the imperial office. No emperor's contribution to the architecture of Rome, for example, could rival the already mythical dimensions of one who had found a city built of brick and left it made of marble (according to the boast attributed to Augustus by his Hadrianic biographer Suetonius).[22] The accretion of imperial fora around the site of the original Forum Romanum (see **34**) and the addition of grand buildings to the Forum itself, like the temple of Antoninus and Faustina, begun in 141 or the Basilica Nova [**33**] and the temple of Romulus constructed by

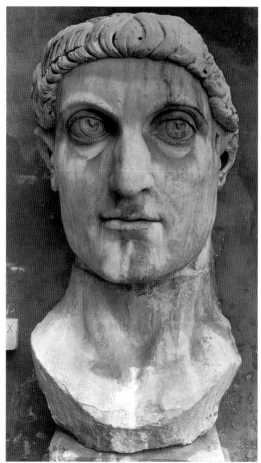

33

The Basilica Nova of Constantine and Maxentius, Roman Forum, *c.* AD 307–13.

The reign of Maxentius in Rome (306–12) saw an impressive programme of construction and sculpture, some of which (including possibly the triumphal Arch of Constantine) was taken over and completed by Constantine after his defeat of Maxentius in 312. A huge building (80 m by 25 m) rising to a height of 35 m, the Basilica Nova was planned by Maxentius to have an east-west orientation along its long axis, with a porch at the east end and an apse at the west. Constantine switched the design, opening an entrance on the long south side and an apse on the rear of the north side opposite.

Maxentius in the early fourth century, mark this imperial slotting into tradition. The constant process of conserving, restoring, and adding to earlier art—of which the Arch of Constantine is the most flamboyant surviving example with its traditional form, reused and recut sculptural reliefs and fourth-century additions—was an affirmation of continuity and an authorization of status altogether as powerful (and self-promoting) as the genealogical messages of family resemblance in portraiture.[23]

Trajan's Forum[35] was the last and largest of the imperial fora built in the proximity of the old Republican Forum Romanum. This complex, designed by the architect Apollodorus of Damascus and dedicated in 113, was entered through a monumental arch leading to a vast square of colonnades behind which opened hemicycles and at the far end the Basilica Ulpia. Through the basilica stood a second area which included Trajan's Column flanked on either side by libraries and his temple (which Hadrian built after his death, so completing the whole complex as a monumental sign of his filial piety).[24] As an imperial forum (admittedly, grander than all its predecessors), it affirmed its continuity with a tradition going back more than 150 years to Augustus' adoptive father, Julius Caesar. But the column [36] broke every precedent. Not only was it decorated with the famous spiral frieze representing the military campaigns of Trajan in Dacia, but its base was to serve as the burial site of Trajan's ashes after his death in 117

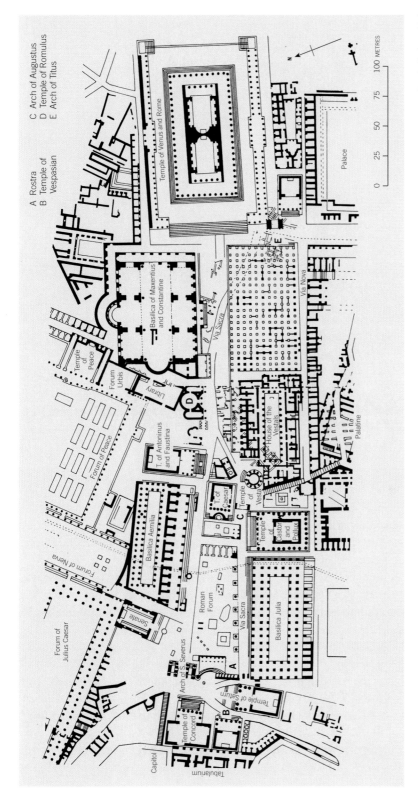

A Rostra
B Temple of Vespasian
C Arch of Augustus
D Temple of Romulus
E Arch of Titus

Temple of Venus and Rome

Palace

Basilica of Maxentius and Constantine

Temple of Peace

Forum Urbis

Library

Via Sacra

Via Nova

House of the Vestals

Palatine

Forum of Peace

T. of Antoninus and Faustina

D

Basilica Aemilia

Forum of Nerva

Senate

T. of Caesar

Temple of Vesta

Temple of Castor and Pollux

Forum of Julius Caesar

Roman Forum

Via Sacra

Basilica Julia

Arch of S. Severus

A

C

Temple of Saturn

B

Temple of Concord

Capitol

Tabularium

0 25 50 75 100 METRES

34
Facing page: The imperial
fora situated to the north of
the Roman Forum.
This page: The Roman Forum
and its later imperial additions.

Plan of Trajan's Forum with its
complex of libraries, basilica,
temple, piazza, and statues,
as well as the column beneath
which the emperor was
buried. To the right is the
hemicycle of Trajan's market.

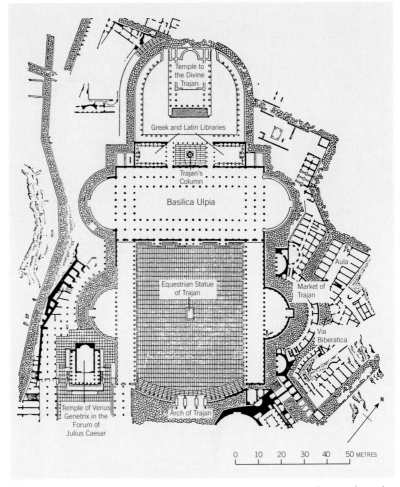

Temple to
the Divine
Trajan

Greek and Latin Libraries

Trajan's
Column

Basilica Ulpia

Aula

Equestrian Statue
of Trajan

Market of
Trajan

Via
Biberatica

Temple of Venus
Genetrix in the
Forum of
Julius Caesar

Arch of Trajan

N

0 10 20 30 40 50 METRES

36

Trajan's Column, Rome,
AD 113 (opposite, left).

Made of Luna marble and
exactly 100 Roman feet
(30 m) high, the column was
crowned by a gilded bronze
statue of the emperor. Its
functions were commemor-
ative (since its height was said
to be the same as that of the
hill removed to build it), honor-
ific (of Trajan's triumph over
the Dacians), and funerary
(since the emperor's ashes
were buried beneath it).
The frieze on the shaft is a
helix of 23 whorls, unfolding
from bottom to top and con-
taining over 2,500 figures;
it represents Trajan's Dacian
campaigns, for which he
was voted a triumph in 116.
The frieze may have been
carved after Trajan's death
as part of the Hadrianic
programme to honour the
deceased emperor.

(in profound contradiction of Roman custom since it lay within the *pomerium*, the original boundary line of the city of Rome).[25]

The novelty was soon to become a model: a number of later emperors, all explicitly following Trajan, erected similar columns with sculpted helical reliefs.[26] In Rome, the column of Marcus Aurelius was erected after his death (in 180) in the vicinity of his temple and—like the column of Trajan—was decorated with a frieze celebrating his military achievements [**37**].[27] In late fourth-century Constantinople, the New Rome, triumphal columns were erected by Theodosius I (perhaps dedicated in 383 or 384) and Arcadius (in 402, although only dedicated in 421).[28] Although the last two have not survived (except for a few fragments), the Arcadian column was sketched by a number of artists in the sixteenth and seventeenth centuries when it was still in good condition [**38**].

Hadrian, who clearly played a significant role in the completion of Trajan's forum and temple, chose not to build his own forum in Rome. Yet in his many building activities in the city, he showed a strong

adherence to the Trajanic policy of balancing innovation with tradition. In the Campus Martius at the north of the city, for example, he undertook extensive restorations of the Augustan monuments such as the Ara Pacis (the area around which was repaved).[29] The pinnacle of such 'restorations' was the Pantheon, built between about 118 and 128 [**39**]—whose façade retained its Augustan inscription recording Marcus Agrippa as the builder. But the new Pantheon was an entirely innovative building in its spatial and visual effects: it consisted of a sphere wrapped in a cylinder, with the upper half of the sphere forming a spectacular dome, and was lit only by an oculus—or opening—in the centre of the dome.[30] The Pantheon was clearly intended as a tour de force, an aesthetic and technical masterpiece. While the rhetoric of retaining Agrippa's inscription spoke of a deliberate modesty within the continuity of tradition, the building's breathtaking novelty proclaimed the emperor's supreme act of surpassing the past.

The extent of imperial self-advertisement in relation to restorations varied with different reigns. Severus Alexander (222–35), we are told, followed Hadrian in respecting the dedications of his predecessors:

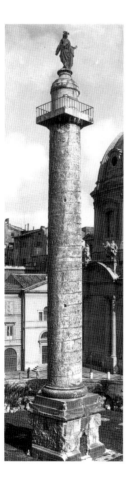 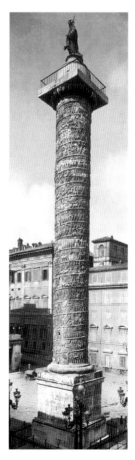 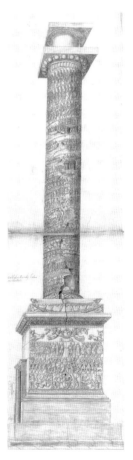

37

The Column of Marcus Aurelius, Rome, AD 180–92 (middle).

Made of Luna marble in imitation of Trajan's column and of approximately the same height, the column of Marcus was also crowned by a portrait statue. Its frieze, representing the Marcomannic wars fought by the emperor in the 170s, is designed in fewer spirals than that of Trajan, and cut in much deeper relief. While this was almost certainly to increase its visibility, the column's sculpture has frequently been seen as a milestone in the development of late-antique (non-naturalistic) styles.

38

The column of Arcadius, Constantinople, between AD 402 and 421 (far right).

This drawing sketched in sepia in a vellum album by an anonymous German artist in 1574 is of the west side of the column. It is one of three views in the album which together form the best record of a monument which is now almost entirely lost. A spiral of 13 bands wove round the shaft which stood 100 feet high. The narrative of the frieze probably represents Arcadius' victories over the Goths in AD 400, while the base shows images of Christian Imperial triumph.

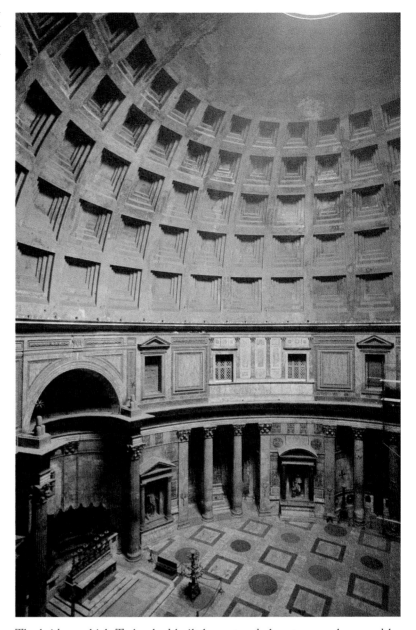

This radically experimental architectural tour de force, certainly the masterpiece of all surviving Roman architecture, disguises its Hadrianic innovations behind the retention of Marcus Agrippa's dedicatory inscription for the original building on the site, put up at the end of the first century BC. (This page, interior; facing page, exterior).

The bridges which Trajan had built he restored almost everywhere, and he constructed new ones, but on those that he restored he retained Trajan's name.[31]

His ancestor Septimius Severus (193–211) was not so restrained. In the somewhat tart comment of Severus' contemporary, the senator Cassius Dio:

He restored a very large number of the ancient buildings and inscribed on them his own name, just as if he had erected them in the first place from his own private funds.[32]

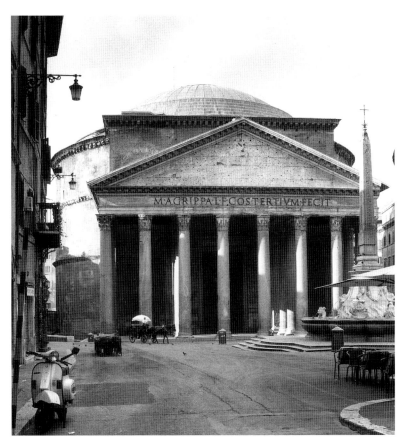

Some of the difficulties and proprieties surrounding imperial inscriptions are revealed by a statute of the joint emperors Marcus Aurelius and Lucius Verus, of about AD 162 or 163. They refuse permission to the council of Ephesus to melt down old statues of former emperors:

As for the ancient statues of emperors that you say are stored in the council hall, to put it briefly, we decree that all shall be preserved with the names of those emperors for whom they were made and that none of that material whatever shall be transformed for our images, for we are not at other times eager for our own honours and still less shall we endure that the honours of others be converted to us. But as many of the statues … [whose characteristic] features can be recognised, these, as it seemed to you after consideration, ought to be preserved under the same names as those for whom they were named. But for images so excessively corroded, as you report, and no longer able to represent features, perhaps capable of identification in part from inscriptions on their bases or from records preserved in the council hall … the names may be supplied, so that honour may be received for our predecessors, which would vanish completely with the melting down of the images.[33]

Many of the complex issues of imperial self-propagation emerge in this statute. The rhetoric of modesty, and of preserving a pious respect for the past, was important not only to a particular emperor's

40

Gold coin of Trajan, struck in Rome, c. AD 114–16.

The reverse shows Trajan's column in Rome, with the imperial statue holding a globe and sceptre on a small platform on top. The column stands on a rounded base with a door in front, on which two eagles are perched.

41

Gold coin of Trajan, struck in Rome, c. AD 115

The reverse shows Trajan's forum in Rome. Six columns, on a podium of two steps, carry an entablature crowned with statuary including a six-horse chariot group in the centre. Between the central columns is an arched door-way, flanked by pedimented niches, perhaps shrines, with statues. The obverse is **28**.

self-image, but also to the whole tradition of imperial continuity. On the other hand, there was a persistent temptation—not only for individual emperors (like Severus in Dio's account) but especially for those who sought to flatter an emperor and so gain some material benefit—to melt down old statues or refurbish old buildings and set up something new in the current emperor's name. In the context of a long and distinguished cultural heritage, with plenty of images and buildings at any one time in a sorry state of repair throughout the empire, the urge to aggrandize the present was all the more powerful. Marcus and Lucius in this statute go for a very moderate or conservative policy of what might be called minimum intervention, but they have the statute inscribed in a very public place in Ephesus in order that their moderation be well advertised! At the same time, by erecting this inscription, the Council of Ephesus—having rather overstepped the mark in making its request—was announcing its political correctness. It should be added that the inscription goes on to allow for the melting down of statues in really very bad condition—allowing of course for the very conversion of others' honours to those of the current emperors which the bulk of the text inveighs against.

Parallel with the actual making of buildings or images under imperial auspices, and with the use of inscriptions to identify the donor or recipient of honours, was the commemoration of such dedications in the coinage. Coin issues of Trajan, for instance, record many of his major monuments in Rome—the forum of Trajan, and (in the forum) Trajan's column and his bronze equestrian statue [**40, 41**]. By placing such images on the reverse of coins which were adorned on the obverse with the emperor's portrait, the imperial image-makers were not only establishing a direct relationship between emperor and monument, but were disseminating the image of the emperor as patron of the arts throughout the whole empire. This strategy went back to Augustus, and it was far from being centrally controlled. Local coinages around the empire reflected and emulated such visual moves. However, the coinage could be a more subtle instrument of imperial image-making than is demonstrated by such relatively crude propagandist gestures. Emperors might use the coinage to assert their continuity with the tradition of earlier reigns, as when Antoninus Pius had coins struck in 158–9 showing the temple of the deified Augustus [**42**] or when Philip the Arab (244–9) celebrated the millennium of the city of Rome in 248 by striking coins showing the famous temple of Venus and Rome constructed by Hadrian and Antoninus Pius, and dedicated in about 141 [**43**].

Likewise, the coinage might assert an association with significant statues, gods, or temples beyond Rome in other parts of the empire. Numerous Roman emperors from Claudius in the first century AD to Valerian and Maximus in the third, depicted the famous temple and

42

Gold coin of Antoninus Pius, struck in Rome, c. AD 158–9.

The reverse shows the Temple of Augustus (and is inscribed to confirm this). The temple is represented in front view, with eight columns rising from a two-stepped podium and crowned with a sculpted pediment. Inside are seated cult statues of Augustus and his empress Livia; two statues stand in front. On the roof is a chariot group and standing figures at the angles representing Romulus on the left (holding spear and trophy) and Aeneas on the right (carrying his father Anchises and leading his son Ascanius).

43

Gold coin of Philip I, struck in Rome, AD 248.

The reverse shows a temple in front view, with six columns rising from a three-stepped podium and crowned with a sculpted pediment. Inside is seated the cult statue of the goddess Roma. The inscription, 'saeculum novum', refers to the fact that Rome celebrated her thousandth anniversary in 248, during the reign of Philip the Arab, in celebration of which this coin was issued.

cult image of Artemis of Ephesus on their coins (see **44**, for example). In this way the representation of art—whether contemporary or classic, whether sacred (as with temples), or rather more secular (as in depictions of the circus or amphitheatre)—proved, at least on the coinage, to be a significant means both of announcing continuity and of affirming a cultural cohesion across reigns and across the empire.

No affirmation of change—and at the same time of continuity—was more marked than the creation of new capitals in the later empire. Already with the accession of Hadrian in 117, emperors had begun to spend as much time travelling in the provinces as they spent in Rome. By the third century, the need to man the frontiers, defending the empire equally from foreign invaders and rivals for the throne, finally put paid to the administrative and political pre-eminence of Rome. As the historian Herodian, writing in the third century, baldly put it: 'Rome is where the emperor is'; and, in the words of a tetrarchic panegyrist describing the meeting of Diocletian and Maximian in Milan in winter 290–1, 'the capital of the empire appeared to be there, where the two emperors met'.[34] In late antiquity, the triumphal visits of emperors to Rome, now a largely ceremonial capital (for instance, the triumphs of Aurelian in 274 and Probus in 282, the *adventus* of Diocletian in 303, Constantine in 312, and Constantius in 357), were climactic exceptions to the normal operation of the imperial court. Instead of residing in Rome, emperors began to set up their own capitals in places more convenient or less inimical. Hence Marcus Aurelius (161–80) and Maximinus I (235–8) spent much time in Sirmium near the Danube, Valerian (253–60) occupied Antioch in Syria as his capital in the east, Gallienus (260–8) set up his headquarters at Milan.

With the creation of the tetrarchy, the empire acquired a multiplicity of courts, with different emperors favouring different cities. In the west, the Augustus Maximian held court in Milan, while his Caesar, Constantius Chlorus, resided in Trier. In the east, the Caesar Galerius' main capital was at Thessalonica, while Diocletian, the founder of the tetrarchy, set up his court at Nicomedia in Asia Minor (where he had first been proclaimed emperor in November 284). However, on his abdication in 305, he retired to the imperial villa he had built at Spalato in his native Dalmatia. Much of this palace survives as sections of the modern town of Split [**45**]. The palace at Split, with its walled perimeter, temples, and streets, resembles a cross between a fortress and a city. Its public pièce de résistance was the great imperial mausoleum [**107**] and peristyle [**46**]. It was, of course, not a city; but it was a palace with all the material advantages, imperial ceremonies, and luxuries of a capital city.

The final break with Rome was Constantine's foundation of a new imperial capital—the Second Rome—at Constantinople, inaugurated in 330 [**47**]. Nothing so potently symbolized the rupture with a pagan

44

Silver coin of Hadrian, struck in Asia Minor.

The reverse shows the cult statue of Artemis of Ephesus, wearing a high crown, with fillets draped from her hands and two stags beneath who look back towards her (compare **134** for a statue of the goddess). The obverse is **27**.

and Italian-dominated past than this bold and spectacular act—nothing less than a refocusing of the entire empire around a new centre of gravity. Yet the building of Constantinople was a profoundly traditional enterprise. Its foundation ceremonies obeyed the ancient pagan rituals for founding cities; its fora, hippodrome, baths, and palaces embraced the urban models of its great predecessor. Above all, it was to be adorned with art, especially statues, lifted from every province of the empire—masterpieces of (pagan) distinction by canonical artists like Phidias and Praxiteles whose number and fame eclipsed even those of Rome.[35] In the words of Constantine's Christian biographer, Eusebius (the bishop of Caesarea):

[. . .] the city which bore his name was everywhere filled with bronze statues of the most exquisite workmanship, which had been dedicated in every province, and which the deluded victims of superstition had long vainly honoured as gods with numberless victims and burnt sacrifices.[36]

The main difference from pre-Christian cities was in the replacement of temples with churches, but even the number of these was moderate initially. A list of AD 425 gives only 14 churches built in nearly a century of the city's existence.[37]

As the new capital developed, it did so much on the pattern of Old Rome. Emperors added fora (including those of Theodosius—complete with column, basilica and triumphal arch on the model of the forum of Trajan in Rome—dedicated in 393, and Arcadius, built after

45

Restored plan of Diocletian's palace at Split.

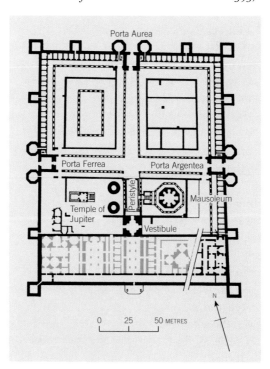

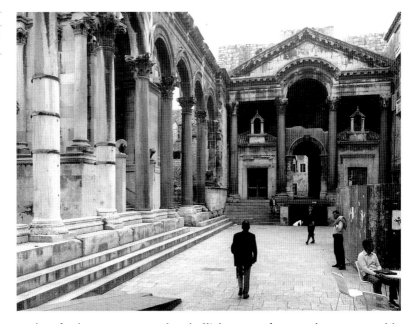

A large courtyard flanked
by open colonnades and
culminating in a ceremonial
pediment, the peristyle led
to the main residential wing.
The pediment stands on red
granite columns imported
from Egypt and at its apex
stands a stone plinth 4.26 m
wide, which would have
supported an imperial statue.

403) and other monumental embellishments. Among the most notable
survivals are the porphyry column of Constantine originally with a
sculpted pedestal and a bronze statue of the emperor on top,[38] the
colossal bronze statue of an unidentified fifth-century emperor
brought by the Venetians to Barletta after their sack of Constantinople
in 1204 [48], and the sculpted base of an obelisk raised by Theodosius in
the Hippodrome in 390 [49].[39]

The carvings of the Theodosian base signal the continuity with
earlier Roman public reliefs in which the emperor was displayed as an
icon in his official robes of state. The obelisk stands on a double base,
the lower part of which gives inscriptions in both Latin and Greek
honouring the emperor as well as reliefs of the act of erecting the
obelisk and of the games. The four sides of the upper base, carved in
the late-antique stylistic tradition going back to the Arch of
Constantine, are divided—like the Brescia ivory [15]—into two zones.
At the top, in the centre, is the imperial box at the Hippodrome, with
the emperor and his family, surrounded by attendants. In the bottom
zone are reliefs of spectators and barbarians giving homage. The
base—standing in the Hippodrome—reflects the public rituals of the
Hippodrome in which the emperor and his court would preside over
the games. The hierarchy of spectators, from barbarians via Roman
citizens to the emperor himself, was potently displayed to those very
spectators on a monument whose lower base and inscriptions cele-
brated the emperor's glory in erecting the obelisk in the first place.
Even the actual stone of the obelisk is envisaged as Theodosius' obedi-
ent servant. The Latin inscription, presented as if the obelisk were
itself speaking, reads:

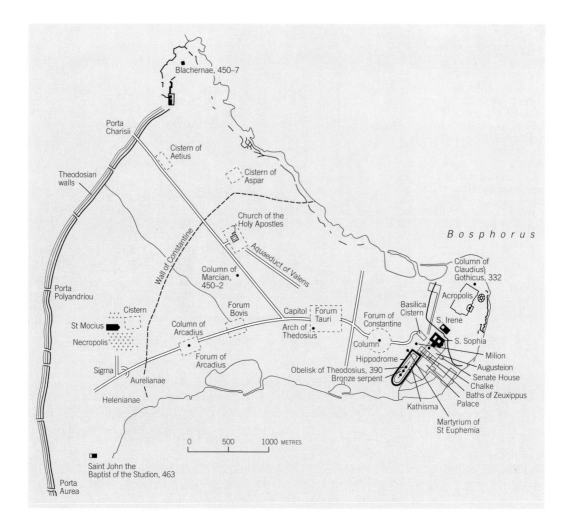

Blachernae, 450–7

Porta
Charisii

Cistern of
Aetius

Theodosian
walls

Cistern of
Aspar

Church of the
Holy Apostles

Wall of Constantine

Aquaeduct of Valens

Bosphorus

Column of
Claudius
Gothicus, 332

Porta
Polyandriou

Column of
Marcian,
450–2

Acropolis

Forum
Bovis

Capitol Forum
Tauri

Forum of
Constantine

Basilica
Cistern

S. Irene

Cistern

St Mocius

Column of
Arcadius

Arch of
Thedosius

S. Sophia

Necropolis

Column

Milion

Sigma

Forum of
Arcadius

Hippodrome

Augusteion

Obelisk of Theodosius, 390
Bronze serpent

Senate House

Aurelianae

Chalke

Helenianae

Baths of Zeuxippus

Kathisma

Palace

Martyrium of
St Euphemia

0 500 1000 METRES

Saint John the
Baptist of the Studion, 463

Porta
Aurea

47

Map of Constantinople in the
reign of Theodosius II (died
AD 450).

Formerly reluctant, I was ordered to obey the serene lords and carry the palm of the extinct tyrants. Everything yields to Theodosius and his everlasting offspring. So conquered and vanquished, I was raised to the lofty sky in three times ten days while Proclus was judge.[40]

The traditions of dedicating state reliefs, statues, and larger monuments in addition to building-complexes, epitomized by these few Constantinopolitan remains, were central to the advertisement of the imperial presence in Rome itself. Among the most prominent testimonies to the emperors' glory and place in the succession, were equestrian statues in gilt bronze, like the great portrait of Marcus Aurelius which originally showed him trampling a fallen barbarian and was probably erected following his triumph in 176 [**50**].[41] Although dressed in civilian rather than military costume, the connotations of the mounted emperor dominating the barbarians made clear allusions to conquest in war (compare Trajan, **53**). The equestrian portrait thus

48

Colossal bronze statue of an emperor, 3.55m high.

Transported to Barletta as part of the Venetian booty following the sack of Constantinople in AD 1204, this statue was originally an honorific imperial portrait. It is impossible to identify the sitter in the absence of an inscription. Guesses range from Valentinian I (emperor 364–75) to Marcian (emperor 450–7).

The obelisk base of
Theodosius I from the south,
Constantinople, AD 390.

The marble obelisk occupied
a position along the central
line of the Hippodrome in
Constantinople. It has two
bases: the lower base on
the south-west side shows
a depiction of chariot racing
in the Hippodrome, and the
south east side shows the
panegyrical Latin inscription.
The upper base boasts reliefs
showing the emperor and his
family (in the imperial box at
the centre) presiding over the
games. On the south-west
side they are surrounded by
the court and bodyguard,
while below them are the
spectators, and two figures
flanking a staircase. On the
south-east, the side which
faced the imperial palace,
the emperor is presenting a
wreath of victory at the close
of the games.

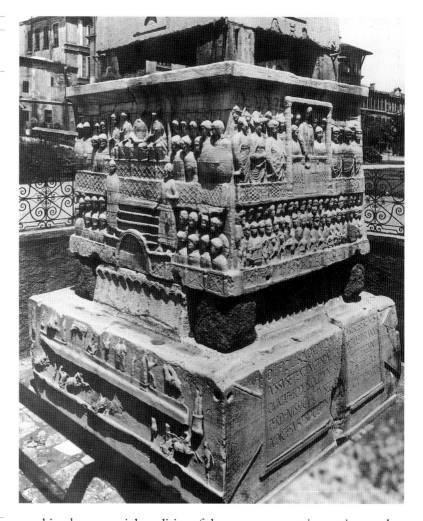

50

Gilded bronze equestrian
statue of the emperor
Marcus Aurelius, from Rome,
c. AD 176.

One of the few Roman bronze
sculptures to survive above
ground, this object has been
on continuous public display
in Rome since its making.
It may originally have stood
on a column, which is how
it was displayed after 1187,
when Pope Clement III placed
it, with a number of other
antique sculptures, outside
the Lateran Palace. In 1538
it was transferred to the
Capitol where it formed the
centrepiece of Michelangelo's
Renaissance piazza.

combined two crucial qualities of the emperor, creating an image that
was simultaneously triumphant and civilian. This statue, which only
avoided destruction during the middle ages because it was wrongly
believed to represent Constantine, the first Christian emperor, is our
single surviving equestrian bronze, although other examples are
known from literary descriptions, fragments, and images on coins.[42]
The practice of erecting both such statues and triumphal arches (also
represented on coins)[43] went back beyond the empire to Republican
Rome.

The arches, some single-bayed like that of Trajan at Benevento [51]
and some with three bays like the arches of Severus and Constantine in
Rome [1, 52], combined the forceful presence of a grand architectural
form with much space for the carving of surfaces with imperial propa-
ganda. The iconography of figural panels might relate to specific polit-
ical concerns in the time of erecting the arch. For instance, the triumph
of Septimius Severus in 202 is carved on the frieze of his arch in Rome,

51

Trajan's arch at Benevento, c. AD 114–18.

Richly decorated with figural relief sculpture, this arch appears to celebrate imperial reforms and benefactions—especially the establishment of peace—in Italy and the provinces (see the detail, **59**). Although it strongly emphasizes the beneficial results of Roman conquest, its iconography is a long way from the overt militarism of Trajan's column, his monument at Adamklissi, or the reliefs of the great frieze which originally stood in his forum in Rome.

52

Arch of Septimius Severus, Roman Forum, erected AD 203.

The main subject of the now rather eroded relief sculpture is the emperor's Parthian triumph of 202, while the entire attic storey is given over to the inscription.

just as the victories of Titus and Constantine are represented on their arches, while the alimentary system of providing free corn to the poor, which Trajan sponsored, provided the context for the prominent panel of imperial benefaction in the central passageway of the Benevento Arch [**59**].[44] At the same time the reliefs on official monuments showed the emperor in the iconic and archetypal roles of state. He presides over public ceremonials, as in the Theodosian base [**49**]. He performs sacrifice, as in the Severan Arch of the Argentarii [**23**] or on the only surviving base from a five-column monument erected by Diocletian in the Roman Forum in 303 to celebrate the *decennalia* of the tetrarchy, which shows the traditional *suovetaurilia* sacrifice with its procession of a pig, sheep, and bull [**60**]. He dispenses justice, as in the panel from an arch of Marcus Aurelius, reused on the arch of Constantine [**12**]. He speaks to the people, as in the Constantinian frieze [**7**] and addresses the troops. He enters cities [**87**], and so forth. One of the most celebrated of the earlier fragments incorporated into the Arch of Constantine are portions of a great frieze celebrating Trajan in his dramatic military role as conqueror over the Dacians [**53**].

Such images transcend the specific politics of any individual reign and glorify a condition of being: the emperor was not merely a person, he was the definition and symbol of the nature of the Roman state. Since, as the statute of Marcus Aurelius and Lucius Verus implies, the excuse for erecting most monuments was honorific—a victory, for example, or an anniversary—this iconic use of images rendered the particular dedication more than simply a flourish of individual self-congratulation. By entering what was already by the later second century a hallowed *collection* of imperial statues, arches, and temples in Rome, buildings like Diocletian's five-column monument (represented in the background of the *adlocutio* relief from the Arch of Constantine [**7**]) or the Severan and Constantinian arches, as well as statues like Marcus' equestrian bronze, became both a gesture of traditional self-promotion at the hands of their dedicators (often public bodies, like the Senate, or private guilds, like the money-changers who put up the Arch of the Argentarii) and imperial bids for a reputation in posterity. Providing a worthy spectacle in the visual environment of the city was a necessary (if not sufficient) condition for a claim to perpetual glory. This is in part why, on the Arch of Constantine and before that on the Arcus Novus of Diocletian (erected in Rome in 293),[45] *spolia* culled from earlier monuments were reused. One way the Arch of Constantine affirmed the legitimacy of Constantine's succession was to cut his (or his ancestors') portrait into those of Trajan, Hadrian, and Marcus (see **6**, **12** and **53**). He was not merely like the great emperors of the second century, he was their spirit—their imperial grandeur—embodied. His arch and that of Diocletian not only added a later item to the number of imperial monuments in Rome, they integrated

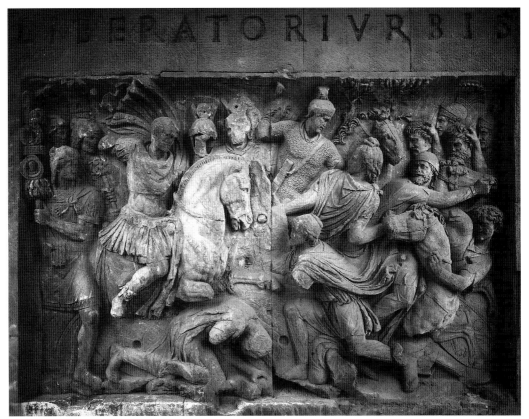

53

The emperor Trajan in battle, marble relief, *c*. AD 118.

This panel comes from the 'Great Trajanic Frieze', which probably belonged originally to Trajan's forum in Rome. This section, and three others, were subsequently incorporated into the central bay and the attic storey of the Arch of Constantine. The figures are nearly 3 m high, and the original frieze was at least 30 m long. The iconography shows Trajan (his head later recut to resemble Constantine), without helmet and on horseback, in personal triumph over the Dacians— one of the enemy is trampled beneath him, one pleads for mercy and the others turn in flight before his victorious advent.

themselves into the collection by exhibiting some of the collection's prime specimens within their own sculptural adornment.

While Constantine's arch (erected *c*.312–15) has been excoriated for the novelty of the style of its fourth-century sculpture (as we have seen), it is worth noting how traditional was its form [1].[46] It is in fact closely related to the Arch of Septimius Severus (erected in 203) [52],[47] whose three openings resembled the Parthian Arch of Augustus and whose long sides—punctuated between the bays by free-standing columns with composite capitals resting on tall pedestals—owed much to the Parthian Arch of Nero also in Rome. The Severan Arch, a celebration of the emperor's Parthian victories of 198, was in part a visual attempt to link his military successes in the east with those of the past. Just as Severus had himself and his family adopted retrospectively into the Antonine dynasty, so the arch associated him with the triumphs of the Julio-Claudians. These Parthian allusions are absent from the Arch of Constantine which celebrates not a victory over a foreign foe but the rather more delicate theme of conquest in civil war. This is one reason why, in its architectural form as well as in its subject matter and iconography, the Arch of Constantine is so relentless in establishing its hero as a rightful heir of the great imperial tradition.

In late antiquity, the empire—now a Christian realm—needed to

affirm its difference from the pagan past while simultaneously insisting on its heritage of continuity with the Roman imperial tradition. In this context, some aspects of imperial imagery remained strongly traditional—as we have seen with the Theodosian and Arcadian columns, the reliefs of the obelisk base and the colossal statue from Barletta. But certain aspects of the imperial image began to change. Portraits of the emperor in the luxury arts like books, ivories and silver plate still show him performing the offices of state but in a kind of resplendent and full-frontal isolation. In a consular portrait made for a Roman codex-calendar for the year 354, Constantius II is shown seated in a jewelled toga and diadem dispensing coins from his right hand in the imperial ritual of *sparsio* [**54**]. No recipients of his bounty are represented, and the emperor's isolation is emphasized by the curtained niche in which he sits.[48] Likewise, in the ivory diptych of the consul Probus (carved to announce his tenure of the office in 406) the young emperor Honorius

54

The emperor Constantius II, enthroned in jewelled imperial dress, halo and sceptre, dispensing coins in the act of *sparsio*. From a copy executed in 1620 of a ninth-century manuscript copy of a codex-calendar made in Rome in AD 354.

Constantius and the Caesar Gallus appear in the calendar as the consuls for the year 354. The iconography of imperial benefaction, or euergetism, goes back to reliefs on the Arch of Constantine and to scenes from Trajan's arch at Benevento.

Ivory diptych of Anicius
Petronius Probus, consul
in AD 406, from Rome.

This diptych represents the
22-year-old emperor of the
west, Honorius, whose name
is inscribed above his halo,
and was carved in 405 or 406.
Dressed in the garb of imperial
triumph, the left-hand image
of the emperor holds an
orb surmounted by a victory,
and a banner crowned by
the christogram, which is
inscribed 'you will conquer
always in the name of Christ'.
In the right-hand wing,
Honorius holds a sceptre
and an oval shield.

is twice depicted as the triumphant military monarch [**55**]. In the left-hand leaf he holds an orb surmounted by a winged victory and a banner bearing the christogram and a Latin inscription announcing that his conquests are in the name of Christ.[49] Again the emperor is isolated in a niche. Unlike earlier images of imperial triumph (for example the majestic equestrian sweep of the Trajanic frieze) this is an emperor who represents the distant and hieratic symbol of conquest rather than a semblance (however remote, however idealized) of its actuality.

In both these portraits the emperor is shown with a halo. His isolation is not merely from the rest of the social hierarchy: it is sanctified with iconographic markers which were soon to become the norm for the representation of saints. A truly magnificent example of such sanctified splendour in the emperor can be seen in the portrait of Theodosius on a silver missorium found in western Spain which commemorates the emperor's *decennalia* in 388 [**56**].[50] This image combines the emperor's sacred isolation with a symbolic portrayal of his social world. Theodosius is much larger in scale than the other figures, is adorned with diadem and halo, and sits alone in the large niche of a great pediment (resembling that at Diocletian's palace, **46**). To either side are his co-emperors, Valentinian II, and Arcadius, much smaller

56

Silver missorium, or commemorative dish, celebrating the *decennalia* of the emperor Theodosius I in January 388.

With a diameter of 0.74 m and a weight of more than 15 kg, this dish was a valuable possession and was eventually buried in southern Spain because of its value as bullion. It may have been an imperial gift, and could have been made in Rome or Constantinople.

in scale and holding orbs, and beside them are the bodyguards. To the lower left, Theodosius hands a document, possibly the codicils of his appointment, to a dignitary (perhaps the recipient or even the commissioner of this splendid silver plate, weighing 50 Roman pounds), and beneath reclines the personification of the earth symbolizing the universal dominion of the Christian empire. This great icon of imperial majesty is still recognizably in the tradition of such relief sculptures as the Theodosian obelisk base, the fourth-century frieze on the Arch of Constantine and even the triumphal procession from the frieze of Septimius Severus' arch in his home town Lepcis Magna, dated to about AD 203 [**85**], but it is significantly simplified. Instead of a large number of attendants filling the image's space, the court is represented symbolically by very few figures; instead of a merely central and

Onyx cameo, thought to depict the emperor Honorius and his wife Maria on the occasion of their wedding in AD 398.

somewhat large emperor, Theodosius is heavily differentiated both by his setting in the niche and by his halo (as well as dominating the field of the missorium in scale).

The isolation of the jewelled, sacred emperor—elevated by state ritual and by his halo—from the ordinary world, is in sharp contrast with the more collegial and familial image of earlier times. Emperors like Antoninus Pius and Septimius Severus had used art to propagate the image of an ideal family—ideal in life (as on the Severan tondo and the panels of the Arch of the Argentarii, where all members participate in a family portrait, ironically in the event of Caracalla's later murder of his brother Geta in 211 [**22, 23**]), and ideal in death (as on the column base of Antoninus which represents the joint apotheosis of the emperor and his wife Faustina, [**13**]).[51] Even in the most hierarchical dynastic imagery of the second century, like the frontal dynastic relief from the Great Antonine altar at Ephesus [**82**], the imperial family was still recognizably a family, women, children, and all. This iconography of the ideal family did continue into late antiquity, for example in the Rothschild cameo in Paris which represents a fourth-century emperor and empress (perhaps Honorius and his wife Maria on the occasion of their marriage in 398, see **57**). The emperor and his queen look back, in their classicizing hairstyles to the days of their Julio-Claudian predecessors, while the central gem in the imperial diadem, with its Christian monogram, signals the new dispensation. There is still a certain familial informality in what was probably a private imperial commission—with the emperor gazing to the right while his wife, behind him, looks towards her spouse as if for reassurance. By contrast, the 'family' of the missorium is an entirely formal affair—a portrayal of official hierarchy in the use of scale, enthroned frontalism, and centrality.

But neither the image of family unity nor that of sacred isolation

should be regarded as necessarily reflecting any kind of reality. Emperors, like modern politicians, were at the hands of their image-makers. Just as the happy family of Septimius Severus belies the actuality in which the elder son slaughtered his younger brother in the year of their father's death in order to secure his throne, so the mighty and hieratic icon of Theodosian majesty (excluding even the image of a single lady) disguises a court in which imperial women wielded at least as much influence and perhaps more actual power than the likes of Faustina two centuries before.[52] These images tell us not about how the imperial family really was, or even how such families were perceived. Rather, they give us an insight into how the state wished its rulers to be seen and how changes in time—social, ideological, intellectual— effected quite significant changes in the forms, appearances, and styles of such self-presentation.

Part II

Images and Society

Art and Social Life

4

When art is not doing a specific job (like promulgating an imperial image, representing a deity's form, or celebrating a deceased person) it is arguably fulfilling a still more important social role. It defines the textures of social life, the houses and streets where people live, the adornments of rooms and of persons, the spaces in which the crucial rituals of civic society—rituals of religion, of patronage and status, of acculturation and friendship—are performed. In short, art and architecture formed the very fabric of the cultural and social world of ancient Rome, the space in which the individual's identity was played out in relation to the world in both the private and the public spheres. Images were central to the experience of what it was to be a Roman—on every level from the imperial family to a freedman, from being a member of the provincial élite to being a slave—in the way that the flavour is at the heart of a meal, though it may not be what provides the protein and the carbohydrate. Roman history was lived in the ambience of Roman architecture and art, and to that extent the role of the visual is essential to any understanding of Roman history.

Yet because art forms the setting where the fantasies and ideals of a society may be represented, imagined, negotiated, it is for that very reason a dangerous guide to actuality. The flavour of a meal fosters the desire and the pleasure of eating; it is not necessarily a good representation of the ingredients which went into the cooking. Though the temptation is almost overwhelming, we must resist any simple interpretation of images as documentary illustrations of 'daily life'.[1] A wonderfully evocative object, such as the unpretentious relief from Ostia showing a woman selling vegetables [58], seems instantly to plunge us into the bustling reality of shopping in the port of Rome at the close of the second century AD. The panel—whose exact provenance is unknown, but which may well have served as a sign advertising a shop or market, or could equally have had a funerary function—is vivid: the vendor stands at a trestle-table displaying assorted produce, with other vegetables stacked on the shelves behind and in the wicker basket below the counter.[2] Yet we can never know the extent to which reality was *like* this. Certainly, the relief shows an ideal—a well stocked shop (though the actual vegetables for sale are hard to identify), apparently a

Detail of 69

Inner medallion of Sevso's hunting plate, silver, partially gilded with niello inlay, fourth century AD.

Five diners, one female, recline at an open-air picnic. Above and below are scenes of hunting (elk and wild boar) as well as fishing, while beside and immediately below the picnic food is being prepared. The Christogram occupies the apex of the medallion rim where the inscription begins.

Marble relief with a vendor selling vegetables, from Ostia, late second or early third century AD.

successful venture—but that ideal is at least as much an advertisement as it may be a reflection of actuality. The very isolation of the vendor in her stall's space may have struck a rather false note in the chaotic reality of an actual market where women like her worked.

Representing status

Slaves and the lower classes

None the less, such images throw a rare light on to the social world of the lower classes, not as others (their betters, their exploiters) may have envisaged them, but as they wished to portray themselves. Like the image of the centurion pouring a libation on his own funerary altar [**16**], this relief is not a portrait in the naturalistic sense, so much as an idealization of an individual in terms of the job which provided both a livelihood and a social identity. We cannot determine from art the precise facts of the social reality to which these images allude and whose ideals they construct. The vegetable-seller relief may have been commissioned by a solitary shopkeeper or the owner of a whole string of such shops (for example), while the funerary relief, also from Ostia, showing a man and his wife with a scene from the games [**14**] certainly indicates some connection with chariot racing, but we can never know if the man was a charioteer, a sponsor of chariot teams or an official of the course. Nevertheless, from such images we can feel the pride with which Romans represented and celebrated the realities of their lives, whether in personal commemorations or in public advertisements.

Marble relief of Trajan distributing the *alimenta*, subsidies of grain or money, to fathers accompanied by their children. From the passageway in the central bay of Trajan's arch at Benevento, *c.* AD 114–18.

The emperor, now bereft of his head, stands to the left. In front of him are four female personifications with crenellated crowns who probably represented the main cities of the empire, as well as children and their fathers.

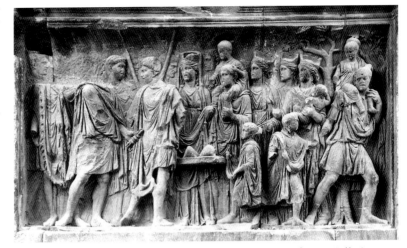

By contrast, most images of the lower classes, and especially images of slaves and servants, were the products of élite patronage. They showed the people, not as they were or as they wished to be seen, but through a purview at least in part determined by aristocratic tastes. For example, the poor families with children receiving Trajan's benefaction in the famous relief from the Benevento arch [**59**], or the soldiers beneath the imperial dais (let alone the barbarians receiving justice) in the relief of Marcus Aurelius now on the Arch of Constantine [**12**] are depicted to add grandeur to the status and majesty of the imperial presence that is the real subject of such scenes. In these images, the iconographical positions of the figures and the thematic emphasis on the emperor as benefactor work together to represent the lower classes as little more than a backdrop of recipients of imperial action and generosity. In the case of the Benevento panel, the emperor—to the left of the scene and now unfortunately without his head—oversees the distribution of either money or grain. The image's emphasis on families and especially fathers and children receiving his largesse inevitably throws into relief the emperor's own official status as *pater patriae*—father of the fatherland, supreme father of all these fathers and children.[3]

In the case of slaves, the visual denotation of class is even more strongly marked. Take the *victimarii*, the slaves carrying axes who accompany the procession of bull, pig, and sheep in a sacrificial relief on one of the faces of a base from Diocletian's five-column monument (erected in the Roman Forum in AD 303 to celebrate the *decennalia* of the tetrarchy). They are represented naked [**60**],[4] while the high official who leads this *suovetaurilia* procession, as well as the imperial figures who appear on the other sides of the base, wear togas. The slaves' social status is defined visually by their nudity and their attributes, the axes, which signal the messy aspects of the slaughter—bleeding, and cutting up of the sacrificial carcasses—that were left to the slaves rather than

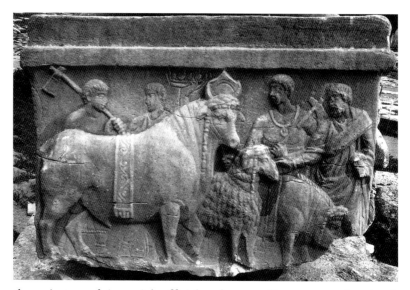

Scene of sacrificial procession
from the only surviving column
base of Diocletian's five-
column monument, erected
in AD 303 to celebrate the
decennalia of the tetrarchy.

The whole monument is
represented on the Arch of
Constantine (see **7**). In this
relief an official in a toga leads
the traditional *suovetaurilia*,
sacrifical procession of pig,
sheep, and bull, accompanied
by two nude slaves carrying
axes and one attendant
bearing a dish of fruit.

the priests and imperial officials who grandly oversaw the ritual.
Again, we cannot know if such sacrificial attendants were *actually*
always naked (as they usually are on sacrificial reliefs), but nudity was
certainly a useful pictorial convention in the distinguishing of social
class. The irony is that in the libation scene on another face of the same
base, the one nude figure is not a slave but the god Mars (recipient of
the *suovetaurilia* sacrifice and identifiable by his helmet). *His* nudity is
a sign of divinity by contrast with the togate emperor and his courtiers.
In both the cases of the slaves and of Mars, nudity by contrast with
clothing works as a visual signifier of status—but how different are the
meanings implied between slavery and godhead!

One response to slaves in élite circles was to turn their representa-
tion into parody or to apotropaic, even semi-magical, uses. For example,
on the threshold between two warm rooms from the Northwestern
Baths at Timgad in Roman North Africa, a floor mosaic from about
AD 200 was found showing a black bath attendant holding a huge
phallus which emits either urine or semen [**61**]. An image like this (and
many survive from Pompeii and Ostia) had numerous potential mean-
ings.[5] Representing a slave carrying a fire shovel (very appropriate in
the context of the baths' heated rooms), the mosaic may be intended to
provoke a laugh at the crudity of the action and the enlarged phallus—
this slave is not exactly performing to his job description! In the con-
text of public nudity (and associated suggestions of moral depravity) in
the baths,[6] the mosaic raises questions about the acceptablity of sexual
display. But the phallus also carried apotropaic significiance by ward-
ing off the evil eye, and in this sense the image not only warned the
viewer (through the attribute of the shovel) about the heat of these
rooms but it also allowed the baths' user to trample on the black demon
of ill omen which popular superstition tended to associate with

Ethiopians.[7] All such meanings, from the comic to the demonic, are inevitably permeated by popular attitudes which combined an openly acceptable racism against blacks with disdain for slaves. And in such representations, realism has been left far behind in the satirical exaggeration of the penis for parodic, lewd, or magical reasons.

The élite

The arts commissioned by, or made for, an élite market represent their patrons, of course, much more as they wished to be seen. Public honorific statues, like the portrait of Plancia Magna, wearing her finest dress, from a niche in the city gate she financed for her native city of Perge in Asia Minor [19], show subjects at the apogee of their social status, as they would have wished to be regarded. Plancia Magna, in chiton and himation, wears a priestly diadem marking her out as

61
Floor mosaic, depicting a Negro bath attendant with extended phallus. From the Northwestern Baths, Timgad, North Africa, c. AD 200.

priestess of the imperial cult—an immensely significant official and civic postion announced also by the inscription on the statue's base. More private images were no less proud in their validation of the patron's grandeur—for example, the image of Projecta going to the baths on the lid of the Projecta casket in the Esquiline treasure captures not only the chaos of family life, but also the wealth of a lady with servants and gilded silver caskets as precious as the one on which this scene was hammered and the ones which this scene itself represents [17]. If the finery of the lady was at bottom a reflection of the status of her husband and their family, then this image may ultimately have gestured beyond the portrayed to the dignity of an élite family, its head the *pater familias*, and the future wealth of its heirs. At the highest social level—and among the most expensive of all luxury arts—were the sardonyx cameos created for the imperial court. Take the cameo showing Julia Domna, wife of Septimius Severus, in the guise of the moon goddess, Luna, perhaps here equated with the Syrian goddess from Julia's own Palestinian homeland [62].[8] The empress, assimilated to divinity, drives a chariot drawn by two leaping bulls, in a miniature image simultaneously exquisite, immensely precious (both for its materials and its workmanship), and outrageous in its implications about the personal divinity of the living empress.

Portraits of the élite—whether displayed in public spaces (like the city gate and the exteriors of tombs), or in more private locations (like the statues of ancestors which traditionally adorned Roman houses or the images placed by a family inside its own burial chamber)—had a public profile. They maintained an aura of the appropriate social dignity. But there were also much more personal images—likenesses on

63

Portrait medallion of Gennadios, perhaps from Alexandria, third or fourth century AD. Gold leaf, engraved with a fine point, on sapphire-blue glass.

The inscription, in Greek with the dialect of Alexandria, says 'Gennadios, most accomplished in the musical art'.

rings or medallion disks mounted as pendants, like a group of ravishing portraits engraved in gold on a ground of sapphire-blue glass which seem so persuasive in their naturalism that they might be black-and-white photographs [**10**, **63**]. The power of such portraits to carry affection and to evoke emotion in the loved ones who wore them is beautifully attested in this passage from the novel *Chaereas and Callirhoe* written by Chariton of Aphrodisias in Asia Minor, probably in the mid-first century AD and still widely popular (at least to judge by the surviving papyrus fragments from Egypt) in the second century. The pregnant Callirhoe, captured by slave traders,

beat her breast with her hand, and saw Chaereas' portrait on her ring. She kissed it and said: 'Truly I am lost to you, Chaereas, separated from you by so vast an ocean! You are mourning for me and repenting and sitting by an empty tomb, proclaiming my chastity . . . and I, Hermocrates' daughter, your wife, have been sold this day to a master!'[9]

Later in the novel, when forced to take a new husband, Callirhoe holds the picture to her womb and holds a conference: 'Here are three of us, husband, wife and child; let us decide what is best for us all.'[10] Such portraits—like the imperial likenesses we examined in Chapter 3—have an almost magical or talismanic power to replace their subjects when the sitter is absent. This magical quality of an almost hyper-real recall of the person portrayed is another face of the use of images as apotropaea or talismans to ward off the evil eye: in the case of Callirhoe's ring, the image summons a presence deeply desired, while the ithyphallic black figure from the Timgad baths may have been intended to repel a danger (a potential presence) equally feared.

The space which ladies like Callirhoe inhabited—whether as mistress of the house or as one of its slaves—was the Roman *domus*, and

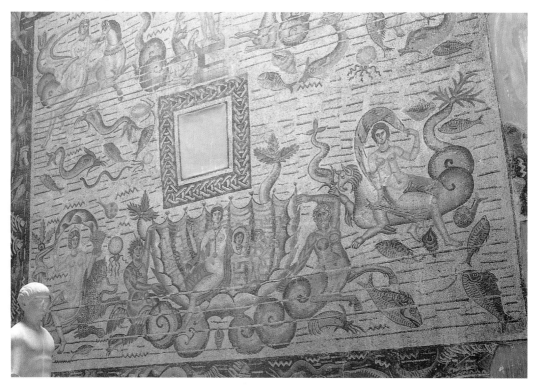

64

Floor mosaic from room XI of the Maison de l'Âne, Djemila, Algeria (ancient Cuicul, in Roman North Africa), late fourth or early fifth century AD.

The main scene, showing the toilette of Venus, seated on a shell held up by tritons, is surrounded by a border which includes apparently unrelated mythical scenes—Perseus and Andromeda, Orpheus, Hero and Leander.

especially the great aristocratic villa.[11] One remarkable aspect of the decoration of aristocratic villas throughout the empire is the attempt to create what might be described as a visual microcosm of the whole of social experience through the spectacular mosaics which adorned the floors. We cannot say with much certainty how such floors related with the rest of the decor—architecture, furniture, ornamentation, sculpture, paintings, and ceilings—since for the most part only the floors are recoverable through archaeology. But it is clear that a great villa—like the fourth-century example from Piazza Armerina in Sicily, with over 40 rooms covered by some 3,500 square metres of mosaics—created a visual illusion in some social depth of élite life. From love-making to the pursuit of more public pleasures like hunting, dining, or the circus, from the depiction of the world of work through which slaves sustained the estate's lifestyle to the mythological and divine universe which formed the imaginative and religious cosmology of the villa's inhabitants,[12] mosaic scenes circumscribed the identities of the villa's occupants. This range of subjects and their intimations seems to have allowed the villa's owner and his family (not to speak of the guests they aimed to impress) to indulge in a fantasy of plenitude in which all that the world can offer—including wild beasts from the most exotic climes—could be found (in representation, at least) close at hand within the microcosm of the private dwelling.

Mythological images, like the Triumph of Venus from the Maison

de l'Âne in Djemila (ancient Cuicul, in Algeria [**64**]) are frequent. In the coastal context of Roman North Africa, marine imagery—including Neptune, Venus, and Oceanus—was particularly popular. This example, from a grand villa perhaps decorated as late as the early fifth century, combines the mythological and religious implications of placating Venus and Neptune (an image of whose statue bearing a sceptre appears above the scene with Venus), with the much more domestic vignette of the goddess, enclosed in her boudoir-like cockleshell performing the last touches of her toilette in front of a mirror held by a Cupid.[13] Here the mythology gestures to the twofold function of the villa as simultaneously a private retreat for its owner and his family, as well as being the scene for their aristocratic display before their peers. Images of myth evoked the rich imaginative world of religion, romance and education in the classical tradition which formed some of the key categories and principles by which the empire's citizens chose to live their lives (even relatively late into the Christian era). It is significant that such pagan imagery continued unabated and apparently unproblematic in the private world of the late-Roman élite. This villa appears to have been decorated at the very period that St Augustine himself was Bishop of the nearby town of Hippo.

The pleasures of the élite are wonderfully caught by a great range of hunting mosaics found in villas from every part of the empire.[14] These hunts implicitly take place within the landholdings of a villa's own estates, though the beasts pursued and killed are often from the exotic extremes of the empire's territories. A trapezoidal panel in a villa from Antioch in Syria dated (by a coin found in the mortar in which the mosaics were laid) to the period during, or just after, the reign of Constantine, shows mounted horsemen attacking wild beasts [**65**].[15] The three panels making up the rest of the floor of this room show another hunting scene like this one, a mythological version of hunting in the confrontation of Meleager and Atalanta with the Calydonian

65

Floor mosaic, from a villa in Antioch on the Orontes in Syria, second quarter of the fourth century AD.

This panel from a large floor shows three hunters on horseback attacking wild beasts in a landscape setting.

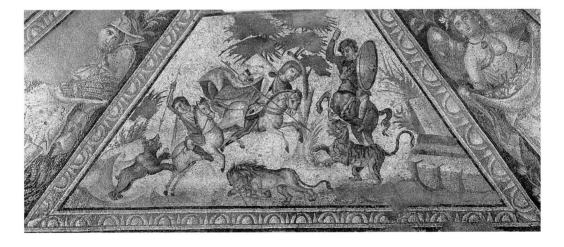

Floor mosaic from Cherchel,
Algeria (ancient Caesarea in
Roman North Africa), early
third century AD.

These scenes of farming have
a persistent emphasis on the
earth— ploughing, digging,
hoeing—which seems
appropriate in the context
of decorating a floor. This
picture shows the mosaic in
its current museum display
hanging on a wall.

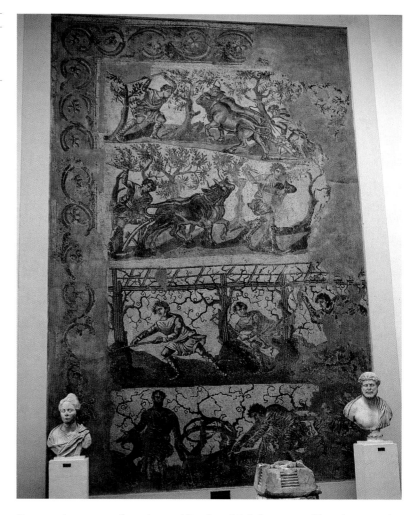

Boar and a scene of rustic sacrifice in which hunters offer a hare to the
statue of Artemis. The floor as a whole puts the representation of a spe-
cially popular élite activity into a context at once belonging to villa life
and simultaneously touched by the grandeur of mythological exempla
and divine approval. The images of the seasons which occupy the
spaces between the trapezoidal panels elevate the occupation further
by giving it a timeless, or at least perennial, quality.

The villa's microcosmic self-representation of its ideal world was
completed by images of working servants and slaves. The evocation of
the economic realities, whereby the estate's wealth was generated,
could be effected by the conceit of Cupids and children vintaging
grapes (a familiar motif which came to have religious significance
through its Dionysiac and later its Christian connotations) or by more
'realistic' imaging of the villa's means of production and wealth-
creation. The Severan mosaics from Cherchel (ancient Caesarea on
the coast of Numidia) made in the early third century, show men in

peasant costume on four registers ploughing the fields, broadcasting handfuls of seed, and labouring in the vineyard [66].[16] In the bottom register, an overseer observes the work on the grapevines—inscribing the whole scene into the context of villa agriculture. These servants, however realistic, are visualized in the perfumed atmosphere of a rural idyll—the pastoral fantasy of the landowner about those who sustain his standard of living.

One aspect of the villa's power as a context for the grandiloquent self-presentation of its owners was this ability to figure itself—its resonances of work, leisure, and myth. But beyond this, the villa's microcosmic pretentions extended even to representing the pleasures of civic and urban space, as well as to the potential for self-parody which we have already seen in the Piazza Armerina children's chariot race [20]. The largest known of all Roman chariot-racing mosaics, that at Piazza Armerina, like mosaics surviving from Gerona and Barcelona in Spain, shows quite explicitly and in great topographic detail and accuracy, the Circus Maximus in Rome (detail, 67).[17] Other chariot-racing mosaics, such as the floor discovered at Lyons in the early nineteenth century, seem to allude to more local, or iconographically more stereotyped, versions of the games. It is testimony to the grandeur displayed by a villa like Piazza Armerina (isolated in the middle of Sicily) that it should incorporate so specific a reference to urban public ritual at the ceremonial heart of the empire.

67

Detail of chariot racing in the Circus Maximus, floor mosaic from the villa at Piazza Armerina in Sicily, first quarter of the fourth century AD.

This pavement, occupying the floor of an important room in the villa's baths, is 23.5 m by 5.75 m. The detail shown depicts the winning charioteer receiving a palm from an official at the end of the race.

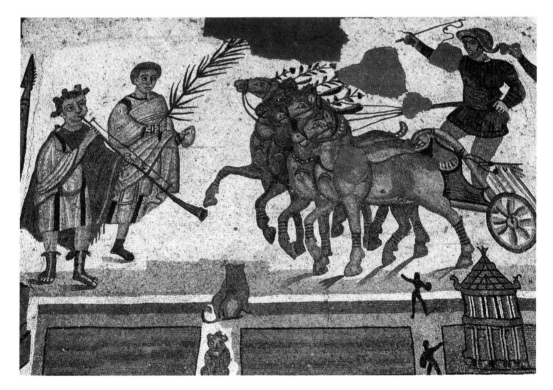

68

Silver tableware from the
Mildenhall Treasure (found
in Suffolk), fourth century AD.

The accoutrements of domestic life: rituals of dining

If the Roman world entertained one supreme ritual for its élite, it was
the long and lavish process of dinner.[18] The banquet was where philo-
sophy took place (as famously enshrined in the near-canonical
Symposium of Plato, and emulated in a number of later works like
Plutarch's nine books of *Table Talk* and Athenaeus' *Sophists at Dinner*).
It was where friendship flourished, where opportunities for seduction
were at their greatest, where privileged clients might meet their patron
in a kind of ritualized intimacy, where the process of acculturation
between provincial aristocrats and Roman administrators could most
easily and readily develop. Among the greatest satirical works of
Graeco-Roman literature are parodies of the long ceremonial of feast-
ing—like the *Dinner of Trimalchio*, an episode from Petronius' *Satyrica*
(sections 26–79) in which an utterly tasteless host parades his wealth
and ignorance before an equally tasteless array of guests (with hilarious
results), and Lucian's *On Salaried Posts in Great Houses* (sections 14–19),
where a guest ignorant of the rituals of dinner is pilloried for his pains.
To accompany and enhance the myriad ramifications of this most
socially central of activities, the empire—and especially the late
empire—contrived some of the most expensive and spectacular table-
ware ever created.

A number of silver hoards, buried in late antiquity, and found in
recent years throughout the empire (in sites as far apart as Carthage in
North Africa, Kaiseraugst near Basel, and Mildenhall and Thetford in
eastern England) have yielded evidence of the fabulous implements
for dining created for the late-Roman aristocracy [**68, 69**]. Silver statu-
ettes and candelabra, plates, bowls, and dishes adorned tables from
which guests ate with all manner of silver spoons. We have silver wine-

strainers, toothpicks and every kind of assorted implement—some chased or engraved with designs, some inscribed with witticisms or invocations.[19] A group of sixth-century silver spoons found in Turkey and most now in the British Museum has a series of inscribed tags in Latin and Greek such as (on one spoon) ' "Most men are evil" declared Bias of Priene' and—as it were in response—'Those who detest pleasure' (!); or (on another spoon) 'Oh handsome youth, do not believe too much in beauty' along with 'you cannot be beautiful without money'.[20] From such material we can evoke a world of banter and play in the élite dining room, combined with a systematic display of the host's family wealth paraded before clients and guests in the form of solid silver plate. Petronius' Trimalchio not only engraved his name on his more prominently displayed grander pieces of silver but also the weight of the objects (*Satyrica* 31). When a dish breaks, he has his slaves sweep away the silver with a broom alongside the other rubbish (*Satyrica* 34).

The fourth-century Sevso Treasure, which only came to light in the 1980s from a provenance still unknown, boasts some of the heaviest silver objects yet discovered.[21] Among its great dishes, Sevso's hunting plate [**69**, see the detail at the front of this chapter]—a huge item of solid silver decorated with niello inlay and some gilding—is over 70 cm in diameter and weighs nearly 9 kg. The inner medallion, neatly echoing many of the mosaic themes of contemporary villas (the most likely setting in which the treasure would have been used or displayed), depicts an open-air feast along with all the activity of slaves and attendants which brought it into being: servants hunting and fishing, as well as the cutting up of the carcasses and the cooking of the meat. Around the medallion's rim is a Latin inscription beginning with a christogram, which reads 'May these, O Sevso, yours for many ages be, small vessels fit to serve your offspring worthily'.

Despite the dish's discrete Christianity, every other aspect of its design and self-presentation is typical of late-Roman aristocratic display. The inscription is explicit in lauding not only Sevso but also his heirs (for whom this very plate was a significant heirloom, buried—alas, we know not where—when times became dangerous, in order to preserve it for its owners). And it is grandiloquent in its false modesty, referring to 'small vessels'. In fact, the 14 surviving objects of the Sevso treasure, at a total weight of nearly 69 kg (209 Roman pounds), make it one of the heaviest of all treasures surviving from late antiquity, with the greatest average weight per object. One wonders whether a plate like this one was actually used at table (despite its iconography of the catching, preparing, and eating of game) or whether it was not rather a room decoration creating a lavish ambience for aristocratic late-Roman dining.

Alongside the expensive dinner-settings of precious metal, were placed prestige items less expensive in material but still more exquisite

69

Silver, silver gilt, and bronze
tableware and toiletry pieces,
from the Sevso treasure, of
unknown provenance, fourth
century AD.

and valuable in their workmanship. The supreme examples of fourth-century Roman glass were the cage-cups—blown vessels, often made from several layers of differently coloured glass, whose thick walls were cut away with all the panache of the finest gem-carving to produce an effect simultaneously delicate and spectacular [**70**].[22] Such cups could either be abstract in design, with coloured meshes nestling over a colourless base and a carved inscription, as in the Trivulzio cage-cup, which says 'Drink! May you live for many years!',[23] or figured as in the case of the Lycurgus cup, now in the British Museum [**21**].[24] The wit of such objects—referring lightly to the effects of the events for which they were made—indicates much about the ritual of dining: from as early as Petronius to the fifth century, at least, the banquet was a key place for the display not only of wealth but also of learning and the sophisticated results of a civilized education.

Paideia in the household

One of the chief ways of buying into the élite in the Roman world was through *paideia*, the world of education and classical culture which underwent a revival in the Second Sophistic and became so highly regarded that emperors themselves presided over the speeches and debates of learned men.[25] *Paideia* had many interlocking aspects. It combined command of grammar and training in the arts of oratory

70

Cage-cup from the fourth
century AD, with a translucent
green inscription and light
blue meshes on a colourless
body.

This intact example of a late
Roman cage-cup was found
near Novara in northern Italy.

Terracotta lamp, from
Athens, first half of the
third century AD.

The central disc, inside a
rim of rosettes linked by
tendrils, has a mythological-
pornographic scene with
Leda making love to the swan.

with the kinds of learned skills from medicine and physiognomics to astrology and mathematics, in which the sophists were society's leading experts. It included learning and expertise (not least the careful compilation of handbooks) in every area of arcane or antiquarian knowledge, from history and geography to mythology, archaeology, and the interpretation of dreams.[26] The need for an acquaintance with at least something of this cultural background led to a demand for private tutors and teachers of culture: the Elder Philostratus himself, the contemporary historian of the Second Sophistic, was one of these. His wonderful descriptions of paintings, published in the early third century, are presented as pedagogic discourses delivered in a wealthy house to an audience of young men, eager to learn about art. And the perfect arena in which to display such a smattering of erudition was in the mythological images which adorned so many items in the repertoire of Roman culture, from textual references in speeches to visual representations on clothing, in art, and on the multiple material objects used in private life.

As we have seen in the case of mosaics, one way for the Roman household to demonstrate its owner's command of *paideia* was in the depiction of the mythological world. By the fourth century, mythological imagery had come to represent that indefinable theme of 'Hellenism' which was itself shorthand for a cluster of concepts— nostalgia, ancient culture, and pagan religion—that together encompassed the traditional world-view, looking back to an era before Christian innovation.[27] Such mythology had many uses. Fine terracotta lamps made from a wax mould (such as **71**) were of a higher quality than most mass-produced pottery wares, but were still relatively

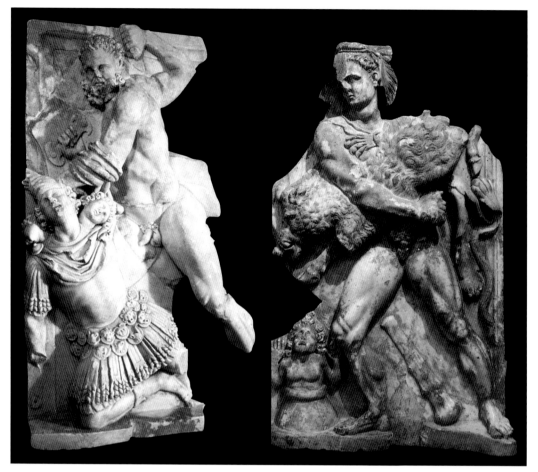

The labours of Hercules, from the villa at Chiragan, southern France, marble, fourth century AD.

Left: a bearded Hercules fights Geryon. Right: a beardless Hercules wrestles with the Erymanthian Boar.

humble by comparison with, say, silver or specially cut and engraved glass.[28] This lamp, made for the Athenian market in Attica and found in the excavations of the Athenian Agora, depicts Leda and the swan.[29] While its mythological subject matter justifies it in the world of educated learning, like many a nineeenth-century nude with a mythological title, this iconography was clearly a licence for an elegant but vivid (and vividly realized) piece of erotica. Given the undertones of sexual suggestion which had imbued the symposium since before Plato's time, such lamps with erotic scenes would hardly have been inappropriate in the ancient equivalent of the candle-lit dinner.

In the world of élite dining, such items—whether lamps, silverware, or textiles with mythological iconography—could be used to spark themes in conversation, to display the learning of both host and guests. Petronius satirizes this game of pretentious one-upmanship with biting effect. Trimalchio holds forth:

Now I'm very keen on silver. I've a number of three-gallon goblets engraved with Cassandra killing her sons, and the boys lying there dead—but you would think they were alive! I have a bowl my patron left—with Daedalus

shutting Niobe in the Trojan Horse. What's more, I have the fights of Hermeros and Petraites on some cups—all good and heavy. No, I wouldn't sell my connoisseurship at any price.[30]

Quite apart from the appalling joke about the naturalism of the dead boys being so lifelike that one might imagine they were alive (!), every mythological reference in this grand parade of 'connoisseurship' is totally wrong. It was Medea, not Cassandra, who killed her sons; and it was Pasiphae, not Niobe, for whom Daedalus constructed a wooden cow (not the Trojan Horse). Hermeros and Petraites appear to have been contemporary gladiators (famous in the way that football or pop stars are nowadays), whom Trimalchio's version of learned expertise has somehow transformed into joining the list of mythological heroes.

In the villa context, intimations of culture were particularly emphasized by collections of sculpture or paintings. The private museum sometimes comprised objects arranged around the house and may also have included a special picture or sculpture gallery, like that described by the Elder Philostratus in his *Imagines*. Its collections, which often combined antique objects and mythological themes with portraiture, were the perfect way to establish that subtle impression of wealth, education, and taste with which an élite host would wish to impress his guests (as Trimalchio attempts and so spectacularly fails to do).[31] The deep-rooted appeal of such objects, even for late-antique Christians, can be felt in these lines by the Christian poet Prudentius, writing at the close of the fourth century:

> Let the statues, the work of great artists,
> stand clean: let them be our country's loveliest
> ornament, and let no tainted usage steep the
> monuments of converted art in sin.[32]

Here, while the poet pleads for the elimination of any religious, and especially sacrifical, value to traditional art (hence his attack on 'tainted usage steep[ing] the monuments . . . in sin'), he upholds its worth as art for art's sake, as an aesthetic and museological monument to the past glory of *Romanitas*.

The collection of over 120 pieces of sculpture found at a private villa at Chiragan in southern Gaul appears to have been acquired as part of a grand programme of decoration in the fourth century. The sculptures are an eclectic mix of works from late-Republican times to the fourth century, combining large mythological reliefs of the labours of Hercules and 12 tondo busts, apparently carved by a sculptor from Aphrodisias in Asia Minor, with copies of famous Greek works, genre scenes, mythological subjects, and a number of portraits [72]. Some of the older works appear to have been restored in late antiquity. This kind of collecting, coupled with other aspects of the villa's decor—its silver, mosaics, paintings, and so forth (now largely lost, but broadly

imaginable from comparable contemporary examples elsewhere in the empire)—show a culture where prestige could be acquired through the parade of tradition. The presence of venerable objects, or objects with venerable themes, brought the owner the mark of distinction.

Perhaps the most intimate of objects surviving from the world of antiquity's daily life are the Coptic textiles from Egypt, carefully preserved for us with such perfection by the dry sands of the desert climate.[33] Such fabrics were used for dress, for adorning rooms and buildings, for the burial of the dead. With their glowing colours and the abstraction imposed on the forms by the technical demands of weaving cloth, they are among antiquity's most splendid and under-rated remains. Not only do they boast an abundance of all kinds of imagery —from portrait busts to birds and foliage, from pagan myths to Christian scripture—but they attest to the continuance of this heady combination of themes as late as the eighth century. For a mythological example, take this detail of Dionysus in a niche adorned by vines, prob-ably dating from the fourth century [73]. The god is the central figure in a linen and wool tapestry (originally perhaps 10 m long) showing Dionysus and his cult—including Ariadne and Pan, and a number of other followers.[34] Whether the decoration of a wall or couch with this textile would have implied the adherence of an initiate to Dionysiac religious cult, or would have been a less sacredly charged declaration of *paideia* in the form of mythological imagery, or would just have been an appropriate and suitably lavish adornment for a nobleman's drinking party (like the Lycurgus cup [21], perhaps), we can never know.

Of all the private objects which signalled their owner's wealth and *paideia*, perhaps the supreme examples—at least in the detailed atten-tion they demanded from their viewers, if not necessarily in the cost of their materials and labour—were books. The end of the first century AD—the very period with which this book starts—had seen the intro-duction of a new kind of book, whose influence was ultimately to be as revolutionary as the invention of printing in the fifteenth century and perhaps of computer technology in the modern era. In place of the papyrus roll, the codex (which was handled like a modern book) was invented.[35] It was made from folded leaves of vellum (themselves manufactured from animal skins) or, initially, from papyrus leaves (see the fragment from an illuminated papyrus codex, **162**). Vellum was much more durable than papyrus. A codex could accommodate far more text than a roll (just as a computer disk can accommodate far more information than a book)—the whole of Vergil's writings, for example, could fit in one codex when previously each of the *Aeneid's* 12 books had occupied a separate papyrus roll. Moreover, a codex was far easier to handle than a roll: instead of progressively rolling and unrolling the scroll of papyrus, readers could just turn the pages of a codex, as you are turning the pages of this very book. Roll and codex

73

Linen and wool tapestry from Coptic Egypt, fourth century AD.

The nude Dionysus and Ariadne, with cloaks falling from their shoulders, occupy the central pair of a long series of arcades framing various personifications and deities most of them with haloes. This particular tapestry—itself only a fragment—is 7.3 m in length and 2.2 m high.

continued in joint use until the fourth century, when the codex finally became the more significant form.[36] The great disadvantage of the parchment codex was its cost: the two fifth-century manuscripts of Vergil's works in the Vatican Library (known as the Vatican Vergil and the Roman Vergil) required the skins of 74 and 205 sheep respectively.[37] Relatively few books appear to have been illustrated in the Second Sophistic and late antiquity (at least to judge by the extent of survivals), but some—both in roll and codex form—were to be the ancestors of the great tradition of medieval illumination (our earliest dated illustrated codex is the calendar of 354 which survives in a seventeenth-century copy, see **54**).[38]

The Vatican Vergil, made in the early fifth century AD, of which 75 folios survive out of perhaps 440 original leaves, contained the three canonical works of Vergil (the *Eclogues*, the *Georgics* and the *Aeneid*) with about 280 illustrations. The text appears to have been copied by a single scribe in brown ink in the normal upper-case script used at the end of the fourth century, known as 'rustic capitals'. The placing of the illuminations appears to have been determined by the scribe (or the

book's designer)—since blank spaces of about two thirds of a page or occasionally a whole page were left in order to be painted later. At least three different illuminators worked on the illustrations.[39] This page [74] shows the famous scene of Dido in a watchtower distraught at the sight of Aeneas sailing away at dawn. It illustrates the text which would have occupied the (now lost) facing page (*Aeneid* 4.586–91), here in Dryden's famous translation of 1691:

> When from a tow'r the Queen, with wakeful eyes,
> Saw day point upward from the rosie skies:
> She looked to seaward, but the sea was void,
> And scarce in ken the sailing ships descry'd:
> Stung with despight, and furious with despair,
> She struck her trembling breast, and tore her hair.
> And shall th' ungrateful Traytor go, she said,
> My land forsaken, and my love betray'd?

A beautiful codex of this sort invites both careful reading and looking. Unlike most of the arts explored in this book, manuscript illumination places the visual in a very close and interpretative relationship with a specific text which the pictures illustrate. While ancient statues frequently had inscriptions and epigraphs (see **19** and **137**, for example), and many other art-works (from glass drinking-cups to silverware, like the Projecta casket or the Sevso plate) had inscribed invocations, these were primarily aids to the viewer in understanding the image. They provided an interpretative context, and were in effect secondary to the image. But in a book, images serve as a visual commentary on a particular text. In this case, some famous lines which are themselves part of a much read and commented-upon narrative, are given special prominence by the use of illumination. The images together underline the importance, even the canonical nature, of the narrative as one significant enough to illustrate in this expensive way. They may add a frisson of visual exegesis, as the linear process of reading a narrative is transformed into a picture apprehended in a single glance. Here, for example, the white walls of Dido's tower are wonderfully counter-pointed by the white sails of the ships (both realized with the same lattice of brown ink), providing a last visual hint of the union of Aeneas and Dido in the very portrayal of their separation. The intimacy of Dido's misery in Vergil's text is somewhat distanced by the artist's choice of painting a broad seascape, with Dido and Aeneas seen equally from an 'objective' distance, rather than having Aeneas pictured from Dido's perspective, looking out from her tower while love recedes into the distance.

The creation of the illuminated manuscript provides one of *paideia*'s supreme contributions to the transformation of Roman art into the art of the middle ages. It comes as no surprise that it would be Christianity

74

The Vatican Vergil, velum codex, probably made in Rome, first half of the fifth century AD, fol. 39v.

This illumination, showing Dido's distress as Aeneas sails away, illustrated the text from Vergil's *Aeneid* on the facing page. It is by the 'second painter' of the three who have been identified as the illuminators of the book.

which really took up and developed the art of illumination—using it to make all manner of visual and thematic commentaries on a Biblical text which was to be not only canonical as literature (in the way that Homer and Vergil had become by the fourth century) but also sacred as the revealed word of God. Indeed, it is possible that the first illuminated codices were in fact Christian books (like the Quedlinburg Itala, **161**), which the late-Roman manuscripts of Vergil and Homer were in fact attempts to imitate. Illustration reverses the ancient primacy of the image. In antiquity, images had been a principal means for thinking about culture and society: they had, in their own right, formulated definitions of status, identity, and ethnicity; they had helped people to conceive of the appearance of their gods and their rulers. But in manuscript illumination—in the illustration of given and canonical texts, rather than, say, oral mythological narratives—images were subservient to, secondary to, the primacy of the word (which, at least as far as Christianity is concerned, as St John tells us, was in the beginning). The manuscript image stands not for itself, but for a pre-ordained text which it seeks to make visual. Pictures no longer speak. They illustrate.

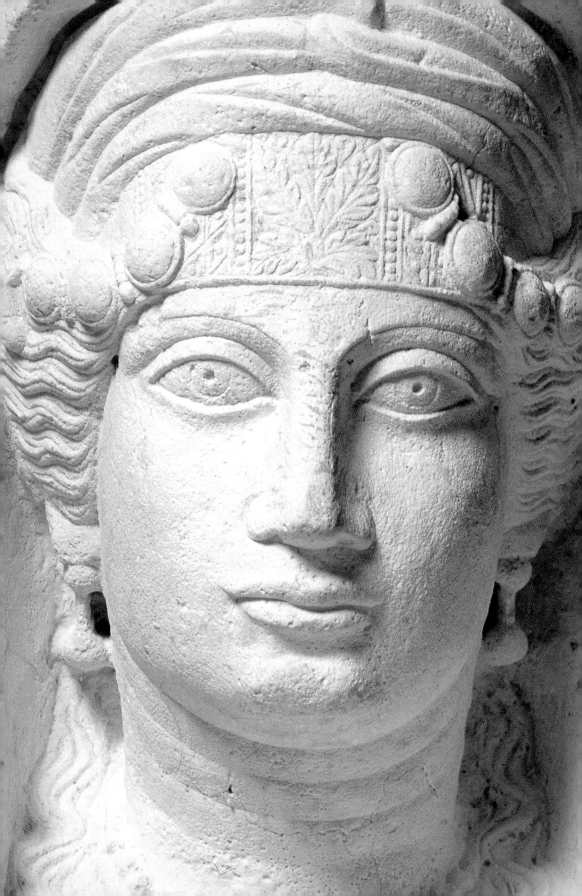

Centre and Periphery

5

The lady gazes out beyond us, resplendent in her finest jewels, purple robe, and distinctively stylish hair [**75**]. A powerful work of fierce, impressionistic naturalism, her portrait—painted in wax encaustic on a wooden panel—compels respect. This is a lady of substance and wealth, a Roman aristocrat, perhaps from Trajan's times.[1] A different lady, this time sculpted in white limestone, gazes not so much at us as through us [**76**]. She too is in her finest dress—'dumb-bell' earrings, necklace, stiff diadem on her head surmounted by a turban and a veil. She is presented as a mother, cradling her child in her left arm, and also as a daughter herself: This time we know her name, for the inscription says 'Tibnan, daughter of Hagegu, son of Maliku. Alas!'[2]

Both these images are commemorations of death. They show the deceased in the prime of life, accoutred in the fullest panoply of social distinction and womanly finery. We cannot know of course if these ladies died in the relative youthfulness of adult maturity or if this is how their mourners chose to remember them though they perished in old age. Tibnan, whose inscription is written in the Palmyrene dialect of Aramaic, is a relief bust of the later second century from a tomb, a work typical of the funerary art of Roman Palmyra in Syria. The frontal abstract style, the specifically Palmyrene dress and demeanour, the very language of her inscription, proclaim Tibnan's origins in the great expanse of the Roman east. It was a world of cosmopolitan cities like Antioch, Baalbek, and not least Palmyra itself—whose wealth, amenities, and architectural splendour proclaimed the triumph of Roman ways of life, yet whose syncretistic and eastern-orientated religions, whose styles of art and whose languages affirmed a deeply held identity in their own cultural ways.[3] Just as Palmyra's great temple (constructed in a fairly orthodox Roman style) was dedicated to the Syrian god Bel, so Tibnan's tomb affirmed her at least as much a Syrian lady as she was a subject of distant Rome.

The 'Jewellery girl', as she was named by Flinders Petrie who excavated her in the nineteenth century, is a portrait originally attached to a mummy from Hawara, the necropolis of Arsinoe which was the chief city of the district of Fayum in Egypt. She seems a Roman lady—especially because of the wonderful realism of her painting which

Portrait orignally attached to a mummy, encaustic on wooden panel, from Hawara in the Fayum, Egypt, *c.* AD 110–30.

This panel represents a young woman in a crimson tunic with an unusually rich array of jewellery.

Funerary relief of Tibnan,
painted white limestone, from
Palmyra in Syria, second half
of the second century AD.

This is one of many hundred
relief busts from the tombs of
Palmyra, showing a labelled
frontal figure, sliced at the
midriff.

makes one feel one could have known her; yet her image too proclaims
a *local* identity. For all her urbane sophistication, the 'Jewellery girl' was
buried in Egyptian, not in Roman, style. Her Graeco-Roman painted
likeness was inserted into a mummy adorned and prepared for burial in
an entirely un-Roman way. She is the product of a specially Egyptian
way of death, with the portraiture techniques of Classical art adapted
to the needs of that most locally specific of death rituals, embalming
and mummification. In their mute but visually eloquent way, these two
images represent some of the complications of Roman cultural hege-
mony and provincial identity in the subject peoples of the Roman
world.

Local identity and empire-wide acculturation: the problems of 'Romanization'

The Roman empire was a vast domain. Its geographical extent—with
all the attendant difficulties of administration, travel, and policing—
encompassed a mass of numerous populations. The peoples of the
empire, stretching in a great circle around Italy in the centre—from
Britain and Gaul in northern Europe to Libya and Egypt in north
Africa, from Spain in the west to Syria and Asia Minor in the east—

77

Colonnaded street looking towards the 'Arch of Trajan', Timgad, North Africa, late second century AD.

represented a multitudinous and diverse collection of languages, customs, religions. As Virgil prophesied, the art of government was to be the Romans' supreme imperial skill; and it truly was an art to create a sense of cohesion in this vast cultural array. On a political level, the third century saw the creation of a number of splinter kingdoms within what had been the confines of the empire, not least that of Queen Zenobia, whose attempt to set up an independent Palmyra was crushed by Aurelian in 272, but also the Gallic empire of Postumus (260–9) and the British domain of Carausius (c.285–93). None the less, in cultural terms, the peoples of the Roman world had become Roman in more than mere overlordship: they were Roman—on quite fundamental levels—in identity and civilization, Roman in many rituals of their environment and daily lives. And by nothing was Roman identity so propagated and so pronounced as by the visual culture of Roman architecture and art.

The process whereby Gauls, Libyans, and Levantines might share the ideals of a single culture, despite all their manifest differences, is called 'Romanization'. It involved imparting a series of deeply Roman social structures to willing local communities and in particular to the élites. Private villas across the empire began, in certain respects, to incorporate features of Roman architecture and decoration; aristocrats took up the élite pursuits of sophistic education and Roman dining. Cities adopted some specifically Roman forms of building and civic planning—the forum, the basilica, arcaded streets, temples in the

Roman style [77]—and some specially Roman popular activities, such as baths and gladiatorial games. Just as cricket (not to speak of the English language) has become a defining characteristic and an abiding passion in the countries which were once part of the British Empire, so the games (and the amphitheatres which housed them) became a ubiquitous enthusiasm in the Roman world. The countryside was criss-crossed by Roman roads and aqueducts [78], Roman bridges, and forts. The state was administered by Roman law. As we have seen, the image of the emperor and the temples of the imperial cult were spread throughout the provinces, guaranteeing a kind of symbolic and religious unity. In AD 212, the emperor Caracalla made legal what was by then already actual—and granted full citizenship to all free inhabitants of the empire.

Yet the vigorous assertion of local identity shown by the portraits from Palmyra and Fayum warns us not to exaggerate the effects of Romanization. On subtle levels it met with strong resistance, as Greeks or Syrians or Egyptians clung to certain aspects of their venerable past, to local rituals, and provincial customs, which distinguished them from their upstart Roman conquerors, and from each other. In effect, the business of becoming Roman (whether welcoming or burdened by Roman rule) was a complex process of compromise and self-assertion, of accepting the political status quo but transmuting it from within.[4] Take the case of that pinnacle of indigenous Greek triumphalism, the Acropolis at Athens, built in the fifth century BC to

78

The Pont du Gard, a bridge carrying the aqueduct of Nîmes across the River Gardon, Southern France. Built of squared stone at the end of the first century BC, this monument (49 m high and 269 m long) was kept in good repair throughout the period covered in this book.

The remains of the temple
of Olympic Zeus, completed
by Hadrian and dedicated
in AD 132.

celebrate Athenian political ascendancy. By the time it was visited by the Greek-speaking traveller Pausanias sometime around AD 160, the Romans had marked their dominion on the monument, placing not only a great bronze charioteer group of Agrippa, Augustus' minister, by the Propylaea (the only entrance to the Acropolis), but also a compact circular temple of Rome and Augustus right in front of the main eastern façade of the Parthenon itself. Pausanias, who could hardly have missed these conspicuous sights and who is usually scrupulous in recording what he sees, ignores them pointedly. Yet he remarks on a portrait statue of Hadrian *inside* the Parthenon, and elsewhere he records Hadrian's inscription of achievements in the sanctuary common to all the gods.[5] Pausanias' relations to the Romans in this supreme Athenian monument—what he mentions and what he disregards—are a wonderful example of the complexity of denial and acceptance, of resistance and affirmation, of archaizing Greek sympathies yet modern Roman affiliations, which Roman identity and its acculturation to local tradition comprised.

Identity is the issue at stake in the arts of the provinces: local identity in relation to the centre, the centre's self-projection as propagated to the periphery, the place of the individual in the midst of these centripetal and centrifugal patterns. Take the case of the great benefactors who adorned Greece in the second century AD. These men, professionals in the practice of euergetism—or public giving—funded a spectacular renaissance of construction.[6] Hadrian's philhellenic inclinations may have been apparent from his portraiture in Rome, but nothing paraded his enthusiasm for Greece so publicly as his great series of buildings there.[7] In an act of recompense for his repeated benefactions to their city (an aqueduct, a library and stoa, the great temple of Olympic Zeus, see **79**), the Athenians erected an honorary

80

Restored elevation of the
Arch of Hadrian, Athens
(erected AD 131).

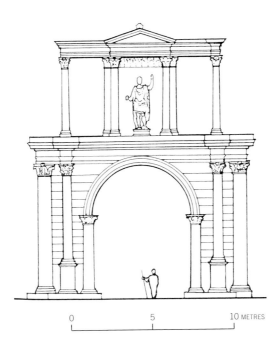

0 5 10 METRES

arch for the emperor in about AD 131 [**80**]. The inscriptions on the arch
were loud in Hadrian's praise. On the west, it said 'this is Athens, the
ancient city of Theseus'; on the east, it said 'this is the city of Hadrian
and not of Theseus'. The Olympeion, the largest temple ever built in
honour of Olympian Zeus, was Hadrian's supreme fulfilment of his
classicizing mission in Greece. The temple, originally begun by the
Peisistratid tyrants in archaic times and partly constructed by
Antiochus Epiphanes in Hellenistic times, had lain unfinished for
nearly 300 years. After Hadrian completed it and dedicated its vast cult
statue of Zeus ('it surpasses in size all other images except the colossi at
Rhodes and at Rome: it is made of ivory and gold and considering the
size, the workmanship is good', Pausanias tells us),[8] the precinct was
filled with statues of the emperor, dedicated by all the Greek city states.

Hadrian was a Romanized Spaniard masquerading as a Greek, but
other—local—men felt the need to compete. The millionaire and
Athenian sophist, Herodes Atticus (c. AD 101–77), consul at Rome in
143 and tutor in Greek letters to the emperors Marcus Aurelius and
Lucius Verus, established his credentials in his motherland with a
series of benefactions which rivalled the emperors themselves.[9] Like a
few other virtuosi of euergetism, such as Opramoas of Rhodiapolis in
Lycia, Herodes lavished splendid dedications on his chosen sites—a
stadium and odeon in Athens, a stadium at Delphi and the
nymphaeum at Olympia. It was by his stadium in Athens that Herodes
was eventually buried, an exceptional honour since the tomb lay within
the city walls. The tomb of Opramoas at Rhodiapolis (in Asia Minor)
is remarkable for its inscriptions covering the walls, which list his

innumerable dedications and carefully detail the amounts spent![10] In
Ephesus, in Asia Minor, the heirs of the distinguished local former
consul, Caius Julius Celsus Polemaeanus, built their ancestor a great
library in about AD 120 [**81**]. A lofty rectangular hall with an apse,
beneath which was the mausoleum of Celsus himself—again it was a
singular honour to be buried like Trajan or Herodes Atticus within the
city walls, the edifice was fronted by a magnificent carved façade.[11]

These hyperbolic instances of second-century giving and com-
memoration are apparently parallel. But while the emperor provided a
paradigm of lavish generosity which came to define his imperial status
and vocation, Herodes, Opramoas and Celsus' heirs were *imitating*
imperial largesse. Hadrian's was an empire-wide mission of public
building (from Hadrian's Wall in the north of Britain to his great
dedications in Greece, from the refounding of Jerusalem—as Aelia
Capitolina—to the spectacular temples in Rome), while Herodes and
Opramoas behaved like little monarchs in Greece and Lycia—

impressing their compatriots with an emperor-like grandeur. Though both Celsus and Herodes were flamboyantly entombed within their city walls, their model was the emperor Trajan, whose ashes Hadrian buried beneath the column in Trajan's forum at the very centre of Rome in AD 118. If the emperor's identity as monarch came in part to depend on his buildings in the provinces as well as in the centre, that of his wealthy but ultimately locally based imitators was above all related to their public benefactions at home.

Perhaps the supreme surviving imperial monument in all Asia Minor was the great Antonine altar, set up in the second century AD at Ephesus, not far from the Library of Celsus.[12] Most of the sculpture from this has found its way to the Kunsthistorisches Museum in Vienna. It is still uncertain precisely which emperor the altar was erected to honour, or when; but the most probable subject is a

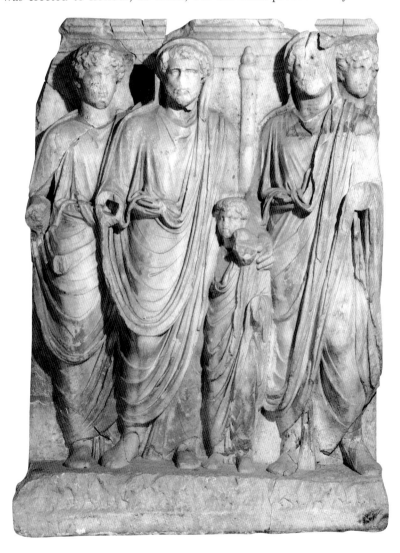

82

Dynastic relief from the great Antonine altar at Ephesus, probably after AD 169.

The quiet frontality of this scene is somewhat earlier than the strong emphasis on frontal images in Roman imperial art which is particularly evident under the Severans and thereafter. It may be that this was a deliberate stylistic choice to impress spectators in a provincial context.

celebration of the life and apotheosis of Lucius Verus, the co-emperor of Marcus Aurelius who died in 169 and spent a large part of his reign (as many as four years from 162–6) in the east. The altar's monumental U-shape and its vivacious baroque sculptural style recall the Hellenistic extravagance of such models as the great altar of Pergamon, not very far from Ephesus up the coast, which had been the centrepiece of a grandiose programme of royal monuments created by the Attalid kings of the second century BC. A substantial portion of the iconography of the Ephesus altar celebrates the victories of the Roman army over eastern barbarians—not just a cliché of imperial triumphalism in the cultural context, but a very specific reference to the protection of the wealthy cities of the Roman east from the depredations of Arab marauders and the persistent threat of Parthia. Indeed the main purpose of Lucius' trip to the east was to wage a successful war against the Parthians and to recapture the client kingdom of Armenia. The rest of the altar's imagery ties this iconography of protection into the dynastic glory of the ruling family—with scenes of apotheosis (perhaps that of Verus in 169) and a grand frontal image of the imperial succession showing Hadrian in the centre flanked by the young (still beardless) Marcus Aurelius and Antoninus Pius, the latter holding the little Lucius Verus [82].

83

Restored elevation of Trajan's victory monument (the Tropaeum Traiani) at Adamklissi, Romania (dedicated in AD 109).

84

Metope (no. xlii) from Trajan's victory trophy, Adamklissi (Romania), AD 109.

This scene shows a Dacian family—father, mother, and child—with their possessions in an ox cart, fleeing the incursion of Roman rule. In front of the family strides a bearded Dacian warrior, naked to the waist, in breeches and carrying a long sword.

The Ephesian altar makes great efforts to ground its celebration of rulers from distant Rome in an eastern context. Not only in style and form, but also in the protective suggestions of its battle scenes, the altar attempts to assimilate Roman dominion to a setting at once provincial and venerable, both a proud city with an ancient heritage and yet only one more city within the great sweep of the empire's possessions. Like Vibius Salutaris' procession of images—local and cosmopolitan—within the city of Ephesus, the altar sought to negotiate its city's distinguished place in the east in relation to the greater whole of the empire, of which the Aegean coast of Asia Minor was only a part. In this sense the altar shows a sensitivity to the same complexities of cultural identity as, say, the portrait of Tibnan. But while Palmyrene art asserted the particularity of Palmyrene identity within the empire, imperial art at Ephesus tried to assimilate the message of imperial control and the specific dynastic politics of Rome within the local context of Asia Minor's arts, military vulnerability, and culture.

A parallel combination of imperial self-proclamation and yet (in certain respects) assimilation to local needs, can be seen in the victory monument set up by Trajan at Adamklissi in Dacia (modern Romania) in about AD 109.[13] A huge circular concrete drum (about 100 feet in diameter) on a nine-stepped platform, surmounted by a conical roof and trophy rising to the height of Trajan's column in Rome, the Adamklissi monument [83] was dedicated to Mars the Avenger. Embedded in its walls were 54 sculpted metopes, of which 49 survive. These depict scenes of combat, conquest, booty, and prisoners (e.g. 84). In this, the monument clearly resembles the themes of the great Trajanic frieze,

[**53**], and of Trajan's column, (**36**, **40**). But here the style is radically different. Instead of employing Roman artists of the type who carved the column, the builders of the Dacian trophy used local sculptors who visualized their subjects with all the vitality, vigour, and non-classicism of 'barbarian' art. The grandeur of the conflict is simplified and humanized by reducing the battles of legions into symbolic scenes of hand-to-hand combat. The enemy, represented with no less humanity than their Roman foe, are shown noble in battle and noble in defeat, noble even in the flight of families in the face of conquest.

Of course, Adamklissi proclaims not Roman protection but the brutalities of conquest. Yet it does so by giving the conquered a visual voice (as it were), by letting the story—the Romans' version of the story, to be sure—be told in a visual form familiar, even natural, to the Dacians. In this sense it resembles that other great monument of a foreign victor, the Bayeux tapestry, whose images were embroidered by Saxon hands though they told the victors' tale of Norman conquest. Like the Bayeux tapestry, Adamklissi's testimonial to a foreigner's victory—brutal and never sentimental—none the less gives the conquered their dignity. Like the Antonine altar later in the same century, the trophy's propagation of an imperial theme to the provinces shows a marked sensitivity to local conditions and needs.

Late antiquity: the periphery's ascendancy at the expense of the centre

This sensitivity to the presentation of Roman hegemony in terms of the periphery's specific contexts and attitudes was to be gradually transformed after the second century into an increasing emphasis on the periphery at the expense of Rome, as emperors became less and less 'Roman', more and more provincials made good. The origins of Trajan, Hadrian, and Marcus lay in the province of Spain, though these second-century emperors were thoroughly Romanized. But by the beginning of the third century, Septimius Severus came from Africa (and had married a Palestinian wife) while his successors, Elagabalus and Severus Alexander were Syrians. Severus, inaugurating a tradition to last long into Byzantine times,[14] celebrated his provincial origins by lavish works in his native city of Lepcis Magna in Tripolitania, North Africa, where the imperial court probably wintered in 202–3 and to which Severus granted tax exemptions and the special status of subjection to Italian law in 203.[15]

In the excavations which recovered Lepcis from the sands of the Sahara in the 1930s, the remains of a huge four-way commemorative arch, spanning the junction of two streets, were found. Among the sculptures of the frieze is a triumphal procession showing the emperor full frontal in his chariot with his sons, Caracalla and Geta, on either side [**85**].[16] Exuberantly carved with great drill lines to emphasize the

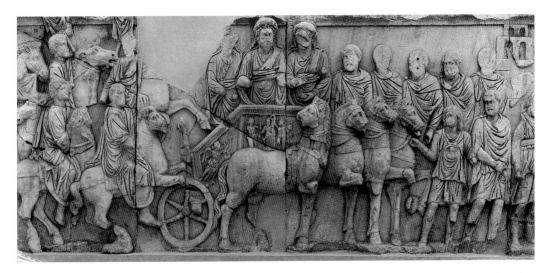

draperies and to clarify forms intended to be seen from a great height, the Lepcis reliefs anticipate the Constantinian friezes of the Arch of Constantine both in execution and in schematic form. This is a military portrait of the emperor as triumphant icon—still amidst the moving cavalry and horses, central between horsemen and infantry, frontal though his chariot is galloping to the right. Recalling the dynastic relief from the great Antonine altar [82], the imperial party is not only frontal and centred but displays a dynastic politics of succession with Severus flanked by his sons. As a conception of imperial might, designed to impress the provincials, and at the same time to celebrate the glorious elevation of the city's supreme son, the Lepcis relief brings to mind the purple descriptions by Dexippus and Ammianus of emperors who ruled when Severus was long dead.

In addition to the spectacular expressionism of the arch, Severus' builders constructed a forum, basilica and temple—all finally ready for dedication under Severus' son Caracalla in about AD 216. Here, using artists who appear to have come from Greece and Asia Minor, a new monumental quarter was erected. The workmanship of the surviving carved pilasters of the basilica is exquisite; the figures are cut in deep relief until they are almost in the round, emerging from flamboyant undergrowth.[17] Some represent Dionysus, others Hercules engaged in his labours [86]. By lavishing such expenditure on Lepcis—not just buildings and decoration, but the importation of artists and materials from distant parts of the empire at great expense—Severus began to formalize in material terms the gradual movement of the empire's centre of gravity towards the periphery. Already in the second century, Hadrian's long travels and his favoured residence in the villa at Tivoli outside Rome had signalled the beginning of the end of the centre's pre-eminence. By the late second century, Marcus' long enforced military sojourn on the Danube fighting a defensive war—rather than

Marble pilaster from the basilica, Lepcis Magna, North Africa, showing the Labours of Hercules, early third century BC.

The basilica at Lepcis was dedicated in AD 216. The deep cut ornamental pilasters flanking both its apses at either end of the building celebrate the two patron deities of Lepcis Magna, Hercules and Dionysus.

Trajan's earlier offensive drive to Dacian conquests—marked a clear signal that the periphery would now be the site of the empire's prevailing *Realpolitik*. But from Severus, this was made architecturally concrete in imperial cities established outside Rome by an emperor whose connections with the provinces (in Septimius' case, especially with Syria and Africa) were greater than with the centre. It may be resentment of this in part that led the Roman senator Cassius Dio to criticize Severus' waste of money on the prodigious construction and repair of buildings.[18] And it may also be that Severus' keenness to construct buildings in Rome, including his arch [**52**], was in part designed to 're-assure' Romans that he was really one of them.

Certainly, less than a century later, as we have seen in Chapter 3, provincial capitals with imperial pretensions were being established by the tetrarchs all over the empire. In Salonica in northern Greece, for example, which became the main centre for the court of Galerius between 293 and 311, the emperor erected a monumental quarter (like

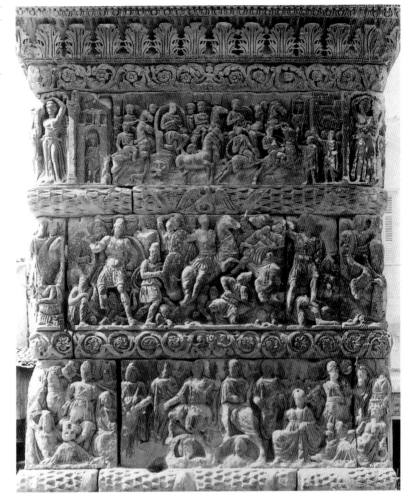

Sculpted relief from the
south-west pillar of Galerius'
quadrifonal arch at Salonica,
c. AD 298–303.

The upper tier shows the
emperor's *adventus* into a city
accompanied by cavalry and
welcomed by the populace;
in the upper right, beside the
city's gate, is a temple whose
cult statue waits to receive the
emperor. In the middle tier,
Galerius triumphs in battle
over the Persians, recalling
his victories in 297–8. In
the lowest tier, closest to
the viewer's eye level, the
four tetrarchs sit enthroned,
surrounded by kneeling
personifications of the
provinces and, ranged on
either side, a variety of gods
from Jupiter and Mars to Isis,
Serapis and Fortuna.

that at Lepcis) with a palace, hippodrome, mausoleum, and proces-
sional way. At the point where the processional way leading from the
palace complex to the mausoleum crossed the via Egnatia, Galerius
erected a great triumphal arch of a similar quadrifonal type to that of
Severus at Lepcis Magna.[19] Unfortunately, like the Lepcis arch, this
survives only in part so that it is impossible to reconstruct its full icono-
graphic scheme. However, it was clearly designed to celebrate the
Roman victories of the emperor over the Parthians (like a string of
other official monuments from Augustus' now-lost Parthian arch in
the Roman Forum via the Antonine altar to Septimius Severus' arch
in Rome, **52**). The scene of Galerius on horseback—his head sur-
mounted by an eagle carrying a wreath of triumph—crushing a Persian
enemy [**87**], so reminiscent of the great Trajanic frieze [**53**], focuses
the victories of 297–8 on the person of the emperor, while the scene
immediately below this (showing the four tetrarchs enthroned) places
Galerius' glory in the context of the collegiate system of rule set up by

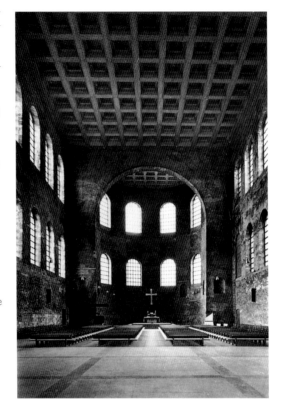

The Basilica, interior view
looking north, Trier, early
fourth century AD.

This huge rectangular hall
(29 m by 58 m), on a north-
south axis, is crowned by a
semi-circular apse for imperial
audiences at the north end.
Only the left-hand wall and
the curve of the apse actually
survive from antiquity, the rest
of the building having been
destroyed when the basilica
was incorporated into the
episcopal palace of Trier
in the middle ages (and later
restored). Built of solid brick,
the basilica was originally
decorated with marble revet-
ment in the interior, mosaic in
the apse, and painted stucco
on the outside. In antiquity, the
building was equipped with
underfloor central heating.

Diocletian. Like the Antonine altar, the Adamklissi trophy and the
arch at Lepcis, the arch of Galerius exports the traditional repertoire of
Roman triumphal themes and imperial icons to the provinces. But un-
like Trajan or even Septimius Severus, Galerius was no provincial aris-
tocrat made good in Rome; he was an uneducated peasant from Illyria
who rose, like Diocletian himself and a number of other emperors of
the third century, through the ranks of the army. His arch marks not
the sophisticated—even sensitive—imposition of the centre's cultural
apparatus on to the provinces but rather the periphery's appropriation
of the centre's most archetypal monuments and iconography. Where
Trajan's Adamklissi monument was a clear assertion of conquest and
imperial control, where Severus' arch at Lepcis affirmed a local origin
yet always in the context of that emperor's focus on Rome as his capital,
Galerius' arch was a triumphant acclamation of his own capital city. It
represented the claim of the empire's great civic, military, and imperial
centres to be the equal of Rome—a claim which would shortly become
reality when Constantinople supplanted Rome as the premier imperial
capital.

Galerius' companion as Caesar in Diocletian's tetrarchy, established
in 293, was Constantius Chlorus, the father of Constantine the Great.
As his capital, for the quarter of the empire encompassing Britain,
Gaul, and Spain, Constantius chose Trier, an ancient and prosperous

89

The Porta Nigra, Trier, early fourth century.

A very impressive main gate with relatively little defensive usefulness, the Porta Nigra was probably never completed, which is why the masonry is in such a crude state of finish.

90

Restored elevation of the exterior of the basilica at Trier, seen from the north (early fourth century AD).

city on the Moselle. Like Galerius, he laid out a new quarter including a palace (of which the basilica, or imperial audience hall, still survives, **88**), baths, a circus and city walls.[20] The walls boasted imposing gates, like the surviving Porta Nigra [**89**], which were designed at least as much to *impress* both insiders and outsiders as they were to be functional defences. The basilica, a severe and plain rectangular building with an apse and narthex [**88, 90**] is one of the surviving architectural masterpieces of the tetrarchy. Its simplicity belies considerable sophistication of effect. The hall's purpose was to concentrate all attention on the emperor enthroned in the apse (as was the purpose of the gabled pediment in the peristyle of Diocletian's palace, [**46**], and on the

missorium of Theodosius, [56]). To do this, the windows of the apse were made shorter than those of the nave, springing from a higher point, with the effect that from inside the building the apse, and the emperor in it, appeared to have a greater height and depth than was in fact the case.

Excavations in the palace complex at Trier after the bomb damage of the Second World War brought to light the remains of another tetrarchic building from the first quarter of the fourth century. A number of fragments of very high quality painting from a plaster ceiling were discovered showing panels of putti interspersed with busts of women in ornate jewellery and haloes [91]. It has been suggested that these are portraits of ladies in the imperial house, ideal representations or personifications.[21] Whatever their specific significance, these fragmentary images in rich colour schemes evoke a distant but distinct echo of the lavishness reserved for the imperial style in the Roman

92

The land walls of
Constantinople, built under
Theodosius II, AD 412–13.

empire's northernmost cosmopolitan capital. Since we do not know
the function of the room, whose ceiling so fortuitously survives, it is
impossible to tell how expensive its decoration was, or whether it
represented the best that imperial Trier could offer. If so, it would be a
sign of the relative poverty of the northern capital, which could not
afford gold leaf for carved ceilings, and had instead to make do with
mere painted *trompe l'oeil*.

The supreme culmination of the empire's increasing emphasis on
its peripheries would be the establishment of Constantinople by
Constantine in AD 330. This was more than simply a centre for the local
Caesar's court, like Salonica or Trier, or a genuflection to an emperor's
birth-place, like Lepcis. It was the new Rome, the Christian Rome,
founded and embellished to replace the old Rome as the new hub of
the Christian empire. It collected into itself vast quantities of remains
—both from Classical antiquity (especially statues from Greece and

Asia Minor) and from the Christian past (above all, relics and the bodies of saints). Like Trier, Salonica, and Rome itself, after Aurelian built new walls in the 270s, Constantinople was a defensible fortress as well as a cosmopolitan metropolis. At the beginning of the fifth century, the city prefect Anthemius—ruling in the name of the infant emperor Theodosius II—constructed the apogee of all late-antique defences, the legendary land walls which would protect Constantinople throughout the Byzantine era [**92**]. Well-nigh impregnable to assault (though never entirely safe from treachery), the great Theodosian walls resisted all sieges until the city fell to the Venetians in 1204, and then to the Turks in 1453.

The visual dynamics of Romanization

This chapter has sought to show both the complexity of acculturation (in that it needed to accommodate, Janus-like, both the centre and the provinces) and the gradual shift of balance away from Rome towards new capitals on the empire's periphery. In art and architecture, these processes gave rise to the need to impress more than one audience at once—locals, outsiders, and Roman subjects from elsewhere in the empire. On the level of style, the arts of the provinces show an extraordinary range. Even at the most expensive, imperially sponsored (or at least imperially sanctioned) level, monuments relatively close in date like Trajan's trophy at Adamklissi and, say, Trajan's kiosk—a small roofless temple, built in the ancient Egyptian style on the island of Philae near Aswan on the Nile in Upper Egypt—are very far apart in their visual appearance and influence. Just as the Adamklissi metopes

93

Relief in the ancient Egyptian style from the Roman *Mammisi* (birth house) beside the Ptolemaic temple at Denderah, early second century AD.

Trajan as Pharoah, on the right, makes an offering to Isis who is suckling her son Horus.

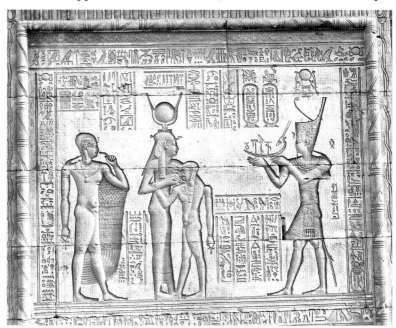

show the mark of their barbarian artists from the north, so imperial monuments in Egypt (including Trajanic reliefs in the temples at Esna and Dendera [**93**], as well as a host of reliefs and steles dating from Augustus to Diocletian) are carved in a pristine ancient Egyptian style handed down via the Ptolemies from Pharaonic times. Such Egyptian reliefs, where the particular emperor is only identifiable through his hieroglyphic inscription, slot him into the most ancient of divine-ruler traditions as being but the next in a line of sacred kings stretching back virtually to the beginning of time.

These monuments signal the persistence and importance of non-Roman ways of seeing, and the need to accommodate peripheral conceptions and views. Both Adamklissi and Trajan's images in Egypt allow power to be visualized in ways that are hardly Roman at all. Was the nature of imperial authority itself changed by being imaged in terms dictated by provincial attitudes? In the short term, perhaps the answer is 'no'; but in the longer term, the empire's shift of balance to a series of peripheral centres may well owe something to its willing acceptance and acculturation of non-Roman and provincial views. But the openness to markedly local styles promulgating, for instance, entirely non-Roman pantheons of deities, or—like the Palmyrene portrait of Tibnan—asserting through style a local identity, was also a licence for a certain amount of internal resistance to Romanization on the part of subject populations.

Take, for example, on a much less elevated social level, the bronze bust of what is probably a local Celtic goddess found at Cirencester, in England, in the courtyard of a third-century Roman house [**94**].[22] The sharply delineated eyes, wedge-shaped nose, and symmetrical crest of undulating waves which represents the hair, seem wholly uninfluenced by Graeco-Roman naturalism. They look forward to the barbaric glories of Insular, Saxon, and Romanesque art in the middle ages, just

as the Pharaonic Trajan supplicating Isis gazes back into ancient Egypt without ever a wink or whisper at the naturalistic styles that had made such an impression on the arts of the Mediterranean after the Greek Revolution of the fifth century BC.

The persistence of this kind of provincialism is an important element in Romanization. On the one hand, it may represent (especially in imperially sanctioned art) the careful attempt to compromise between local and ruling identities, and to weld out of the combination of the two in any one province a new identity which encompassed both. Yet at the same time the tenacity of a non-Roman, non-Classical, visual culture on the empire's periphery (and here one must include even significant parts of Italy, relatively close to the imperial centre) represented a constant assertion of local identity in the face of the classicizing naturalism of the styles associated with conquest and foreign rule. The little goddess from Cirencester was not only a non-Roman deity, she was entirely untouched by Rome in her appearance. The very presence of Roman power in Britain at this time may have given images like this a charged meaning. Just as the fusion of Roman and peripheral styles (or the incorporation of Roman themes in foreign forms) might signal a newly fused identity, so the survival of provincial customs and styles might equally assert a subtle denial of *Romanitas*.

Yet, as with judging the different styles of the reliefs on the Arch of Constantine, we must be wary of assuming that ancient viewers, patrons, or consumers drew the kinds of conclusions we might expect from what may seem to us very clear differences. Certainly Greeks and Romans recognized the divergence of styles. The satirical essayist, Lucian, comments in the second century AD on how the Celts portrayed the god Heracles, or Hercules as the Romans spelt it (whom he says they call Ogmios) 'in a most peculiar manner'.[23] After describing a painting briefly, he says 'you would think him anything but Heracles! Yet, in spite of his looks, he has all the equipment of Heracles.' Lucian's consternation at what seems to him a very eccentric mix of form and iconography is resolved by a Celtic interpreter who explains that the Celtic Heracles is different from the Greek, in that he represents eloquence rather than strength and is visualized as an old man rather than a youthful hero. Lucian, himself a Syrian by birth though he wrote in Greek, is sensitive to provincial style and iconographic idiosyncrasy as signals of local identity. His short piece on the Celtic Heracles, despite its rather demeaning tone about people Lucian regards as being virtual barbarians, shows us a cultivated citizen of the empire taking seriously the attitudes and local loyalties which give rise to, and are expressed by, provincial style.

In the fourth-century Roman villa at Lullingstone in Kent, unearthed in 1949, the dining room boasts some Romano-British mosaics, executed in local materials and by a local hand, representing

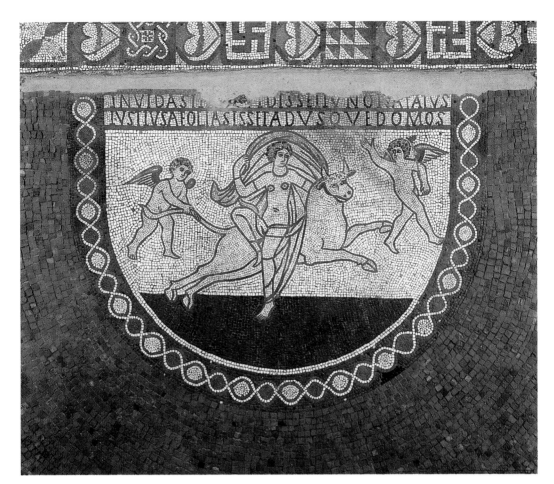

Floor mosaic from a Roman villa at Lullingstone in Kent, fourth century AD.

The image shows Europa sitting side-saddle on the bull, largely uncovered by diaphanous drapery, and accompanied by cupids. The scene occupied the floor of the apse in the *triclinium*, or dining room.

Europa and the Bull and Bellerophon killing the Chimaera.[24] These are archetypal Classical themes represented in a linear late-antique style. The Europa panel [95] has an inscription in the form of an elegiac couplet which reads:

> Had jealous Juno seen the swimming of the bull,
> With greater right, she would have gone to Aeolus' Hall.

This is an excellent example of late-antique *paideia*. It refers obliquely to Vergil's *Aeneid* (I. 50), where Juno tries to persuade Aeolus to destroy Aeneas' ships by summoning a storm at sea. The reference jokingly transfers the goddess' wrath to her adulterous consort Jupiter, who has donned the guise of a bull in order to carry Europa off over the waves. The learned classical panache of the inscription may seem at odds (to our eyes) with the parochial late-antique style of the mosaic—especially when it is compared with the contemporary but much more sophisticated mosaics from Antioch [65] or Piazza Armerina [67], let alone the rather later mythological scene from Djemila [64]. Yet the house's owner displayed nearby two typically Mediterranean over-

life-sized portrait busts probably carved from Greek marble in the east in the second century and subsequently imported into Britain.[25] In the third century, these busts were set at the top and bottom steps of a staircase leading to the basement.

Did the owners of the villa make anything of what seems to us a stylistic and temporal divergence between the busts and the mosaics? The Lullingstone villa—with its evident learning, its antiquarian collecting, and its British provincialism—poses keen questions about the nature of Roman identity on the periphery. One might even say, especially after Caracalla's grant of citizenship to all free inhabitants of the empire in 212, that the definition of Roman identity was the mix of what those people did and cherished. Lullingstone is a potent example of how, by the 330s, that mix had come to incorporate elements of highly eclectic provenance from the schematism of the mosaics to the high classicism of the busts and the inscription. The addition of a room at Lullingstone with painted Christian decoration in the later fourth century only served to accentuate the complexity of the mix.

On the purely stylistic level, the various provincial styles (often labelled 'sub-antique' or 'expressionist' and even defined as belonging to antiquity's 'third world',[26] though in fact what they have in common is a denial of the Graeco-Roman canon of naturalism) became more significant, more influential, as the empire's centre of gravity shifted from the ancient metropolis to the newer capitals in the provinces. By the fourth century, the 'provincialism'—which is to say, the non-naturalism—of tetrarchic art (from the bases of Diocletian's five-column monument [**60**], via various porphyry tetrarchs [**29**, **30**] including a group from Rome, to the fourth-century reliefs of the Arch of Constantine [**7**], as well as countless religious images dedicated by the followers of all kinds of oriental cults) had certainly made its impression even on the visual environment of the centre. Indeed, in the full marriage of the periphery's non-naturalistic styles with the classicism which Roman art had inherited from Greece—the marriage that *was* the art of the middle ages—one might say that Romanization's goal of unifying divergent identities had finally succeeded.

From Romanization to Christianization

Just as images helped make the empire a recognizably *Roman* world, as well as expressing provincial identity—even resistance—so they were to prove a key weapon in the armoury of Christianization. Both Romanization and Christianization shared the principal concern of transforming identity (individual and collective) by fusing traditional and local concerns with a centripetal sense of belonging to a larger whole. What is striking about the role of art in Christianization is that it began as a religious community's resistant affirmation of self in the face of the persecutions and disapproval of the establishment. The

earliest visual symbols of Christianity (the chi-rho monogram, see the frontispiece to Chapter 4, p. 106, for instance, or the image of the fish) functioned in the Christian community as a proclamation of non-pagan identity. But, after Christianity became the dominant religion of the Roman state, its images swiftly adapted to the multiple demands of proselytism and universalizing incorporation, very much on the model of the Romanizing tendencies of the state which it had previously resisted.

Art, especially the funerary art of catacombs and sarcophagi, was to serve as a significant means of marking a Christian identity of resistance during the years of persecution in the third and early fourth centuries, just as Tibnan's image had affirmed her Palmyrene sense of self. This quality of resistance is especially marked in the popularity of images representing the martyrs who had died rather than compromise with Roman paganism—an iconography and ideology whose importance only increased after the Peace of the Church (see the images of the Roman martyrs Adauctus and Felix, as well as St Peter in the Catacomb of Commodilla, **104** and **105**, as well as the Junius Bassus Sarcophagus, **130**). It was precisely the link between symbolic images and Christian identity before the advent of Constantine which provided the impetus for art as a major implement in the post-Constantinian campaign of conversion. Images told in an accessible visual form the complex and unfamiliar scriptural stories (many of them borrowed from Judaism, and unknown to an audience of Roman Gentiles) which were otherwise available only to the literate or to those who heard them expounded in sermons. Images not only reinforced the explicit verbal teachings of the Church with visual illustration, but they juxtaposed Old and New Testament themes in ways created by Christian theologians; and they thus taught rather sophisticated methods of Biblical exegesis in a relatively simple and highly accessible manner. As we shall see later, this use of images would serve as one of the methods by which particularly Christian modes of thinking about the world came to be broadly communicated. That is, art would serve as a principal means for transmuting a world characterized by pagan identities into one dominated by the beliefs, attitudes, and myths of Christianity.

On the architectural front, just as typically Roman buildings like basilicas and theatres had been exported throughout the empire as a means of Romanization, so lavishly decorated churches—and civic topographies of several churches—created both a Christian visual environment and a space for the new patterns of public liturgy and worship needed by a religion which had suddenly ceased to be secret or persecuted. The emperors themselves leapt into the vanguard of church building, just as in pagan times they had been among the principal temple builders. Constantine in particular was prolific in his

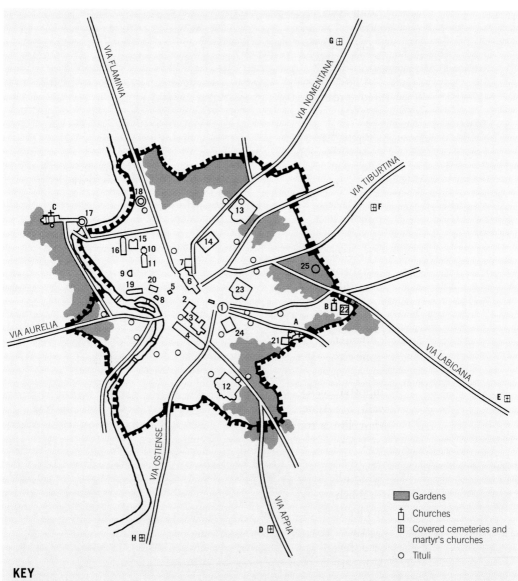

KEY

1 Colosseum	**12** Baths of Caracalla	**23** Baths of Trajan
2 Forum Romanum	**13** Baths of Diocletian	**24** Temple of Claudius
3 Palatine	**14** Baths of Constantine	**25** Minerva Medica
4 Circus Maximus	**15** Baths of Severus Alexander	**A** Lateran Basilica
5 Capitol	**16** Stadium of Domitian	**B** S. Croce in Gerusalemme
6 Imperial Fora	**17** Mausoleum of Hadrian	**C** St Peter's
7 Market of Trajan	**18** Mausoleum of Augustus	**D** S. Sebastiano
8 Theatre of Marcellus	**19** Circus Flaminius	**E** Sts Peter and Marcellinus
9 Theatre of Pompey	**20** Porticus of Octavia	**F** S. Lorenzo
10 Pantheon	**21** Castra Equitum Singularium	**G** S. Agnese
11 Baths of Agrippa	**22** Sessorium	**H** Shrine of St Paul

Legend (map):
- Gardens
- Churches
- Covered cemeteries and martyr's churches
- Tituli

Map of the city of Rome in
the reign of Constantine,
c. AD 330. The main ancient
monuments and Christian
buildings are given.

foundations of churches—in Rome, in Jerusalem, in Constantinople.[27] But soon, at any rate in Rome, imperial patronage of churches was rivalled and even surpassed by clerical and aristocratic foundations— just as local millionaires competed with the emperors in the civic euer- getism of the second century.[28] In all this, and in the remarkable and rapid spread of church buildings through the new Christian domain, what the architecture of Christianization borrowed from that of Romanization was the aim and means of propagating a collective sense of identity through the visual. Moreover, once Christianity was unequivocally the *Roman* religion, the ancient dynamic of 'Romaniz- ing the barbarians' came to be reinterpreted as an active process of conversion.

None the less, despite what was on many levels a deep continuity of purpose and a strong similarity of method in the dynamics of Romanization and the spread of Christianization, the ruptures of Christianity with the pagan past were profound. In the case of ancient cities, like Rome or Milan, the building of Christian churches— initially on the sites of the principal Christian cemeteries going back to pagan times (sites sanctified by their martyrs' tombs)—involved a fundamental transformation of urban topography. The tombs were not in the city centre (which was invariably the ancient monumental heart of a major city) but on its peripheries, outside the walls. All the most important early churches in Rome—St Peter's, St Paul's outside the walls, Sta Agnese outside the walls, San Lorenzo outside the walls, Sts Marcellinus and Peter—were either outside the city or, in the case of the Lateran Basilica (the first Cathedral of the Popes) and Sta Croce in Gerusalemme (where the relic of the True Cross was kept), just inside the south-eastern edge of the perimeter but on its very borders [96]. Establishing a new sacred topography around the outside of the city involved a radical redefinition of the ritual patterns of urban life. Instead of the sacred focus being concentrated in the centre (as had been the case in pagan Rome), it would forever be directed to the city's periphery.[29] In due course, the forum—the very heart of ancient Rome—would become little more than an easy quarry for reusable stone. Exactly the same transformation took place in Milan [97], where apart from the cathedral in the city centre, the major churches and their relics surrounded the city's outer walls.[30]

In terms of the kind of identity promulgated by Christianization, there was a still more profound rupture from the attitudes of the pagan past. Romanization was, as we have seen, a constant effort to com- promise between subjectivities and to build something new out of the potential conflicts of identity between conquering Rome and her provinces. It was a loose, inclusive, unsystematic process with an end- less and admirable ability to adapt, to masquerade, to syncretize. Thus it was in the end equally Roman for emperors to appear in any visual or

Map of Milan, c. AD 400
showing the main fourth-
century churches.

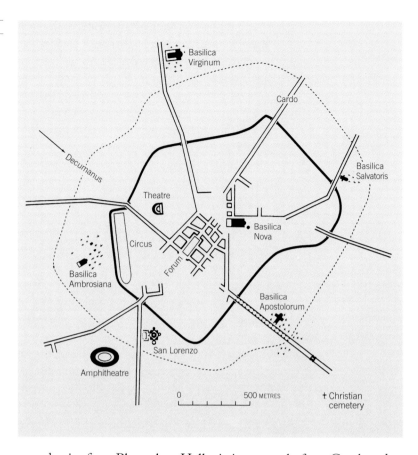

Basilica Virginum

Cardo

Decumanus

Basilica Salvatoris

Theatre

Basilica Nova

Circus

Forum

Basilica Ambrosiana

Basilica Apostolorum

San Lorenzo

Amphitheatre

0 500 METRES + Christian cemetery

sacred guise from Pharaoh to Hellenistic monarch, from Greek god to imitator of Christ, from traditional Roman to barbarian tribesman. But Christianity was unhappy with compromise.[31] It aimed to exclude others—other faiths, other iconographies, even Christian themes that were deemed heretical—from what would ultimately be its total and categorical redefinition of the world. Though it might adopt many a stylistic trait or motif, many an iconographic feature, to its new repertoire of visual forms, though it might adapt many a pagan temple into becoming a Christian church (from the Pantheon and the temple of Antoninus in Rome to the Parthenon itself),[32] none the less Christianity eventually rejected the loose syncretism characteristic of Roman toleration in favour of an intellectually and theologically rigorous excision of all paganism, all heresy. Of course, in our period, the ideal orthodoxy espoused by theologians was hardly the norm, except for its repetition in sermons. Pagan practices, attitudes, and images survived long into the heyday of Christendom,[33] though eventually they were all but extirpated. In the visual field, Christianity was responsible for the wholesale dismantlement of numbers of great pagan temples (most famously, the temples of Alexandria including the great Serapeum in 391) and the destruction of many sacred images.

It attempted in the end not only to drain the world of any surviving shreds of pagan belief and ritual, but even to eliminate any vestige of what it defined as secularity.[34] In both their distinct similarities and their quite radical differences, the comparison of Romanization and Christianization typifies with great economy the nexus of continuity and transformation which the world of late antiquity was about.

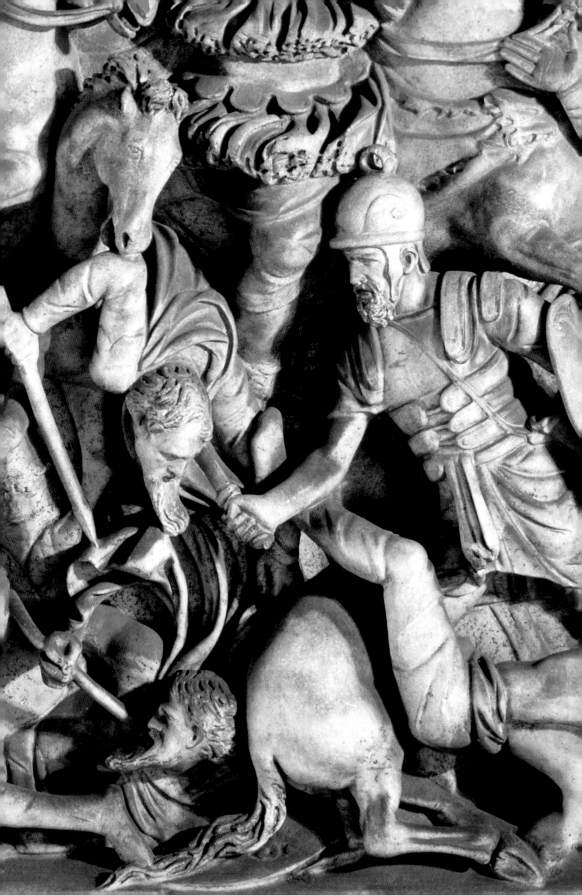

Art and Death

The marking of a death is perhaps the moment at which human beings especially reflect upon the vanished life they are mourning and their own mortality. It is no surprise that memorials of the dead occupied a cardinal position in the repertory of Roman art, providing a continuing livelihood for artists, a special purchase of remembrance for patrons, and a visual focus for the rituals of burial and commemoration. Reaching back into Etruscan times, Italian culture had long produced a rich art and architecture of death—cinerary urns, statues of deceased ancestors, funerary altars, relief carvings to be installed on the walls of tombs, all kinds of tomb chambers and mausolea. We have already seen a number of such funerary commemorations, with particular attempts to focus on special features of the deceased's working life, such as the man remembered as a soldier and pious sacrificer on his funerary altar [16], or the freedman with a career in the circus commemorated with his wife in the charioteer relief from Ostia [14]. We have seen how funerary portraits from very different provinces of the Roman world, like Palmyra and the Fayum, strove to display the deceased in their finest dress and their adult prime of life [75, 76]. It is especially in death that a lifetime's social position and identity came to be defined through the last rites and commemorative images. The art of death is a kind of summation of, and a visual eulogy on, the life which has passed away. It is also a testimony to the inheritance and status of the survivors—marking out the identities of the living through the portrayal of their dead.

On the outskirts of their towns, Romans had built cities of the dead filled with tombs instead of houses, whose streets evocatively echoed the streets of the living. The tombs of the great or the wealthy were grand structures set in funerary gardens, those of the poor little more than holes in the ground.[1] In short, the sociology of Roman death closely mirrored that of Roman life, its double or counterpart.[2] And in both, the material accoutrements of status—above all, the figurative arts—functioned as a powerful marker of identity. Around Rome itself (but later also in Naples and Sicily), a peculiar habit of digging large underground complexes for the burial of families and other social groups developed in early imperial times. The first such underground

burial sites were *columbaria*, large chambers containing 'dovecote'-sized niches for urns and chests with ashes; the latest were the vast funerary mazes of catacombs and *hypogaea*, in which pagans, Christians, and Jews were inhumed in body-length *loculi*, or coffin-sized hollows (sometimes inserted within *arcosolia*, or arched niches), spanning the walls of corridors and chambers (called *cubicula*) for many miles underground and often on several levels.

Traditionally, the privileged funerary rite in Rome was cremation and burial in an urn. As we have seen in the special case of imperial consecration, as late as the early fifth-century apotheosis ivory leaf [11], pagan Roman culture maintained the belief that burning on a pyre was the supreme death ritual. But precisely in the period of the Second Sophistic, the priority of cremation began to give way to a fashion for inhuming the body intact (and sometimes embalmed) in a novel kind of funerary container—the carved marble sarcophagus.[3] The very choice of inhumation and sarcophagi as coffins (both associated with the burial customs of Greece and Asia Minor) is a sign of the empire's enthusiasm for things Greek in the reigns of Hadrian and his successors.

The themes which became popular in the decoration of sarcophagi are no less Greek-focused. Most common, after the relatively less ambitious (and less expensive) traditional funerary imagery of garlands, is a wide range of mythological iconography remarkable for its systematically *Greek* rather than Roman focus. Such images placed a Roman corpse in a coffin framed by visual and narrative allusions to Greek myths, which redefined the character, life, and afterlife of the deceased by means of a Greek cultural identity. Somewhat rarer is a vogue for biographical and battle scenes, and other images of 'daily life'—sometimes presented in a mythical guise or with the accompaniment of divine personifications, heroic figures, or Cupids engaged in the action. The emergence and popularity of the sarcophagus from the second to the fifth centuries (precisely the period with which this book is concerned) offered excellent scope and a good visual field for relief sculpture which would work to enhance the grandeur and define the identity of the dead in terms both personal (through particular allusions to favourite myths or through the inclusion of portrait-heads of the deceased on the mythological figures depicted) and general (through the heightened analogy of an individual's life with an elevated mythical reality). The great number and quality of the surviving examples offers the opportunity for a detailed exploration of the melting pot of Roman iconography—its careful transformation of foreign themes (Greek myths, eastern—for example Dionysiac—religious subjects and eventually Judaeo-Christian scripture) to the needs and inclinations of the Roman dead and their mourners.

Through the art of Roman death we can trace most precisely two

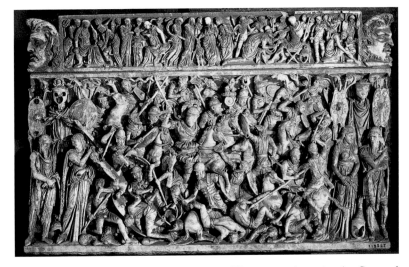

Marble 'battle' sarcophagus, from Portonaccio on the Via Tiburtina, c. AD 180–90.

The main scene represents a battle, while images from the protagonist's life adorn the lid. The face of the principal figure in the centre of the visual field was never finished.

special aspects of the transformation of Roman culture in the Second Sophistic and late antiquity. First, the way the sarcophagi adapted Greek mythology to a Roman context gives the richest visual instance of the more general Hellenization of the empire's ways of life. The myths were not merely told and retold, but—through abbreviated narratives which illustrated only parts of a fuller story—the mythological stories on Roman coffins demanded an involvement, an active retelling from their viewers. Thus, Greek culture was not so much imposed on, as elicited from, its Roman viewers: it became part of their identity. Second, in the specific case of Christianity from the early third century onwards, the images of sarcophagi, catacombs and (later) mosaics spread more than just the narratives of an unfamiliar scripture. On the pattern of the abbreviated narratives from Greek myth, early Christian funerary art put together apparently unconnected images from the Old and the New Testaments (and later from the martyr tales of the Christian saints). And thus it transmitted a particularly Christian way of thinking—that typological method whereby the old presaged the new, and the present was foreshadowed by the past.

Elevating the dead: identity, narrative, and representation

Like the state icons, which portrayed emperors in their roles of eternal splendour as generals or huntsmen or dispensers of justice, images of the dead were commemorations which sought to elevate their subjects. The dead person, instead of being merely one citizen among thousands, was to be raised to a special status—a status he may have held for his own family, but which was generalized by allusion to mythical or distinguished social themes. Whether biographical or mythological in iconography, a sarcophagus was purchased by a dead person's relatives to celebrate and aggrandize the deceased. The famous Portonaccio sarcophagus [98], for example, was carved to give glory to its occupant as

a soldier.[4] The deceased is placed just off centre appearing on his charger in the midst of an epic battle. The scene is flanked by trophies and conquered barbarians intimating that the mêlée ended in Roman victory. He rides behelmed and triumphant through the fray, larger in scale than the other figures, like Trajan on the great Trajanic frieze [**53**]. On the lid, from left to right, are scenes of the first bath of the protagonist as a child, of his marriage (in the centre), and of him as a successful general granting mercy to a conquered barbarian, on the model of emperors like Marcus Aurelius (see **12**). Both on the lid and in the main scene, the face of the heroic subject—originally intended to bear the portrait of the dead man—has been left unfinished. Clearly the sarcophagus was cut and remained near-completed in the sculptor's workshop until its eventual patron should purchase it, even perhaps before his family chose it. The fact that the features of the protagonist were never cut may imply that—despite all the indications of the iconography—someone quite different from a distinguished soldier was ultimately buried there. A likely case of precisely such a change of intended occupant is the fourth-century sarcophagus of St Helena from Rome [**9**], whose military subject matter seems oddly inappropriate to a saintly queen.

The style and subject matter of this virtuoso piece suggest a date close to the column of Marcus Aurelius (made *c.* AD 180–92), which—no less than Trajan's column—was also a funerary commemoration for its dedicatee, highlighting his glories in battle [**37**]. Like the column of Marcus, which reveals to us the emperor as his heirs wished him to be seen (a very different image from the introspective author of the *Meditations*), the Portonaccio sarcophagus is a purely conventional portrait of a life. It elevates its occupant as a general, doing the great deeds a general should do, without the specific or personal reference which would have been manufactured by the provision of portrait features. Of course, had those features been added, the sarcophagus would have been no more 'truthful' a biography—its rhetoric would simply have rung true. In this sense, though apparently adorned with biographical imagery, such sarcophagi are in fact no less mythologizing than representations of mythical heroes like Achilles, Hercules, or Theseus in battle.

Much more peaceful in mood, though still biographical and to some extent still military in its themes, is a mid-third-century sarcophagus from the catacomb of Praetextatus, which is famous because it has been thought to be the coffin of the emperor Balbinus, who reigned briefly in 238 [**99**].[5] Here the protagonist and his wife are repeatedly represented with very fine portrait-heads—on the lid, where they recline on a funerary bed in an iconography reaching back to Etruscan times, and below in each of the two scenes of the main body of the sarcophagus. To the right, the deceased man and his wife (her head is now

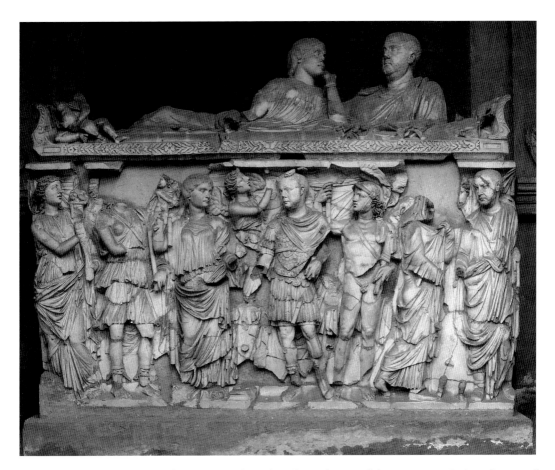

99

Marble 'biographical'
sarcophagus, from the
catacomb of Praetextatus,
fourth decade of the third
century.

This sarcophagus has been
associated with the emperor
Balbinus, who died in AD 238.

lost) stand holding hands and united by a now missing figure of
Hymenaeus. In the middle (in a scene which occupies the whole cen-
tral and left part of the visual field), the protagonist in full Roman
military garb makes sacrifice in the presence of his wife and a series of
personifications including the nude Mars beside him. Again the
imagery is no more than conventional, despite the strongly personal
'feel' imparted to it by the excellently carved portrait-heads. In one
sense the highly traditional iconographical scheme (funerary bed,
marriage, sacrifice) is slightly unconventional: this sarcophagus un-
doubtedly does raise the role of the wife to being—at least in pictorial
terms—virtually the equal of her husband. Yet this is no more the
case than in other imperial images of the second and third centuries
(such as the apotheosis relief of Antoninus and Faustina [**13**], or the
many joint and family portraits featuring Septimius Severus and Julia
Domna [**22**]), where wives accompany husbands in both personal and
public contexts.

These kinds of biographical images serve to mythologize the
deceased with the epic grandeur of battle or the accompaniment of
deities. By contrast, the mythological sarcophagi strip the dead man of

his civic identity by wrapping him in the narrative of a mythical hero, yet at the same time raise him to the near-sacred world of that narrative. Take for instance a sarcophagus from Rome, now in the Palazzo Doria, dating to the last decades of the second century [3].[6] In the centre, the flamboyant mythical hero Meleager performs his feat of glory, skewering the Calydonian boar. Behind him and before him are two representations of his beloved, Atalanta, a rare draped figure and the sole female, amidst the nude mélange of heroic men. In the small frieze of the lid, in stark contrast to the scene of triumphant success below, the dead Meleager is carried in procession while his grieving mother Althaea commits suicide to the right.

This sarcophagus, despite (perhaps even because of) its exuberant facility, is by no means unique; the main scene is more or less exactly replicated in a sarcophagus now in the Capitoline Museum. Its heroic drama represents not only the killing of a monstrous beast but also the great love of Meleager and Atalanta, which the hunt for the Calydonian boar occasioned. The theme posits an analogy with the deceased, suggestively raising him to the level of great warrior and great lover. Of course, to those who knew the dead person, it is always possible that such grandiose assertions ventured on the ironic. The lid, however, in a scene of marked congruity with the dead man's funeral, echoes on the heroic level both his death and his relatives' grief.[7] The imagery chosen suppresses a key feature of the myth—the fact that Althaea, Meleager's mother, was herself responsible for her son's death. For, in a fit of rage in revenge for Meleager's killing of her brothers (an act depicted on the left end of the sarcophagus), Althaea burned the brand on whose destruction, the Fates had decreed, Meleager's life would come to an end. Whether this elision of, yet allusion to, the depths of inter-familial violence, enmity, and revenge underlying the myth had any resonance for the deceased and his family, we can never know. But there is no doubt that the reference to, and abbreviation of, complex myths had the potential to carry multiple and not always straightforward allusions or suggestions when read against the actual lives of the dead.

Just as mourners could find meaning by commemorating their dead with heightened 'biography' or through the guise of myths, so others in the same period turned to more overtly religious associations. In 1885, a group of nine late second-century sarcophagi were discovered in two underground sepulchres near the Porta Pia in Rome. Seven of them are now in Baltimore. Most of these—probably part of a single burial programme belonging to a single family— allude to the mythology of the god Dionysus. Perhaps most impressive are the representations of the meeting of Dionysus and Ariadne [100], and of the Indian Triumph of Dionysus which shows the god in his chariot pulled by panthers and accompanied by a procession of Pans, satyrs, and Silenus with ele-

100

Marble 'mythological' sarcophagus, from Rome, about AD 200.

Dionysus, with his entourage of maenads, satyrs, and panthers approaches Ariadne sleeping on Naxos. Pan reveals the maiden to the god, while Cupid hovers between Dionysus and Ariadne, behind whom appear a group of local personifications. There is some damage (especially the loss of Dionysus' head) and the lid is not in fact original to this sarcophagus.

phants and lions.[8] This kind of imaginative ethnography of natural wonders and exotic animals (real and imaginary) is typical of the fiction of the Second Sophistic (from the novels to pagan hagiographic tracts, like the *Life of Apollonius of Tyana* by Philostratus), and it is quite possible that the imagery of such coffins was designed to place their occupants on the heightened plane of the divine never-never land of Dionysiac travels. But equally, it is likely that this group of sarcophagi, and others like it, may allude specifically to the mystery cult of Dionysus—one of the most venerable and vital of the ancient initiate religions, which—like so many other religious cults—enjoyed a revival in precisely this period.[9]

Clearly the potential allusions of waking from sleep to the vision of the god, as Ariadne wakes to find Dionysus before her, are capable of a number of religious and spiritual interpretations. Indeed, visions of gods were particularly associated with sleep in antiquity—for example the great epiphany of Isis to Lucius which forms the climax of Apuleius' second-century novel, *The Golden Ass*,[10] and the numerous instances of incubation, when pilgrims to healing sanctuaries slept in the temple hoping for a vision of the god or a cure to appear in the night.[11] On the Baltimore sarcophagus, Dionysus, drunk with love and wine, leans on a satyr in the centre of the image, his head unfortunately lost. To the right, Cupid and Pan lead the god's way to the sleeping maiden, uncovering her before him. The implications are simultaneously revelatory and erotic; but the scene's sense of a triumphant union-in-the-making depends on the fact that, when Ariadne fell asleep on Naxos (during the return voyage after the killing of the Minotaur), Theseus abandoned her there. Ariadne is a figure of desertion and loss, a jilted and cheated lover, as well as the potential consort

of a god. Does this theme have an allegorical message about being cheated of life by the sleep of death, only to wake to a new world of heavenly, Dionysiac, bliss?

Myth and the adaptation of culture in the sculptors' workshops

Roman sculptors provided sarcophagi, decorated with narrative sculpture, to the demands of patrons. As we have seen, different clients found mythological, biographical, or religious themes to their taste, and in their different ways all such narratives could celebrate, elevate, and/or allegorize the vanished lives of the dead. All these iconographic methods of commemoration are paralleled by literary themes in the consolatory speeches given by Sophistic rhetoricians to eulogize the dead.[12] To cater for the range of demand, sculptors adapted their iconographic repertoires from myth to myth, from theme to theme. For instance, the teeming imagery of a battle sarcophagus, like the one from Portonaccio, could be transformed into a mythological subject—such as the love of Achilles and Penthesileia at the moment of her death on the battlefield—by adapting just the centre of the visual field into an image of the lovers. Of the many such adaptations, particularly intriguing is the transformation of the image-type of the sleeping Ariadne to a number of other mythological sleepers—Rhea Silvia, whose rape by Mars while she lay in slumber occasioned the births of Romulus and Remus (one of the rare Roman myths depicted on the sarcophagi), and Endymion, the sleeping shepherd who was loved by Selene, the goddess of the moon [101].[13]

A mid- to late-third-century sarcophagus from Campania, now in the British Museum, shows a figure apparently representing Endymion lying amidst winged Cupids, some with torches and musical instruments, some vintaging grapes [101].[14] Originally, the main figure was carved to represent Ariadne in a pose and drapery fairly close to that of the Baltimore sarcophagus. When the sleeper was recut to become a male, the breasts had to be reduced, the portrait face transformed and a penis (now lost) inserted into what is still clearly a female pudenda. Most surprising of all, is the fact that this Endymion, isolated entirely from any mythological narrative, lies with his eyes open—fully awake. This is peculiar (though not absolutely unique in the corpus of surviving Endymion images on the sarcophagi) since a central aspect of the myth of Endymion was his eternal sleep.

At about the same time, in the later third century, the same workshops which produced these pagan images were adapting the same image-types to meet an increasing demand from Christian sympathizers for Christian themes. The sleeper who had once been Ariadne, Rhea Silvia, and Endymion became—in a very similar pose, though now wholly nude—a figure of Jonah, the Old Testament prophet and typological precursor of Christ, resting beneath the gourd vine after his

Marble 'mythological' sarcophagus, from Campania, mid- to late third century AD.

The subject of this sarcophagus, a semi-nude reclining figure amidst vintaging and music-playing Cupids, is usually interpreted as Endymion (on the basis of his pose). He was certainly recut in antiquity from a reclining figure of Ariadne, much like that in **100**.

ordeal with the whale.[15] For example, on a sarcophagus of about 290 excavated in the vicinity of the Vatican [**102**], the whole narrative of Jonah and the whale, including the 'Endymion pose' beneath the gourd, is represented in the company of other Biblical scenes including the raising of Lazarus (to the left), Noah receiving the dove (centre, right), and Moses, or perhaps St Peter, striking water from the rock (in the centre, top).[16] Of course for Christian mourners, this narrative had deep religious connotations not only in Christ's raising of the dead but also in the story of Jonah whose survival of the whale was interpreted as foreshadowing Jesus' Resurrection and the permanent conquest of death. Indeed, Noah emerges from an Ark which seems deliberately sculpted to resemble a coffin. Yet for the sculptors of this coffin, these Christian subjects may have had no more meaning than any other theme they were paid to create. It was simply another set of myths for a group of cult members little different from the initiates of Dionysus. Christian myths, just like Greek myths, were visualized through the adaptation and combination of a stock set of image-types.

The transfiguration of the type of Endymion into Jonah should give us pause for thought in the case of the recut Endymion sarcophagus in the British Museum. It has been suggested that a young man's sudden death and the immediate need for a coffin caused this piece to be purchased from workshop stock and recut to provide a suitable theme—for a man rather than a dead woman. Yet this hardly explains why the sleeping Ariadne should have been turned into a *waking* Endymion. It is equally possible that this waking Endymion surrounded by angels and vintaging Cupids could have been seen, by a Christian, as Jonah—the type of Christ. Grapes—one of the key iconographic attributes of Dionysus, god of wine—were themselves rapidly to be identified with the God who described himself as the True Vine, who transformed water into wine, who transformed wine into his own blood. In short, the identity of this sleeping but wakeful figure recut from Ariadne could be mythological, Dionysiac, even Christian. The meaning would depend on what a viewer wished to read into it, would accord with what mythological system viewers used to interpret the image.

The formal and narrative fluidity of such interchangeable image-types echoes a fluidity of interpretation and a flexibility of meaning in

102

Marble 'frieze' sarcophagus, from Rome, last quarter of the third century AD.

The main subject is the story of Jonah, with the prophet thrown overboard to the whale on the left, being regurgitated by the monster at the centre right and lying beneath the gourd, above right. The Jonah cycle is interspersed with other scenes, some Biblical—for instance, the raising of Lazarus (top left), Moses, or St Peter, striking water from the rock (top, centre left) and Noah receiving the dove (just above the whale spewing up Jonah, centre right)—and others, such as the scenes on the far right-hand side, perhaps non-scriptural. An early and assured development towards the two-tier pattern of Christian sarcophagi (see e.g. **130**), the decoration on this coffin is much restored.

late-antique Rome. The emperor Alexander Severus (222–35) is reported, according to the late-fourth-century *Historia Augusta*, to have worshipped in his private shrines not only the deified emperors, his ancestors, and images from diverse religious cults—Orpheus, Jesus, Abraham, Apollonius of Tyana—but also famous Roman writers like Vergil and Cicero, mythical heroes like Achilles, and his namesake, the heroic Alexander the Great.[17] This remarkable amalgam of apparently contradictory cults echoes the meanings of images on the sarcophagi: like the British Museum 'Endymion', the sacred and symbolic emblems of late antiquity were open to multiple, flexible, and not always exclusive interpretation and combination. The artists in the sarcophagus workshops created a narrative iconography of abbreviated scenes where viewers had to supply the connections and fill in the meaning, where the image-types might even allow the telling of more than one story.

In the vital and active process of adapting types to service the demands of their customers, the sarcophagus sculptors were busy transforming Roman culture beneath their chisels. It is in part due to them, and to their counterparts, the painters of the catacombs, that a Christian art was able to emerge at all in Rome—entirely out of the forms and themes of its pagan environment. Just as these artists had made Greek myths and religious themes meaningful to a Roman clientele, so they made Christian subjects Roman and in the process began a fundamental transformation in the identity of the Roman state. By the

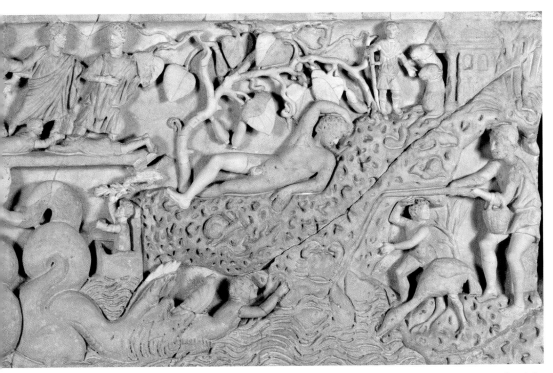

mid-fourth century, the dynamic energy of Greek, Roman, Jewish, Christian, mythological, and biographic adaptation—even visual syncretism—was yielding to the new religious and political dominance of Christianity. While the earliest Christian catacombs and sarcophagi, dating from the first half of the third century, like the Catacomb of Callistus, represented a careful construction of minority identity in response to a perceived hostile environment and a persecuting state,[18] there was a gradual increase of triumphalism in Christian funerary art made during the fourth century. Despite some examples of religious syncretism, reaching well into the fourth century and even beyond, Christian art, initially and especially funerary art, rapidly began to acquire an increasingly standardized iconography and a content more and more suited to the developments of theology and dogma. One particularly Christian contribution to the art of 'mythological narrative' was the typological running together of Old and New Testament images—creating a new kind of sacred mythology where one set of stories foreshadowed and were fulfilled in the other, where the present was presaged by the past.

We have seen this on the flat surface of the Jonah sarcophagus from the Vatican, but it is equally the case with the paintings in the catacombs, whose imagery encompasses both the visiting viewer and the dead buried there. In the vault of an *arcosolium* niche covering a tomb in the Via Latina Catacomb in Rome, painted in about 320—in the years just after Constantine's conversion—Christ as the Good

Shepherd appears flanked by scenes of Jonah spewed out by the whale, to the left, and Jonah beneath the gourd, to the right [103].[19] On the wall behind is a niche with a peacock, beside which are scenes of Adam and Eve with the serpent on the left, and a woman in the orant position of prayer (on the right). Here, in this small space, arching over and behind a coffin, an abbreviated narrative symbolic of the whole Christian dispensation has been elegantly displayed. The Fall from grace in the garden of Eden is redeemed by the incarnation of Christ, whose resurrection is foreshadowed and represented in Jonah's emergence from the whale. The place of the believer—the dead person, her relatives, any visiting spectators—is firmly established by the orant whose reward (like those buried in this catacomb) will be to join Christ's sheep in the vault. These kinds of images on coffin and catacomb create a new relationship of the individual Roman with a new mythology, a new past. The world referred to is no longer ancient Roman but a narrative of Judaeo-Christian scripture. As the Old Testament reflects the New, so the good lifetime deeds of the Christian dead may foreshadow (it is hoped) their salvation after death.

By the late fourth century, the narratives conveyed by such typology had become more political and more triumphant—as in the 'Cubiculum Leonis' from the Catacomb of Commodilla to the south of Rome, outside the walls [104].[20] In the ceiling is a bust of Christ between alpha and omega, the beginning and the end. On the far wall Christ appears again, with a gospel book in one hand and his other

104

View of the 'Cubiculum Leonis', Catacomb of Commodilla, late fourth century AD.

In the vault are square panels with stars; Christ between alpha and omega occupies the large central panel. On the back wall, Christ appears between St Adauctus and St Felix. On the wall of the left-hand accosolium, St Peter strikes water from the rock.

raised in blessing, between the local martyrs Adauctus and Felix. In the *arcosolia* to the left and right are scenes of St Peter striking water from the rock (just visible in **104**) and St Peter's denial of Christ with the cock crowing [**105**]. Here the Old Testament is hardly represented (there is in fact one scene in the room's visual programme of Daniel in the lions' den, a type of the Resurrection and Christ's harrowing of Hell). The emphasis is no longer on Palestinian or Jewish roots: it is all on Rome. The message of this imagery is not just that the incarnation was presaged in Hebrew scripture, but that its implications and effects were special for Rome itself. The main characters in the Cubiculum Leonis apart from Jesus himself, are Roman saints—Peter, Christ's successor and the first pope, and Peter's successors, Felix and Adauctus, witnesses to Christian persecution and salvation, the saintly lineage which ensured the Faith's survival in the city. The dead persons buried in the Cubiculum Leonis lie as witnesses to, and in an iconography which bears witness to, not just the rise of Christianity but its triumphant ascendance in Rome.

Of course, one might well question the objectivity of such iconographical propaganda: it coincides, even in contemporary Roman funerary imagery, both with syncretistic art like the mix of pagan and Christian paintings in the later fourth-century rooms of the Via Latina Catacomb (see **4** and **144**) and with the outright paganism of, for instance, the apotheosis ivory [**11**]. None the less, in predominantly

St Peter denies Christ while the cock crows. Right-hand *arcosolium*, 'Cubliculum Leonis', Catacomb of Commodilla, late fourth century AD.

Christian initiate circles (the circles which were poised by the late fourth century to dominate the empire's political life), it is this flavour of triumph which dominates the greatest of the later sarcophagi—like that of Junius Bassus [**130**] or the sarcophagus from the later part of the fourth century now in the church of Sant' Ambrogio, Milan.[21] The back of this virtuoso piece of early Christian sculpture shows Christ between the 12 apostles at the gate of a city [**106**], framed by its arch like Diocletian in his peristyle at Split [**46**] or Theodosius on the missorium [**56**], his feet anointed by kneeling women. Christ is enjoining his apostles to go forth and preach his word to all the nations in an iconography which effectively predicts the triumph of Christianization.

Imperial death: from pagan to Christian times

The art of death provides a frame, or a narrative, to commemorate a life. If ordinary men and women resorted to the grandeur of association with the heroes of myths and with gods, what of those for whom the act of dying itself conveyed divinity through the rituals of apotheosis, who through their lives were conceived (at least by the mass of the populace) as the heroes of living myths? As we have seen, Hadrian broke all precedent by burying the ashes of Trajan, his deified predecessor, under the column in Trajan's forum. Trajan's column [**36**] is thus the greatest of all Roman historiated funerary monuments, as well as being a complete exception. It is the ultimate example of a biographical memorial, tracing—indeed, mythologizing—the heroic battles and deeds of its protagonist in a miniature detail which it is unlikely any viewer could have followed. Much argument has been devoted to which episodes from the Dacian wars are represented in the column's scenes, but its total effect is less historical than mythologizing, less a

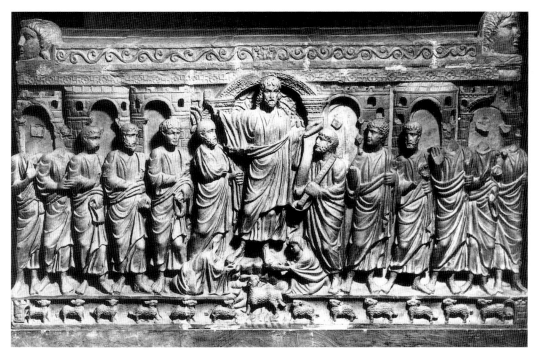

document than a panegyric, whose ultimate message—the achievement and outcome of all the beetling action of the scrupulous surface carving—was to provide a virtually endless epic of glory as the context for the great statue of Trajan towering on the column's top.

Hadrian himself chose to emulate Augustus and built a great circular mausoleum in which his ashes and those of the imperial family might lie. Augustus' tomb in the Campus Martius had served to bury his successors until the death of Nerva in AD 98. Hadrian's circular mausoleum on the right fork of the Tiber was to be the burial site of the Antonine and Severan emperors, before in later years it became the Papal fortress of Castel Sant' Angelo.[22] The pattern of an encircling enclosure—crucially a centralised building, whether a circle, an octagon, or even a cross—designed to function as part burial ground, part temple to a god, was to remain the model for commemorating imperial and royal death into the middle ages and beyond. Indeed, when Constantine's church builders sought an architecture to mark the ultimate of sacred tombs, the Holy Sepulchre where Jesus had been buried in Jerusalem, they too chose the circular form. In the later years of the pagan empire, for those emperors whose reigns did not end in ignominy, mausolea came to be institutionalized as special, personal tombs. In the case of the tetrarchs, these were located not in Rome but in the private villas to which they retired.

One of the main focal points of Diocletian's palace at Split is his mausoleum—an octagonal building whose lavishly ornamented interior of red granite and porphyry columns, niches, and carved friezes

The mausoleum of Diocletian, Split, c. AD 300–6.

An octagonal stone building with a domed circular chamber inside, Diocletian's mausoleum was lavishly adorned. In the interior, there are two tiers of columns imported from Egypt (the bottom of red granite, the top of alternating grey granite and porphyry), with two tiers of marble projecting orders rising from Corinthian capitals atop the pillars and with a stone frieze beneath the entablature of the second storey representing hunting scenes with erotes, garlands, and masks. On the exterior steps, leading up to the mausoleum, were placed a number of sphinxes of different-coloured stones also brought from Egypt.

was surmounted by a dome perhaps covered in mosaic [107].[23] In the inner chamber, probably, rather than in the crypt beneath, was placed the emperor's porphyry sarcophagus—much like those of Constantina and St Helena in Rome (see 9). Likewise, in Romuliana, modern Gamzigrad, in the palace which Galerius (emperor 293–311) constructed for his retirement, archaeologists have found the remains of two similar octagonal mausolea—of which the later probably housed Galerius' remains [108].[24] Other tetrarchs preferred circular tombs, like the round mausoleum built by Maxentius (emperor

Hypothetical reconstruction of the mausoleum of Galerius at Romuliana (modern Gamzigrad in eastern Serbia), the city where Galerius was born and which was renamed after his mother, Romula. Excavated in 1993 on the plateau outside the main palace of Romuliana, this mausoleum and a second (thought to be the burial place of Galerius' mother) were part of an impressive ceremonial complex including two tumuli c. AD 306–11.

0 1 2 3 4 5 METRES

Plan and reconstruction of the Mausoleum of Helena and the adjacent basilica of Saints Peter and Marcellinus, c. AD 330.

Chapel and catacombs

Basilica of Sts Peter and Marcellinus

Mausoleum of Helena

N

0 5 10 15 20 METRES

306–12) by his circus in a complex of buildings on the Via Appia outside Rome and the great mausoleum initially constructed by Galerius as part of the palace complex of his capital, Salonica.[25] This rotunda, whose interior walls were originally faced with marble panels and its dome with mosaic (like the later mausolea at Centcelles and of

110

The mausoleum of Sta
Costanza, exterior view, Rome,
c. AD 350.

Like most Constantinian
churches (and tetrarchic
buildings before them), Sta
Costanza is relatively simple
on the outside. Lavishness of
decoration and furnishings
were reserved for the interior.

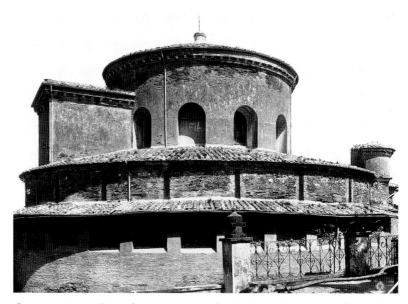

Constantina in Rome), remained unfinished on the emperor's death in
311 and in the event was never used. It is an irony of history that this
building and the mausoleum of Diocletian—the intended resting-
places of the great persecutors—have survived by being transformed
into Christian churches. In such enclosed semi-sacred structures, the
imperial death rites of pagan Rome took place.

These kinds of commemorative temple-tombs for the consecrated
imperial dead continued into Christian times, though now they were
built as chapels. The mausoleum by the Via Labicana in Rome, part of
the Constantinian complex of the basilica and catacombs of Sts
Marcellinus and Peter, was probably built for Constantine himself,
before he founded Constantinople [**109**]. It was in fact used for his
mother, Helena, and it was here that her sarcophagus was excavated.[26]
The circular chapel at Centcelles, near Tarragona in northern Spain,
was perhaps the mausoleum of Constantine's son, Constans, who was
emperor in the west from 337 to his death by murder in 350. The frag-
mentary but impressive mosaics in the dome combine Christian reli-
gious themes (such as Daniel in the lions' den and the Hebrews in the
fiery furnace) with secular subjects from élite aristocratic life, like
hunting.[27] The most remarkable surviving example of a fourth-century
imperial tomb is the mausoleum of Sta Costanza, attached to the basil-
ica of St Agnese on the Via Nomentana in Rome, and probably the
burial-place of one of Constantine's daughters [**110, 111**]. An impres-
sive circular building with a cupola lit by 12 clerestory windows, this
mausoleum housed the porphyry sarcophagus of Constantina. It still
retains some of its original fourth-century mosaics in the ambulatories,
depicting decorative and vintaging scenes in the great Classical tradi-
tion of Rome reaching back via Diocletian's baths to the baths of

111

The mausoleum of Sta
Costanza, interior view,
Rome, *c.* AD 350.

A dark, barrel-vaulted ambu-
latory running all the way
round this circular building
surrounds the domed centre,
which rises from an arcade
carried by 12 pairs of com-
posite columns. The centre
is flooded by light from the
12 cupola windows. The
original mosaics survive in
the ambulatory.

Caracalla [**112**], as well as two apses with Christian themes which are probably later additions. The cupola itself was adorned with a mosaic programme which apparently combined Christian and secular subjects like Centcelles, but which were destroyed in order to create a baroque decor in 1620.[28]

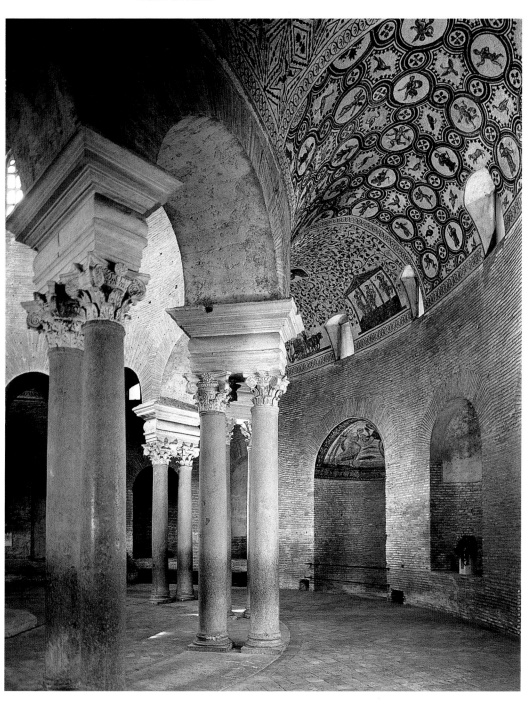

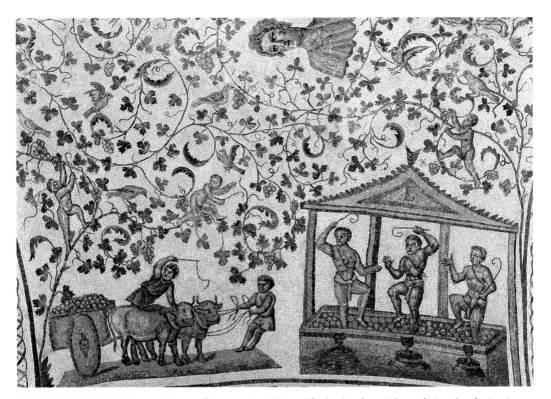

112

Detail of the ambulatory mosaics, mausoleum of Sta Costanza, Rome, c. AD 350.

The theme of vintaging children and cupids—originally borrowed from Dionsyiac cult—became widely popular in late antique religions and especially in Christianity, whose founder had declared 'I am the True Vine' (John 15: 1).

It was Constantine himself who broke with tradition by designing a new type of sacred mausoleum for his remains in the new capital, Constantinople. The Constantinian church of the Holy Apostles, which later became the burial site of the Byzantine emperors, was the only church in the city completed by Constantine's death. It was either cruciform in shape, its arms roughly of equal length on the plan of a Greek cross, or it was a circular mausoleum on the pattern espoused by Diocletian, Galerius, and Helena. Unlike the tetrarchic mausolea, it was not associated with a palace complex; but like Trajan's column, it broke with funerary norms by establishing this imperial tomb within the city walls. In fact the church of the Holy Apostles, by the Adrianople Gate of Constantinople, occupied the highest point within the walls. Beneath the central dome surrounded by shrines inscribed with the names of the 12 apostles themselves, Constantine—the thirteenth apostle—was laid in state in a sarcophagus in May or June 337.[29] It was, by any standards, a sumptuous mausoleum:

He had the church built to a vast height, and he decorated it splendidly with slabs of various colours which covered it from the foundation to the roof. And over the roof he put finely fretted work and overlaid it everywhere with gold. The outside portion, which protected the edifice from rainfall was of bronze rather than tiles, and this too gleamed with an abundance of gold. It brilliantly reflected the rays of the sun and dazzled the distant onlooker. A well-carved tracery of bronze and gold encircled the entire dome.[30]

No longer was the dead person simply encased in narratives—mythological, biographical or sacred—which elevated his life through association or allegory. Not for Constantine just a shared space in connection with earlier monarchs, or the scenes of scripture which graced the mausoleum mosaics at Centcelles and Rome; instead he was entombed as a saint among the apostles, as a relic among the most sacred relics of his new faith. Subsequent history was to turn the church into the grandest depository of sacred relics in Christendom, beginning with the arrival of the corporeal remains of St Timothy in 356, followed by Sts Andrew and Luke in 357. The church of the Holy Apostles established scriptural—or at least apostolic—Palestine in Byzantium; it constructed a sacred topography through reconstituting the chosen companions of Christ himself by collecting and displaying their physical remains. In the midst of this church-sized liturgical reliquary—presumably planned as such by Constantine himself—the emperor was buried, tying his remains in perpetuity to the sacred tradition of Christ's own successors. In terms of the political aesthetics of Constantine's reign, the Holy Apostles was the culmination of a process of embodying the emperor in the image of his predecessors which had been memorably inaugurated in the Arch of Constantine. But whereas in the Arch, Constantine had been aligned with (his very portrait carved into) the images of his most distinguished *imperial* precursors, in the church of the Holy Apostles he was entombed among the apostles themselves. The Holy Apostles created a new and immensely influential artistry of death. No longer was mere representation sufficient; sanctity depended upon the very presence of, the tangible access to, a sacredly endowed memento. The cult of relics, the bones and fragments whose very substance was like a physical doorway into the holy, had begun.[31]

Part III

Images and Transformation

Art and the Past: Antiquarian Eclecticism

Antiquarianism does not straightforwardly reveal the past; it always reinterprets it. Reproduction (whether in textual descriptions, visual evocations, or direct copies) is interpretation; to attempt historical, narrative, or archaeological accuracy is inevitably to transform. The remarkable feature of the period explored in this book was that this transformation, which ultimately reconfigured a pagan Classical culture into the Christian world of the early middle ages, took place through a series of repeated visual, literary, and conceptual meditations on the past. One might even say that the transfiguration of culture in late antiquity was the product not of rejecting the past in favour of something new, but of constantly reworking the past in a spirit of almost reverential respect until the new emerged from the process.

I shall argue in this chapter that this process of backward-looking interpretation was a most powerful means to transform Roman art from the pagan culture of the high empire to the world of early Christendom. The arts of the empire in the second and third centuries, in the period known as the Second Sophistic, became what they were by a comprehensive classicism, a deep antiquarian examination of the arts, rituals, and myths of the canonical Greek past. In the case of the visual arts, this classicism can be observed most clearly on two fronts: first, the forms of classical Greek art guide the choice of styles; second, Greek (rather than Roman) mythology inspires the subject matter. Throughout the era with which this book deals, the spirit of antiquarianism remained unabated. But, in late antiquity, the secure assurance that the canon of the Greek past provided the only privileged model on which to base the representations and self-identities of the present, was lost. While some continued to rely heavily on classicizing forms and pagan myths, others (especially the late emperors) turned to Roman state art to sanction the present by means of the glorious imperial tradition, while others still moved away from pagan mythological models to new religious paradigms—especially after 312 to Christianity. Christians developed a method (called Christian 'typology') of relating past to present, by using the stories of the Old Testament to prefigure or foreshadow the narrative of Christ's Incarnation and Passion.

Detail of 136

Marble statue of Discobolus, the Discus Thrower, from Rome, probably first half of the second century AD.

A copy of Myron's famous bronze original from the fifth century BC, this particular example—discovered on the Esquiline Hill in 1781—was the most celebrated Discobolus during the nineteenth and early twentieth centuries.

Classicism in the Second Sophistic

The Second Sophistic was a period of distinctive archaism in Graeco-Roman culture.[1] Not only was there a widespread interest in all things ancient from myth and history to monuments and art-works, but this antiquarian past was pursued and studied with an enthusiastic vitality both scholarly and amateur. Second-century men like the Greek-speaking travel-writer Pausanias dedicated large portions of their lives to visiting virtually every ancient statue and village in the famous parts of mainland Greece; and Pausanias himself recorded his findings for posterity. Others, like the essayist Lucian of Samosata or the orator Aelius Aristides, indulged in the literary equivalent of this topographic archaeology by referring assiduously to the canon of Classical literature and by composing their writings in an 'atticist' form of the Greek language which looked self-consciously back to the most elegant literary productions of the Classical era in the fifth and fourth centuries BC.[2] Broadly speaking, the revival of Greek culture in the second and third centuries AD (in every area from rhetoric to philosophy, from history to fiction, from the making of statues and paintings to the description and appreciation of art)—a revival so vigorous that it has been called a 'renaissance'—was also a transformation. The arts of the past, recapitulated in terms of present concerns and appropriated to current social and cultural needs, ceased to be what they had been and became something new.

On its most direct level, the visual equivalent of this transformative antiquarianism is the so-called 'Roman copy'.[3] Greek masterpieces by famous names of the Classical and Hellenistic eras were freely copied by the thousand and often quite radically transformed in the process by artists who may never have seen the original statues or paintings which their model books reproduced. Not only were the fine details of ancient sculptures transmuted in such modern adaptations, but their whole context of display and appreciation was changed, often profoundly altering the meanings which the original would have had in its original setting. Take this dialogue from an essay by Lucian, writing in the mid-second century AD:

'Have you not observed on coming in', said he, 'a very fine statue set up in the hall, the work of Demetrius, the maker of portrait statues?' 'Do you mean the discus-thrower', said I, 'the one bent over in the position of the throw, with his head turned back towards the hand that holds the discus, with one leg slightly bent, looking as if he would spring up all at once with the cast?' 'Not that one', said he, 'for that is one of Myron's works, the Discobolus you speak of. Neither do I mean the one beside it, the one binding his head with the fillet (the Diadoumenus), the handsome lad, for that is Polyclitus' work. Never mind those to the right as you come in, among which stand the tyrant-slayers, modelled by Critias and Nesiotes; but notice the one beside the fountain'[4]

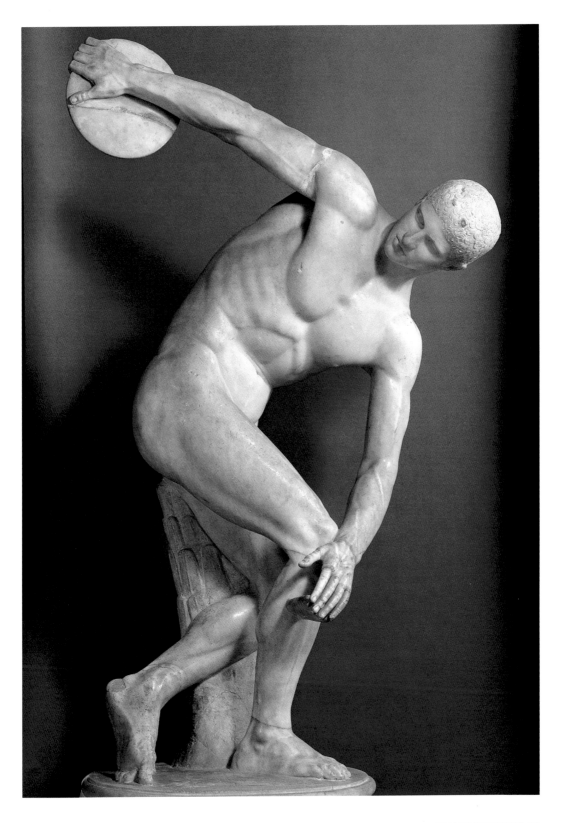

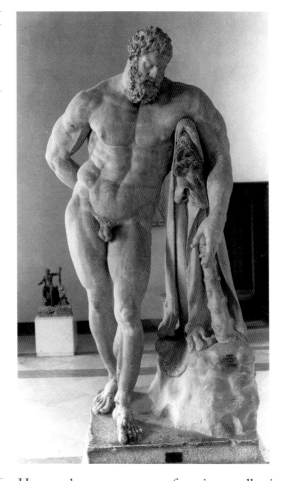

Here we have an account of a private collection displaying copies of some of the most famous sculptures of fifth-century BC Athens. They are placed together in the Graeco-Roman equivalent of a museum, depriving them of their individual status as sacred or civic dedications and turning them into representative specimens in the history of art. Not all viewers are equally sophisticated—one of the speakers here does not know that Myron rather than Demetrius made the famous Discobolus [**113**]—and indeed it was part of the function of such collections to allow their owners to display their knowledge and erudition. One reason, of course, for the error about the sculptor is that *this* Discobolus might indeed be the work of a contemporary artist called Demetrius: with Roman copies there is always an ambivalence about whether the actual modern sculptor or the original creator of the design should be credited as *the* artist. The famous Hercules from the Baths of Caracalla, for example [**114**], has an inscription proudly claiming it as the work of the artist Glycon, but is almost certainly an enlarged version of a statue by Lysippus, the court sculptor of Alexander the Great.

Academy

Rocca
Bruna

Canopus

Baths

Vesti-
bule

Baths

Piazza
D'Oro

Stadium

Triclinium

Poikile ('Percile')

Island
villa

Private suite
('libraries')

N

0 50 100 150 200 METRES

Panel from a floor mosaic, from Hadrian's Villa, Tivoli, third or fourth decade of the second century AD.

This small pastoral scene shows goats in a bucolic landscape with a brook over which a standing statue presides. Beneath the statue a painting—perhaps a votive dedication—has been left, which the goat in the centre is examining with obvious attention. The scene reflects and may even parody the settings of several romantic novels from antiquity (such as Longus' *Daphnis and Chloe*, and Achilles Tatius' *Leucippe and Clitophon*) which begin with descriptions of pictures displayed in sacred and occasionally pastoral settings. The novels' action develops as an apparent attempt to explore the meaning of the picture.

We owe the bulk of our knowledge of the development of Greek art to such copies, problematic though they are in reflecting what their prototypes actually looked like. For in addition to all the adaptations (in scale, medium, and form) of any replica, copies from the period of the Second Sophistic interpose a particular antiquarian idealization of the past on to their models. These images show fifth- or fourth-century BC art not as it was, but rather as it was desired to be in the Roman empire. Between original and copy stands a dream of the past as an ideal place. In part, the Second Sophistic's copying combined age-old Roman traditions of classicism and collecting with rose-tinted mythologizing nostalgia. Among the most famous of all surviving Roman sculptures are copies of this sort—such as the Apollo Belvedere [5], Glycon's Farnese Hercules [114], and the Discobolus [113]. This last statue, one of a number of surviving copies (many of them incorrectly restored in very different ways since the sixteenth century), shows the tell-tale signs of a copy: the tree-trunk support and the strut joining the left hand with the right leg demonstrate that this is a marble version of a bronze original. As can be seen, it has been rather well described by Lucian—although there is no guarantee that either the sculptor of this piece or Lucian himself had ever seen Myron's bronze original.[5]

The apogee of Second Sophistic monuments is the great villa constructed by Hadrian at Tivoli, near Rome [115].[6] Designed as the supreme imperial residence, the villa epitomizes the antiquarian eclecticism of the era. It possessed vast collections of statues and other art-

117

Marble statue of Aphrodite of Cnidos, from Hadrian's Villa at Tivoli, third or fourth decade of the second century AD.

A copy of the famous marble nude of the fourth century BC by Praxiteles, the statue originally showed Aphrodite drying herself after her bath and covering her private parts with her hand. Famous second-century variations on the Praxitelean theme include the Venus de' Medici and the Capitoline Venus.

works such as mosaics [**116**]—many of them copies of the canonical masterpieces of Classical art. It boasted complex architectural juxtapositions of pastiche versions of the empire's more exotic territories. And it displayed all this in the lavish grandeur of an imperial theme park. The villa was not only the literal hub of empire, in that it became Hadrian's favoured residence when he was in Rome, but it was also a showcase of a highly Hellenocentric selection of what the empire had to offer. In the words of Hadrian's biographer:

His villa at Tivoli was marvellously constructed, and he actually gave to parts of it the names of provinces and places of the greatest renown, calling them, for instance, the Lycaeum, the Academy, the Prytany, the Canopus, the Poecile, and Tempe. And in order not to omit anything, he even made a Hades.[7]

The villa was perceived as redeploying the treasures of empire in miniature; it reconstituted the empire under the special conditions of a museum's display, as it were. Hadrian was not merely amassing single sculptures (as was the collector in the passage from Lucian), he was collecting replicas of entire monuments.

The round temple of Venus at Tivoli, for example, is a replica of the famous temple of Aphrodite at Cnidos which was built in the Doric style in the fourth century BC. At the centre of the temple was a marble copy of the great cult image of Aphrodite made by Praxiteles which stood in the Cnidian temple and was renowned as the first and supreme female nude in Classical art [**117**]. Many were the stories of human passion excited by the original statue and retold with gusto by Graeco-Roman writers. In this case, the reflex of Hadrianic museology is to display the replica in a version of its original setting—to recreate not only the statue but the whole Cnidian temple as a viewing experience. In one sense, like the 'Greek temples' erected in English landscape gardens, the Tivoli replica remained a temple although it was no longer a ritual centre. But, by being reproduced and re-erected in a different context, the temple and its cult image were in many ways distanced from their original purpose and sanctity, desacralized— even desecrated—by their copying and appropriation into a setting of imperial leisure.

By contrast with the version of Praxiteles' Aphrodite, many of the other 'greatest hits' of the past—copies of such masterpieces as the Discobolus of Myron, the satyr of Praxiteles and the Crouching Aphrodite said to be by Doidalsas—were displayed in groups with other sculptures, like the similar collection of great works described by Lucian. Images like the copy of the Tyrannicides of Critios and Nesiotes said to have been found at Tivoli [**118**] or the fragments of Polyclitus' Doryphorus found in the Small Baths of Hadrian's Villa, were totally decontextualized by becoming items in the history and

The Tyrannicides, reportedly from Hadrian's Villa at Tivoli, second century AD.

This pair, a marble copy of a famous bronze group by the fifth-century BC sculptors Critios and Nesiotes, has been celebrated since the sixteenth century, during which it passed from the collection of the Medici to that of the Farnese family in Rome. The bearded head of Aristogiton is a plaster cast, the original being lost.

appreciation of Greek art by Roman connoisseurs, rather than the specific objects of dedication they had once been.

The Tyrannicides, a bronze statue pair set up in 477 BC depicting the lovers Harmodius and Aristogiton who had killed the tyrant Hipparchus in 514 BC, was one of the most famous monuments on the Athenian Acropolis, frequently mentioned in ancient writing on art.[8] In their Athenian context, they combined an effervescent public celebration of some particular features most characteristic of Athens—the politics of democracy and the practice of male homosexuality—with the then revolutionary artistic style of naturalism. In the Hadrianic context of civilized and antiquarian philhellenism, their democratic politics was pointedly dissipated in their status (and that of Greece itself) as a possession, while their sexual content was inevitably emphasized by comparison with the bearded Hadrian (e.g. **2**) and his youthful lover Antinous (see **123**) whose portrait was so conspicuous in the Villa and elsewhere. This statue group, now a marble replica resplendent in a second-century context, captures well the transformative nature and interpretative quality of Second Sophistic antiquarianism. The Tyrannicides are clearly a distinguished specimen in the heritage of the glorious past and the ancestry of the present. But that past is highly selective—preferably eliding issues less than useful to the interests of the imperial present (like democracy and freedom from tyrants) while proclaiming a genealogical linkage with modernity in the matter of 'Greek love'.

This accumulation of sculptures from many periods and parts of the empire transformed the geographic present and the heritage of the past; and so too did the architecture of the Villa. The so-called 'Canopus', with its long pool dominated at the southern end by a complex with a half-domed apse [**119**], may have been a monumental tourist souvenir recalling the exotic pleasure centre of Canopus near Alexandria in Egypt, or it may have been the site of a memorial cenotaph to Antinous who had been drowned in Egypt, or it may have been an elaborate dining area, or it may have been all three. Its profuse sculptural decoration included objects evoking Egypt (such as sculptures of a crocodile and the Nile), copies of famous Greek works (including the Caryatids from the Erechtheum in Athens and versions of the famous Amazons by Phidias and Polyclitus at Ephesus) and mythological monsters (such as Scylla).[9] While every individual element may have had a discrete geographic and historical provenance, the combination attested to the synthetic triumphalism of empire in allowing Hadrian to sample every flavour of his domains in the melting pot of his own palatial villa.

If the palace at Tivoli represents Second Sophistic classicism on the grand imperial scale, the same conflation of antiquarian exoticism with Roman luxury can be found in the great public dedications in the cities.

119

The so-called Canopus, from Hadrian's Villa at Tivoli, first half of the second century AD.

The mixture of sculpture, architecture, and landscape setting in this scenic canal captures well the aesthetic and spatial effects by which the Villa's designers sought to create a rustic paradise outside Rome.

In particular, the spectacular complexes constructed by the imperial family and leading aristocrats for public bathing were resplendent with magnificent mosaics, marbles, and sculptures.[10] Describing the baths of Claudius Etruscus in Rome, the poet Statius writing in the latter part of the first century AD, sings of 'baths that sparkle with bright marbles':

The doorways do not yield in splendour, the ceilings are radiant, the gables glitter with mosaics of pictured life . . . Nothing is common there, nowhere will you mark (mere) bronze, but from silver is the glad wave poured and into silver it falls.[11]

Even allowing for some rather florid poetic exaggeration, these baths were clearly a lavish affair—filled with the most expensive finishes and ornaments.

For a sense of the sculptural decoration of such buildings, take the Baths of Caracalla in Rome, built by the Severan emperors in the first third of the third century [**120**]. This huge complex, capped with virtuoso architectural flourishes including a dome virtually the span of the Pantheon and an elaborate groin-vaulted frigidarium,[12] boasted—in addition to splendid marble revetments and mosaic floors—a remarkable programme of sculptures both colossal and life-size.[13] These included the Farnese Hercules (so-called after the Renaissance collection into which it found its way), a statue nearly three and a quarter metres high, showing the almost grotesquely muscular hero resting after his 12 labours [**114**].[14] The statue was displayed between a wall and a column in the central hall of the main building of the baths, so that its meaning could become clear only after a visitor had seen it from both sides. Behind his back, Hercules carries the apples of the

Hesperides in his right hand. These were the object of his twelfth and most difficult labour—which explains both his weary demeanour and his presence in this building (that is, the need for a bath)!

Still more spectacular than the Hercules is the so-called Farnese Bull [121]—a colossal marble group the better part of 4 metres high and 3 metres square. This was possibly placed in an apse at the eastern end of the main building and was open to a long, unimpeded, view across the entire axis of the baths. The sculpture represents the culminating episode of the myth of Dirce, whose cruelty to Antiope was punished by Zethus and Amphion (Antiope's sons) tying her to a wild bull.[15] While the Hercules is a flamboyant remodelling by the Athenian Glycon of a Classical original by Lysippus, the Farnese Bull combines the themes of a mythological extravaganza with artistic conflations from a number of earlier visual prototypes and especially a late-Hellenistic version of the same theme. These sculptures—and the others especially commissioned for the Baths of Caracalla (some 40 have been excavated to date)—represent a high-quality programme of Classical exuberance, like those of Hadrian's Villa, but this time in the most publicly accessible of social venues. Both collections would remain important in future times: later emperors added their own statues to the Villa and the Baths of Caracalla, so that in the fourth century, for example, portraits of the emperors Valens and Valentinian were set up in the latter.

While Tivoli and the Baths of Caracalla demonstrate the extent and varieties of classicism on a public scale, very similar issues may be seen to pervade relatively less elevated schemes. A group of eight

120

Plan of the Baths of Caracalla, Rome, AD 212–16.

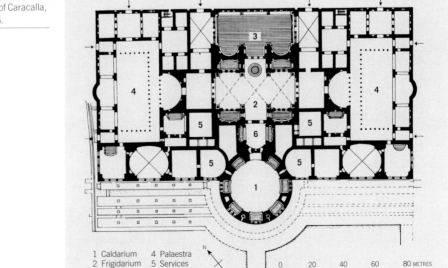

1 Caldarium 4 Palaestra
2 Frigidarium 5 Services
3 Natatio 6 Tepidarium

0 20 40 60 80 METRES

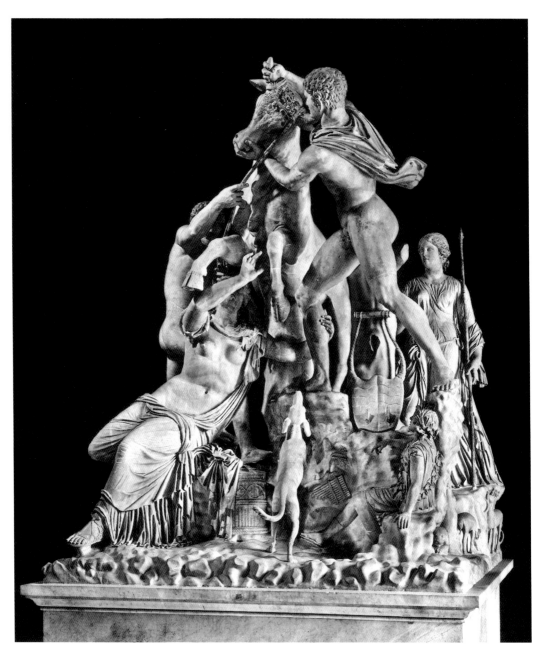

sculpted reliefs, excavated from a church floor in Rome during the seventeenth century, gives a good impression of a visual programme from the second century AD.[16] Known as the Spada reliefs after the palace in Rome where they are now displayed, the panels appear to have been made to be exhibited as pairs both in compositional terms and thematically. All represent scenes from Greek myths—usually seizing not upon the most violent or dramatic action but rather on a mood of tranquil contemplation. The different elements of each relief—figures,

121

The Punishment of Dirce,
marble group (3.7 m high),
known as the 'Farnese Bull',
from the Baths of Caracalla,
Rome, late second or early
third century AD.

This colossal group is thought
to be a free and enlarged
Roman copy of a Hellenistic
original of c.150 BC by
the artists Apollonius and
Tauriscus of Tralles which was
mentioned by the Elder Pliny.

landscape, and so forth—seem to be borrowed eclectically from the repertoire of Classical models. In a mythological relief, perhaps related to the Spada group and now in the Capitoline Museum [**122**], Perseus with his elegantly draped cloak is adapted from a late-Classical type of Hermes which seems derived from the work of Praxiteles, while Andromeda in her swirling draperies is a neo-Attic dancing girl, related to a lost fifth-century BC prototype of a dancing Maenad which was popular with Roman copyists.

Here we have not the direct copying of Greek masterpieces but a complex elaboration of varied references to canonical models. Reliefs, like the Perseus panel, are a collection of reworked prototypes, newly combined and embedded in a modern but backward-looking compositional form. Thus the Spada relief of Bellerophon brings to mind Polyclitus' Doryphorus, for example, while Diomedes in the relief of the theft of the Palladium is a copy of a statue-type attributed to the Greek sculptor Kresilas. But the finished panels are a fundamentally Roman, Second Sophistic, product—a creative transformation of the given models into idealizing antiquarian compositions with a romantic mood. The single vignette, in this case the movement of Perseus and Andromeda to their first embrace, comes to sum up the whole myth—so the beheaded sea-monster evokes the exertions by which the hero came to win his girl. Likewise, in his description of a statue of Narcissus gazing into the pool, the late Second Sophistic writer Callistratus evokes the tragedy of the whole myth in the single image:

In the nature of the eyes art had put an indication of grief, that the image might represent not only Narcissus but also his fate.[17]

Like the ancient novels with which they are contemporary, the references of these relief panels to the past (in their formal borrowings and mythological subject matter) are placed in a pastoral setting designed to be both distant from contemporary reality and—by that very distance—to allow a potential commentary on modern attitudes and ways of life, or on the mythical world they represent. In large part, these reliefs—like the sculptures in Hadrian's Villa at Tivoli or the Baths of Caracalla—work by presupposing a learned and cultivated spectator. Not only must the viewer be at home with the myths—deducing from the sea-monster's severed head and the rock, for instance, that this pair represents Perseus and Andromeda rather than any other mythological combination of lovers—but much of the frisson of such images must have come from the viewer's ability to recognize the models and allusions from which the scene is so deliberately constructed. Such art requires, in the words of Lucian 'not a poor spectator but a cultivated one, somebody who does not pass judgement only with his eyes, but also applies thought to what he sees'. Although Lucian is writing in this case of a programme of paintings, what he says

Marble relief panel of Perseus
and Andromeda, from Rome,
second century AD.

is equally applicable to programmes of sculpture: 'The accuracy of
the technique and the combination of antiquarian interest with the
instructive value of the themes are truly seductive and call for a culti-
vated observer.'[18]

A sense of what is implied by such sculptures or paintings for the
'cultivated observer' can be intimated from a number of superb
ekphraseis, or rhetorical descriptions, of paintings representing Perseus
and Andromeda dating from the second and third centuries, roughly
the period when our relief was carved. Lucian himself describes such a
painting (in fact a representation of the killing of the monster rather
than the union of the hero and heroine), commenting that 'the artist
has represented much in little'.[19] That 'much' is not only the rest of the
mythical narrative but also the sum of implications, identifications,
and fantasies which such mythological pictures allow viewers to read
into them. This eroticized account of the terrified Andromeda from
the description of a painting appears in Achilles Tatius' second-
century novel *Clitophon and Leucippe*:

There is a curious blend of beauty and terror on her face: fear appears on her
cheeks, but a bloomlike beauty rests in her eyes. Her cheeks are not quite per-
fectly pale, but brushed with a light red wash; nor is the flowering quality of
her eyes untouched by care—they seem like violets in the earliest stage of wilt-
ing. The artist had enhanced her beauty with this touch of lovely fear. Her
arms were spread against the rock, bound above her head by a manacle bolted
in the stone. Her hands hung loose at the wrist like clusters of grapes. The
colour of her arms shaded from pure white to livid and her fingers looked

dead. She was chained up waiting for death, wearing a wedding garment, adorned as a bride for Hades. Her robe reached the ground—the whitest of robes, delicately woven, like spider-web more than sheep's wool, or the airy threads that Indian women draw from the trees and weave into silk.[20]

Here the intense sexuality of the maiden laid out, tied up and powerless before the viewer's (and the sea-monster's) gaze is imbued with a male fantasy of death, terror, and rescue. While Achilles is never crude in his innuendoes, it is clear that the wispy draperies reveal more than they cover, that the bridal terror and the images of flowers and fruit about to wilt carry with them the voyeur's anticipation for a spectacle of ravishment, even of rape. In the Capitoline relief, the otherwise profuse draperies become virtually see-through and cling 'like spider-web' around Andromeda's breasts and thighs—displaying her erotic nudity full-frontal, even as they pretend to disguise it. As in Achilles' description, while the viewer within the panel is the apparent recipient of this erotic vision (Perseus, and in Achilles' case also the sea-monster), clearly the viewer whose pleasure Andromeda must satisfy is the one looking at the image.

In a description by Philostratus from the early third century AD, of a painting closer to our relief since 'the contest is already finished and the monster lies stretched out on the strand, weltering in streams of blood', the erotic gaze of Andromeda is more directly pointed towards Perseus:

Her beauty is enhanced by the circumstances of the moment; for she seems to be incredulous, her joy mingled with fear, and as she gazes at Perseus she begins to send a smile towards him.[21]

Likewise, Perseus 'lifts his chest, filled with breath through panting, and keeps his gaze upon the maiden'. Here, the viewer—like the viewer of the Capitoline panel—is offered the sight of lovers transfixed. It is uncertain whether the panting of the hero's chest is due to his exertions in slaying the monster or his anticipation at getting the girl! Clearly such paintings and sculptures were designed to allow a range of responses—symbolic, creative, voyeuristic—not strictly warranted by the scene depicted but rather implied by a knowledge of the mythological narrative, its literary sources, and other visual representations.

The qualities of the art we have been looking at—a sophisticated antiquarian classicism drawing on eclectic sources to demonstrate its scholarship, taste, and expertise—has been labelled 'nostalgic', 'romantic', even 'sentimental'. Certainly its focus on the past as a series of collectables to be replicated and reused is apparent not just in programmatic works like the Spada reliefs or Hadrian's Villa. Single objects exhibit these qualities of classicism—such as the statue of Antinous, Hadrian's lover, from Tivoli, showing him as Egyptian

Marble statue of Antinous in
Egyptian dress and posture,
from Hadrian's Villa at Tivoli,
AD c.130–38

This is one of numerous high-
quality portraits—many of
them from Tivoli and several in
Egyptian garb—of Hadrian's
favourite, who died in Egypt in
AD 130. They are usually dated
between his death and that of
Hadrian in 138, during which
time Hadrian established
several cults of Antinous.
It is quite possible, however,
that some of these statues
were made later in the second
century by adherents of the
Antinous cult.

pharaoh [123]. This combines traditional Egyptian form (in the stiff
pose, the rolled pieces of linen carried in both hands, the head-dress)
with the delicate naturalistic treatment of musculature and features
typical of Greek art. Equally, as we saw in the previous chapter, the
relief carvings on sarcophagi, which became popular in this period,
combine iconographies looking back to eclectic Greek prototypes but
add the potential allegory or commemoration which arises in a memo-
rial for the dead. A Hadrianic example from the Villa Albani shows
Hephaestus and Athena, accompanied by the four seasons and some
other personifications, offering armour to Achilles [124].[22] This high-
lights both a moment of personal glory sanctioned by the gods (since
this armour would bring Achilles everlasting fame as the killer of
Hector) and, at the same time, pinpoints Achilles' mortality through

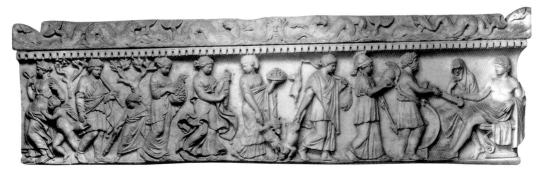

the seasons and the image of passing time. The mythological content, far removed from the actualities of the sarcophagus' Roman context, reflects suggestively on the life of the deceased as a glorious one and also upon the mortality of the viewer who contemplates this iconography on an object of burial.

The classicism of the sarcophagi takes us out of the world of expensive élite patronage evoked by the imperial palaces, imperially sponsored public buildings and the wealthy collections praised in the writings of Lucian and Philostratus. Sarcophagi, costly though they may have been, were accessible to a lower stratum of patrons who purchased their art ready made (or all but finished except for the addition of a portrait-head) at the sculptor's workshop. This is a very different way of commissioning art from ordering—perhaps even having a hand in designing—elaborate large-scale sculptural fantasies like the Farnese Bull or a quantity of thematically and compositionally related reliefs like the Spada panels. Nonetheless, these more private and humble monuments—not just sarcophagi, but also funerary reliefs and portrait statues—also indulged the vogue for antiquarian and classical allusion. There are a number of reliefs and statue-groups with figures in the guise of mythical heroes or canonical statues, such as a couple represented in a relief of about AD 200 as Venus and Mars [**125**]. Here individual portrait-heads have been added to images which conflate earlier models much like the Spada reliefs. The nude woman poses in a variation of the posture of the Hellenistic Venus of Capua, while the comparatively modest Roman draping of her husband—implicitly Mars to her Venus—suggests that this is a portrait of freedmen.[23] Such images, like those sarcophagi which were completed by adding portrait-heads of the deceased to the protagonists of the mythical action depicted, attempted to elevate the lives and status of the portrayed on to the level of mythical narrative. Nonetheless, there is a certain irony (perhaps lost on the commissioners and sculptors of this work) that this portrait of marital faithfulness in death uses the mythological paradigm of adulterous infidelity. The myth of Venus and Mars was famous precisely because Venus' husband, Vulcan, had caught the couple *in flagrante delicto*.

Marble relief portrait of a man and woman as Venus and Mars, perhaps from Rome, late second or early third century AD.

Classicism in the late empire

Far from being extinguished by the advent of Christianity, the classicism we have been exploring continued with powerful effect into late antiquity.[24] Impressive collections and single sculptures have been excavated from late-antique élite contexts in Rome and Ostia, in Aphrodisias in Asia Minor, in Antioch and Amman in the Middle East, in Alexandria and Carthage in Africa, and in Gaul. In these fourth- and fifth-century settings, examples of earlier sculpture, many restored in the late-Roman period and some presumably treasured antiques in their own right, were combined with extremely competent contemporary versions of classical prototypes; and occasionally fragmentary older works were conflated by late-Roman artists into a new pastiche.[25] We have already touched on some impressive collections and combinations of this sort—like the villa at Lullingstone in Kent, England, or that at Chiragan in southern France. The Chiragan collection of sculpture includes earlier imperial and private busts (often heavily restored in late antiquity), and a number of statuettes as well as

12 tondo busts and panels showing the labours of Hercules made in late antiquity [**72**].[26]

In many ways, the supreme embodiments of classical collecting by the fourth and fifth centuries were the capital cities, Constantinople and Rome itself, with its plethora of statues, reliefs, and buildings spanning at least five centuries.[27] Here is Ammianus Marcellinus' description of the reaction of Constantius II, Constantine's son, when he entered the eternal city for the first time during his *adventus* of AD 357:

When he had come to the Rostra, the most renowned Forum of ancient dominion, he stood amazed; and on every side on which his eyes rested he was dazzled by the array of marvellous sights. . . . He thought that whatever first met his gaze towered above all the rest: the sanctuaries of Tarpeian Jove so far surpassing as things divine excel those of the earth; the baths built up in the manner of provinces; the huge bulk of the amphitheatre, strengthened by its framework of Tiburtine stone, to whose top human eyesight barely ascends [i.e. the Colosseum]; the Pantheon like a rounded city district, vaulted over in lofty beauty; the exalted columns which rise with platforms to which one may mount, and bear the likenesses of former emperors [i.e. the columns of Trajan and Marcus] the Temple of the City, the Forum of Peace, the Theatre of Pompey, the Odeum, the Stadium, and amongst these the other adornments of the Eternal City. But when he came to the Forum of Trajan, a construction unique under the heavens, as we believe, and admirable even in the unanimous opinion of all the gods, he stood fast in amazement, turning his attention to the gigantic complex about him, beggaring description and never again to be imitated by mortal men.[28]

While this purple passage of imperial gasping captures somewhat hyperbolically the grandeur of Rome as a collection of venerable monuments *par excellence*, it is striking that many of the monuments it cites survive and remain canonical to this day. For Ammianus, Rome is already a museum city, a tourist's wonderland of history to be experienced as heritage and as art.

In the Forum, perhaps the supreme concentration of Rome's most venerable political art and statuary, Constantine raised his arch in the early fourth century (see **126** and also **1**). Its much discussed incorporation of pieces from earlier monuments—Trajanic [**53**], Hadrianic [**6**] and Aurelian [**12**]—parades the taste for eclectic visual antiquarianism, quite apart from the political impact of such appropriations, with the portrait of Constantine replacing the heads of his predecessors. The Arch of Constantine is, in this sense, still a monument deeply typical of the Second Sophistic, but with the interest in earlier models no longer focused on mythical narratives and famous statues from the Classical Greek past. Rather, the arch's typological reliance is transferred to the great monuments of Roman imperial history—to the arts which commemorated the glorious emperors before the third-century

Schematic plan of the
four faces of the Arch
of Constantine, with the
arrangement of the reliefs
and their sources, Rome,
c. AD 312–15.

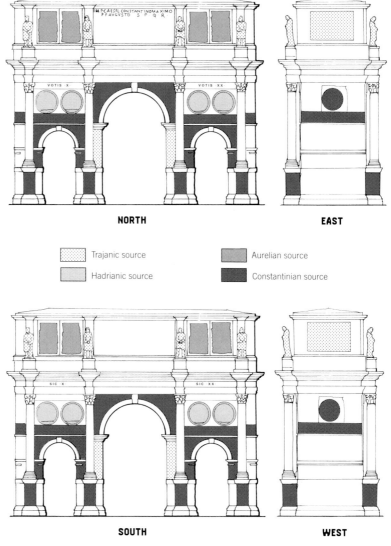

NORTH

EAST

Trajanic source

Hadrianic source

Aurelian source

Constantinian source

SOUTH

WEST

crisis, the emperors in whose purple Constantine himself was
enthroned. Thus Trajan on his charger [**53**] or Marcus Aurelius dis-
pensing justice [**12**] are the canonical models, the historically sanctified
prototypes for Constantine—just as Andromeda was cast as a dancing
Maenad and a Roman freedwoman could pose as Capuan Aphrodite.
One of the advantages of such typological eclecticism to the political
thrust of the arch was that the very stylistic variation of Constantine, in
his Trajanic, Hadrianic, Aurelian, and fourth-century appearances on
the monument, stood for the divinely sanctioned nature of his princip-
ate announced by the monumental inscription on both sides of the
arch, which referred to the 'impulse of divinity'.

 In creating the arch, Constantine and his designers were actively
dismantling a number of Rome's more distinguished imperial monu-

ments for their *spolia*. This process of collecting effectively by removal and demolition was hardly new, but it reached its zenith in the fourth and fifth centuries with the need to adorn Constantinople in the style befitting an imperial capital. In the words of St Jerome, 'Constantinople was dedicated by denuding virtually all the cities' in the Greek east of their antique statues.[29] We have seen how these pagan statues could prove somewhat embarrassing to a Christian apologist like Constantine's biographer, Bishop Eusebius (see above, p. 90). But the scruples of churchmen notwithstanding, the city's public places were filled with ancient monuments guaranteeing its heritage as the New Rome. In the Hippodrome, Constantine erected the sacred bronze tripods brought from the Temple of Apollo at Delphi as well as the statues of the Dioscuri whose temple had previously stood on the spot. Inside the Senate House, he placed the statues of the Muses from Mt Helicon, and in front of it the images of Zeus from Dodona and Athena from Lindos. The baths of Zeuxippus were the setting for some 80 statues, mainly antique bronzes, described in an extant poem (*Palatine Anthology*, book II).[30] These, like numerous collections from the preceding two centuries, mixed historical figures such as Pompey and Julius Caesar, with famous writers from Homer to Apuleius, orators such as Demosthenes and Aeschines, philosophers like Plato and Anaximenes, mythical characters like Hermaphroditus, Ajax, and Paris, and images of the pagan gods. In effect, an entire myth-historical past was manufactured through the collection, in the midst of which the populace of the Christian capital came to bathe.

Later emperors saw it as their duty to enlarge these collections— Constantius II (337–61) dedicated at least two ancient statues in the Hippodrome, while Theodosius II (408–50) added four bronze horses from Chios, possibly those removed by the Venetians and placed on the façade of San Marco. The most spectacular collection of fifth-century Constantinople was that assembled by Lausus, one of Theodosius' principal courtiers, in his private palace.[31] Its jewel was the chryselephantine (ivory and gold) statue of Zeus from Olympia, carved by Phidias in the fifth century BC and long regarded as one of the Seven Wonders of the World. But it included works by many of the greatest classical masters—not least Lysippus and Praxiteles, whose famous Aphrodite of Cnidos was one of Lausus' most exquisite marbles.[32] In this late-antique vogue for collecting, we witness a significant change from Hadrianic or Severan times. Once the religious scruples against removing a famous and perhaps miracle-working pagan cult deity from its temple (for purposes which were not in any way sacred) had vanished, with the advent of Christianity, all the classic objects themselves—however deeply they may have been identified with a specific sacred site, like Olympia or Cnidos—could be removed with impunity. While Hadrian's Villa or the Baths of Caracalla are

Ivory leaf from a diptych issued in the names of the Symmachi and Nicomachi families, Rome, last or penultimate decade of the fourth century AD.

The other leaf of this diptych also survives (in worse condition, in the Musée de Cluny, Paris). One of the most assured examples of late-antique classicism—erudite, stylistically self-conscious, framed by a lotus-palmette border—this object was commissioned under the auspices of families who formed a powerful pagan circle in Rome during the years when Christianity began to persecute paganism.

essentially accumulations of Roman copies and replicas of great works, the vast collections of fourth- and fifth-century Constantinople and Rome were packed with the great originals. They had become theme parks of the vanishing pagan past.

The urge to look backwards is as much the key to late-antique art as to that of the Second Sophistic. But by the dawn of the fourth century, the notions of *which* past to look back to were much less clear than in the times of Hadrian and Lucian, or Caracalla and Philostratus. Some still sought their models in the visual and mythological past of pagan antiquity, the grand tradition of the time-approved canon. Examples include the wonderful series of ivories and silver plates from the late fourth century which may well have been produced for the circle of wealthy pagan aristocrats who continued to dominate the Roman

The Corbridge lanx, rect-
angular silver dish, discovered
in Northumberland, second
half of the fourth century AD.

The lanx is solid cast, with
figures in low relief and the
decoration produced by
chasing and engraving.
An inscription on the back
records its weight in Roman
measure as 14 pounds,
3 ounces, and 2 scruples.
The place of manufacture
is unknown.

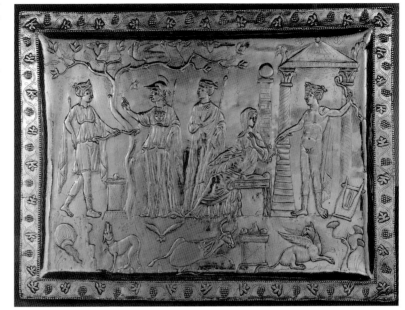

Senate [**127, 128**]. Others, in particular the emperors, appear to have
turned to the tradition of official state reliefs to ground their own posi-
tion in earlier imperial prototypes (as we saw above in the case of the
Arch of Constantine and in Chapter 3 with the columns of Theodosius
I and Arcadius). Most significantly, the Christians—who rapidly came
to dominate the empire during the fourth century—began to turn
away from pagan Greek mythology to a new past in which to base their
present, namely the Jewish myths which make up the Old Testament
and which were typologically interpreted as foreshadowing the life and
death of Christ. It was by the standards of the new sacred narrative of
the Incarnation and Resurrection that a good life and death were to be
judged in the present.

 Let us look briefly at this wealth of 'pasts', their uses and their allu-
sions in late-Roman art. The Symmachorum leaf [**127**] is from an
ivory diptych whose two leaves appear to celebrate an alliance of two
great pagan families in late-antique Rome, the Symmachi and the
Nicomachi.[33] The panel shows a priestess, executed in a cool classiciz-
ing style, in neo-Attic dress wearing a fillet and ivy wreath in her hair.
She appears to be making a Dionysiac offering by scattering incense
over a small fire at a country altar in the company of an attendant. Its
figures owe much to earlier types, especially Roman coins bearing the
image of Pietas. Made in the context of the Theodosian empire, with
its rigorous ban on pagan sacrifice implemented after 391, the ivory's
elegant Classical form reinforces the pagan emphasis of its icono-
graphy—which looks back to the religious practices at the heart of
paganism. It is no surprise that Quintus Aurelius Symmachus,
the head of his family and almost certainly one of those involved in

commissioning this panel, intervened with Theodosius when the latter attempted to remove pagan rites and altars in the city.

No less classical in either style or iconography, although perhaps less so in the force of its imagery, is the Corbridge lanx [**128**], a rectangular silver dish from the late fourth century found in the eighteenth century by the river Tyne in northern England.[34] Its iconography shows five figures in a sacred landscape including a nude Apollo, perhaps meant to be a cult image, standing with his bow in his hand and his lyre by his feet in front of a temple to the right, and Artemis and Athena by an altar and a tree to the left. The two female figures in the centre have not been convincingly identified, while the animals—a dog, stag, and griffin—seem to refer to the cult of Artemis and Apollo. It may be that there was a 'strong' pagan religious meaning to this obscure iconography—related to a particular text now lost, or to a specific cult promoted at the place where the lanx was made (Ephesus, Alexandria, and Delos have all been suggested). But it may equally be that the dish offers a vision of a generalized and now slowly evaporating classicism confined to the pastoral ambience of mythological conflations. Just as the iconography seems to combine elements from different sources (including what might have been a Judgement of Paris as the inspiration for the three central figures), so the subject matter may be creating its own mythological pastiche of diverse deities without a particular religious or even narrative theme.

While the Symmachorum ivory and the Corbridge lanx represent an assured combination of Classical style and subject matter (though perhaps with rather different investments in the pagan significance of their imagery), the dramatic Hylas panel [**129**] made in the *opus sectile* technique is much less naturalistic in style.[35] It comes from the secular basilica built on the Esquiline hill in Rome by Junius Bassus, consul in 331 (and father of the city prefect who commissioned an outstanding Christian sarcophagus in 359). Bassus' basilica was spectacularly decorated with mosaics made of sawn marble pieces—giving them an abstract and colourful effect. The panel shows the myth of Hylas, lover of Hercules, who went to fetch water by a pool and was drowned by the water nymphs who fell in love with him and pulled him in. Around the main scene is an Egyptianizing frieze in late-antique style. Whether the meanings of the image reflect some now-lost allegory about the soul and desire, or simply the characteristic urge to display learning and familiarity with both Greek mythological and Egyptian culture in the splendid public monument of a late Roman aristocrat is not now clear. The use of *opus sectile* became popular in this period not only in secular contexts but also for church ornament, as in the nave wall decoration over the arcade of the fifth-century basilica of Santa Sabina on the Aventine (see **151**) and the atrium walls of the fifth-century Lateran baptistery.

Opus sectile panels from the basilica of Junius Bassus, Rome, mid-fourth century AD. Made from sawn marble, hard stones, and glass paste. The upper panel shows the myth of Hylas being pulled into the water by the nymphs. Below are late-antique renderings of Egyptian motifs, which may be simply decorative or may have had a significance, in connection—for instance— with the motif of Hylas' death. The lower panel shows a procession of riders led by an aristocrat in a chariot drawn by white horses, perhaps a portrait of Junius Bassus himself. The right hand raised in a gesture of power, clenched as here or holding a *mappa* (white cloth), seems to have become a symbol of aristocratic prestige in the imagery of the fourth and fifth centuries, especially in sculpture and ivory.

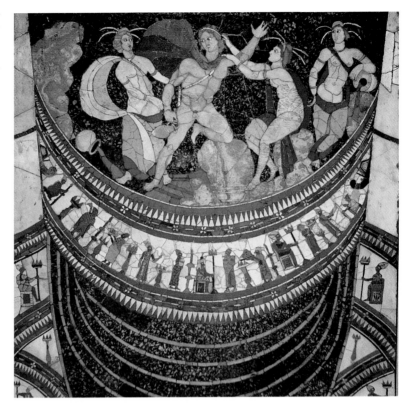

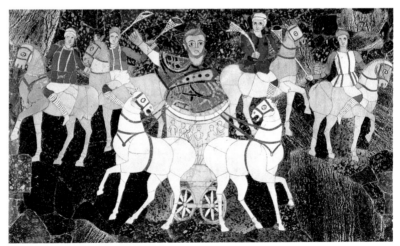

By contrast, just one generation later, Bassus' son—also called Junius Bassus—was buried in a superbly made two-tier sarcophagus carved in an assured classicizing style [**130**].[36] The upper edge of the sarcophagus is inscribed:

Junius Bassus, a man of the highest rank, who lived 42 years, 2 months, in his own prefecture of the city, newly baptized, went to God, the 8th day from the Kalends of September, Eusebius and Hypatius being consuls [25 August 359].

Marble 'columnar' sarcophagus of Junius Bassus, from Rome, AD 359.

A virtuoso piece, decorated in deep-cut relief in two tiers (there is some restoration). The individual scenes are placed between the columns, except for the confrontation of Christ and Pilate which occupies the two inter-columniations at the top right. The two central scenes, which signal the triumph of Christ before his death (below, the advent into Jerusalem) and after (above, the presentation of the law to Peter and Paul), are marked as special by the columns on either side which depict Cupids vintaging, while the remaining columns have spiral strigilation.

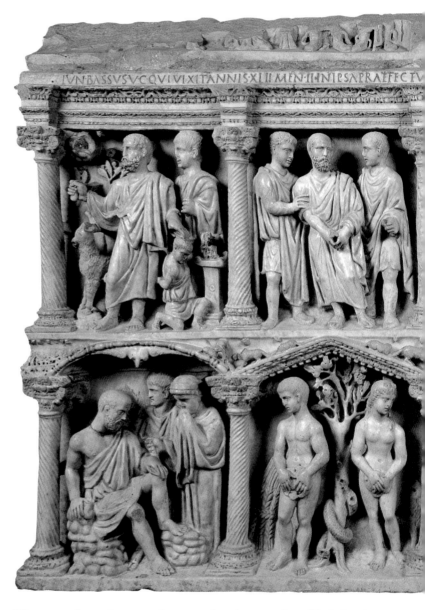

The sarcophagus' scenes show an already maturing Christian icono-graphy with a series of Christian 'pasts' evoked in its complex array of images. In the centre of each register are images of Christ in glory—above, Christ enthroned over a representation of the world, giving the law to Peter and Paul, the two Biblical Roman martyrs whose tombs

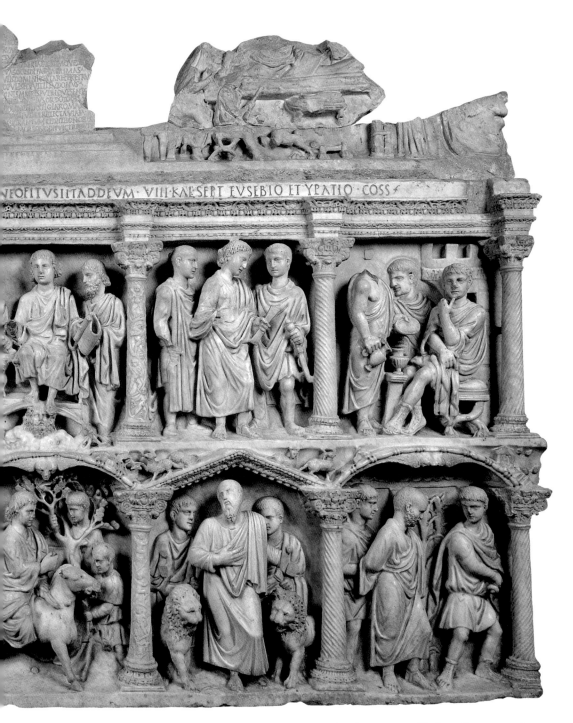

were already attracting pilgrims by the 350s; and below, Jesus entering
Jerusalem in triumph on Palm Sunday a week before the Crucifixion.
On the upper register, to the left of Christ are the Sacrifice of Isaac, an
Old Testament prefiguration of the Passion and Sacrifice of Christ,
and beside it the arrest of St Peter, who would be crucified in imitation

of Christ in Rome. To the right are the arrest of Christ himself and his trial before Pilate. In the lower register, to the left are scenes of Job in distress and Adam and Eve in the Garden of Eden, Old Testament examples of man's fall and even—in the case of Job—of man's testing by God; on the right are Daniel in the lions' den (the central figure here has wrongly been restored as a Christian saint), a typological foreshadowing of the Resurrection itself, and the arrest of St Paul, the other great scriptural saint martyred in Rome as a witness to the Incarnation.

For our purposes, what matters here is the complex interplay of different 'times'—the actual and very precisely recorded time of Junius Bassus' baptism and death in August 359; the Old Testament past which is four times made to prefigure, prophesy, and explain the narrative of Christ's Passion on the sarcophagus; the story of Christ (the time when God was incarnate upon earth)—his arrest, implying the whole Passion narrative, and his triumphs both before death in the entry to Jerusalem and after death in his enthronement as lord of all the world; and finally the time of the Roman martyrs—whose arrests imitate that of Christ and whose deaths stood for the death and persecution of all Christians in the centuries up to 312, just before Bassus himself was born in 317. These 'pasts' are further complicated by the somewhat syncretistic imagery on the sarcophagus' two ends which depict the seasons, and the fragmentary scene on the lid which appears to show a funerary meal for the dead in the manner of second-century Roman grave monuments. In addition, there are six somewhat damaged scenes in the spandrels of the arches of the lower register which appear to represent Old and New Testament themes with lambs in the place of persons. In effect, the Junius Bassus sarcophagus, admittedly the masterpiece of its genre, offers us a vision of the whole Christian world-view which incorporates and transforms certain elements from earlier antiquity (notably the cult of the dead and the kinds of seasonal imagery we saw in the second-century Villa Albani sarcophagus, **124**) but which pointedly ignores the sorts of references to pagan myth and ritual popular in the pre-Christian period and also in many fourth-century works like the Corbridge lanx or Symmachorum ivory.

The Junius Bassus sarcophagus *is* antiquarian, not only in style, but also in its constant reference to times before the present—to the Rome of Peter and Paul, the narrative of the Incarnation and the past of the Old Testament. Moreover, its antiquarianism is particularly slanted towards Rome by emphasizing both the political position of Bassus as city prefect and the Christian history of the city reaching back to the apostolic missions of Paul and Peter. Although the range of Christian 'pasts' and the dynamics of Christian typology as demonstrated by the Bassus sarcophagus are, generally speaking , more complex and sophisticated than those offered by pagan art (in part because Christian texts

offered such a rich basis for this kind of interpretation), none the less they are not significantly different in kind or method from the political typology of the Arch of Constantine or the backward-looking allusion of, say, the Corbridge lanx. Yet, the contrast with the kinds of past evoked by the art sponsored by Bassus' younger pagan contemporaries like Symmachus, or by his father's basilica, could not be more pointed. What has changed is not the passion for nostalgic antiquarianism, but rather the vision of the paradigmatic past to which the spirit of classicism is directed.

We can get some sense of the difference which this change of vision made by comparing the antiquarianism of such Christian monuments with, say, that of Pausanias in the second century AD. Pausanias travelled through mainland Greece, looking at temples, images, and famous sites. In every place the myths, the literature, and the history of a canonical Classical past were alive—vibrantly recalled in the stories told to him by local guides and in the rituals enacted throughout the countryside. Pausanias' Greece was an enchanted land where the grandeur of the past and the sanctity of the local gods were made present in every footstep and evoked in every statue.[37] For the commissioners of the Junius Bassus sarcophagus, that world was dead. They turned to a totally different past—the sacred history of the Jews, whose great events had taken place on the periphery of the empire in Palestine. They emphasized one story above all others—a miracle narrative of a semi-mythical holy man whom they believed to be the son of God. And—having erased totally the relevance of all the local myths so prized by the culture of Pausanias—they had to make their stories locally meaningful in terms of Christian narratives of martyrdom and conversion. The Bassus sarcophagus is as local in its focus as any object confronted by Pausanias, but its Rome is that of Peter and Paul (and by extension all the martyrs and confessors). The achievement of such a transformed vision of the world in so short a time is little short of astonishing.

Art and Religion

8

An epoch of transformation

In no area over the period which this book treats, save for the visual arts themselves, was the transformation of Roman culture so acute and so profound as in religion. The most obvious and dramatic change was Constantine's affirmation in 312 of the beliefs of a persecuted sect. The establishment of Christianity in material, administrative, and even theological terms (and not least in Constantine's sponsorship of Christian art and architecture), was so overwhelming that by the end of the fourth century a minority cult had become the official religion of the empire. But—as with the changes in the visual arts—the ground for this signal transfiguration of Roman culture was long in the preparing in pagan times. The second century already saw a move from a monopolistic situation in which Romans shared a common and generally accepted civic religion towards what has been termed a 'market place' in which religious adherence to one or other of a number of cults became a matter of debate, anxiety, even doubt. The broad pluralism, which had enabled Roman religion in the Republic and early Empire to accept the gods and convictions of conquered foreigners, moved towards a system of interacting and competing cults between which individuals could choose, while at the same time (except in the unusual case of Jews and Christians) not rejecting the broad banner of civic ritual and imperial cult.[1]

While distinctly nuanced from city to city, the imperial cult acted as a religious unifier, bringing together the followers of all the empire's diverse gods (once again except for the uniquely monotheistic Christians and Jews) in a series of civic rituals which affirmed the state's well-being and that of its ruler.[2] At the heart of the imperial cult, as the divinity made visible and appeasable, stood the remarkably standardized image of the god-emperor, sometimes erected in his lifetime—as in the case of the statue inscribed 'the god Hadrian' from the imperial cult room in the sanctuary of Asclepius at Pergamon [131].[3] Represented in divine nudity, but not yet divested of the military cloak and armour of monarchic imperium, this image—probably the recipient of sacrifices and rituals (such as clothing or crowning) as well as a focus for appeals and petitions—brought the sacred charisma of the centre

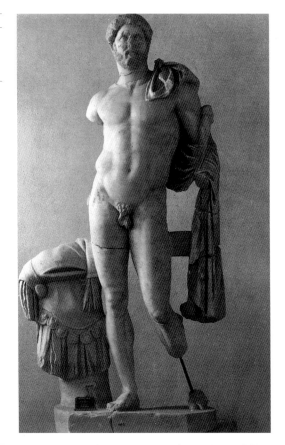

into the city of Pergamon in Asia Minor. The imperial cult was thus an add-on to the multiple and manifold religions of Roman polytheism, which served to bind centre and periphery in a shared universalism in which all parts and social spectra of the empire united before the presence of its divine ruler's charisma.[4]

Just as the centre strove to bind the provinces through a universalizing imperial cult, so during the second and third centuries, the various cults of the provinces—from the established civic religions which had flourished for centuries in specific locales (like the worship of Artemis of Ephesus) to the mystic fringe (like the worship of mystery gods from Isis, Dionysus, and Mithras to Jesus Christ)—also took on universalist claims and pretensions, such as the offer of salvation.[5] It was precisely these claims by different religious groups that led to the atmosphere of conflictive, competitive, and creative religious pluralism in the later empire, with each cult making ever-increasing demands on its adherents and offering ever-deeper levels of spiritual identity. Different cults put their wares on the table, as it were, offering (through initiations, sacred images, and allegorical mythologies) different kinds of spiritual identity to their followers—identities which could be broadly supportive of the imperial system, only ambivalently so, or downright

133

Gold coin of Elagabalus, minted at Antioch, c. AD 218–19.

The obverse shows Elagabalus, who was only 13 when he obtained the purple in 218. He is beardless to indicate his youth. The reverse of this coin shows the triumphal car drawn by four horses which carries the conical stone idol of Elagabalus' Baal, protected by four parasols. As in Herodian's description, no human being holds the chariot-reins.

resistant.[6] It is a potent irony that Christianity—the most explicitly resistant of all the cults—should (like the proverbial poacher turned gamekeeper) ultimately supplant the pagan religion of the centre and become itself the official cult.

In the third century, with the collapse of dynastic continuity and political order, the imperial cult appears to have become severely undermined at precisely the point when a focalizing universalism affirming unity and salvation from chaos was most needed. While second-century rulers like Commodus had already attempted to boost their sacred charisma by masquerading as deities, succeeding emperors in the third century tried to bolster the entire religio-political system with the introduction of a succession of supreme gods, to whom all other deities were subordinate. A bust of Commodus from Rome, dating to about 190, shows the emperor in the guise of Hercules—with a club and lion skin—having just completed his great labour of fetching the apples of the Hesperides, which he displays in his left hand [**132**].[7] The cornucopiae beneath the imperial bust and the orb with its signs of the zodiac refer to the cosmic majesty and fruitful reign of this Hercules, while the kneeling Amazon is a defeated foe—conquered by Hercules in myth but also standing for the barbarians over whom emperors conventionally triumphed. This kind of personal interpenetration of emperor and Olympian deity—so that one cannot know if it is Commodus dressed up as Hercules or Hercules embodied in Commodus—was relatively conservative beside the attempt by Elagabalus, the Syrian priest of Baal who reigned from 218 to 222, to subordinate the whole of Rome's pantheon to a foreign god.[8]

Here is how Herodian, a contemporary of Elagabalus, describes the emperor's attempts in Rome to establish the supremacy of his god, a large conical black stone from Emesa in Phoenicia [**133**]:

> The god was set up in a chariot studded with gold and precious stones and driven from the city to the suburb. The chariot was drawn by a team of six large, pure white horses which had been decorated with lots of gold and ornamented discs. No human person ever sat in the chariot or held the reins, which were fastened to the god as though he were driving himself. Elagabalus ran along in front of the chariot, but facing backwards as he ran looking at the god and holding the bridles of his horses. . . . Along both sides of the route people ran with a great array of torches, showering wreathes and flowers on him. In the procession, in front of the god, went images of all the other gods and valuable or precious temple dedications and all the imperial standards or costly heirlooms. Also the cavalry and all the army joined in. After the god had been conducted and installed in the temple, the emperor carried out the festival sacrifices . . .[9]

In the 220s, Elagabalus tried and failed to foist Baal on a reluctant Rome. In the 270s, Aurelian (the Illyrian soldier who reigned from 270–5) attempted to establish Sol Invictus as the supreme deity. Under

the tetrarchs, Diocletian transformed the cults of Jove and Hercules to support the imperial positions of the two senior members of the ruling quartet, the Augusti. In the mid-fourth century, in direct retaliation against Christianity, Julian the Apostate (sole emperor 361–3) attempted to promulgate a new paganism centred on Helios-Mithras.[10] But ultimately it was to be Constantine's brilliant espousal of the mystery religion of Jesus Christ—a rare blend (by ancient standards) of initiation, monotheism, scripture, and revelation—which transformed the Roman state by imparting to its citizens the intense feelings of an exclusive identity associated with a mystic cult.[11]

Image and ritual in traditional religion

Images were at the centre of traditional religion in the Graeco-Roman world. They were less aesthetic masterpieces (though some were regarded as great works of art) than sacred objects, like Elagabalus' black stone, which could be dressed, touched, and paraded, which could be offered votive dedications and sacrifices, which were to be worshipped since in a profound sense they shared an identity with the god in whose image they stood. Out of hundreds of examples in the pilgrimage through Greece described by Pausanias in the latter part of the second century, take the sanctuary of Asclepius at Titane:

One cannot tell of what wood or metal the image is, nor do they know the name of the maker. . . . Of the image only the face, hands and feet can be seen, for it wears a tunic of white wool and a cloak. There is a similar image of Health; this too, one cannot see easily because it is so surrounded with locks of women's hair, which the women cut off and offer to the goddess, and with strips of Babylonian raiment.[12]

These images, covered by clothes and votive offerings, can hardly be seen. They matter for Pausanias not because of their artists (who are unknown) nor for their materials (which cannot be discovered) but for their place at the centre of a sacred world of pilgrimage and ritual, of festival and initiation, of dreams, taboos, and cures.[13] The rituals surrounding images and temple sanctuaries were multifarious and varied in their details. Of Bryseae in Laconia, Pausanias writes:

There still remains here a temple of Dionysus with an image in the open. But the statue in the temple only women may see, for women by themselves perform the sacrificial rites in secret.[14]

By contrast, in the sanctuary of the Syrian Goddess at Aegeira in Achaea, he tells us that the taboos relate not to gender and secrecy, but to special days and special restrictions on food:

They enter on stated days, but must submit beforehand to certain customary purifications, especially in the matter of food.[15]

The so-called 'beautiful Artemis', marble copy of the cult statue of Artemis of Ephesus, found in Ephesus, first quarter of the second century AD.

At the great temple of Artemis in Ephesus, according to Pausanias' contemporary, the novelist Achilles Tatius, the sacred prohibitions affect not only gender but also issues of virginity and whether a pilgrim was born free or a slave:

From ancient days, the temple has been forbidden to free women who were not virgins. Only men and virgins were permitted here. If a non-virgin woman passed inside, the penalty was death, unless she was a slave.[16]

The great statue of Ephesian Artemis, which survives in over a hundred ancient replicas and copies made in antiquity, was an image famous for her special status as palladium of the city of the Ephesians, rather than for the artistry of her making [44, 134]. The original statue was made of wood (blackened over the years by anointing with oil)—but only the face, feet, and hands were visible (like those of Asclepius at Titane) through a mass of robes adorned with talismanic images and symbols. On her body, the goddess wore a mummy-shaped cover adorned with winged beasts including lions, stags, griffins, bulls, and sphinxes, as well as rosettes and bees. On her chest, was a wreath of flowers, a zodiac, and a representation of four Nikes (victory figures)—alluding to her cosmological and triumphal qualities. Most controversially, she boasted a series of oval pendants which have variously and inconclusively been identified as breasts, eggs, or bulls' scrota.[17] This particular version, probably made in Trajanic times and found in 1956

in Ephesus itself, is one of the most beautiful surviving life-size replicas. We know from a number of ancient sources that processions, like that sponsored by Caius Vibius Salutaris (see p. 58), and other rituals served to tie the image (located in one of antiquity's grandest temples on the outskirts of the city) into the process of urban life and the foundation myths of Ephesus.[18]

Underpinning this ritual life of sacred images, was the conviction that the statue did not just represent the deity but was—at least on some level—identical with the god.[19] Ancient statues, acting as the divine figures they embodied, could thus intervene miraculously in the ordinary world of their worshippers' experience—providing cures, prophesies, and meaningful dreams. Pausanias' contemporary, the famous orator Aelius Aristides (AD 117–c.185), who was a frequent pilgrim to the healing shrines of Asclepius (like the one Pausanias visited at Titane),[20] reports many dreams during which Asclepius and other gods—appearing often in the forms of their statues—provided him with (at least temporary) alleviation of his physical ills. For example,

It seemed to me that Serapis, in the form of his seated statues, took some form of lancet, and made an incision around my face, going somehow under the gum itself in the root of the lips, as it were, removing and purging refuse and changing it to its proper state.[21]

Such an example of divine dentistry through dreaming was possible because of the vivid and precise way ancient devotees *saw* their sacred images. In his handbook to the interpretation of dreams (the *Oneirocritica*), Artemidorus of Daldis—another writer of the second century—insists that (at least for the dreamer seeking the significance of his or her vision) 'statues of the gods have the same meaning as the gods themselves'. The dreamer, if he or she is to interpret the vision correctly, must be acutely aware of the visual details and attributes of the image perceived in the dream:

Statues that are fashioned from a substance that is hard and incorruptible as, for example, those that are made of gold, silver, bronze, ivory, stone, amber or ebony are auspicious. Statues fashioned from any other material as, for example, those that are made from terracotta, clay, plaster or wax, those that are painted, and the like, are less auspicious and often even inauspicious.[22]

To grasp the meaning of the dream, the dreamer had to look and to remember with a remarkable precision.

Mystery cults and new religions: art and the construction of identity

Graeco-Roman religion, though its temples were filled with inscriptions, was (with the exception of Judaism and Christianity) not scriptural. Gods were, to a large extent, defined by their images and their

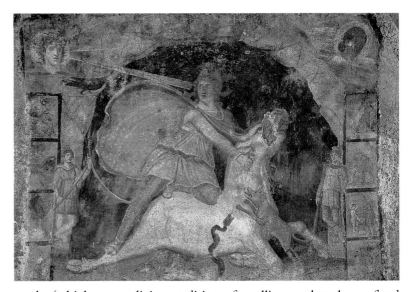

Mithras kills the bull at the entrance of a vaulted grotto. A snake and dog lick the blood, while a scorpion (now rather damaged) clasps the bull's testicles; the bull's tail ends in a sprig of corn. To the left and right are busts of the sun and moon, with the Mithraic torch-bearers, Cautes and Cautopates, beneath. In the panels on the sides are eight small scenes representing aspects of Mithraic mythology.

myths (which were a living tradition of retellings rather than a fixed scripture). In this sense, ancient religion was hardly theological. Except for relatively rare philosophical meditations on the meaning and nature of the gods, the peoples of antiquity tended to appease the higher powers with rituals, pilgrimages, and dedications without worrying too much about what those higher powers were, or how they should best be understood. Art did not provide a commentary on religion, it *was* religion; the statue of Artemis of the Ephesians was not just an image of Artemis or a particular interpretation of her, on the contrary, she *was* the goddess. When gods like the Ephesian Artemis or Elagabalus' Baal of Emesa, closely associated with particular civic communities or temples, travelled through the empire, they did so by means of their images—either the originals (as in the case of Elagabalus' Syrian deity) or through a diffusion of copies and replicas. Such copies—for example statues of Artemis of the Ephesians—provided a focus (say, in Rome, at Lepcis Magna, or in mainland Greece) for the worship of a deity whose full meaning could not be separated from the original city whence she came.[23]

In the so-called Oriental cults, which became so popular in the later second and third centuries,[24] images maintained their role of defining the identity, the meaning, even the 'theology' of the god and his mysteries. In part, the visual meanings of the mystery gods and their sanctuaries were established by their radical differentiation from the norms of Graeco-Roman religious practice and its representation.[25] When Mithras kills the bull, for example, in a cult icon repeated in dozens of Mithraic temples from Syria to Britain, he stabs him in the neck with a knife—quite unlike the traditional norms of bull sacrifice [135]. He wears Phrygian dress, drawing attention to the Oriental origins claimed by his cult and paraded by his Persian name. The bull's blood is

lapped up by a group of symbolic animals—a snake and a dog—with a scorpion clutching the bull's testicles. None of this reflects the actualities of ancient sacrifice or the norms of its representation: it is an icon constructed for a symbolic and mystical system accessible only to those initiated into the Mithraic mysteries.[26] Almost no texts, and certainly no sculptures, survive from Mithraism—making it highly likely that none existed. Like the majority of Graeco-Roman religions, its tenets, initiations, and sacred myths were oral. What made a Mithras sanctuary recognizable was its visual coding and decoration, its particular architectural form, the stereotypical nature of the imagery. It is, indeed, quite possible that actual religious practices and beliefs varied radically between mithraea in, say, Ostia, Dura Europos in Syria [140] and in the military camps on the German frontier or at Hadrian's Wall. In this case, it was the art that made the totalities of these different local cults into a recognizable religion.

136

The Parabiago plate, silver with gilding, found in northern Italy, variously dated from the second century to the late fourth century AD with the latter perhaps the most likely.

The plate, with a diameter of 0.31 m, is cast in high relief with gilding and engraving of excellent quality.

Marble relief of L. Lartius
Anthus, a priest of Ma-
Bellona, from Rome, probably
early third century AD.

L·LARTIO·ANTHO·CISTOPHO
RO·AEDIS·BELLONAE·PVLVINENSIS
FECIT·COVINTIVS·RVFINVS·FRATRI·ET
DOMINO·SVO·PIENTISSIMO·CVI·ET·
MONVMENTVM·FECIT·INTERIVS·AG
RO·APOLLINIS·ARGENTEI·QVINTIVS
RVFINVS

What Mithras shared with an ancient established civic deity like Ephesian Artemis was an empire-wide propagation through images, a distinct foreignness (by Roman standards) implied by the oddity and symbolism of iconography, and a claim to universal or cosmological significance through the use of astrological imagery.[27] What was different about Mithras was his novelty, as a newly created god adapted from the Persian Mithra some time in the first or second century, and the fact that there was no specific place of origin (no temple at Ephesus) where the central cult icon was kept. Indeed, unlike Artemis or Elagabalus' Baal, there was no archetypal image in which the deity was embodied. Like Jesus, Mithras could be omnipresent. He was equally present in all his images.

Mithraism was only one of numerous cults. From the east, the Roman empire was permeated by the religions of Dionysus, Jupiter Dolichenus, Cybele and Attis, Isis and Serapis, and numerous others—not least, Jesus Christ. Like Mithraism, the meanings of these cults were ultimately comprehensible only to initiates, and their imagery (through which we know them best) was often constructed in opposition to that of traditional Roman practice. A silver-gilt dish found at Parabiago in northern Italy [**136**] shows Cybele, the Great Mother, and Attis, her youthful paramour whose tragedy was self-castration.[28] Attis wears a Phrygian cap, like Mithras, and the two ride together in a quadriga drawn by lions towards the right. The visual field is crowded with images: the sun and moon at the top; earth, ocean, and the seasons below; the top half of a figure of Atlas holding up an elliptical ring with a standing youth inside it on which the zodiac is engraved; a three-stepped base with an obelisk entwined by a snake to the right. Like the cult image of Mithras killing the bull, this scene seems overdetermined with symbolic imagery professing grand cosmic claims and hidden meanings. Much hinges on (the still controversial matter of) the plate's date: if it is second or third century, then it is most likely that its subject matter represents a religious iconography steeped in the symbols of initiation. If it is fourth or fifth century (as is perhaps more likely), then—like the Corbridge lanx [**128**]—it may be an amalgamation of once-potent sacred imagery designed to evoke the fast-vanishing Classical past and the culture of pagan *paideia* in an already Christian cultural context.

Just as art marked out the identities of gods, so it defined their worshippers and priests. In a relief discovered near Rome, thought to date from the early third century, L. Lartius Anthus, as a priest of Ma-Bellona (a conflation of the old Roman war-goddess Bellona with the Cappadocian goddess Ma), is shown dancing ecstatically with whip and double axes (for self-flagellation), long hair, and rolling eyes [**137**].[29] His dress, wreath adorned with medallions of deities and gold torque—as well as his instruments of self-mutilation—all accord with representations of the galli, castrate followers of a number of eastern cults including those of Cybele (imitating Attis' self-castration) and the Syrian goddess. Describing the galli at the great Fire festival in the main sanctuary of the Syrian goddess (at Hierapolis or Mabbug in Phoenicia), the second-century Syrian writer Lucian says the following:

They cut their arms and beat one another on the back. Many stand about them playing flutes, while many others beat drums. Still others sing inspired and sacred songs. . . . On these days too men become galli. For while the rest are playing flutes and performing the rites, frenzy comes upon many, and many who have simply come to watch subsequently perform this act. . . . The youth for whom these things lie in store throws off his clothes, rushes to the centre

and takes up a sword which has stood there, I believe, for this purpose for many years. He grabs it and immediately castrates himself. Then he rushes through the city holding in his hands the parts he has cut off. He takes female clothing and women's adornment from whatever house he throws these parts into.[30]

This grand relief, now in the Capitoline Museum, was probably a funerary commemoration. It vividly marks the way Anthus' identity as a Roman (proclaimed both by the inscription and the very act of setting up this kind of memorial) has become fused with a very unRoman sense of self, generated through cult adherence to an ecstatic religion from the east. While there may be some question about the religious seriousness with which an object like the Parabiago plate takes its Cybele and Attis imagery, there is little doubt in a relief like this, or in the scene of Mithras' bull-slaying, that art is proclaiming an initiate ideology and affirming a mystically sacred truth. Moreover, as the Lucian quotation implies, going to the rites of such eastern cults was no light-hearted matter. Even if there is an element of parody in Lucian's description, it nonetheless implies that those who went just to observe might be swept up by the spirit of divine ecstasy and transform their identities (as Lartius Anthus transformed his) in an irreversible act of frenzy.

The earliest Christian art was closely analogous to the arts of the Oriental cults. Indeed, Christianity itself was in many ways a typical mystery religion. Its imagery and mythology alluded to the east (for instance in the Phrygian caps of the Magi and the Hebrews in the Fiery Furnace, see e.g. **153**); its worshippers were represented in a special iconography (their arms raised in the 'orans' position, see **159**) which, although borrowed in strictly formal terms from the Graeco-Roman repertoire,[31] contradicted the traditional Roman images of worship no less firmly than Anthus' whip and axes; it reversed the norms of Roman sacrifice not just visually (like Mithras), but by denying the very validity of animal sacrifice as a means of worship. In the period before Constantine established Church councils to root out heresy, 'Christianity' resembled the cults in encompassing a remarkable range of possible positions (from Gnostic denials of the Resurrection and suggestions that Christ might be female, to the radical insistence on chastity proclaimed by extreme ascetics like the Manichees).[32] The establishment of an iconography was one way of holding this diversity of positions together. Like the arts of other Oriental cults, the earliest Christian art—dating to the early third century—either adorned the places where Christians worshipped (such as the Baptistery discovered at Dura Europos in Syria) or the tombs where they were buried (including catacombs and sarcophagi). In effect, like Mithraism and the other cults, Christians used visual images to proclaim a set of sacred myths, which were foreign to the

shared experience and established norms of the Roman world, but which they affirmed as more true than the other mythologies available in Roman culture. It was by these images and stories that Christians defined their identity. In this sense the sarcophagus of Junius Bassus, for example [**130**], is not so radically different (as an identity-affirming funerary commemoration) from the Capitoline relief of Lartius Anthus as a priest of Ma-Bellona.

Ultimately, however, there were two areas in which the Christians differed most markedly from the other cults. First, theirs (at least in the version of Christianity that came to be Orthodox) was a monotheistic God who would not tolerate the multiplicity of Graeco-Roman deities. At its extreme form, this meant that some intitiate Christians were prepared to die rather than perform the acts of sacrifice and emperor-worship normal in the Roman world. Their identity was still more focused and passionately held than in the other cults: unlike the followers of Mithras or Isis, some Christians were martyred for their faith. The ideology of martyrdom—of believers being willing to give up everything for their God—was a most powerful formulator of religious zeal, even more so (because it could be communal rather than just personal) than the self-castration (in its way a kind of martyrdom of the male) which enthusiasts of Cybele or Ma-Bellona, like Lartius Anthus, inflicted upon themselves. Second, Christianity was a scriptural religion, propagated by a book and developed as a theology through commentaries on its sacred texts. This gave it a longevity, a self-sustained literary tradition, an organized ability to communicate across continents, inconceivable in the small-scale oral culture of the mystery religions or in the affirmation of parochial locality offered by the civic religions of antiquity. The scriptural nature of Christianity— with the Bible as a sourcebook for the creation and interpretation of images—was to have fundamental implications for the development of art. Not only would narrative art come to illustrate a canonical tradition, but artists, patrons, and viewers could have recourse to scriptural texts and interpretative commentaries in their responses to images. Monotheism and scripture—both inherited directly from Judaism— were to give Christianity a profound advantage in the battle for a dominant religion which took place in the fourth century; and they made Christianity a remarkably good choice for Constantine to fasten upon in his search for a religion that would bolster the Roman empire with the intensity of a sectarian identity.

Differentiation and syncretism: cultic creations of meaning

As cults competed with each other, two trends can be observed in the visual evidence. On the one hand, there was an aggressive self-definition through the denial of features archetypical of other cults (as

138

Map of Dura Europos in Syria, with the main buildings and temples.

we have already seen in the case of Mithraic sacrifice); on the other, there was a remarkable process of syncretism which seemed designed to blur the differences and bolster each cult with what was strongest or most typical about its competitors. That these two diametrically opposed tendencies should coexist at the same period is only evidence of the quite extraordinary vibrancy and power of late-antique religion across all the cults (and not just in Christianity).

A good example of such competitive self-assertion can be observed in Dura Europos (see **138**). This garrison town, on the borders of the Roman and Parthian empires, changed hands several times, but was retaken for the Romans by Lucius Verus in 165 and remained Roman until it was finally sacked and destroyed by the Sassanids in the 250s.[33] Along a single street, just off the main gate of the city at the south-west wall, temples to the Graeco-Syrian deity Zeus Kyrios and to the Semitic Aphlad as well as a Christian house church and a Jewish

Fresco of Otes and
Yahbishimshos making sacri-
fice, from the Temple of Bel,
Dura Europos in Syria, third
century AD.

synagogue [141] stood virtually side by side—flourishing, decorated,
and redecorated in the third century AD. It is entirely possible, from the
existence of a local (Parthian influenced) 'Durene style' common to the
paintings and sculptures surviving from the numerous temples of
Dura, that the same schools of local artists created the decoration for
what seem to us mutually exclusive cults.[34] In effect, the temple
remains of Dura offer a juxtaposition of cults by location, a kind of
spatial syncretism. In the same relatively restricted space (restricted not
only by the city walls but also by the special circumstances of a frontier
town straddling the borders of the Roman empire and its primary foe
in the east), the visual culture suggests a high degree of competitive
interconnection between the cults. The juxtaposition of cults at Dura,
and the propagation of each cult's identity through art, allows us to see
the visual articulation of some interesting theological differences
through the syncretism of a broadly uniform site.

A third-century fresco from the Temple of Bel in the north-west
corner of the town (within the area occupied by the Roman military
precinct), shows two men performing sacrifice, accompanied by boy
acolytes, before the figures of five deities [139]. The three better pre-
served deities, standing on globes, look like early versions of what
would become the standard iconography for archangels—clad in
cuirass, cloak, ankle-high boots or Parthian trousers, beardless, with
haloes, and carrying spears. The sacrificers identified by inscriptions in
Greek as the local senator Yahbishimshos son of Abdaathes and the
eunuch Otes, are also beardless and dressed in white.[35] Like other fres-
cos from the same temple,[36] the scene of Otes and Yahbishimshos cele-
brates the central act of traditional pagan religion—that of sacrifice—
and elevates the figures (probably the painting's patrons) by emphasiz-
ing their role as sacrificial mediators between the city and the gods.
The main cult-niche of the Mithraeum, situated not far from the
Temple of Bel within the military compound at the north end of the
same street along the western city wall where the synagogue and house
church were also located, comprises a grand icon of gypsum bas-reliefs
and paintings signed by the artist Mareos [140].[37] Both reliefs show
Mithras killing the bull; they are surrounded by two arcs of painted

Cult niche from the Mith-
raeum at Dura Europos
in Syria.

The two gypsum cult reliefs,
of Mithras killing the bull, both
inscribed with the dates of
their dedication (in AD 168 and
170–1), have traces of colour.
The lower one has insets of
glass and jewellery. The
surrounding paintings date
from a later phase in the cult,
c. AD 250.

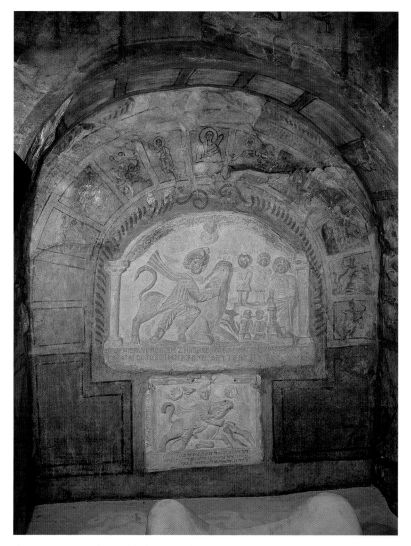

decoration on the wall plaster, plus a third arc in the ceiling and wall of
the niche surrounding the cult reliefs. To the sides of the outer arc
stand two figures in Parthian dress, perhaps initiate priests or donors.

Like the identities of the five gods in the Temple of Bel, the precise
meanings of these images are lost in a combination of fragmentary sur-
vival and the oral transmission of cult secrets in antiquity; but they
attest to a complexity and sophistication of sacred iconography only
surpassed by the art of one other building in Dura—the synagogue.
What the Mithraeum and the votive murals of the Temple of Bel have
in common is an emphasis on sacrifice in which the gods are directly
visualized. Mithraism, of course, turned the norms of sacrificial action
upside down; its worshippers did not perform sacrifice to gods, who
were ordinarily imagined as arriving to partake of the offering (as is
visualized in the Otes fresco), rather—in the case of Mithraism—the

god himself was his own sacrificial priest. But in both examples, the god was present—in the temples' adornment and (according to the viewers' beliefs) actually manifest in the temple enclosure itself.

By contrast, in the synagogue and the Christian building—that is, in Judaism and early Christianity—God was not made present in the same way. He was an invisible God, attested through his actions and interventions in history, allegorized through visual representations and a scriptural mythology, but never visibly manifest in a graven image.[38] While it may seem strange that the most un-iconic (indeed anti-iconic) of religions should have resorted to the rich programme of narrative images we find in the Dura Synagogue (painted in the 240s), in fact the Dura frescos are not unique in the Judaism of their time.[39] Like the much cruder images of the Christian house church, and by contrast with the temples of non-scriptural traditions, the Dura synagogue paintings [**141**] are dependent on a scripture. In effect, they illustrate subjects from the Jewish canon—narratives of Jacob (Israel), of Moses, David, Solomon, and other Jewish heroes or prophets—which were simultaneously a history of the Jewish people and a visual commentary on scripture. There is no need to assume that the artists were using an illustrated book as the model for their programme,[40] but they were undoubtedly in debt—like the illustrators of the earliest illuminated manuscripts—to the broad thrust of a scriptural narrative and to its numerous commentaries and expositions (for example, the Midrash).[41] The synagogue paintings differ fundamentally from

141

The synagogue, Dura Europos in Syria, general view of frescos, *c.* AD 245.

These murals are the most extensive example of large-scale Jewish decoration from antiquity. The main focus, the Torah shrine against the west wall, is decorated with objects of Jewish cult (like the menorah candlestick) and with the sacrifice of Isaac. The walls above the benches are painted with three tiers of narrative images representing scenes from Jewish scriptural history.

Detail from the frescos of the
synagogue, Dura Europos in
Syria, c. AD 245.

This image represents two
episodes from the history
of the Ark of the Covenant
(as related in the first Book of
Samuel 5 and 6). On the right,
the idol of Dagon has fallen to
the ground in its temple after
the Philistines installed the
captured Ark there. On the
left, the Philistines send the
Ark away by putting it on a cart
drawn by cattle and leaving
it to the animals to take it
where they will. The order of
the narrative, from right to left,
follows the direction in which
Hebrew is read.

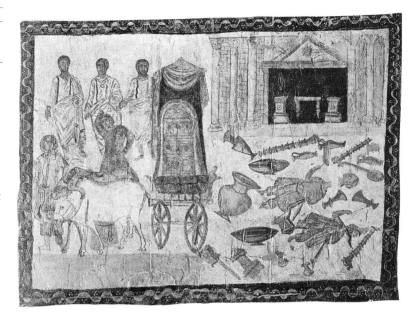

Christian art in that the Jewish themes are not seen as typological alle-
gories or foreshadowings of a different—Christian— Revelation (like,
say, Jonah and the whale in Roman catacombs and sarcophagi). They
stand for themselves and not for something else.

Interestingly, in the mixed religious context of Dura Europos, a
number of the chosen images—for instance the contest between Elijah
and the prophets of Baal or the episode when the Ark of the Covenant
caused the collapse of the idol of Dagon [142]—seem specifically
targeted against local pagan polytheism (such as that practised by
Mithraists or the devotees of Bel, who was himself a local version of
Baal). It is as if, in the special conditions of a frontier town in the centre
of the great religious ferment of the late-antique east, the juxtaposition
of cults and the likely sharing of artists led to each cult affirming its
identity with ever more fervent force. In the case of a number of
Durene temples (such as the Temple of Artemis, the Mithraeum, and
the synagogue) competition between the cults motivated a series of
repeated, ever grander, rebuildings, with increasingly complex icono-
graphic schemes. In the synagogue (as in the Bible itself), several visual
subjects actually attacked the gods of the pagan environment, defining
the monotheist Jews by contrast with their polytheist and idolatrous
neighbours. Such religious polemic (against paganism and against
Christian heretics) would become a significant factor in later Christian
art (see 162). By contrast, the visual assertion of sacrifice by the pagans
not only made a strong appeal to the central sacred rite in their reli-
gious system, but obliquely it commented on rival religions which
were either non-sacrificial (as in the case of Christianity) or had lost

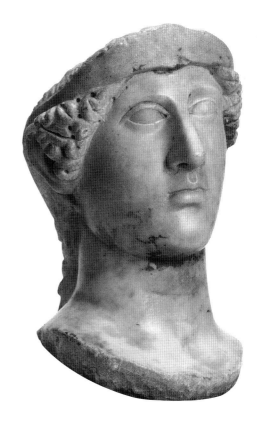

143

Three cult objects found in the London Mithraeum..

Top, left: Head of Serapis, perhaps from Italy, *c.* AD 200, marble, 32.2 cm high. Top, right: Head of Minerva, second century AD, marble, 25.3 cm high. Right: Relief of Mithras killing the bull within a zodiac, perhaps carved in Britain, late second or early third century AD, marble, 43.2 cm high and 50.8 cm wide.

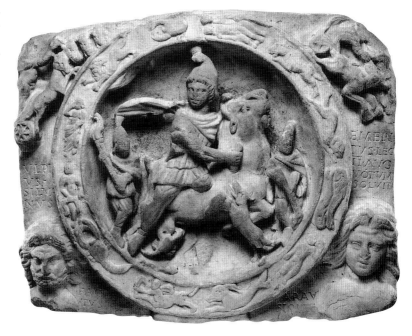

144

144

Hercules leads Alcestis back to Admetus, from the right-hand arcosolium of Cubiculum N, Via Latina catacomb, Rome, third quarter of the fourth century AD.

Hercules, with club, lion skin and a blue halo, holds Cerberus, the hound of hell. According to the myth (recounted for instance in Euripides' play, *Alcestis*), when Admetus was fated to die, his wife Alcestis chose to die in his place but was rescued from the hands of death by Hercules who brought her back to her husband.

the possibility for scripturally enjoined sacrifice (as in the case of Judaism, after the destruction of the Temple in Jerusalem in AD 70).

If the spatial juxtaposition of the temples of third-century Dura (and their images) served to highlight *differences* between the different cults, at the same period (and on into the fourth century) syncretism was operating within the cults elsewhere in the empire to efface those very differences. In the Walbrook Mithraeum, discovered in London in 1954 and founded a little before the final fall of Dura in *c.*256, a mix of objects from a whole variety of Roman cults were found together, in addition to the sculptures of Mithras himself [**143**]. These included heads of Minerva and Serapis, as well as images of Mercury, Dionysus, and the Great Mother.[42] Did this mix of deities, many of them specific to apparently different Oriental cults, signal a particular syncretized version of such paganisms in far-away Britain? Did the adherents of one cult—that of Dionysus—take over a holy space previously dedicated to Mithras and bury the Mithraic images before setting up their own (in the way that so many Christian churches in Rome were built over Mithraea, for instance San Clemente and Santa Prisca)? Had all these gods, by the time the temple was abandoned some time after AD 350, become subservient to Mithras (in the way that the emperor Julian, at just that period, was attempting to create a pagan church with Helios-Mithras as its supreme deity)? Certainly, in the early part of the third century (at least, according to the fourth-century evidence of the

Historia Augusta), no less a person than the emperor Severus Alexander (222–35) worshipped a very odd mixture of gods in his private shrine: his deified imperial predecessors shared honours with the wise man Apollonius of Tyana as well as Jesus Christ, Abraham, Orpheus, Vergil, Cicero, Achilles, and Alexander the Great![43]

Still more striking, as a case of syncretism, is the art of the Via Latina catacomb in Rome whose cycle of paintings dates to between AD 315 and 370.[44] Most of its frescos are renderings of the typical repertoire of early Christian art, like the scene of Abraham about to sacrifice Isaac [4] which was seen as a prototype of the death and Resurrection of Jesus himself. But one room, sandwiched between two rooms filled with Christian themes, and painted—or so it appears from stylistic analysis—by the very same painters of those Christian scenes, is decorated with an entirely pagan cycle representing the deeds of Hercules.[45] One of the lunettes of the room's two *arcosolia* represents the death of Alcestis (who agreed to die in place of her husband Admetus), while the other shows Hercules returning Alcestis to Admetus after having descended to Hades to bring her back from the dead and having tamed Cerberus, the hound of hell, while he was there [144]. Such iconography—in a religious funerary context—is potent with allegorical significance; it implies a triumph over death, just like Christ's own descent into Hell and Resurrection from the dead. What is surprising (shocking even, to those who would wish Christianity to be unsullied by this kind of paganism) is that the artists, patrons, and viewers of the Via Latina catacomb were quite happy to create their own syncretistic mix of pagan, Jewish, and Christian themes.

Even single objects combine pagan and Christian religious references. For example, the front part of the lid of the Projecta casket, a silver box from Rome (whose back we have already examined [17]), combines an image of Venus at her toilet, every bit as pagan as the mosaic from Djemila [64], with an inscription urging Secundus and Projecta (the casket's commissioners, one presumes) to live in Christ.[46] Likewise, a fourth-century mosaic floor from a Roman villa at Hinton-St-Mary in Dorset, England, combines an early image of Christ (his

145

Strigilated marble sarcophagus from Ostia, second half of the third century AD.

In the central figured panel, Orpheus stands playing his lyre, with a tree and bird to the left and a sheep below. In the panels on the right and left ends of the sarcophagus, are clothed figures standing in front of knotted curtains, accompanied by or holding scrolls, turning towards Orpheus. The lid is inscribed with the Christian formula, 'Here Quiriacus sleeps in peace'.

Greek labels in the mosaic:
ΝΥCΑ · ΑΝΑΤΡΟΦΗ · ΝΥΜ · ΦΑΙ · ΑΜΒΡΟCΙΑ · ΤΡΟΦΕΥC · ΕΡΜΗC · ΔΙΟΝΥCOC · ΝΕΚΤΑΡ · ΘΕΟΓΟΝΙΑ

146

Floor mosaic from Nea Paphos in Cyprus, first half of the fourth century AD.

Hermes in his winged cap, enthroned and accompanied by personifications of Theogonia ('divine birth') and Nectar, presents the infant Dionysus to a group of nymphs. Two figures, the male Tropheus and the female Ambrosia, approach in adoration. All the figures are labelled with their names. The scene is a striking pagan version of the theme of the epiphany of a divine child, which would become one of Christianity's most significant iconographic forms (see **153**).

head inscribed within the chi-rho monogram) with a scene of the pagan hero, Bellerophon slaying the Chimaera.[47] The ultimate cases of such syncretism are the numerous conflations of Christ with old pagan deities like Orpheus [**145**], Hermes the sheep-bearer, Sol Invictus, and others.[48] And just as some within early Christianity strove to make their faith accessible through assimilations with paganism, so some polytheists began to appropriate aspects of Christian iconography to present their gods in pseudo-Christian terms. In a fourth-century mosaic from Nea Paphos in Cyprus, the infant Dionysus (looking to all appearances like a baby Jesus) is represented seated in the lap of Hermes, surrounded by various personifications [**146**].[49] The appropriation of the thematics of the Virgin and Child to a Dionysiac iconography is paralleled by the equally striking assimilation of Christ and his Mother to Isis suckling the baby Horus. In a late fourth- or early fifth-century statue from Coptic Egypt, the Isis mysteries parade an example of what would become Christianity's single most potent icon to bolster their own late-antique manifestation, as Isis gives the breast to her divine son [**147**].[50] It is by no means impossible that Christianity borrowed the Virgin and Child theme from such images of Isis.

All such images, whether from the broadly secular context of villa life, or from the sacred ambience of temple or tomb, beg the question of how art was to be viewed. Clearly these iconographies conflated from different cults could be interpreted in very different ways—as

147

Limestone statue of Isis giving the breast to the infant Horus ('Isis Lactans'), from Antinoe in Egypt, late fourth or early fifth century AD.

This statue, nearly a metre high, is a late example of a fairly popular Graeco-Egyptian iconography of Isis (for an earlier version, see **93**). It is not impossible that a Christian viewer might have taken the mother and child for Mary and Jesus, if they were displayed in an appropriate setting. Some of the earliest Virgin and Child imagery (including that of Maria Lactans) comes from Egypt in this period, including a possibly fifth-century incised plaque from the Fayum and one of the marginal illustrations from a papyrus chronicle made in Alexandria in the beginning of the fifth century (for another image from this, see **156**).

openly allegorical and mutually supporting, as appallingly heretical (in the eyes of both die-hard Christians and committed pagans) or as just another kind of *paideia*. There was no one interpretation, and this in itself throws light on the remarkable flux and creativity of sacred art and exegesis in the third and fourth centuries. This period was (in religious and artistic terms) a kind of melting pot where all the traditions of antiquity—from centre to periphery, from élite to relatively plebeian—were thrown together, combined, redefined, and adapted, ultimately to produce something both wonderfully new and at the same time deeply indebted to the Classical heritage. That new product would be the Christianity, and the arts, of the middle ages.

Christian triumph: a new religion as state cult

Describing the atmosphere in Constantinople in May 381, the year of the Second Ecumenical Council of the church, Bishop Gregory of Nyssa (himself a participant in the proceedings) commented:

Throughout the city everything is taken up by such (theological) discussions: the alleyways, the market places, the broad avenues and the city streets; the hawkers of clothing, the money-changers, the food vendors. If you ask about

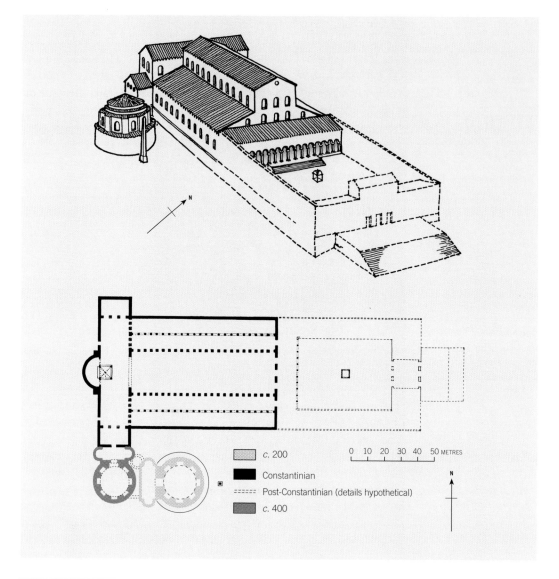

small change, someone will philosophise to you about the Begotten and the
Unbegotten, if you ask the price of bread, the reply comes, 'the Father is
greater and the Son is a dependent'. If you inquire whether the bath is ready,
someone will respond, 'the Son was created from not being'.[51]

Allowing for a certain amount of comic exaggeration, the implications
of this sketch are none the less momentous. By the end of the fourth
century, theology had come, at least in the great cosmopolitan centres,
to be a way of alluding to issues of political ascendancy (for example by
noting which theological cause the emperor backed). It marked the
relationship between the great metropolitan sees (the empire's five
Patriarchates in Rome, Alexandria, Antioch, Constantinople, and
Jerusalem) as represented by the influence of their theological, litur-

gical, and ecclesiastical positions. It established the relative importance of different ethnicities and provinces as defined by the theologies of their local church hierarchies. In effect, theology had become a prime means of thinking about everything else—so many of this book's earlier themes (the relation of the individual and the state, the issue of public and private identity, the dynamics between centre and periphery) now became explicated and culturally debated through theological discourse. The very means of reflecting on the nature of the individual and the state had become Christianized.

If the century between, say, 250 and 350 was a golden age of mystery cults—a melting-pot of syncretism, and pluralistic competition, then the following hundred years from the mid-fourth to the mid-fifth century saw a systematic attempt by the newly triumphant Christian establishment to exclude all that was pagan or heretical. In 391, Theodosius the Great banned sacrifice, the fundamental means of pagan worship, in a comprehensive law summing up earlier anti-pagan legislation going back to Constantine himself.[52] About the same time, the more enthusiastic Christians in the east destroyed some of polytheism's most famous shrines—the sanctuary of Zeus at Apamea in 388, the great Serapeum in Alexandria in 391, the pagan temples of Gaza in 402.[53] Beside this two-pronged assault of episcopally sponsored iconoclasm and state legislation, went the establishment of a canonical Christianity. The distillation of orthodoxy out of the morass of pre-Constantinian Christianities was a process of self-definition through an increasingly complex theology. The great Ecumenical Councils of the church, at Nicaea in 325, Constantinople in 381, Ephesus in 431, and Chalcedon in 451 not only worked progressively to establish ever more doctrinally pure theology but—by every subtle nuance of wording—systematically excluded large numbers of those whose beliefs were dubbed 'heretical' and hence anathematized.[54] On the level of the visual arts, this process of narrowing, defining, excluding, led to the slow creation of a canonical iconography for Christian representations which would be largely in place by the dawn of the sixth century.

It is hard to overestimate the transformation in the religious life of the Roman empire triggered by the adoption of Christianity as the state cult. For Christians, a small persecuted minority in the early fourth century, it meant a radical upheaval with the dedication of vast churches at imperial expense in place of their small informal places of clandestine meeting and worship. In the space of some 20 years, Christians in Rome found their liturgy transformed to fill the huge spaces of churches like St Peter's on the Vatican hill [148], built by Constantine between 320 and 327, which was about 120 metres long and 64 metres wide. At the same time, these Christians found their beliefs, rituals, and sacred texts codified, vetted, and organized in the

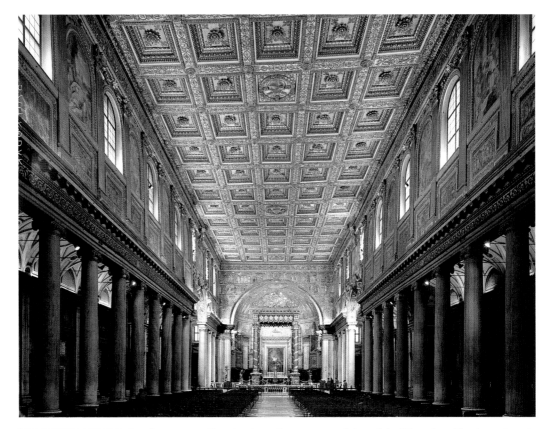

interests of orthodoxy by a powerful and brilliantly effective church hierarchy (its leaders among the most passionate, committed, and talented intellectuals and administrators ever produced by antiquity), supported by the emperor himself. Indeed, Constantine presided in person at the first Ecumenical Council which he himself called at Nicaea in 325, when the tenets and wording of the Nicene Creed were first formulated.

Soon the structures of mutual dependence between church and emperor were strained as each sought to influence the other in pursuit of rather divergent interests. While many in the church hierarchy attempted to develop the essence of a sectarian Christianity born out of persecution and martyrdom, the emperors aimed to incorporate many aspects of traditional civic religion and in particular the old pagan imperial cult into Christian modes of worship.[55] The adaptation of Graeco-Roman civic religion such as we explored earlier in this chapter (with its mass of taboos, processions, and sacred images, its culture of pilgrimage, dreams, and miracle cures, as well as the formal dedication of honours to the emperor) to a cult which had in the past been in part defined as diametrically opposed to such practices, was bound to be difficult. It helped motivate several spectacular rows between bishops and the imperial family,[56] not least the confrontations between

Theodosius I and Ambrose of Milan in the 380s and 390s,[57] between the empress Eudoxia (wife of Theodosius' son, Arcadius, emperor 383–408) and John Chrysostom, Patriarch of Constantinople, in 403–4,[58] and between the empress Pulcheria (sister of Arcadius' successor, Theodosius II) and Nestorius, Patriarch of Constantinople from 428–31.[59]

At stake was not just power politics, but the very issues of religious identity which had underpinned the development of the first Christian art. However, while Christianity—as but one of many Oriental cults—had affirmed itself in part by contradiction of other late-antique religions' normal practices, now its very ideology of contradiction (whether the imagery of martyrdom and persecution, the rejection of pagan rituals like sacrifice, the adherence to an exclusive and single god, or the assertion of a Jewish mythology) was in the peculiar position of being canonical: out of the mystic fringe, Christianity had become the establishment. In Christian art, this would lead to a new monumental usage of the typological imagery which had been part of the earlier repertoire of rethinking the present in terms of a Judaeo-Christian rather than Graeco-Roman past. At the same time, some space had to be made for the traditions of civic religion inherited from antiquity and second nature to Christianity's Graeco-Roman converts, and also for the uses of Christian art not just to affirm a sectarian identity but to promulgate that identity through the active process of conversion and Christianization.

An official religion and its public presence

In the building of churches the divisions at the pinnacle of society were reflected in the competitive patronage of emperors, bishops, and aristocrats. In Rome, for example, the great churches on the city's periphery (St Peter's, St Paul's, San Lorenzo, Sta Agnese, Sts Peter and Marcellinus, the Lateran and Sta Croce in Gerusalemme) were sponsored by Constantine himself and his successors. But many of the smaller but exquisite churches within the city walls were built by the popes (for instance, Sta Maria Maggiore, constructed by Sixtus III, 432–40 [149]) or by other patrons with a need to establish a Roman base (such as Sta Sabina, built in 422–32 by Bishop Peter of Illyria, [150]).[60] Likewise, in Milan it appears that the imperial family was responsible for the church of San Lorenzo with its two adjoining mausolea, S. Aquilino and S. Ippolito, while Bishop Ambrose founded many of the city's other major churches.[61] Most of these early churches followed the basilica plan inherited from antiquity (for instance the fifth-century churches of Sta Sabina and Sta Maria Maggiore, compared with, say, the Trier basilica from the fourth century, see **88** and **90**, or the basilica of Constantine and Maxentius, **33**)[62] but a few, like San Lorenzo, Constantine's church of the Holy Apostles in

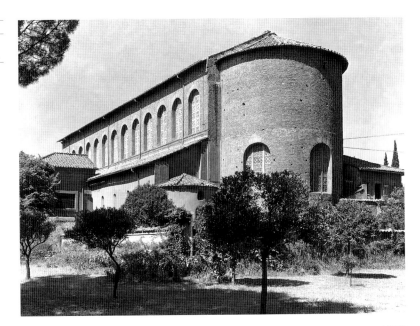

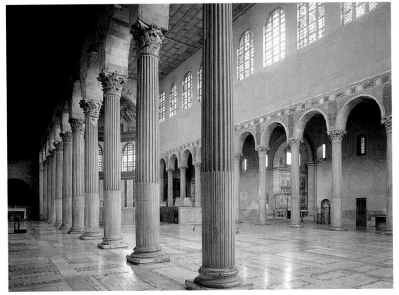

Constantinople or the rotunda of the Holy Sepulchre in Jerusalem adopted the centrally planned form which looked back to buildings like the Pantheon [**39**].

These churches—the setting for urban liturgies and processions including the carrying of relics, icons, and *palladia* as well as for the great ceremonies of eucharistic celebration and baptism—were sumptuously decorated. The fifth-century interior of the basilica of Sta Sabina on the Aventine [**151**] gives a glimpse of a largely vanished flowering of fifth-century monumental decoration. The arcades are exquisitely covered in non-figural marble inlays in the same *opus sectile*

152

Panel from the doors of the church of Santa Sabina, Rome, cypress wood, second quarter of the fifth century AD.

A unique survival, these doors are the best preserved Christian wood carvings from the late-antique west. Eighteen panels out of 28 survive on the outer face of the doors, somewhat altered, restored and rearranged (so that the original order is lost). This scene shows the prophet Elijah ascending to heaven in his chariot.

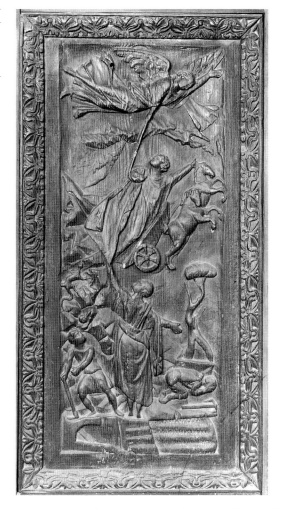

technique used for the secular basilica of Junius Bassus a century earlier [129]. Over the western entry to the church on the interior side was a large dedicatory mosaic with an inscription and personifications of Church and Synagogue, while the wooden doors—also surviving from the fifth century—are one of the finest early examples of Christian typological iconography on a truly grand public scale.[63] They combine Old Testament themes such as the life and miracles of Moses and the heavenly ascent of Elijah's chariot [152] with a cycle of narrative scenes from Christ's ministry and passion.[64]

Built, like Sta Sabina, to celebrate the resurgence of Christian Rome after the sack of the city by Alaric the Goth in 410, the church of Sta Maria Maggiore boasts an extensive surviving programme of early Christian mosaic decoration. Although the apse is now lost, 27 of the original 42 panels lining the walls of the nave still remain, as well as the glorious mosaics of the triumphal arch. Erected in the 430s by Pope Sixtus III, the church has an iconography with a double theological

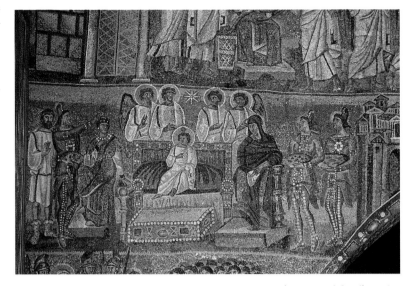

agenda. First, it celebrates the Virgin as *theotokos* (bearer of God) in the wake of the deliberations of the third Ecumenical Council of Ephesus in 431. Second, it comprehensively reinterprets a detailed Old Testa- ment cycle (on the nave walls) in terms of its fulfilment in the triumph of Christianity.[65] It is not just that specific Old Testament themes prefigure the events of Christ's life, but that the whole narrative of Jewish history is presented as subservient to, completed in, the Incarnation. The experimentalism of early Christian art is still very much in evidence in the mosaics' unusual iconography (by later stand- ards). For example, in the unique scene of the epiphany on the triumphal arch, the Christ child (more young boy than baby) sits in a jewelled throne with four angels behind him and his mother seated to his right. The three Magi, in Phrygian dress, approach with their gifts from both sides [153]. Such visual programmes in the major churches transposed the relatively small-scale typological images of catacombs and sarcophagi, as well as the still tinier Christian imagery of gems, glassware, and ivory (e.g. 158) to a monumental grandeur. In doing so, they transformed a sectarian imagery of cult identity into a canonical iconography of state religion where the only place for pagans (such as the Magi) or Jews (the figures in the Old Testament cycles) was as a stage to be surpassed in Christianity's teleology of triumphalism.

Of the relatively few churches with significant surviving remains from the first half of the fifth century, the most beautiful for its mosaics is the 'mausoleum of Galla Placidia' at Ravenna. A miniature Greek cross with a square cupola which from the inside appears as a dome, this chapel still boasts its upper walls and ceiling covered with original mosaics. Spectacular patterning and star-spangled vaults enclose scenes rich in the imagery of baptism, paradise, and the Second Coming [154]. The full meaning of the iconography is not clear, nor is

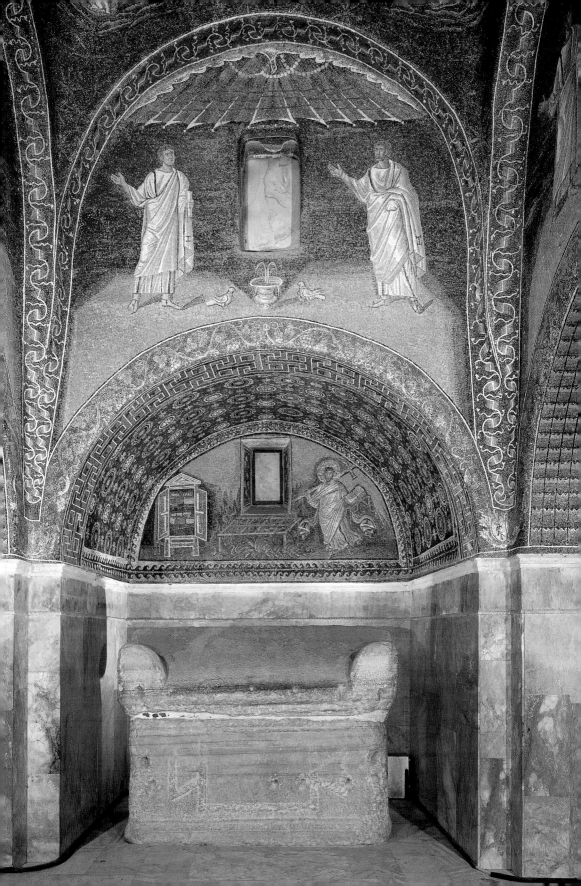

The San Nazaro reliquary, silver gilt casket, dedicated in 386 and interred beneath the main altar of St Ambrose's Basilica Apostolorum in Milan. The face shown here depicts the Judgement of Solomon

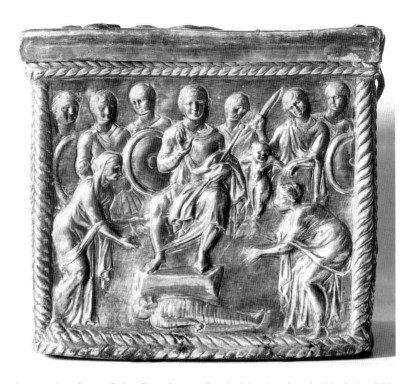

the precise date of the foundation (probably the first half of the fifth century), nor even the identity of the patron.[66] However, the 'mausoleum' is a unique testament to the splendour of imperial Ravenna in the fifth century, when the town served as the principal court of Galla Placidia, daughter of Theodosius the Great, her husband Flavius Constantius III (emperor in the west, 421) and her son Valentinian III (emperor 424–55).

Sanctity, relics, and Christianization

The great churches were major sites of urban congregation in which bishops had the opportunity to regale large sections of the population with sermons. Moreover, churches rapidly became—just like the ancient temples they replaced—the houses of sacred objects. Instead of the black stones and cult statues of antiquity, Christianity developed—especially in the late fourth and early fifth century—a cult of relics. The hallowed bones of the saints, martyrs, and confessors, kept in precious boxes, were venerated, exposed on holy days, carried in procession—to all appearances just like the Baal of Elagabalus or the images in Salutaris' procession in Ephesus. They became the focus for pilgrimage, and the guarantee of sanctity not just of a particular church but, by extension, of the city where the church stood.[67]

An example of a fourth-century reliquary is the silver box, perhaps commissioned by St Ambrose himself, to contain the relics of the apostles [155]. Deposited beneath the altar of the Basilica

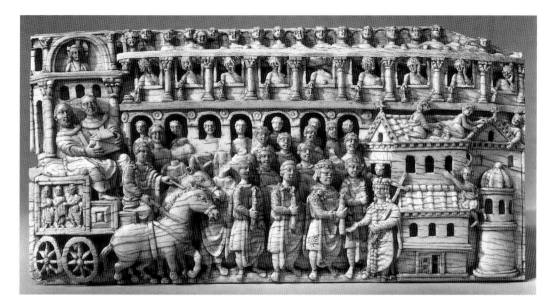

Apostolorum, later the church of San Nazaro, which Ambrose dedicated in Milan in 386, the box has images of Christ enthroned amidst the apostles on the lid, the Virgin and Child between eight figures on the front, Joseph and his brothers or Daniel and the elders on the back, the Hebrews in the fiery furnace with an angel and the Judgement of Solomon on the sides.[68] Executed in a mannered style, the casket is material evidence of the promotion of the cult of relics by the Italian bishops in the late fourth century. Ambrose himself was responsible for exhuming the bodies of numerous martyrs in Milan and Bologna in the 380s and 390s, while his colleague Pope Damasus was doing the same in Rome.[69]

By contrast, at the same period in the east, the imperial family was propagating the cult of relics itself and appropriating for its own ends the civic ceremonials which accompanied the bringing of relics into a city.[70] An ivory panel now in Trier, possibly the long side of what was once an oblong reliquary casket, may depict the translation of the relics of St Stephen (the first martyr) from Palestine to Constantinople [**156**].[71] The relics—concealed in a small gabled box (perhaps just like the one of which this very ivory plaque was part)—arrive in the care of two bishops on an imposing wagon drawn by mules. The procession before the cortège is led by the emperor Theodosius II himself, while it is met by his sister, the formidable Pulcheria, dressed in full imperial splendour and carrying a cross in front of the chapel specially constructed as a depository for the relics. In its visual evocation of public rituals, the Trier ivory attests the power of such ceremonials in late antiquity. Its form echoes the depiction of imperial *adventus* on Galerius' arch at Salonica [**87**], where the emperor is drawn on his carriage towards the city's main temple on the right. Yet, ironically, it

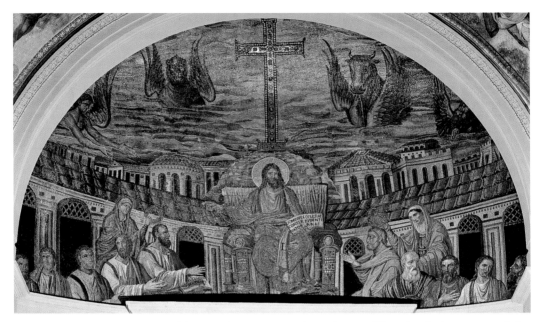

Apse mosaic from the church
of Santa Pudenziana, Rome,
c. AD 390.

Adapted from an earlier
Roman baths building, this
small church was provided
with an impressive mosaic.
The mosaic was drastically
cut down on all sides in 1588
and has been much restored.
Christ is enthroned in the
centre, holding a book on
which is inscribed 'Lord,
preserver of the church of
Pudenziana'. Five apostles
are ranged on each side (the
last two were lost in the
sixteenth-century trimming),
with Peter and Paul closest to
Christ and both crowned with
wreaths. Behind is a cityscape
of Jerusalem.

resembles—rather too acutely perhaps—Herodian's desciption of the entry into Rome of Elagabalus' Baal (see above, p. 218). Like Baal, St Stephen's sacred remains arrive in a chariot, like Baal his procession is led on foot by a worshipping emperor. Instead of flowers and wreaths, Stephen's relics are showered with incense by the little figures leaning out of windows above the arcade along the route. Like Baal, the procession is crowded with worshippers, and—like Baal—Stephen is finally installed in a newly built temple.

The supreme Christian model for such spirituality before material things imbued with sacred power was pilgrimage to the Holy Land— to see the very places where Christ himself had lived. The imperial family not only embellished Jerusalem and Bethlehem with splendid churches, but itself led the fashion for pilgrimage in the persons of St Helena, the mother of Constantine, and of Eudocia, wife of Theodosius II, who spent most of the years 443–60 in Palestine. The impact of Jerusalem, as the image of a heavenly ideal, can vividly be caught in the finest surviving apse mosaic of the fourth century, from the church of Sta Pudenziana in Rome [**157**]. Though much restored and not a little cut down, the mosaic shows Christ enthroned beneath a great jewelled cross and the four apocalyptic beasts. He is in the midst of his apostles, who are within the confines of the church of the Holy Sepulchre with—behind them—a cityscape of the new Jerusalem, revived, rebuilt, rediscovered in Christian times, and now transported, as a picture of paradise made possible, into contemporary Rome.[72]

On the small scale, objects—often with complex Christian iconographies, like a third- or fourth-century Jonah gem from the British Museum [**158**], or the gold-glass tokens, whose pictures of saints like

158

Engraved Christian gem, carnelian, third or fourth century AD.

Two trees extend from either side, meeting at the top with a star between. Below, to the left, is a figure in the orans position between two animals, perhaps Daniel in the lions' den. At the centre left is the Good Shepherd, carrying a sheep on his shoulders; at his feet are two sheep and two fishes. At the centre right is a dove with an olive branch. To the right is an abbreviated Jonah cycle with the ship, the sea-monster and the prophet resting beneath the gourd, which forms the tree extending over the right-hand side.

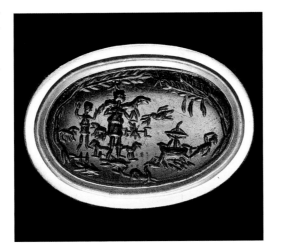

159

Gold-glass medallion, perhaps from the bottom of a cup or bowl, cut back to the decorated disc, from Rome, fourth century AD.

St Agnes, whose name is inscribed above her head, stands frontally in the orans position between two columns on which doves are perched. Agnes was one of Rome's most popular early martyrs. This example, still in place in the catacomb of Pamphilus, shows how such tokens were embedded in the catacomb walls as votive, commemorative, or protective talismans for the Christian dead.

Agnes, Peter, and Paul [**159**] opened the possibility for a personal devotion which would ultimately lead to the cult of icons—were prolific.[73] They took the cause of Christianization beyond the monumental programmes of the churches into the homes of believers. The very association of such objects with a purchase at a great pilgrimage site, like Jerusalem or one of the Roman basilicas, gave them something of the value of a relic by their origins in a holy place.

The promulgation of Christian typological imagery—whether in grand programmes like Sta Maria Maggiore sponsored by the pope, in important private commissions like the Bassus sarcophagus [**130**] and Cubiculum C of the Via Latina catacomb [**103**], or in rather more humble contexts like the Jonah gem and the gold-glass tokens, was vital. It no longer simply affirmed one among many cult identities

The 'Brescia Lipsanotheca' ivory casket, perhaps a reliquary or a box for eucharistic bread, probably from Italy, second half of the fourth century.

Exquisitely carved in extensive and miniature detail, all four faces of the box as well as the lid are covered in Old and New Testament scenes. The side shown is one of the shorter ends.

(grounded in Jewish Palestine rather than Mithraism's pseudo-Persian mythology or Isis' Egyptian origins). Rather, it was designed to teach (especially to the illiterate) what had fast become a canonical story, a mythology whose repetition confirmed Christian identity in the Christian empire. What was taught by art was not just a set of myths, but a means of interpreting them: the whole pattern of typological exegesis as neatly laid out by juxtaposed pictures, as in a late fourth-century box now in Brescia.[74] The right end [**160**] shows three tiers of images, topped by the lid whose edge has medallion portraits of the apostles. In the upper tier, the Hebrews in the fiery furnace appear between scenes of Moses at the Burning Bush and receiving the Tablets of the Law. In the much larger central tier, Christ heals the blind man and raises Lazarus from the dead. At the bottom, is the story of Jacob—his meeting with Rachael, his wrestling with the angel and Jacob's ladder to the far right. The Old Testament scenes are some of the key moments of Judaism: Jacob's contest with the angel which led to his being renamed Israel, his ladder, the visions of Moses, are among the supreme Jewish revelations of God. Yet these are to be read as but shadows, little hints (as small as the upper and lower tiers beside

the triumphant centre) in relation to the cycle of Christ. The Christian images specifically cap the Jewish revelations by having Christ grant true vision to the blind man (whose first sight is immediately of Christ himself as God incarnate), and give true life to the dead.

The viewer of the Brescia casket is being educated in a Christian way of thinking, a mode of subsuming all possible pasts, which is radically different from the old ways of defining Roman identity, whether political, personal, or religious. In being able to make any sense at all out of these scenes, the viewer needed access to a deep knowledge of Christianity—through exposure to scripture, sermons, and plenty of art. The casket presupposes (and fosters) such knowledge, just as the mythological sarcophagi presupposed a grasp of the myths which they represented. But the difference is that Christian knowledge was not the result of a haphazard conflation of oral tradition and a rhetorical education; it was a carefully orchestrated process of religious initiation through mysteries (like baptism) controlled by a complex hierarchy of priests and theologians. The very existence of images like the Brescia casket speaks of the triumphant success of Christianity in transmitting its sacred message to a huge, empire-wide, audience.

Epilogue

Art and Culture: Cost, Value, and the Discourse of Art

9

The value of art—economic, aesthetic, and cultural—is often controversial. For our period, an assessment of this theme is complicated by paucity of evidence and by the inevitable difficulties of interpreting what the Greeks and Romans said about their art. Comments which were meaningful to them need to be interpreted in terms which are meaningful to us. The very fact that we have inherited so many of their aesthetic concepts—including naturalism and imitation, a focus on the human body, and an admiration of *trompe l'oeil*—only serves to confuse the issue: for what we mean by the praise of illusionism (for instance) may not be quite the same as what our ancient sources meant, but it may not be possible to ascertain exactly what the differences are.

The earnings of artists: Diocletian's price edict of AD 301

It is notoriously difficult to compare the economic significance of what is apparently the same commodity at different times. The value given to the handiwork of painters and sculptors, for example, is only comprehensible in relation to the range of relative prices and incomes in any given society at any one time. In other words, comparison needs to take account of very complex systems of interrelated prices, in which no single item can be directly or simply compared across history with another item from a different economic infrastructure. Although the products of artists—such as panel paintings or marble reliefs—from antiquity, the middle ages, the Renaissance, and the modern world might in principle be compared, the values given those items within their cultures (economic, aesthetic, spiritual), even when they are historically recoverable, are simply impossible to assess against each other, except in the most general terms.

None the less, we possess an edict on maximum prices, issued by the emperor Diocletian in AD 301, which does give some sense of the earnings of painters and other decorative artists, relative to other craftsmen and the providers of other services. The prices edict is a complex document to use. It survives in inscriptions, fragments of which have been found in nearly 40 locations, mostly from Asia Minor, Greece, and Egypt. The full text, painstakingly engraved in both Latin and Greek,

Detail of 116

lists about a thousand items and dictates maximum prices for the most common goods and services, as well as maximum wage rates (including those for painters, mosaicists, and modellers in clay or stucco, but not for sculptors). The problems include whether the edict represents the reality of fixed maximum prices in AD 301, or whether it was an ideal—promulgated by the government in response to rampant inflation—which was immediately outdated and never workable. Also, it is uncertain whether the edict's pricing system applied in all parts of the empire (the epigraphic evidence of archaeologically excavated fragments of the inscription is heavily weighted to the east), and whether it was enforced with equal rigour in all provinces. Quite apart from its accuracy during the time when it was meant to be enforced (which is impossible to assess), it is uncertain when it ceased to operate, though it would be surprising if it outlasted Diocletian's decision to abdicate in 305. Finally, even if its relative prices are a true economic portrait of tetrarchic society, how far can we extrapolate from this snapshot of 301 to the relative values of the same spectrum of goods and services in, say, 100 or 450?[1]

In the section on wages (7), the edict prescribes its highest single daily rate for figure painters, which has been taken to mean painters of both wooden panels and figure scenes on walls.[2] They received 150 denarii daily, six times as much as the lowest paid—sewer cleaners, farm labourers, and water carriers (on 25 denarii)—and three times as much as the majority of craftsmen, including stone-masons, cabinet-makers, carpenters, lime burners, wagonwrights, blacksmiths and bakers (all on 50 denarii). Wall-painters and modellers in stucco or clay earned 75 denarii daily, still one and a half times as much as the majority. Wall mosaicists and workers in marble pavements received 60 denarii, while floor mosaicists and workers in plaster earned 50 denarii. We should remember that these are intended as maximum wages, and lower rates were perfectly acceptable within the dictates of the edict's legislation (although not perhaps in actuality). While artists do appear at the top end of this scale and hence seem relatively well paid, their earning power is put into some perspective by other figures. Scribes with the best-quality handwriting received 25 denarii per hundred lines (which amounts to a rather higher daily wage than figure painters, if only they had the custom), while teachers—on rates of between 50 and 250 denarii per pupil per month—presumably earned somewhat less (unless they took on a great many pupils), but had more security of income. Lawyers received 250 denarii for opening a case and 1000 for pleading it.

The broad picture painted by the edict (which unfortunately excludes any mention of marble carving or sculpture) is of artists occupying a relatively high place on the scale of craftsmen. But this was, in effect, the lowest wage-earning scale among freedmen and Roman

citizens (and it is the only scale with which the edict bothers), stretching down to sewage workers and farm hands. The tax exemptions for artists and artisans of all kinds enacted by fourth-century emperors from Constantine to Valentinian I, in order to combat a shortage of such craftsmen, support this impression.[3] The list of professions appended to a law promulagated under the name of Constantine in AD 337, includes painters, sculptors, workers in mosaics, and architects alongside potters, glass-workers, step-makers, blacksmiths, and carpenters, as well as physicians.[4] None of this represents anything like the status achieved by famous artists in the Renaissance or after. One might think that the exclusion of sculpture from Diocletian's edict means that its creators were more valued and paid better than other artists. Yet, as the Constantinian list of professions implies, this is unlikely. In a fascinating essay, which purports to be autobiographical, Lucian comments in the mid-second century AD on the sculptor's lot—a profession which he claims to have thought seriously of taking up but which, needless to say, he rejected in the interests of a rhetorical education. A sculptor

will be nothing more than a workman, doing hard physical labour . . . an obscure person, earning a small ignoble wage, a man of low esteem, classified as worthless by public opinion—neither courted by friends, feared by enemies, nor envied by fellow citizens—just a common labourer, one of the swarming rabble[5]

Worse still, 'even if you should become a Polyclitus or a Phidias', Lucian is told, 'and should create many marvellous works, everyone would praise your craftsmanship, to be sure, but no one who saw you, if he had any sense, would want to be like you; for no matter what you might be, you would be considered a workman, a man who has naught but his hands, a man who lives by his hands'.[6]

The value of art

However, this comparatively lowly estimate of the material worth of the artist's craft (even that of figure painters and sculptors) is complicated by the very high prestige of art itself. This is well illustrated by an interesting disagreement in Roman law about the ownership of painted panels. In a passage from the *Institutes* of Gaius, a jurist writing in the second half of the second century AD, we find the following passage:

What a man builds on my land becomes mine by natural law, although he built on his own account, because a superstructure goes with the land. Much more is this the case with a slip which someone has planted on my land. . . . On the same principle, it has been held that what another has written on my paper or parchment, even in letters of gold, is mine, because the lettering goes with the paper or parchment. . . . But if someone has painted on

my panel, namely an image, the contrary is held, the opinion preferred being that the panel accedes to the image. The reason supporting this distinction is hardly satisfactory.[7]

Gaius is unhappy at the break in the legal principle, but accepts that the special quality imbued to a wooden panel by the hand of an artist transforms its value to such an extent that, in the case of a dispute, the ownership must go to the patron of the artist and not to the owner of the panel itself. It is not the value of the materials placed on the panel which makes the difference (since even gold lettering fails to transfer the ownership of parchment to the scribe), but implicitly the quality of the artist's work. While Gaius does not overtly discuss the issue of artistic quality, the revision of his *Institutes* commissioned by the sixth-century emperor Justinian (promulgated in AD 533) is explict:

If one person paint on another's board, there are some who think that the board accedes to the picture while others hold that the picture, whatever it be, accedes to the board. To us, however, it is preferable that the board accede to the painting. For it is absurd that a painting by Apelles or Parrhasius should, by accession, become part of a cheap board.[8]

The early third-century jurist, Paulus, who was an official at the courts of Septimius Severus, Elagabalus and Severus Alexander, comes down on the other side from Gaius and Justinian in considering the same dispute. But he too concedes the point about the value of the painter's handiwork:

Whatever is written on my paper or painted on my board becomes mine. Although in the case of a painting some writers have held the opposite, on account of a painting's value, yet where one thing cannot exist without the other, it necessarily accedes to the other.[9]

Here, Paulus insists on the consistency of legal precedent and gives its philosophical basis as a matter of existential priority. Yet he accepts that there is a special value in art, which he expresses in economic terms (the word he uses in Latin, *pretium*, is the normal word for 'price'). While all the jurists agree about the value of the artist's work, the precise emphasis—implying cost or quality—is different: Paulus talks of cost, while Justinian's reference to Apelles and Parrhasius suggests the magic touch of genius.

What is significant art-historically in all these discussions, is not the dispute about ownership but the legal consensus that the hand of a master-painter has wrought a significant transformation to the nature of the object. The value—economic and aesthetic—of the artist's intervention is such that both Gaius and Justinian, despite some discomfort at introducing the kind of incongruous precedent which Paulus will not countenance, have no doubt in transferring the ownership from the person who possessed the wooden board to the person

who paid for the painting. Here, art clearly has a very significant place in the cultural imagination—so much so, that it transforms legal convention. What we cannot know is whether an actual case like this dispute ever really came before the courts, or whether this was a textbook exercise. Either way, however, it is not clear whether it was the artistry of specific paintings which swayed the lawyers' deliberations or whether it was the mythical status of canonical geniuses like Apelles and Parrhasius which implied a potential absurdity in allowing the painting's ownership to accede to the panel. The judgement of Justinian explicitly envisages the possibility of work by a modern artist of the quality of Apelles being the subject of dispute, unless it refers to *copies* of famous paintings by canonical artists, like Apelles and Parrhasius. If a case of this sort ever came to court, the lawyers must have seen themselves in the unenviable position of judging the disputed image's *artistic quality* and therefore they preferred to assert a general principle (even if it is one on which they failed to agree). What the whole debate clearly demonstrates is that art was inextricable from the issue of quality, and that quality came down to the special skill of the artist's hand.

Ideal and actual

It may be that the difference in the estimate of art implied by the evidence of Diocletian's edict by comparison with the legal discussion of images depends on the difference between actual art produced in the contemporary world and the canonical nature of priceless masterpieces by the famous artists of the past. While all art offered the potential that its artist would be another Apelles, this (perhaps rather remote) possibility was clearly not going to be reflected in the wages paid to a journeyman painter doing a couple of walls in a villa. Like the modern art market, antiquity's art world encompassed a complex mixture of attitudes from pragmatism to esteem, from value-for-money to high culture and cost, from making an environment socially acceptable to the heights of good taste. Between the poles at either end of this range (from cheap to priceless) there oscillated the constant play of desire, whereby owners, artists, and viewers wished their favoured works—both individual objects and whole collections—to be masterpieces like those in the canon.

Whatever the actual esteem and pay accorded to artists in the Roman empire (and the evidence points relatively low), there is no doubt about the virtually divine status of the great masters of Greek antiquity. Throughout our period, the history of Greek art as the triumphant development of naturalism (recounted in greatest surviving detail in the Elder Pliny's *Natural History*, books 34, 35, and 36, written in the second half of the first century AD) was a subject of frequent

discussion or reference.[10] It is a story in which near-mythical artists, geniuses whose illusionistic panache could deceive even nature herself, became the subject matter of anecdotes and wonder-tales. From legal arguments (like Justinian's ruling in his *Institutes*) to novels, such as the *Satyrica* of Petronius, from philosophical text books to rhetorical speeches and lectures, the names of Zeuxis, Parrhasius, and Apelles among painters, and of Daedalus, Polyclitus, Phidias, Praxiteles, and Lysippus among sculptors, served as archetypal clichés of the ultimate achievements of the human hand.[11] Those enthusiasts who, like Pausanias in the second century, travelled sufficently in Greece and saw enough of the art, were able to acquire considerable connoisseurial expertise in the identification of artists from their surviving and often anonymous works.[12]

The consequences of such esteem for the art of the past were significant. Visual art was seen as an activity which could, in the hands of its finest practitioners, transmute mere stone or pigment through the alchemy of genius into images so life-like that—if only for a delirious moment—one might imagine they were real. In the words of the Elder Philostratus, 'whosoever scorns painting is unjust to truth and unjust also to the wisdom of the poets', while his grandson, the Younger Philostratus, claims that a true master of painting 'must have a good knowledge of human nature and must be able to discern the signs of men's character even when they are silent—what is revealed in the state of the cheeks and the expression of the eyes and the character of the eyebrows and, to put the matter briefly, whatever has to do with the mind'.[13] These high claims about the artist's special access to truth or to the understanding of the mind through the body, were reinforced on the technical level by a series of famous stories in which paintings or sculptures by the masters deceived people or animals into believing that the image was the real thing. One of the anecdotes related by Pliny about the painter Zeuxis tells how

he painted a picture of a boy carrying grapes, and when birds flew up to the fruit, he strode up to the picture in anger with it and said, 'I have painted the grapes better than the child, since if I had rendered the boy perfectly, the birds would inevitably have been afraid of him'.[14]

Just as Zeuxis' grapes deceived the birds, so the most alluring of sculptures—like Praxiteles' famous statue of Aphrodite at Cnidos—were imagined to have seduced several of their human viewers into attempting sexual intercourse.[15]

However little actual craftsmen were paid and however obvious it may have been that their imitations of famous works of the past were but poor copies, the excellence of a fine painting or sculpture could provoke a scintillating rhetorical response from ancient orators and art critics. As Lucian puts it, writing of a beautiful house, a prize object

'excites the speaker's fancy and stirs it to speak, as if he were somehow prompted by what he sees'.[16] Like the legal disputes, it is not clear to what extent the surviving descriptions of art—especially those by Lucian from the second century, the Elder and Younger Philostratus, both writing in the third century, and Callistratus, perhaps writing as late as the fourth century—were actual responses to real objects or were textbook exercises in one of the specific set-piece skills demanded by rhetorical training (technically called *ekphrasis*, or description). But because the overt object of *ekphrasis* was vividness—bringing the image to the mind's eye through the orator's words—such descriptions are excellent evidence for how Greeks and Romans looked at art.[17] They not only reveal ways of seeing, but they also express many of the culturally sanctioned opinions and assumptions which underlay Graeco-Roman responses to art.

In Callistratus' description of a statue of Dionysus, which he ascribes to Praxiteles, the great cachet afforded to naturalism and the orator's attempt to compete verbally with the visual masterpiece, combine to give his account a hyperbolic touch.

Daedalus . . . had the power to devise statues endowed with motion and to compel gold to feel human sensations, but in truth the hands of Praxiteles wrought works of art that were altogether alive. There was a grove and in it stood Dionysus in the form of a young man, so delicate that the bronze was transformed into flesh, with a body so supple and relaxed that it seemed to consist of some different material instead of bronze: for though it was really bronze, it nevertheless blushed, and though it had no part in life, it sought to show the appearance of life and would yield to the very finger-tip if you touched it, for though it was really compact bronze, it was so softened into flesh by art that it shrank from the contact of the hand. It had the bloom of youth, it was full of daintiness, it melted with desire.[18]

The orator's great longing for the statue to be alive, as if that were the supreme goal of naturalism, is transferred on to the statue itself. It is so life-like, so supple, so soft and flesh-like that it too feels desire. We are introduced to it not as a statue but as Dionysus himself who takes the form of a boy in a grove (as the god had the power to do) and happens —it then transpires—to be made out of bronze, although bronze so miraculously unlike itself that it is virtually flesh. The description infuses the viewer (or listener) into its imaginary world; it encourages us to touch and to find the image—like a real person—both yielding to and shrinking away from contact. Callistratus incorporates a reference to the development of art history into his *ekphrasis* by beginning with Daedalus, traditionally regarded as the first great sculptor (and almost certainly a mythical figure), whose work not only rivals reality by endowing statues with motion but can even make inert material like gold feel human sensations. Daedalus is surpassed by Praxiteles, who

flourished in the fourth century BC, whose statue is 'altogether alive', not only in its physical verisimilitude but because it can feel emotions. As Callistratus puts it later in the *ekphrasis*:

It wholly passed the bounds of wonder in that the material gave out evidence of joy and the bronze feigned to represent emotions. . . . The eye was gleaming with fire, in appearance the eye of a man in frenzy; for the bronze exhibited the Bacchic madness and seemed to be divinely inspired, just as, I think, Praxiteles had the power to infuse into the statue also the Bacchic ecstasy.[19]

As Praxiteles surpasses Daedalus, so Callistratus caps even this achievement by presenting the artist as a divine magician who can imbue Dionysus himself, the god of frenzy, with his own sacred madness. Whether this final achievement belongs to the handiwork of Praxiteles or to the rhetorical brilliance of Callistratus himself, is a question the text leaves open for us to reflect upon.

Like Justinian's legal reference to Apelles and Parrhasius, this description is an entirely hypothetical case. It does not matter whether Callistratus was writing of a particular statue of Dionysus, or whether the statue was actually the work of Praxiteles or some later copyist. It does not even matter if Callistratus had no statue in mind at all. Rather, he demonstrates, with great rhetorical virtuosity, how the cultured Graeco-Roman viewer could read into works of art a highly sophisticated fantasy of naturalism and desire in which the apparently objective world of images was deliciously, but at the same time alarmingly, elided with the subjective world of the viewer's imagination. While we cannot relate this *ekphrasis*, nor any others in the works of Lucian, the Philostrati, or Callistratus, directly to an extant work of art, it clearly offers a range of insights into how ancient viewers might have chosen to relate with images (for example the sarcophagus with Dionysus, now in Baltimore [**100**], or the Coptic tapestry showing the god, now in Bern [**73**]).

These texts show how the idealist desire for art to emulate, even to replace, the real, could thrive in the post-canonical era of the Second Sophistic and late antiquity. Despite there being no new Apelles, the rhetoric of the visual imagination was more extravagant and sophisticated than anything surviving from an earlier era.[20] Even if our period did not see itself as creating art which could compete with the masterpieces of the past, it undoubtedly generated a culture of learned and creative appreciation which was crucial to the reception of the arts which it fostered and created, and which this book has explored. The *ekphraseis* are, in their own right, as important for the history of ancient art as are the surviving objects themselves.

The transformation of culture and the discourse of art

It is impossible to put a certain date on the writing of Callistratus, though the scholarly consensus would suggest the late third or early fourth century AD. His work represents a series of what have been called 'Hellenic' attitudes and rhetorical techniques for describing art which would survive long into Byzantium, even though the naturalistic images to which such descriptions related would eventually stop being made. But already, by comparison with earlier *ekphrasis*, Callistratus represents a turn towards a *religious* view of the world which would be characteristic of the Christian middle ages. His work fuses the religious appreciation of images, which we explored in Chapter 8, with the aestheticist celebration of illusionistic effects inherited from the kinds of art criticism represented by the Elder Pliny and the Philostrati. The very naturalism of Praxiteles' Dionysus is an aspect of what Callistratus presents as the statue's divine power: this is a sacred image partly *because of* its naturalism, just as Praxiteles' Aphrodite was sacred in part because she had the power to seduce real men into loving her. Callistratus makes this point explicitly when describing another statue also said to be by Praxiteles:

My discourse desires to interpret another sacred work of art: for it is not right to refuse to call the productions of art sacred. The Eros, the workmanship of Praxiteles, was Eros himself, a boy in the bloom of youth with wings and a bow. Bronze gave expression to him, and as though giving expression to Eros as a great and dominating god, it was itself subdued by Eros; for it could not endure to be only bronze, but it became Eros just as he was.[21]

Here all the rhetorical clichés for describing art as perfect naturalism are employed to represent the image not only as an example of sacred art but as a divine being in its own right, imbued with the living power of the god of love.

With the rise of Christian culture and interpretation, such overtly subjective and fantasy-driven responses to images would be replaced by more scripturally founded (and, in that sense, objective) ways of viewing. Some Christians showed a marked resistance to images altogether, considering them to convey the whiff of pagan practices and idolatrous behaviour, or at best to imply frivolity.[22] The more philosophically inclined of the Church Fathers had a strong argument against the very deceptions of naturalism so praised by Graeco-Roman art critics, like the Younger Philostratus, who wrote:

The deception inherent (in naturalistic art) … is pleasurable and involves no reproach; for to confront objects which do not exist as though they existed and to be influenced by them, to believe that they do exist, is not this, since no harm can come of it, a suitable and irreproachable means of providing entertainment?[23]

Against the justifications of such deception, Epiphanius, bishop of Salamis, who died in AD 403, insisted on calling a spade a spade. He called it 'lying', and wrote that artists

lie by representing the appearance of saints in different forms according to their whim, sometimes delineating the same persons as old men, sometimes as youths, and so intruding into things which they have not seen.[24]

Likewise, St Augustine (AD 354–430) wrote that art was 'unable to be true'.[25] The insistence on truth and the highly moralistic attack on 'lying' were a forceful assault on the values of naturalism. But they only persuaded a small elite of theologians. The Christian community as a whole embraced art with enthusiasm.

What is perhaps more surprising is that the language of ancient art criticism (as practised by the Philostrati and Callistratus), and the rhetorical training which fostered it, survived virtually intact.[26] As late as the ninth century, the great scholar Photius (c.810–c.893), Patriarch of Constantinople, delivered a homily to celebrate the mosaic icon of the Virgin and Child, installed in the apse of the church of St Sophia in 867. Using philosophical and art-historical language borrowed from his deep immersion in the Classical tradition, as well as the formulations of Christian theology, Photius said:

Through art we see a lifelike imitation of her. She looks with affection at the child, yet her expression is detached and distant towards the emotionless and supernatural child. She looks as though she might speak if one were to ask her how she could be both virgin and mother, for the painting makes her lips seem of real flesh, pressed together and still as in the sacraments; it is as if this is the stillness and the beauty of the original.[27]

Like Callistratus, Photius uses the ancient Greek language of imitation and naturalism—although he describes a mosaic (that still survives) which we would not today label 'naturalistic'. Like Callistratus, and the Elder Philostratus before him, Photius imagines a direct address to the Virgin, to which she might reply—just as Praxiteles' Dionysus yielded to and at the same time shrank from Callistratus' imagined touch. Yet, what Photius means by the language of imitation and lifelikeness is no longer an emulation of the external world but rather of what he terms variously the 'still', 'supernatural' and 'sacramental' vision of divine grace, as explicated by Christian theology. This Virgin is 'lifelike' in that she imitates (perfectly, as far as Photius is concerned) an abstract, or theological, relationship inconceivable in ordinary life: 'A Virgin with a Child reclining in her arms for our salvation is a Christian mystery. She is both mother and virgin at the same time, but no shame to either condition'.[28] By a wonderful inversion, the ancient language of naturalism has become, in Christian discourse, elegantly adapted to the description of spiritual mystery. As in

Callistratus, naturalism—the fact that the image is so lifelike, that its lips appear like real flesh—becomes a means of asserting the icon's special status as an image divinely imbued by the spirit of the Virgin herself.

The very conservatism of the Byzantine discourse of art, coupled with its careful transmutation of the kinds of objects which it sought fit to describe, points to the great subtlety of the transformation from Classical to Medieval culture. Even in the area of religion, Photius proves that there was no brutal rupture with all the established norms of ancient Hellenism. Though the effects of Christianization may seem radical from a modern standpoint, they were achieved through much deliberate modulation as well as some outright rejection, through great appreciation of the traditional heritage as well as the abandonment of some of its parts, through a long negotiation of the relationship of Christian identity with its different and often mutually exclusive pasts. Just as many traditional (even 'pagan') motifs, like the images of gods, survived well into the sixth and seventh centuries, so the language of art-appreciation and even the legal categories by which images were assessed (as is shown by Justinian's *Institutes*) were to become a key element of the visual heritage created by medieval culture. Ultimately, in the context of a chapter concerned with discourses of value, even 'classicism' itself would become a highly appreciated criterion of excellence.

DOMINVS ECCLESIAE
CONSER PVDENTI
VATOR ANAE

L

Afterword: Some Futures of Christian Art

In the long term, the effects of the Christianization of the Roman world were overwhelming; they are impossible to quantify. In every area of life and in every part of the empire upon which this book has touched they were to be felt—at different rates, to be sure, and with different results. While religious life and its images showed fundamental changes as early as the mid-fourth century, some aspects of élite or aristocratic secular luxury survived as late as the seventh and eighth centuries. While the forms of most kinds of art may have abandoned naturalism by the mid-fifth century, the discourses for describing art (with their high estimation of naturalism) continued, as we have seen, long into Christian Byzantium to the ninth century and beyond.

In this brief afterword, I want to hint at some aspects of the future of Christian art which were forged in the crucible of late antiquity. First, Christianity caused significant ruptures in narrative representation, engendered by the reliance on a canonical scripture and its interpretations. Second, despite all the apparent changes, the most archetypal of Christian images, the portrait icons of Christ, the Virgin, and the saints, showed striking continuities with the polytheistic cult of images as palladia and idols, which we explored in Chapter 8. Together, icons and narratives show how, in different ways, mature Christian art adapted the visual regimes of its Graeco-Roman inheritance, through both continuity and change, to the needs of western medieval and Byzantine religious culture.

From scripture to symbolism

In visual terms, Christianity brought a new relationship between images and their referents, a relationship of dependence in which the image relied on a prior text—a scripture—for its meaning. We have already seen this post-Christian priority of the text in the case of a famous Classical manuscript, the Vatican Vergil [74]. Now let us look at a page from what is possibly the oldest of all surviving illuminated codices—the velum fragments of the Quedlinburg Itala, a Latin manuscript of the Books of Samuel and Kings, probably written and illuminated in the second quarter of the fifth century in Italy.[1]

Only five folios of what were once more than 200 have survived the

161

The Quedlinburg Itala, velum codex, illuminated manuscript of the Books of Samuel and Kings, fol. 2r. Probably made in Rome, second quarter of the fifth century AD.

manuscript's dismemberment in the seventeenth century. The surviving leaves were used by a bookbinder in the German city of Quedlinburg who cut down the pages, covered the pictures with paste, and glued them inside three book-covers, from which they were rescued in the nineteenth century. Four of the five surviving folios had full-page illuminations on one side and, on the other, the Itala text of the Old Testament, the early Latin translation of the Greek Septuagint version of the Bible (current before St Jerome's Vulgate text, translated from the Hebrew and finished in about AD 400, which gradually superseded the Itala during the fifth century). Folio 2r [161] is a visual narrative encompassing four scenes from the first Book of Samuel, chapter 15.[2] Reading from left to right, top to bottom, the pictures tell how the prophet Samuel, in a carriage drawn by two horses, comes upon Saul, king of the Israelites, in the act of making sacrifice in the city of Gilgal (first scene). The king stands in the typical libation-pouring position of a Roman emperor (see **23**, for example), with two attendants. Samuel informs Saul that God has rejected his kingship because he spared Agag, king of the Amalekites. In the second scene, on the top right, Samuel turns to leave the king, who grasps the prophet's mantle. In the third image, on the bottom left, two scenes are

conflated. Agag (on the far left) begs Samuel for mercy; on the right-hand side, Samuel and Saul raise their hands in prayer together for the last time. In the final scene (very badly abraided), Samuel kills Agag in the presence of Saul outside the walls of Gilgal.

This is clearly a painstaking visual rendering of the text (verses 13–33 of chapter 15), which began on the verso of the illumination (verses 10–17 of chapter 15) and was presumably continued on the book's following pages. Even a cursory glance at the miniature reveals that it is covered with inscriptions. These are of two kinds. After he completed the images, the artist added highlights in gold and wrote labels identifying the action and the pictures in gold script. In the finished version of the codex, the reader would have had both the main text and these label summaries to help decipher the illumination. The otherwise disastrous gluing of these miniatures to book-covers in the seventeenth century, which has led to the loss of a great deal of the painted surface, has had the beneficial effect of revealing quite complicated written instructions to the artist which were inscribed beneath the illuminations and which make up the bulk of the now visible writing. In the first scene, for instance, the instructions read: 'You make the prophet speaking from his carriage facing King Saul sacrificing, and the king's two attendants'. The gold labels read: 'Samuel going down to Gilgal' and 'Saul making a burnt offering'. The artist followed a time-honoured iconographic formula for Roman sacrifice in the image, but in his label he referred back to the Biblical text written on the other side of the illuminated page (and not solely to his instructions) since he chose the scriptural word *holocaust* for 'burnt offering' and not the Latin term (*sacrificium*) used in the instructions. By contrast, the attendants are nowhere mentioned in the Bible, but appear in the image as a direct result of the written instructions. In the third scene (on the bottom left), the artist disregarded or misunderstood his instructions. The instructions say: 'You make where King Saul entreats the enraged prophet that they beseech God on his behalf, and Agag begging to be forgiven'. However, the artist showed Agag beseeching Samuel for mercy first, and—instead of Saul entreating Samuel—he painted second the joint act of prayer which Saul had requested.

All this indicates a highly literary kind of art—both in its making and in its reception. The artist follows specific instructions and may refer also to the Biblical text. His miniature is a visual preface to the scriptural texts it illustrates, which occupy the pages immediately after this picture. But the image is also a commentary on the words, transforming them in certain respects and isolating particular elements of the narrative as more significant or essential. It reduces the text (some 20 verses in all) to four discrete pictures—though one of these, at least, (the third picture, at the bottom left) contains two distinct scenes where the prophet Samuel appears twice. Crucially, the illumination

visualizes the Hebrew world of a Jewish scripture (which here appears in a Latin translation of a Greek translation of the original) in entirely Graeco-Roman terms. In the first scene, for example, Saul is represented as a typical late-Roman emperor in white tunic, cuirass and purple cloak, performing one of the iconic acts of imperial imagery, officiation as a sacrificial priest. Behind Samuel, are the remains of what was originally painted to be a triumphal arch, or perhaps the city gate of Gilgal, rendered as an archetypal Roman public monument. This is a good instance of the consummate way early Christian art operated to naturalize Christian themes in a Roman context, just as the art of the Second Sophistic had rendered Greek themes in such a way as to be generally accessible to Roman as well as Greek consumers. In this way, the cause of Christianization was visually presented as more acceptable, since it was made more familiar.

The specially literary and commentarial nature of the miniatures of the Quedlinburg Itala, whose five damaged leaves must stand for the whole of the earliest Christianity's production of illuminated manuscripts, signals a shift from the art of earlier Roman tradition. The visual imagination, allowed such free rein to fantasize naturalistic illusions in the Philostrati and Callistratus, is constrained by the illuminations' scriptural prototype within the rich—but different—possibilities of textual commentary, comparison, and interpretation. Of course, the illustrations of a book are much more closely text-bound than, say, the mosaics of Sta Maria Maggiore [**153**], or the doors of Sta Sabina [**152**] or the Brescia casket [**160**], none of which could be so conveniently compared with the Biblical texts they represent. But narrative cycles in Christian art would inevitably be more closely tied to canonical scripture and its theological interpretation than the much less dogmatic mythological narratives of antiquity. While it is true that pre-Christian images had interpreted texts, especially the works of Homer, and that astute critics like Philostratus or Pausanias were swift to notice when an image strayed from its literary prototype,[3] there were never the same religious demands for scriptural accuracy, or the constraints of belief, which would—in Christian imagery —have made showing Christ die by any other means than crucifixion (for instance) seem utterly unthinkable.

Pictures remained, in the words of the erstwhile Roman governor and later Christian bishop, Paulinus of Nola (AD 353–431), 'empty figures'. The only sure way to Christianize them was to insist on a Christian interpretative attitude when confronted by art. In part, this was the purpose of written labels, like those of the Quedlinburg Itala. In one of his poems, describing the paintings of Old Testament themes with which he had adorned the new basilica he built at the end of the fourth century for his chosen martyr, St Felix, at Nola in southern Italy, Paulinus wrote:

Now I want you to look at the paintings which adorn the portico in a long series. Crane your neck a little till you take in everything, tilting back your face. The man who looks at these and acknowledges the truth within these empty figures, nurtures his believing mind with an image which for him is not empty.[4]

The way to nurture the mind of faith was to reinforce scripture by reading art as a Biblical text, visually realized on the church's walls. Paulinus goes on to describe how the paintings contain 'everything' written in the Old Testament, including specific references to the Books of Genesis, Exodus, Joshua, and Ruth, how they are above all designed for the illiterate (and erstwhile pagan) peasants who flock on pilgrimage to St Felix's tomb, how each image is—like the Quedlinburg Itala—'explained by inscriptions, so that the script may make clear what the hand has exhibited'.[5] In effect, Paulinus' paintings in Nola are a Quedlinburg Itala writ large on the church's walls: the sacred word is realized as image.

In a letter written in 403, Paulinus again describes the images in the basilica at Nola and in another church he had founded at Fundi. There he includes examples of the poems he composed to explain the paintings and the apse mosaics, which were inscribed in the church's walls. Paulinus' poems extend the scriptural frame of reference to a fully theological commentary. For example,

the apse (of the martyrium of St Felix), which has a floor and walls of marble, is adorned by a vault of luminous mosaics: their pictures are explained by the following verses:

In full mystery sparkles the Trinity:
Christ stands as a lamb, the voice of the Father thunders from heaven
and in the form of a dove the Holy Ghost flows down.
The Cross is surrounded by a wreath, a bright circle,
and around this circle the apostles form a ring,
represented in a chorus of doves.
The holy unity of the Trinity meets in Christ,
but the Trinity has its threefold symbolism:
being revealed as God by the Fatherly voice and the Ghost,
the Cross and the Lamb testifying Him as the sacred sacrificed One,
Kingdom and Triumph being indicated by the purple and the palm.
Christ Himself, the Rock of the Church, is standing on a rock
from which four seething springs issue,
the Evangelists, the living streams of Christ.[6]

While the images along the arcade of the nave (which is probably what Paulinus means by the archaizing word 'portico') are direct realizations of Old Testament narratives, like those of Sta Maria Maggiore, the mosaics of the apse have become highly allusive symbols referring to a complex theology which Paulinus explains at some length in his inscriptions.[7] The images of the apse are not comprehensible through

162

Papyrus Goleniscev, papyrus codex, fol. 6v (fragment). From Alexandria, perhaps early fifth century AD.

This papyrus fragment of an Alexandrian chronicle has a marginal image of the Patriarch Theophilus trampling the temple and idol of Serapis beside the description of the events of the year 391/2. The remains of the inscription 'the holy Theophilus' have been detected above his halo. This image is an early example of the kinds of visual polemic (especially against idolaters, pagans, and heretics) which subsequently became prominent in the Byzantine and western iconographic repertoire.

scripture alone (which did not articuate the doctrine of the Trinity, for example) but through a tradition of theological exegesis, constantly alluding to scripture, by which one might understand for instance that the lamb was Christ, the apostles doves, and the evangelists 'the four seething springs'. The entire visual experience of St Felix's church is envisioned as a three-dimensional confrontation with theology—a physical process of walking through scripture from the Old Testament in the nave to the dogmas of the Incarnation, the Trinity, and the established Church in the apse. The movement is not only from the Old Testament to the New, but also from the relative simplicity of scriptural illustration to the intellectual complexity of full theological

symbolism. In effect, Nola is an early but already highly sophisticated example of what would become the spectacular flowering of visual theology, which is perhaps the supreme achievement of the arts of the middle ages.

From idol to icon

When a Christian mob assaulted the great temple of Serapis in the south-west corner of Alexandria in AD 391, their first target was the cult statue of the god, which had reputedly been created out of precious materials by the Athenian sculptor Bryaxis in the fourth century BC.[8] In the marginal illustrations of a (now very fragmentary) Alexandrian chronicle written on papyrus perhaps shortly after the destruction of the Serapeum, Patriarch Theophilus of Alexandria (bishop 382–412) is depicted, codex and crozier in hand, standing in triumph over the temple and its condemned idol [162].[9] Given the virulent Christian reaction against the pagan abomination of idolatry, it is strange that the icons—which were to become among the most archetypal forms of Christian art—should be so deeply indebted to ancient polytheism's worship of images.[10] Like countless pagan pictures and statues in Graeco-Roman times, from Serapis to Artemis of the Ephesians [134], the late sixth- or early seventh-century icon of St Peter, now at Mt Sinai [163], was carried in liturgical processions, kissed and touched during ritual, worshipped as a visual embodiment of the divine being it represented.[11] Nearly a metre high and more than half a metre wide, this virtually life-size portrait carries no scriptural inscriptions and represents no scene from Biblical narrative. The saint is identified by the iconography of his face and by the keys which he holds in his right hand; perhaps his name would have been written on the (now lost) frame which surely surrounded the image. This is a portrait of a saint whose specific significance as rendered by this icon, like Elagabalus' black stone Baal from Emesa, lies outside time and makes no direct allusion to narrative.

By comparison with the minute attention to Biblical texts in the Quedlinburg Itala or Paulinus' decorations at Nola, the St Peter from Sinai seems defiantly anti-scriptural, anti-theological. Indeed, it was only in the eighth and ninth centuries that Christian theology caught up with portrait images like this and was able to theorize their acceptability.[12] Instead of looking to the scriptural tradition introduced by Christianity and affirmed by so much Christian art, the St Peter boasts of an altogether more ancient heritage. Not only is its function, as a cult image, heavily indebted to pre-Christian precedent, but its form, technique, and iconography all look back to antiquity.

The Sinai St Peter, like the 'Jewellery girl' [75] and many other Romano-Egyptian mummy portraits, was painted in wax encaustic

Icon of St Peter, encaustic
on wooden panel from the
Monastery of St Catherine
at Mt Sinai but of unknown
original provenance, second
half of the sixth century AD.

on a thin wooden panel.[13] Above the saint, in three roundels, like the
imperial portraits on many a consular ivory diptych from the sixth cen-
tury, are images of Christ in the centre, and (probably) St John the
Evangelist and the Virgin. Like St Peter himself, none of these figures
is labelled. The whole form—of a principal figure and small busts in
circular insets above him—is reminiscent of the consular diptychs
which were contemporary with it.[14] By contrast with the frontal gaze of
St John and the Virgin, Peter turns slightly to the left and his face (in
comparison with their very pale complexions) is rendered warmly with
the colouring of flesh. These late throwbacks to the traditions of natu-
ralism culminate in the perspectival niche (complete with classical
ornament) which serves to locate Peter within an illusionistic space.
But the niche is used to create a hieratic setting which focuses the
beholder's gaze on the cult image of the saint: its perspective, like the
arched niche over Theodosius in the Madrid Missorium [**56**], is in the
service of an isolating and focalizing aggrandizement of an essentially
sacred figure.

 Although its creation lies well outside our period, this image is an

excellent test of how deep was the debt which Christian art owed its Roman past. One of the few surviving products of the rise of the cult of icons in the later sixth century,[15] the Sinai St Peter negotiates Christianity's complex dynamics in relation to the Classical tradition. In its function, it comes as close as Christian art would ever come to emulating ancient practices of image worship.[16] The very creation of icons like this would give rise to an iconoclastic reaction during the period known as Byzantine Iconoclasm (AD 726–843) and to a highly theological justification of images in response to Iconoclasm, which would be perhaps the defining events in all Byzantine art.[17] In its forms and techniques, the St Peter panel shows a virtuoso application of the Classical heritage to religious uses and visual traditions, already firmly rooted in non-naturalism, which belong to the Christian middle ages. This is not an object which could have been produced as early as the middle of the fifth century (strictly the end of the period with which this book deals), though non-scriptural sacred portraits, like the St Agnes medallion [159], gesture towards its inception. Nor is the icon in any sense part of a 'paganizing' revival in its intentions or the responses accorded to it, though icons like this featured in cures, visions, dreams, and pilgrimage, just like the cult images of pre-Christian Graeco-Roman antiquity. Rather, the Sinai St Peter's classicism testifies to the power and longevity of the Hellenistic tradition well into the heart of late antiquity's most Christian monastic communities. It shows how—despite the sophistication and elegance of medieval art's visual manipulations of scripture, and hence of textual paradigms from which to create and interpret images—there would always be room for that direct and spontaneous confrontation with the sacred or semi-divine presence, which Roman art—in its imperial, funerary, and especially its religious guises—had developed to such a superlative degree.

Ultimately, Christian objects like the Quedlinburg Itala and the St Peter icon tell, in their different ways, an interestingly complex story about Christianization. Just as the Roman empire would eventually be Christianized, so—through borrowings and references of many kinds—Christianity itself was profoundly Romanized. The process of cultural transition, in the realm of the visual arts and elsewhere, was one of multiple facets of influence and appropriation, with as great a tendency to look backwards as there was to look ahead. The great break which it has been traditional to impose between late antiquity and the 'Dark Ages', or between Roman art and early Christian art, is a modern rhetorical fantasy.

Notes

Abbreviations used here and in the Bibliographic Essay are as follows: *AJA: American Journal of Archaeology*; *CIL: Corpus Inscriptionum Latinarum*; *DOP: Dumbarton Oaks Papers*; *JbAC: Jahrbuch für Antike und Christentum*; *JDAI: Jahrbuch des Deutsches Archäologisches Institut*; *JHS: Journal of Hellenic Studies*; *JRA: Journal of Roman Archaeology*; *JRS: Journal of Roman Studies*; *MD: Materiali e Discussioni per l'Analisi dei Testi Classici*; *PBSR: Papers of the British School at Rome*; *PCPS: Proceedings of the Cambridge Philological Society*; *PG: Patrologia Graeca*; *RA: Revue Archéologique*; *REB: Revue des Etudes Byzantines*.

Chapter 2: A Visual Culture

1. On 'public' and 'private' in the Roman house, see Y. Thébert, 'Private and Public Spaces: The Components of the Domus', in E. D'Ambra, *Roman Art in Context* (Englewood Cliffs, 1993), 213–37 and in P. Veyne (ed.), *A History of Private Life: From Pagan Rome to Byzantium* (Cambridge, MA, 1987), 353–82; A. Wallace-Hadrill, *Houses and Society in Pompeii and Herculaneum* (Princeton, 1994), 17–37; L. Nevitt, 'Perceptions of Domestic Space in Roman Italy', in B. Rawson and P. Weaver (eds), *The Roman Family in Italy* (Oxford, 1997), 281–98; M. George, 'Repopulating the Roman House' in Rawson and Weaver, *The Roman Family*, 299–320.
2. Cassius Dio *Roman History* 75.4–5, Loeb translation by G. Cary. On this passage, see S. R. F. Price, 'From Noble Funerals to Divine Cult: The Consecration of Roman Emperors', in D. Cannadine and S. R. F. Price (eds), *Rituals of Royalty: Power and Ceremonial in Traditional Societies* (Cambridge, 1987), 59–61. On imperial apotheosis, see S. MacCormack, *Art and Ceremony in Late Antiquity* (Berkeley and Los Angeles, 1981), 93–168 and Price, 'From Noble Funerals to Divine Cult'.

3. On this ivory, see A. Eastmond in D. Buckton (ed.), *Byzantium: Treasures of Byzantine Art and Culture* (London, 1994), 57–8 with bibliography.
4. On Dexippus, see F. Millar, 'P. Herrenius Dexippus: The Greek World and the Third-Century Invasions', *JRS* 59 (1969), 12–29.
5. My translation. The original is to be found in F. Jacoby, *Die Fragmente der Griechischen Historiker*, vol. IIA (Berlin, 1926), no. 100, fr. 6, 456–60.
6. Ammianus Marcellinus, *Res Gestae* 16.10.6–8, 10. Loeb translation by J. C. Rolfe with adaptations. On this passage, see MacCormack, *Art and Ceremony*, 39–45 and J. F. Matthews, *The Roman Empire of Ammianus* (London, 1989), 11–13, 231–5.
7. Aurelius Victor, *De Caesaribus* 39.2–4; cf. Eutropius 9.26.
8. The principal discussion of imperial ceremonial is A. Alföldi, *Die monarchische Repräsentation in römischen Kaiserreiche* (Darmstadt, 1970).
9. See J. P. Toner, *Leisure and Ancient Rome* (Oxford and Cambridge, 1995), 17–21. On competitive games and identity, see ibid. 48–9; with bibliography, 150, no.3.
10. On the Circus relief, see D. E. E. Kleiner, *Roman Sculpture* (New Haven and London, 1992), 236–7, with bibliography, 264.
11. The examples are conveniently collected by J. H. Humphrey, *Roman Circuses: Arenas for Chariot Racing* (London, 1986), 208–46.
12. On the Lampadiorum panel, see B. Kiilerich, *Fourth Century Classicism in the Plastic Arts* (Odense, 1993), 143–4, with bibliography.
13. For euergetism and the Circus, see P. Veyne, *Bread and Circuses: Historical Sociology and Political Pluralism* (London, 1990), 398–403.
14. See D. E. E. Kleiner, *Roman Imperial Altars with Portraits* (Rome, 1987), no. 120, 264–6, with bibliography.
15. On the Projecta casket, see K. Shelton,

The Esquiline Treasure (London, 1981), 72–5; Kiilerich, *Fourth-Century Classicism*, 162–5 with bibliography.

16. See for example (on the sophist Favorinus) M. Gleason, *Making Men: Sophists and Self-Presentation in Ancient Rome* (Princeton, 1995), 8–20 and (on Apuleius) Y. L. Too, 'Statues, Mirrors, Gods: Controlling Images in Apuleius' in J. Elsner (ed.), *Art and Text in Roman Culture* (Cambridge, 1996), 133–52.

17. For detailed discussion, text and bibliography, see G. M. Rogers, *The Sacred Identity of Ephesus: Foundation Myths of a Roman City* (London, 1991).

18. Sidonius, *Letters* 8.4.1. Loeb translation by W. B. Anderson, adapted. Further on Sidonius, see J. Harries, *Sidonius Apollinaris and the Fall of Rome* (Oxford, 1994). On the problems of relating his descriptions of fifth-century Gaul with archaeological data, see J. Percival, 'Desperately Seeking Sidonius: The Realities of life in Fifth-Century Gaul' Latonius 56(1997), 279–92.

19. The most accessible account of private life in antiquity is Veyne, *A History of Private Life*, which includes articles by Paul Veyne on the Roman empire, by Peter Brown on late antiquity and by Yvon Thébert on domestic architecture.

20. Lucian, *De domo* 7–8, translated by A. M. Harmon, Loeb edition.

21. Ibid., 7.

22. For some recent discussions, see L. Bek, *Towards a Paradise on Earth* (Odense, 1980), 181–203 (on the view); Wallace-Hadrill, *Houses and Society*, 3–61; J. Elsner, *Art and the Roman Viewer: The Transformation of Art from the Pagan World to Christianity* (Cambridge, 1995), 49–87.

23. For examples from Cyprus and Antioch, see C. Kondoleon, *Domestic and Divine: Roman Mosaics in the House of Dionysos* (Ithaca, 1995), 106–9; generally, see K. Dunbabin and M. Dickie, '*Invidia Rumpantur Pectora*: The Iconography of Phthonos/Invidia in Graeco-Roman Art', *JbAC* 26 (1983), 7–37.

24. On the culture of dining, see K. Dunbabin, 'Convivial Spaces: Dining and Entertainment in the Roman Villa', *JRA* 9 (1996), 66–80, with bibliography.

25. See D. Harden (ed.), *Glass of the Caesars* (Milan, 1987), 244–9, and G. Scott, 'A Study of the Lycurgus Cup', *Journal of Glass Studies* 37 (1995), 51–64.

26. Achilles Tatius, *Leucippe and Clitophon* 2.3.1–2, translated by J. Winkler.

27. On the skeleton at the feast, see K. Dunbabin, '*Sic erimus cuncti* … The Skeleton in

Greco-Roman Art', *JDAI* 101 (1986), 185–255.

28. Petronius, *Satyrica* 34, translated by J. P. Sullivan.

29. Sidonius, *Letters*, 8.4.3.

Chapter 3. Art and Imperial Power

1. Fronto, *Ad M. Caesarem et invicem* 4. 12. 6, translated by A. Birley, with adaptations.

2. On the imperial image and symbolic unity, see K. Hopkins, *Conquerors and Slaves* (Cambridge, 1978), 187–242; on the standardization of types, see S. R. F. Price, *Rituals and Power: The Roman Imperial Cult in the East* (Cambridge, 1984), 172–3.

3. Theodosian Code 9.40.17, translation in C. Pharr, *The Theodosian Code* (Princeton, 1952), 257–8.

4. Basil of Caesarea, *On the Holy Spirit*, 18.45, translated by D. Anderson. See also Athanasius, *Against the Arians* 3.5 for comparable sentiments from a similar date, with K. M. Setton, *Christian Attitudes towards the Emperor in the Fourth Century* (New York, 1941), 196–211.

5. See G. Downey, *A History of Antioch in Syria* (Princeton, 1961), 426–33 and S. Williams and G. Friell, *Theodosius: The Empire at Bay* (London, 1994), 44–6.

6. Libanius of Antioch, *Oratio* 19.60–1, translated by A. F. Norman (Loeb edition).

7. Theodosian Code 9.44, translation in Pharr, *Theodosian Code*, 246.

8. On asylum and manumission, see Price, *Rituals and Power*, 119, 192–3.

9. On images and the imperial cult, see Price, *Rituals and Power*, 188–91 with bibliography and S. R. F. Price, 'Gods and Emperors: The Greek Language of the Roman Imperial Cult', *JHS* 104 (1984), 79–95. On the procession of images at Ephesus, see G. M. Rogers, *The Sacred Identity of Ephesus: Foundation Myths of a Roman City* (London, 1991), 80–126.

10. On the site, see J. B. Ward-Perkins, *Roman Imperial Architecture* (Harmondsworth, 1981), 277, 284–5; on the image, see J. Inan and E. Rosenbaum, *Roman and Early Byzantine Portrait Sculpture in Asia Minor* (London, 1966), 70 (no. 31).

11. Cassius Dio, *Roman History*, 78.16, Loeb translation by E. Cary.

12. Price, *Rituals and Power*, 170.

13. On the Istanbul bust, see B. Kiilerich, *Fourth Century Classicism in the Plastic Arts* (Odense, 1993), 87–9, with bibliography.

14. On the image of Trajan Decius, see D. E. E. Kleiner, *Roman Sculpture* (New Haven and London, 1992), 369–71, with bibliography.

15. On third century imperial portraiture in general, see S. Wood, *Roman Portrait Sculpture 217–260 AD* (Leiden, 1986), 27–48.

16. See *Historia Augusta, Hadrian* 19.9.

17. On Hadrian's beard, its influence, and its implications, see P. Zanker, *The Mask of Socrates: The Image of the Intellectual in Antiquity* (Berkeley and Los Angeles, 1995), 198–266.

18. On the Romuliana statue, see D. Srejoviç 'The Representations of Tetrarchs in Romuliana', *Antiquité Tardive* 2 (1994), 143–52.

19. On the portraiture of Constantine, see Kleiner, *Roman Sculpture*, 433–41, with bibliography.

20. On this theme, with special reference to Nero, see J. Elsner, 'Constructing Decadence: The Representation of Nero as Imperial Builder', in J. Elsner and J. Masters (eds), *Reflections of Nero: Culture, History and Representation* (London, 1994), 112–29.

21. On Augustus' visual programme, see P. Zanker, *The Power of Images in the Age of Augustus* (Ann Arbor, 1988) and—for the propagation of that programme through the public inscription of the emperor's biography—J. Elsner (ed.), 'Inventing Imperium: Texts and the Propaganda of Monuments in Augustan Rome', in J. Elsner, *Art and Text in Roman Culture* (Cambridge, 1996), 32–53.

22. Suetonius, *Lives of the Caesars: Augustus* 28.

23. On issues of conservation and modernization, see N. Hannestad, *Tradition and Innovation in Late Antique Sculpture* (Aarhus, 1994), 13–104.

24. On Trajan's forum, see Kleiner, *Roman Sculpture*, 213–20 and L. Richardson, *A New Topographical Dictionary of Ancient Rome* (Baltimore and London, 1992), 175–8, both with bibliography.

25. On Trajan's column, see S. Settis et al., *La Colonna Traiana* (Turin, 1988), S. Settis, 'La Colonne Trajane: l'empereur et son public', *RA* (1991), 186–98, P. Veyne, *La société romaine* (Paris, 1991), 320–42, and V. Huet, 'Stories One Might Tell of Roman Art: Reading Trajan's Column and the Tiberius Cup' in Elsner, *Art and Text*, 9–31. On the possible Hadrianic date of the frieze and of the decision to bury Trajan at the base, see A. Claridge, 'Hadrian's Column of Trajan', *JRA* 6 (1993), 5–22.

26. For the columns, see G. Becatti, *La colonna coclide istoriata* (Rome, 1960).

27. On the column of Marcus, see Kleiner, *Roman Sculpture*, 295–301, with bibliography.

28. On the Constantinopolitan columns, see Kiilerich, *Fourth Century Classicism*, 50–64, with bibliography.

29. On Hadrian and Rome, see M. T. Boatwright, *Hadrian and the City of Rome* (Princeton, 1987), and especially 33–73 on the Campus Martius.

30. On the Pantheon, see K. De Fine Licht, *The Rotunda in Rome: A Study of Hadrian's Pantheon* (Copenhagen, 1968) and W. L. MacDonald, *The Pantheon: Design, Meaning and Progeny* (Cambridge, MA, 1976).

31. *Historia Augusta*, *Severus Alexander* 26.11 (Loeb translation by D. Magie).

32. Dio, *Roman History* 77. 16. 3 (Loeb translation by E. Cary).

33. A. C. Johnson et al., *Ancient Roman Statutes* (Austin, 1961), no. 259, 214.

34. Herodian 1.6.5 (Loeb Translation by C. R. Whittaker); Latin Panegyric 2 (10), 12.2.

35. On early Constantinople, see R. Krautheimer, *Three Christian Capitals: Topography and Politics* (Berkeley and Los Angeles, 1983), 41–67 and C. Mango, *Le dévéloppement urbain de Constantinople* (Paris, 1985), 23–36.

36. Eusebius, *Life of Constantine* 3.54 (translated by E. C. Richardson).

37. *Notitia Urbis Constantinopolitanae* 16.22.

38. On the Porphyry Column, see C. Mango, *Studies on Constantinople* (Aldershot, 1993), studies II–IV, with bibliography.

39. On the Barletta Colossus see Kiilerich, *Fourth Century Classicism*, 236, n. 789; on the Theodosian base, ibid., 31–49, with bibliography.

40. CIL III. 737, translation by B. Kiilerich.

41. On the statue of Marcus, see Kleiner, *Roman Sculpture*, 270–1, with bibliography.

42. For equestrian images on Roman coins, see P. V. Hill, *The Monuments of Ancient Rome as Coin Types* (London, 1989), 66–71.

43. For images of arches on coins, see Hill, *Monuments of Ancient Rome*, 49–55.

44. On the Arch at Benevento, see Kleiner, *Roman Sculpture*, 224–9 with bibliography and M. Torelli, ' "Ex his castra, ex his tribus replebuntur": The Marble Panegyric on the Arch of Trajan at Beneventum' in D. Buitron-Oliver (ed.), *The Interpretation of Architectural Sculpture in Greece and Rome, Studies in the History of Art* 49 (Washington, DC, 1997), 145–78 and, on this panel, S. Currie, 'The Empire of Adults: The Representation of Children on Trajan's Arch at Beneventum' in Elsner, *Art and Text*, 168–71.

45. On the Arcus Novus, see Kleiner, *Roman Sculpture*, 409–13, with bibliography.

46. On the Arch of Constantine, see Kleiner, *Roman Sculpture*, 444–55, with bibliography.

47. On the Arch of Severus, see Kleiner, *Roman Sculpture*, 329–32 and R. Brilliant, *The Arch of Septimius Severus in the Roman Forum* (Rome, 1967).

48. On the codex-calendar of 354, see M. R. Salzman, *On Roman Time: The Codex-Calendar of 354 and the Rhythms of Urban Life in Late Antiquity* (Berkeley and Los Angeles, 1990).

49. On the Probus diptych, see Kiilerich, *Fourth Century Classicism*, 65–7, with bibliography.

50. On the Missorium of Theodosius, see Kiilerich, *Fourth Century Classicism*, 19–26, with bibliography.

51. See E. Fantham et al., *Women in the Classical World* (Oxford, 1994), 350–60.

52. See K. Holum, *Theodosian Empresses: Women and Imperial Dominion in Late Antiquity* (Berkeley and Los Angeles, 1982).

Chapter 4. Art and Social Life

1. For excellent accounts of private life in the Roman empire and in late antiquity, see the essays of P. Veyne and P. Brown in P. Veyne (ed.), *A History of Private Life: From Pagan Rome to Byzantium* (Cambridge, MA, 1987). If this book has a fault, however, it is its tendency to treat visual materials as somehow accurate or transparent records which simply illustrate the text.

2. Generally on such images of work, see N. B. Kampen, *Image and Status: Roman Working Women in Ostia* (Berlin, 1981) and more briefly N. B. Kampen, 'Social Status and Gender in Roman Art: The Case of the Saleswoman' in E. D'Ambra (ed.), *Roman Art in Context* (Englewood Cliffs, 1993), 115–32. On this relief, specifically, see Kampen, *Image and Status*, 59–64.

3. Further on the Benevento benefaction relief, see S. Currie, 'The Empire of Adults: The Representation of Children on Trajan's Arch at Beneventum' in J. Elsner (ed.), *Art and Text in Roman Culture* (Cambridge, 1996) 153–81, esp. 167–72.

4. On the five-column monument, see D. E. E. Kleiner, *Roman Sculpture* (New Haven and London, 1992), 413–17, with bibliography.

5. See J. Clark, 'Hypersexual Black Men in Augustan Baths' in N. B. Kampen (ed.), *Sexuality in Ancient Art* (Cambridge, 1996), 184–98.

6. On nudity and immorality, see J. P. Toner, *Leisure and Ancient Rome* (Oxford and Cambridge, 1995), 53–64.

7. See K. Dunbabin, '*Baiarum gratia voluptas*: Pleasures and Dangers of the Baths', *PBSR* 57 (1989), 7–46, esp. 42–3.

8. See M. Henig in M. Henig (ed.), *A Handbook of Roman Art* (Oxford, 1983), 156, with bibliography at no. 63.

9. Chariton, *Chaereas and Callirhoe* 1. 14, translated by B. P. Reardon.

10. Ibid., 2. 11.

11. On domestic architecture in the empire (focusing primarily on Africa) see Y. Thébert in Veyne, *History of Private Life*, and on Pompeii (a little before our period) see A. Wallace-Hadrill, *Houses and Society in Pompeii and Herculaneum* (Princeton, 1994).

12. On Piazza Armerina, see A. Carandini, A. Ricci, and M. de Vos, *Filosofiana: The Villa of Piazza Armerina* (Palermo, 1982), K. Dunbabin, *The Mosaics of Roman North Africa* (Oxford, 1978), 196–212 and R. Wilson, *Piazza Armerina* (London, 1983), with bibliography.

13. On the Djemila Venus, see Dunbabin, *Mosaics*, 43, 134, 156.

14. On hunting in the Second Sophistic and late antiquity, see J. Anderson, *Hunting in the Ancient World* (Berkeley and Los Angeles, 1985), 101–53.

15. On the Antioch pavements generally, see D. Levi, *Antioch Mosaic Pavements* (Oxford, 1948), and esp. 236–44 on the scenes from this room. For hunting imagery from North Africa, see Dunbabin, *Mosaics*, 46–64 and for hunting imagery in Cyprus, see C. Kondoleon, *Domestic and Divine: Roman Mosaics in the House of Dionysos* (Ithaca, 1995), 271–314.

16. On the Cherchel mosaics, see Dunbabin, *Mosaics*, 114–8, with bibliography.

17. On the Circus from Piazza Armerina, see J. H. Humphrey, *Roman Circuses: Arenas for Chariot Racing* (London, 1986), 223–333.

18. For a brief discussion of the rituals of dinner, see F. Dupont, *Daily Life in Ancient Rome* (Oxford, 1992), 269–86. See also the imperial period essays in W. J. Slater (ed.), *Dining in a Classical Context* (Ann Arbor, 1991).

19. A good introduction is J. P. C. Kent and K. S. Painter (eds), *Wealth of the Roman World AD 300–700* (London, 1977), 11–62.

20. See M. Mango in D. Buckton (ed.), *Byzantium: Treasures of Byzantine Art and Culture* (London, 1994), 118–20.

21. M. Mango and A. Bennett, *The Sevso Treasure* (Ann Arbor, 1994), esp. 55–97 on the 'hunting plate'.

22. On glass in general, see J. Price in Henig, *Roman Art*, 205–19 and D. Harden, *Glass of the Caesars* (Milan, 1987).

23. On the Trivulzio cup, see Harden, *Glass of the Caesars*, 238–9, with bibliography.

24. On the Lycurgus cup, see Harden, *Glass of the Caesars*, 245–9, with bibliography and G. Scott, 'A Study of the Lycurgus Cup', *Journal of Glass Studies* 37 (1995), 51–64.

25. On *paideia* and power in late antiquity, see P. Brown, *Power and Persuasion in Late Antiquity* (Madison, 1992), 35–70.

26. Broadly on the Second Sophistic, see G. Anderson, *The Second Sophistic: A Cultural Phenomenon in the Roman Empire* (London, 1993); for education, see H. I. Marrou, *A History of Education in Antiquity* (Madison, 1956); for physiognomics, medicine, and astrology, see T. Barton, *Power and Knowledge: Astrology, Physiognomics and Medicine under the Roman Empire* (Ann Arbor, 1994); on physiognomics and sophistic self-presentation, see M. Gleason, *Making Men: Sophists and Self-Presentation in Ancient Rome* (Princeton, 1995); on dreams, see P. Cox Miller, *Dreams in Late Antiquity* (Princeton, 1994).

27. On Hellenism, see G. W. Bowersock, *Hellenism in Late Antiquity* (Cambridge, 1990), 1–13.

28. Generally on terracotta, see D. Bailey in Henig, *Roman Art*, 191–204.

29. On the Leda lamp, see J. Perlzweig, *The Athenian Agora. Vol. VII: Lamps of the Roman Period* (Princeton, 1961), 119–20.

30. Petronius, *Satyricon* 52.1, trans. J. P. Sullivan, with adaptations.

31. On such collections in late antiquity, see N. Hannestad, *Tradition and Innovation in Late Antique Sculpture* (Aarhus, 1994), 105–49, with bibliography.

32. Prudentius, *Against Symmachus* I. 502–5, trans. N. Hannestad.

33. On Coptic textiles, see H. Rutschowscaya, *Coptic Fabrics* (Paris, 1990), with bibliography and fine photographs.

34. On this tapestry, see Bowersock, *Hellenism*, 52–3, with bibliography.

35. On the birth of the codex, see C. H. Roberts and T. C. Skeat, *The Birth of the Codex* (London, 1983).

36. For a brief guide to early books see H. Y. Gamble, *Books and Readers in the Early Church* (New Haven, 1995), 42–54, with bibliography.

37. See D. Wright, *The Vatican Vergil* (Berkeley and Los Angeles, 1990), 75.

38. On illumination, see especially K. Weitzmann, *Illustrations in Roll and Codex* (Princeton, 1947) and also K. Weitzmann, *Late Antique and Early Christian Book Illumination* (New York, 1977).

39. On the Vatican Vergil, see Wright, *Vatican Vergil*.

Chapter 5. Centre and Periphery

1. See E. Doxiadis, *The Mysterious Fayum Portraits* (London, 1995), 78–9, 206; S. Walker and M. Bierbrier, *Ancient Faces: Mummy Portraits from Roman Egypt* (London, 1997), 57–8.

2. See M. Colledge, *The Art of Palmyra* (London, 1976), 70–1, 258; generally on Palmyra, see F. Millar, *The Roman Near East 31 BC–AD 337* (Cambridge, MA, 1993), 319–36.

3. The Roman near east is best discussed by Millar, *Roman Near East*; for architecture, see J. B. Ward-Perkins, *Roman Imperial Architecture* (Harmondsworth, 1981), 307–61.

4. Some careful accounts of provincial identity and Romanization include Millar, *Roman Near East* on the near east, S. Swain, *Hellenism and Empire: Language, Classicism and Power in the Greek World AD 50–250* (Oxford, 1996), G. Woolf, 'Becoming Roman, Staying Greek: Culture, Identity and the Civilizing Process in the Roman East' *PCPS* 40 (1994), 116–43, and S. E. Alcock, *Graecia Capta: The Landscapes of Roman Greece* (Cambridge, 1993) on Greece.

5. Pausanias on the Acropolis: *Description of Greece* I. 22–8; Hadrian in the Parthenon, I. 24. 7, Hadrian's inscribed deeds, I. 5. 5.

6. The classic account of euergetism is P. Veyne, *Bread and Circuses: Historical Sociology and Political Pluralism* (London, 1990).

7. See most recently K. Arafat, *Pausanias' Greece* (Cambridge, 1996), with bibliography.

8. Pausanias, *Description of Greece* I. 14. 6, translated by K. Arafat.

9. On Herodes, see Arafat, *Pausanias' Greece*, 195–201, with bibliography.

10. On Opramoas, see Veyne, *Bread and Circuses*, 149–50.

11. On the Library of Celsus, see Ward-Perkins, *Roman Imperial Architecture*, 288–90.

12. On the great Antonine altar of Ephesus, see D. E. E. Kleiner, *Roman Sculpture* (New Haven and London, 1992), 209–12, with bibliography, and C. C. Vermeule, *Roman Imperial Art in Greece and Asia Minor* (Cambridge, MA, 1968), 95–123.

13. For the Adamklissi trophy, see Kleiner, *Roman Sculpture*, 230–2, with bibliography.

14. For example, in the sixth century the city of Justiniana Prima, built by the Byzantine emperor Justinian (527–65) at his birth-place in

Dardania (on which see Procopius, *On the Buildings* 4. 1. 19).

15. Generally on the art of Lepcis, see J. B. Ward-Perkins, *Studies in Roman and Early Christian Architecture* (London, 1994), 130–220.

16. On the Lepcis arch, see Kleiner, *Roman Sculpture*, 140–2 with bibliography.

17. On the sculpture from the basilica, see Kleiner, *Roman Sculpture*, 343, with bibliography.

18. Cassius Dio, *Roman History* 77. 16.

19. On the arch of Galerius, see Kleiner, *Roman Sculpture*, 418–25, with bibliography; on the topography of Galerius' Salonica, see Ward-Perkins, *Roman Imperial Architecture*, 449–50.

20. On the topography and buildings of Trier, see Ward-Perkins, *Roman Imperial Architecture*, 442–9.

21. See R. Ling, *Roman Painting* (Cambridge, 1991), 195–6.

22. See J. M. C. Toynbee, *Art in Britain under the Romans* (Oxford, 1964), 103–4.

23. Lucian, *Heracles*, 1–6, with the Loeb translation of A. M. Harmon.

24. See Toynbee, *Art in Britain*, 263–4, and G. W. Meates, *The Roman Villa at Lullingstone, Kent* (London and Tunbridge Wells, 1979), 75–82, with bibliography.

25. See Toynbee, *Art in Britain* 59–63, with bibliography.

26. See C. Walter, 'Expressionism and Hellenism', *REB* (1984), 265–87 and J. Trilling, 'Late Antique and Sub-Antique, or the "Decline of Form" Reconsidered', *DOP* 41 (1987), 469–76, with bibliography.

27. In general, see R. Krautheimer, *Early Christian and Byzantine Architecture* (Harmondsworth, 1975), 39–70. On Jerusalem, E. D. Hunt, *Holy Land Pilgrimage in the Late Roman Empire AD 312–460* (Oxford, 1982), 6–27 and idem., 'Constantine and Jerusalem' *Journal of Ecclesiastical History* 48 (1997), 405–24 for Rome, R. Krautheimer, *Three Christian Capitals: Topography and Politics* (Berkeley and Los Angeles, 1983), 7–40; for Constantinople, ibid., 41–68.

28. J. B. Ward-Perkins, *From Classical Antiquity to the Middle Ages: Public Building in Northern and Central Italy 300–850* (Oxford, 1984), 237–41.

29. For the rise of early Christian public liturgy in relation to the disposition of churches, see J. Baldovin, *The Urban Character of Christian Worship* (Rome, 1987).

30. On Rome and Milan, see Krautheimer, *Three Christian Capitals*.

31. Broadly on Christianization, see P. Brown, *Authority and the Sacred: Aspects of the Christianization of the Roman World* (Cambridge, 1995), F. Trombley, *Hellenic Religion and Christianization c. 370–529*, 2 vols (Leiden, 1993), A. Cameron, *Christianity and the Rhetoric of Empire* (Berkeley and Los Angeles, 1991), and R. MacMullen, *Christianizing the Roman Empire* (New Haven, 1984).

32. On the conversion of temples to churches, see Trombley, *Hellenic Religion*, 108–47.

33. On late paganism, see G. W. Bowersock, *Hellenism in Late Antiquity* (Cambridge, 1990), P. Chuvin, *A Chronicle of the Last Pagans* (Cambridge, MA, 1990).

34. On the 'drainage of the secular', see R. Markus, *The End of Ancient Christianity* (Cambridge, 1990), 15–16, 225–8.

Chapter 6. Art and Death

1. See generally J. M. C. Toynbee, *Death and Burial in the Roman World* (London, 1971), also M. Koortbojian, '*In Commemorationem Mortuorum*: Text and Image along the "Streets of Tombs" ' in J. Elsner (ed.), *Art and Text in Roman Culture* (Cambridge, 1996), 210–34.

2. On the sociology of Roman death, see K. Hopkins, *Death and Renewal* (Cambridge, 1983), 201–56.

3. See Toynbee, *Death and Burial*, 39–42 and F. G. J. M. Müller, *The So-Called Peleus and Thetis Sarcophagus in the Villa Albani* (Amsterdam, 1994), 139–70.

4. See D. E. Kleiner, *Roman Sculpture* (New Haven and London, 1992), 301–3.

5. See Kleiner, *Roman Sculpture*, 384–5.

6. See R. Brilliant, *Visual Narratives: Storytelling in Etruscan and Roman Art* (Ithaca, 1984), 145–63, with bibliography.

7. Generally, on memorial, correspondence and analogy in mythological sarcophagi, see M. Koortbojian, *Myth, Meaning and Memory on Roman Sarcophagi* (Berkeley and Los Angeles, 1995), 114–41.

8. See K. Lehmann-Hartleben and E. C. Olsen, *Dionysiac Sarcophagi in Baltimore* (Baltimore, 1942), 12–16 and R. Turcan, *Les sarcophages romains à représentations dionysiaques* (Paris, 1966), 224–5, 230–3.

9. On Dionysus in the Roman empire, see R. Turcan, *The Cults of the Roman Empire* (Oxford, 1996), 291–327 and G. W. Bowersock, *Hellenism in Late Antiquity* (Cambridge, 1990), 41–53.

10. Apuleius, *The Golden Ass* XI.1–3, 7.

11. On dream visions, see R. Lane Fox, *Pagans and Christians* (London, 1986), 150–67.

12. See Müller, *Peleus and Thetis Sarcophagus*, 143–7.

13. On Endymion and his variants, see Koortbojian, *Myth, Meaning and Memory*, 63–106.

14. See S. Walker, *Catalogue of Roman Sarcophagi in the British Museum* (London, 1990), 38, with bibliography, and Koortbojian, *Myth, Meaning and Memory*, 91–2, 137–40.

15. On Jonah and Endymion, see T. F. Mathews, *The Clash of Gods: A Reinterpretation of Early Christian Art* (Princeton, 1993), 30–3, with bibliography.

16. See E. Dinkler in K. Weitzmann (ed.), *Age of Spirituality* (Princeton, 1979), 405–6, with bibliography.

17. *Historia Augusta, Severus Alexander*, 29.2 and 31.4.

18. On pre-Constantinian Christian art (and in particular the Callistus Catacomb), see P. C. Finney, *The Invisible God: The Earliest Christians on Art* (Oxford, 1994), 141–274.

19. See A. Ferrua, *The Unknown Catacomb* (New Lanark, 1990), 93–5.

20. J. G. Deckers, G. Mietke, and A. Wieland, *La Catacomba di Commodilla* (Vatican City, 1994), 89–104.

21. On the Sant' Ambrogio sarcophagus see A. Katzenellenbogen, 'The Sarcophagus in Sant' Ambrogio and St Ambrose', *Art Bulletin* 29 (1947), 249–59.

22. On Hadrian's mausoleum, see M. T. Boatwright, *Hadrian and the City of Rome* (Princeton, 1987), 161–81.

23. On Diocletian's mausoleum, see J. J. Wilkes, *Diocletian's Palace, Split* (Sheffield, 1993), 46–52.

24. On the buildings at Romuliana, see D. Srejovic and C. Vasic, 'Emperor Galerius' Buildings in Romuliana', *Antiquité Tardive* 2 (1994), 123–41.

25. On the mausolea of Maxentius and of Galerius at Thessalonica, see J. B. Ward-Perkins, *Roman Imperial Architecture* (Harmondsworth, 1981), 421–6, 451–4.

26. On Helena's mausoleum, see F. W. Deichmann and A. Tschira, 'Das Mausoleum der Kaiserin Helena und die Basilika der Heilige Marcellinus und Petrus an der Via Labicana vor Rom', *JDAI* 72 (1957), 44–110.

27. On Centcelles, see H. Schlunk, *Die Mosaikkuppel von Centcelles* (Mainz, 1988).

28. On Sta Costanza, see H. Stern, 'Les mosaiques de l'église de sainte-Constance à Rome', *DOP* 12 (1958), 157–218, R. Krautheimer, *Early Christian and Byzantine Architecture* (Harmondsworth, 1975), 68, and Ward-Perkins, *Roman Imperial Architecture*, 431–3.

29. On the church of the Holy Apostles, see R. Krautheimer, *Three Christian Capitals: Topography and Politics* (Berkeley and Los Angeles, 1983), 56–60, J. B. Ward-Perkins, *Studies in Roman and Early Christian Architecture* (London, 1994), 513–15, and C. Mango, 'Constantine's Mausoleum and the Translation of Relics' in Studies on Constantinople (Aldershot, 1993), Study V, with bibliography.

30. Eusebius, *Life of Constantine* 4.58–60, translated by E. C. Richardson.

31. For the 'flood' of relic translations unleashed after 357 in both east and west, see Mango 'Constantine's Mausoleum', 60–1, with bibliography.

Chapter 7. Art and the Past

1. See esp. E. L. Bowie, 'Greeks and their Past in the Second Sophistic', in M. I. Finley (ed.) *Studies in Ancient Society* (London, 1974), 166–209 and S. Swain, *Hellenism and Empire: Language, Classicism and Power in the Greek World AD 50–250* (Oxford, 1996).

2. Swain, *Hellenism and Empire*, 17–64, with bibliography.

3. On Roman copies see e.g. B. S. Ridgway, *Roman Copies of Greek Sculpture* (Ann Arbor, 1984) and M. Marvin, 'Copying in Roman Sculpture: The Replica Series' in E. D'Ambra (ed.), *Roman Art in Context* (Englewood Cliffs, 1993), 161–88.

4. Lucian, *Philopseudes* 18, Loeb translation by A. M. Harmon.

5. On Discobolus, see e.g. M. Robertson, *A History of Greek Art* (Cambridge, 1975), 340–1.

6. For Hadrian's Villa, see S. Aurigemma, *Villa Adriana* (Rome, 1984) and W. L. MacDonald and J. A. Pinto, *Hadrian's Villa and its Legacy* (New Haven and London, 1995).

7. *Historia Augusta, Hadrian* 26.5 (Loeb translation by D. Magie, adapted).

8. The ancient texts on the Tyrannicides are collected and discussed by S. Brunnsaker, *The Tyrant-Slayers of Kritios and Nesiotes* (Stockholm, 1971), 33–45.

9. On the Canopus, see M. T. Boatwright, *Hadrian and the City of Rome* (Princeton, 1987), 143–9.

10. On Roman baths in general, see F. Yegül, *Baths and Bathing in Classical Antiquity* (Cambridge, MA, 1992), 128–83, with bibliography and J. P. Toner, *Leisure and Ancient Rome* (Oxford and Cambridge, 1995), 53–64.

11. Statius, *Silvae* I.5.12, 41–51 (Loeb translation of J. Mozley, adapted).

12. On the Baths of Caracalla, see Yegül, *Baths and Bathing*, 146–63; and J. Delaine,

The Baths of Caracalla, *JRA*, Suppl. 25 (Portsmouth, RI, 1998)

13. On the sculptures, see M. Marvin, 'Freestanding Sculptures from the Baths of Caracalla', *AJA* 87 (1983), 347–84.

14. On the Farnese Hercules, see Marvin, 'Freestanding Sculptures', 355–7, F. Haskell and N. Penny, *Taste and the Antique* (New Haven and London, 1981), 229–32.

15. On the Farnese Bull, see M. Marvin, 'Freestanding Sculptures', 367–8, Haskell and Penny, *Taste and the Antique*, 165–7.

16. On the Spada reliefs, see N. B. Kampen, 'Observations on the Ancient Uses of the Spada Reliefs', *L'antiquité classique* 48 (1979), 583–600 with previous bibliography, R. Brilliant, *Visual Narratives: Storytelling in Etruscan and Roman Art* (Ithaca, 1984), 83–9, F. G. T. M. Müller, *The So-Called Peleus and Thetis Sarcophagus in the Villa Albani* (Amsterdam, 1994), 122–6.

17. Callistratus, *Descriptions* 5.1 (Loeb translation by A. Fairbanks).

18. Lucian, *De Domo* 6 and 21 (translated by F. Müller).

19. Lucian, *De Domo* 22 (Loeb translation by A. M. Harmon).

20. Achilles Tatius, *Clitophon and Leucippe* 3.7.1 (translated by J. J. Winkler).

21. Philostratus, *Imagines* I.29.3 (Loeb translation by A. Fairbanks).

22. On this sarcophagus, see Müller, *Peleus and Thetis Sarcophagus*.

23. D. E. E. Kleiner, *Roman Sculpture* (New Haven and London, 1992), 349–40.

24. On such Classicism generally, see G. W. Bowersock, *Hellenism in Late Antiquity* (Cambridge, 1990).

25. On these phenomena, see N. Hannestad, *Tradition and Innovation in Late Antique Sculpture* (Aarhus, 1994), 105–49.

26. On Chiragan, see Hannestad, *Tradition and Innovation*, 127–43, with bibliography.

27. See e.g. J. Curran, 'Moving Statues Late Antique Rome', *Art History* 17 (1994), 46–58.

28. Ammianus Marcellinus, *Res Gestae*, 16.10.13f. (Loeb translation by J. C. Rolfe).

29. Quoted in C. Mango, 'Antique Statuary and the Byzantine Beholder', *DOP* 17 (1963), 55, my translation.

30. On the Baths of Zeuxippus, see S. Bassett, '*Historiae Custos*: Sculpture and Tradition in the Baths of Zeuxippus', *AJA* 100 (1996), 491–506.

31. On the Palace of Lausus, see C. Mango, M. Vickers, and E. Francis, 'The Palace of Lausus at Constantinople and its Collection of Ancient Statues', *Journal of the History of Collections* 4 (1992), 89–98.

32. On collecting in late-antique Constantinople and Byzantine attitudes, see Mango, 'Antique Statuary', 55–9 and L. James, ' "Pray not to Fall into Temptation and Be on Your Guard": Pagan Statues in Christian Constantinople', *Gesta* 35 (1996), 12–20.

33. On the Symmachorum leaf, see B. Kiilerich, *Fourth Century Classicism in the Plastic Arts* (Odense, 1993), 144–9 and D. Kinney, 'The Iconography of the Ivory Diptych Nicomachorum-Symmachorum', *JbAC* 37 (1994), 64–96, with bibliography.

34. On the Corbridge Lanx, see Kiilerich, *Fourth Century Classicism*, 170–1, with bibliography.

35. On the Hylas panel and its context, see G. Becatti, *Scavi di Ostia VI: Edificio con Opus Sectile fuori Porta Marina* (Rome, 1969), 181–215.

36. On the Junius Bassus Sarcophagus, see E. S. Malbon, *The Iconography of the Sarcophagus of Junius Bassus* (Princeton, 1990), with bibliography.

37. On Pausanias, see J. Elsner, *Art and the Roman Viewer: The Transformation of Art from the Pagan World to Christianity* (Cambridge, 1995), 125–55, K. Arafat, *Pausanias' Greece* (Cambridge, 1996), and Swain, *Hellenism and Empire*, 330–56.

Chapter 8. Art and Religion

1. See further the excellent account of J. North, 'The Development of Religious Pluralism', in J. Lieu, J. North, and T. Rajak (eds), *The Jews among Pagans and Christians in the Roman Empire* (London, 1992), 174–93, with bibliography.

2. For a good general portrait of religion in the empire, see R. Gordon, 'The Roman Empire' in M. Beard and J. North (eds), *Pagan Priests* (London, 1990), 177–255. For the imperial cult, see on the east S. R. F. Price, *Rituals and Power: The Roman Imperial Cult in the East* (Cambridge, 1984) and S. Friesen, *Twice Neokoros: Ephesus, Asia and the Cult of the Flavian Imperial Family* (Leiden, 1993), on the west see D. Fishwick, *The Imperial Cult in the Latin West* (Leiden, 1987).

3. For images and the imperial cult, see Price, *Rituals and Power*, 170–206, Fishwick, *Imperial Cult*, 532–40.

4. On charisma, see Price, *Rituals and Power*, 205–6; on universalism and the imperial cult, see G. Fowden, *Empire to Commonwealth: Consequences of Monotheism in Late Antiquity* (Princeton, 1993), 37–8.

5. On universalism in the pagan empire, see Fowden, *Empire to Commonwealth*, 37–60. Broadly on the problems of soteriology and

salvation, see G. S. Gasparro, *Soteriology and Mystic Aspects in the Cult of Cybele and Attis* (Leiden, 1985).

6. On identity and religion, see J. Rives, *Religion and Authority in Roman Carthage from Augustus to Constantine* (Oxford, 1995), 1–16. On competition within pluralism, see North, 'Religious Pluralism', and on the visual arts as a prime means for promulgating competing religions in the period, see A. Grabar, *Christian Iconography: A Study of Its Origins* (London, 1968), 27–30 and T. F. Mathews, *The Clash of Gods: A Reinterpretation of Early Christian Art* (Princeton, 1993), 3–10. On Romanization and resistance, see Gordon, 'Roman Empire', 235–55.

7. On this bust of Commodus, see D. E. E. Kleiner, *Roman Sculpture* (New Haven and London, 1992), 276–7, with bibliography.

8. On Commodus as Hercules, see Cassius, Dio, *Roman History* 73.7.2, 73.15.2–6, 73.20.2; Herodian, *History* I.14.8–9; *Historia Augusta, Commodus* 8.5, 9.6.

9. Herodian, *History*, 5.6.6–9, translated by C. R. Whittaker (Loeb edition) with slight changes.

10. On Julian the Apostate, see G. W. Bowersock, *Julian the Apostate* (London, 1978) and P. Athanassiadi-Fowden, *Julian and Hellenism* (Oxford, 1981).

11. For a broad account of the third and fourth centuries, see Fowden, *Empire to Commonwealth*, 50–93.

12. Pausanias, *Description of Greece* 2.11.6., translated by W. H. S. Jones (Loeb edition), with adaptations.

13. See further on image and ritual, J. Elsner, 'Image and Ritual: Reflections on the Religious Appreciation of Classical Art', *Classical Quarterly* 46 (1996), 515–31.

14. Pausanias, *Description of Greece* 3.20.3., translated by W. H. S. Jones (Loeb edition).

15. Pausanias, *Description of Greece* 7.26.7., translated by W. H. S. Jones (Loeb edition).

16. Achilles Tatius, *Clitophon and Leucippe* 7.13.2–3 (translated by J. J. Winkler).

17. On the iconography of the image, see L. Portefaix, 'The "Hand-made" Idol of Artemis of Ephesus', in E. Rystedt et al. (eds), *Opus Mixtum: Essays in Ancient Art and Society* (Stockholm, 1994), 61–71, esp. 61–4, with bibliography.

18. See G. M. Rogers, *The Sacred Identity of Ephesus: Foundation Myths of a Roman City* (London, 1991) and J. Elsner, 'The Origins of the Icon: Pilgrimage, Religion and Visual Culture in the Roman East as "Resistance" to the Centre', in S. E. Alcock (ed.), *The Early*

Roman Empire in the East* (Oxford, 1997), 178–99 .

19. See briefly R. Gordon, 'The Real and the Imaginary: Production and Religion in the Graeco-Roman World', *Art History* 2 (1979), 5–34, esp. 7–8.

20. On Aristides and Asclepius, see R. Lane Fox, *Pagans and Christians* (London, 1986), 160–3 and P. Cox Miller *Dreams in Late Antiquity* (Princeton, 1994), 109–17, 184–203, with bibliography.

21. Aelius Aristides, *The Sacred Tales* 3.47 (Oration 49), translated by C. Behr.

22. Artemidorus, *Oneirocritica* 2.39, translated by R. White. On Artemidorus, see Miller, *Dreams*, 29–31, 77–91, with bibliography.

23. On Artemis, see Elsner, 'Origins of the Icon', with bibliography.

24. For a broad account of the cults, see R. Turcan, *The Cults of the Roman Empire* (Oxford, 1996).

25. See further, Gordon, 'Roman Empire', 250.

26. On Mithraic sacrifice, see further J. Elsner, *Art and the Roman Viewer: The Transformation of Art from the Pagan World to Christianity* (Cambridge, 1995), 210–21, with bibliography.

27. On Mithraism and astrology, see T. Barton, *Ancient Astrology* (London, 1994) 197–201, with bibliography.

28. See on the Parabiago plate, J. M. C. Toynbee and K. S. Painter, 'Silver Picture Plates of Late Antiquity: AD 300–700', *Archaeologia* 108 (1986), 15–66, 29–30, with bibliography.

29. On the Lartius Anthus relief, see Gordon, 'Roman Empire', 246–7, and esp., E. Strong, 'A Sepulchral Relief of a Priest of Bellona', *PBSR* 9 (1920), 205–13.

30. Lucian, *The Syrian Goddess*, 50–1, translated by H. Attridge and R. Oden.

31. See Grabar, *Christian Iconography*, 32–3.

32. On the feminine Christ, see Mathews, *Clash of Gods*, 115–41; on sexual renunciation, see P. Brown, *The Body and Society* (London, 1989).

33. For the history of Dura, see A. Perkins, *The Art of Dura Europos* (Oxford, 1973), 1–9, with bibliography.

34. On Durene style, see Perkins, *Art of Dura Europos*, 114–26, but with the strictures of A. Wharton, *Refiguring the Post-Classical City* (Cambridge, 1995), 33–4, 60–1.

35. On the Otes fresco, see J. Teixidor, *The Pantheon of Palmyra* (Leiden, 1979), 74–5, Perkins, *Art of Dura Europos*, 45–7, and F. Cumont, *Fouilles de Doura Europos* (Paris, 1926), 122–37.

36. See Wharton, *Refiguring*, 34–8 on the Konon fresco; generally see Cumont, *Fouilles*, 41–168.

37. On the Dura Mithraeum, see F. Cumont, 'The Dura Mithraeum' in J. Hinnells (ed.), *Mithraic Studies* (Manchester, 1975), 151–214, but the interpretations are to be used with caution (see esp. the paper by R. Gordon in the same collection)!

38. On the invisible God, see P. C. Finney, *The Invisible God: The Earliest Christians on Art* (Oxford, 1994), viii–xi, 275–97.

39. On Jewish art in Rome, see L. V. Rutgers *The Jews in Late Ancient Rome* (Leiden, 1995), 50–99. On the Dura Synagogue, see Wharton, *Refiguring*, 38–51 and J. Gutmann, 'The Dura Europos Synagogue Paintings: The State of Research' in L. Levine (ed.), *The Synagogue in Late Antiquity* (1987), 61–72, with bibliography.

40. As is assumed by K. Weitzmann and H. Kessler, *The Frescoes of the Dura Synagogue and Christian Art* (Washington, 1990), 5–13, see Gutmann, 'Dura Europos Synagogue', 67–9.

41. On scriptural and midrashic antecedents, see Wharton, *Refiguring*, 46–9.

42. See J. M. C. Toynbee, *Art Treasures from the Temple of Mithras* (London, 1986).

43. *Historia Augusta, Severus Alexander* 29.2–3, 31.4–5.

44. See A. Ferrua, *The Unknown Catacomb* (New Lanark, 1990). For shared pagan-Christian burial practices in the context of the Via Cabina Catacomb, see M. J. Johnson, 'Pagan-Christian Burial Practices of the Fourth Century: Shared Tombs?' *Journal of Early Christian Studies* 5 (1997), 37–60.

45. See Elsner, *Art and the Roman Viewer*, 274–9, with bibliography.

46. See Elsner, *Art and the Roman Viewer*, 251–5, with bibliography.

47. See J. M. C. Toynbee, 'A New Roman Mosaic Pavement found in Dorset', *JRS* 54 (1964), 7–14.

48. See C. Murray *Rebirth and Afterlife* (Oxford, 1981), 37–63, with bibliography.

49. See G. W. Bowersock, *Hellenism in Late Antiquity* (Cambridge, 1990), 49–53, with bibliography.

50. See V. Tran Tam Tinh, *Isis Lactans* (Leiden, 1973), 54–5.

51. Gregory of Nyssa, *On the Divinity of the Son and the Holy Spirit* (PG 46.557), translated by R. Lim with adaptations.

52. See F. Trombley, *Hellenic Religion and Christianization* c. 370–529 (Leiden, 1993), vol. 1, 1–97 on the legal status of sacrifice and S. Williams and G. Friell, *Theodosius: The Empire at Bay* (London, 1994), 119–33.

53. See Trombley, *Hellenic Religion* vol. 1, 122–47, 207–22; Williams and Friell, *Theodosius*, 50–60, 65–70, 122–5.

54. On the theology of the first four Ecumenical Councils see e.g. J. Pelikan, *The Christian Tradition* vol. 1 (Chicago, 1971), 173–277.

55. See the discussion of V. Limberis, *Divine Heiress: The Virgin Mary and the Creation of Christian Constantinople* (London, 1994), 7–61.

56. See broadly Limberis, *Divine Heiress*, 34–40, 53–61.

57. See N. McLynn, *Ambrose of Milan* (Berkeley and Los Angeles, 1994), 291–360.

58. See J. H. W. G. Liebeschuetz, *Barbarians and Bishops* (Oxford, 1990), 157–216, K. Holum, *Theodosian Empresses: Women and Imperial Dominion in Late Antiquity* (Berkeley and Los Angeles, 1982), 69–78.

59. See Holum, *Theodosian Empresses*, 147–74.

60. On the patronage of churches, see Ward-Perkins, *From Classical Antiquity to the Middle Ages: Public Building in Northern and Central Italy 300–850* (Oxford, 1984), 236–49.

61. On Milan, see R. Krautheimer, *Three Christian Capitals: Topography and Politics* (Berkeley and Los Angeles, 1983), 69–92.

62. On the early Christian basilica, see R. Krautheimer, 'The Constantinian Basilica', *DOP* 21 (1967), 117–40 and J. B. Ward-Perkins, *Studies in Roman and Early Christian Architecture* (London, 1994), 447–68.

63. On Sta Sabina, see R. Krautheimer, *Corpus Basilicarum Christianarum Romae*, 5 vols (Vatican, 1937–77), vol. 4, 72–98.

64. On the doors of Sta Sabina, see G. Jeremias, *Die Holztür der Basilika S. Sabina in Rom* (Tübingen, 1980) and J. M. Spieser, 'Le programme iconographique des portes de Sainte-Sabine', *Journal des Savants* (1991), 47–82.

65. On the mosaics of Sta Maria Maggiore, see M. Miles, 'Sta Maria Maggiore's Fifth Century Mosaics: Triumphal Christianity and the Jews', *Harvard Theological Review* 86 (1993), 155–75 with bibliography.

66. On the 'Mausoleum of Galla Placidia', see F. W. Deichmann, *Ravenna: Hauptstadt der Spätantiken Abendlandes* (Wiesbaden, 1974), vol. 1, 63–90.

67. On the cult of relics, see P. Brown, *The Cult of the Saints* (London, 1982), R. Markus, *The End of Ancient Christianity* (Cambridge, 1990), 139–55.

68. On the San Nazaro reliquary, see B. Kiilerich, *Fourth Century Classicism in the*

Plastic Arts (Odense, 1993), 181–2, with
bibliography.

69. On Ambrose and the cult of relics, see
McLynn, *Ambrose of Milan*, 211–7, 230–5,
347–50; on Rome see M. Roberts, *Poetry and
the Cult of Martyrs* (Ann Arbor, 1993), 167–87,
with bibliography.

70. See Limberis, *Divine Heiress*, 52–85.

71. On the Trier ivory, see Holum, *Theodosian
Empresses*, 103–9 with bibliography.

72. On Sta Pudenziana, see G. Hellemo,
Adventus Domini (Leiden, 1989), 41–64,
F. Schlatter, 'Interpreting the Mosaics of Sta
Pudenziana', *Vigiliae Christianae* 46 (1992),
276–95, and Mathews, *Clash of Gods*, 92–114.

73. On early Christian portraits and the rise of
the cult of icons, see Grabar, *Christian
Iconography*, 60–86, H. Belting, *Likeness and
Presence* (Chicago, 1994), 78–101.

74. On the Brescia casket and exegesis, see
Elsner, *Art and the Roman Viewer*, 282–7, with
bibliography.

Chapter 9. Art and Culture

1. On the edict of Diocletian, see the text and
translation in T. Frank, *An Economic Survey of
Ancient Rome* vol. 5 (Baltimore, 1940), 305–422,
with S. Williams *Diocletian and the Roman
Recovery* (London, 1985), 128–32 and S.
Corcoran, *The Empire of the Tetrarchs* (Oxford,
1996), 205–33.

2. See R. Ling, *Roman Painting* (Cambridge,
1991), 213.

3. See *The Theodosian Code* 13. 4. 1–13. 4. 4,
with A. H. M. Jones, *The Later Roman Empire*
(Oxford, 1964), 1014.

4. See *The Theodosian Code* 13. 4. 2, with Jones,
Later Roman Empire, 862–3.

5. Lucian, *The Dream or Lucian's Career* 6–9
(translated by J. J. Pollitt, with adaptations).

6. Ibid. Compare also Plutarch, *The Life of
Pericles* 2.1.

7. Gaius, *Institutes* 2.73–8 (translated F. de
Zulueta, with adaptations). See also Gaius
quoted in Justinian's *Digest of Roman Law*
41. 1. 9.

8. Justinian, *Institutes*, 2. 1. 34 (translated by
J. Thomas).

9. Paulus in Justinian, *Digest of Roman Law*,
6. 1. 23. 3 (translated by A. Watson).

10. A useful introduction to ancient views of
Greek art is J. J. Pollitt, *The Ancient View of
Greek Art* (New Haven, 1974). On Pliny, see
J. Isager, *The Elder Pliny's Chapters on Art and
Society* (London, 1991), with bibliography.

11. For a collection of ancient excerpts in
translation discussing the works of individual
Greek artists, see J. J. Pollitt, *The Art of Ancient*

Greece. Sources and Documents (Cambridge,
1990).

12. See K. Arafat, *Pausanias' Greece*
(Cambridge, 1996), 43–79.

13. The Elder Philostratus, *Imagines* I, proem,
1; the Younger Philostratus, *Imagines*, proem, 3
(translations by A. Fairbanks in the Loeb
edition, adapted).

14. Pliny, *Natural History*, 35. 66 (Loeb
translation of H. Rackham, much adapted).

15. On this statue and its ancient literature, see
C. M. Havelock, *The Aphrodite of Knidos and
Her Successors* (Ann Arbor, 1995).

16. Lucian, *De Domo* 4 (Loeb translation of
A. M. Harmon).

17. See further J. Elsner, *Art and the Roman
Viewer: The Transformation of Art from the
Pagan World to Christianity* (Cambridge, 1995),
21–48, with bibliography.

18. Callistratus, *Descriptions* 8.1–3 (Loeb
translation by A. Fairbanks, slightly
adapted).

19. Ibid., 8. 3–5.

20. See J. Onians, 'Abstraction and
Imagination in Late Antiquity', *Art History* 3
(1980), 1–24.

21. Callistratus, *Descriptions* 3. 1 (Loeb
translation by A. Fairbanks).

22. On early Christian attitudes to art, see
C. Murray, *Rebirth and Afterlife* (Oxford,
1981), and P. C. Finney, *The Invisible God:
The Earliest Christians on Art* (Oxford, 1994),
15–98.

23. The Younger Philostratus, *Imagines*,
proem 4 (translated by A. Fairbanks, Loeb
edition).

24. Epiphanius of Salamis, *Letter to the
Emperor Theodosius*, fr. 23–7 (translated by
C. Mango).

25. Augustine, *Soliloquies* 2. 10. 18.

26. See especially H. Maguire, *Art and
Eloquence in Byzantium* (Princeton, 1981) and
L. James and R. Webb, ' "To Understand
Ultimate Things and Enter Secret Places":
Ekphrasis and Art in Byzantium', *Art History*
14 (1991), 1–17.

27. Photius, *Homily* 17.2 (translated by
R. Cormack, slightly adapted). On this text,
see R. Cormack, *Writing in Gold* (London,
1985), 144–51; James and Webb, 'To
Understand Ultimate Things', 12–13;
H. Maguire, 'Originality in Byzantine Art'
in A. R. Littlewood (ed.), *Originality in
Byzantine Literature, Art and Music* (Oxford,
1995), 101–14, esp. 106–9.

28. Photius, *Homily* 17. 2 (translated by
R. Cormack).

Afterword

1. On the Quedlinburg Itala, see I. Levin, *The Quedlinburg Itala* (Leiden, 1985).

2. On folio 2r, see Levin, *Quedlinburg Itala*, 29–32.

3. On Pausanias and Philostratus on Homer, see J. Elsner, *Art and the Roman Viewer: The Transformation of Art from the Pagan World to Christianity* (Cambridge, 1995), 316–17, n. 30.

4. Paulinus of Nola, *Carmina* 27. 511–15 (translated by P. G. Walshe, with adaptations).

5. Paulinus of Nola, *Carmina* 27. 585 (translated by R. Goldschmidt).

6. Paulinus of Nola, *Epistulae* 32. 10 (translated by C. Davis-Weyer, following R. Goldschmidt, with emendations).

7. For a useful handbook of early Christian symbolism, see G. Ladner, *God, Cosmos, and Humankind: The World of Early Christian Symbolism* (Berkeley and Los Angeles, 1995).

8. On this event, see C. Haas, *Alexandria in Late Antiquity* (Baltimore, 1997), 88–9, 162–3.

9. Papyrus Goleniscev in the Pushkin Museum, Moscow, fol. 6v. See A. Bauer and J. Strzygowski, *Eine Alexandrinische Weltchronik* (Vienna, 1905), 122 and pl. VI, verso. For a later dating to about AD 700 (and a resumé of dates given by other scholars), see O. Kung 'The Date of the Alexandrian World Chronicle' in *Kunsthistoriche Forschungen Otto Pächt zu seinen 70 Geburtstag* (Salzburg, 1972), 17–22.

10. On the cult of icons, see R. Cormack, *Writing in Gold* (London, 1985), H. Belting, *Likeness and Presence* (Chicago, 1994), H. Maguire, *Icons of their Bodies* (Princeton, 1996), R. Cormack, *Painting the Soul* (London, 1997), with bibliography. On the origins of the icon in ancient religious practice, see J. Elsner, 'The Origins of the Icon: Pilgrimage, Religion and Visual Culture in the Roman East as "Resistance" to the Centre', in S. E. Alcock (ed.), *The Early Roman Empire in the East* (Oxford, 1997), 178–99.

11. On the Sinai St Peter, see K. Weitzmann, *The Monastery of St Catherine at Mt Sinai: The Icons*, vol. 1 (Princeton, 1976), 23–6.

12. On early Christian portraiture, see A. Grabar, *Christian Iconography: A Study of Its Origins* (London, 1968), 60–86; on the Byzantine theory of icons, see e.g. J. Pelikan, *Imago Dei: The Byzantine Apologia for Icons* (New Haven, 1990).

13. On the technique, see S. Walker and M. Bierbrier, *Ancient Faces: Mummy Portraits from Roman Egypt* (London, 1997), 21–2.

14. See Belting, *Likeness and Presence*, 113–14.

15. On the rise of the cult of icons, see A. Cameron, 'The Language of Images: The Rise of Icons and Christian Representation' in D. Wood (ed.), *The Church and the Arts* (Oxford, 1992), 1–42, esp. 4–15.

16. On Graeco-Roman image worship, see J. Elsner, 'Image and Ritual: Reflections on the Religious Appreciation of Classical Art', *Classical Quarterly* 46 (1996), 515–31 and on the genesis of the icon, Elsner, 'Origins of the Icon'.

17. On Byzantine Iconoclasm see Cormack, *Writing in Gold*, 95–140 and Belting, *Likeness and Presence*, 144–63, with (very extensive) bibliography.

List of Illustrations

The publisher would like to thank the following individuals and institutions who have kindly given permission to reproduce the illustrations listed below.

and Mrs Cornelius C. Vermeule III, courtesy Museum of Fine Arts, Boston.

25. Head of an emperor of the Theodosian dynasty, Constantinople, late fourth or early fifth century AD. Marble. Arkeoloji Müzeleri, Istanbul/photo Hirmer Verlag GmbH, Munich.

26. Bust of Trajan Decius, c.AD 250. Marble. Musei Capitolini, Rome/photo Deutsches Archäologisches Institut.

27. Coin of Hadrian (obverse), struck in Asia Minor, probably after AD 128. Silver. The British Museum, London.

28. Coin of Trajan (obverse), struck in Rome, AD 115. Gold. The British Museum, London.

29. Group of tetrarchs, c.AD 300. Porphyry. San Marco, Venice/photo Michael Holford, Loughton.

30. Monumental head of a tetrarch, from the south eastern baths, Romuliana, c.AD 300. Porphyry. From Dragan Srejovic (ed.), *Late Roman Palaces in Yugoslavia*.

31. Coin of Constantine (obverse), c.AD 306–7. Gold. The British Museum, London.

32. Colossal head of Constantine, Basilica Nova, Rome, c.AD 315–30. Marble. H. 2.6 m. Palazzo dei Conservatori, Rome/ photo Deutsches Archäologisches Institut.

33. Basilica Nova of Constantine and Maxentius, Roman Forum, c.AD 307– 13. 80 × 25 m rising to H. 35 m. Photo Scala, Florence.

34. Roman Forum and later imperial additions. Plan. Oxford University Press.

35. Trajan's Forum. Plan. Oxford University Press.

36. Trajan's Column, Rome, AD 113. Luna marble and gilded bronze statue. H. 30 m. Photo Alinari, Florence.

37. The Column of Marcus Aurelius, Rome, AD 180–92. Luna marble. H. 30 m approx. Photo Alinari, Florence.

38. The Column of Arcadius. Freshfield Album (MS O. 17.2, fol. 13), Courtesy The Master and Fellows, Trinity College, Cambridge.

39. The Pantheon, Rome, c.AD 118–28. Photos: left, Henry Stierlin, Geneva; right, Martin Goalen.

40. Coin of Trajan (reverse), struck in Rome, AD 114–16. Gold. The British Museum, London.

41. Coin of Trajan (reverse), struck in Rome, AD 115. Gold. The British Museum, London.

42. Coin of Antoninius Pius (reverse), struck in Rome, c.AD 158–9. Gold. The British Museum, London.

43. Coin of Philip I (reverse), struck in Rome, AD 248. Gold. The British Museum, London.

44. Coin of Hadrian (reverse), struck in Asia Minor, probably after AD 128. Silver. The British Museum, London.

45. Diocletian's Palace, Split. Restored plan. Drawing after M. I. Finley (ed.), *Atlas of Ancient Archaeology* (London, 1977), 137 © Rainbird Publishers.

46. The Peristyle from Diocletian's Palace, Split, c.AD 300–6. Photo Deutsches Archäologisches Institut, Rome.

47. Map of Constantinople in the reign of Theodosius II (died AD 450). Oxford University Press.

48. Colossal statue of an emperor, fourth or fifth century AD. Bronze. H. 3.55 m. Photo Deutsches Archäologisches Institut, Rome.

49. Obelisk base of Theodosius, AD 390. Marble. Photo Deutsches Archäologisches Institut, Istanbul.

50. Equestrian statue of Marcus Aurelius, Rome, c.AD 176. Gilded bronze. Photo Scala, Florence.

51. Trajan's Arch, Benevento, c.AD 114–18. Photo Alinari, Florence.

52. Arch of Septimius Severus, Roman Forum, AD 203. Photo Alinari, Florence.

53. Relief showing the emperor Trajan in battle, Arch of Constantine, Rome, c.AD 118. Marble. Photo Deutsches Archäologisches Institut, Rome.

54. The emperor Constantius II enthroned, from a copy executed in 1620 of a ninth-century manuscript copy of a codex calendar made in Rome, AD 354. Biblioteca Apostolica Vaticana, (Romanus I, MS Barb. Lat. 2154, fol. 13), Vatican City, Rome.

55. Diptych of Anicius Petronius Probus, Rome, AD 406. Ivory. Tesoro del Duomo, Aosta/photo Alinari, Florence.

56. Missorium, or commemorative dish, celebrating the *decennalia* of the emperor Theodosius I, AD January 388. Silver. Diameter 0.74 m, Weight 15 kg approx. Real Accadémia de la Historia, Madrid/photo Institut Amatller d'Art Hispanic, Barcelona.

57. Cameo depicting the emperor Honorius and his wife Maria on the occasion of their wedding, AD 398. Onyx. Rothschild Collection, Paris/photo Hirmer Verlag GmbH, Munich.

58. Relief with vendor selling vegetables, Ostia, late second or early third century AD. Marble. Museo Ostiense, Ostia Antica/ Fototeca Unione, American Academy of Rome.

59. Relief of Trajan distributing the *alimenta*, Trajan's arch, Benevento, c.AD 114–18. Marble. Photo Alinari, Florence.

60. Scene of sacrificial procession, column base of Diocletian's Five Column Monument,

AD 303. Marble. Photo Deutsches Archäologisches Institut, Rome.

61. Floor mosaic depicting a Negro bath attendant with extended phallus, Northwestern Baths, Timgad, North Africa, c.AD 200. Musée Archéologique, Timgad/ photo Fonds P. A. Fevrier, CNRS (Centre Camille Jullian), Aix en Provence.

62. Cameo of Julia Domna as Luna, early third century AD. Sardonyx. Copyright © The British Museum, London.

63. Portrait medallion of the Musician Gennadios, Alexandria (?), third or fourth century AD. Gold leaf, engraved with a fine point, on sapphire-blue glass. Diameter 4.13 cm. The Metropolitan Museum of Art, New York, Fletcher Fund, 1926 (26.258)/photo © 1977 The Metropolitan Museum of Art.

64. Floor mosaic from room XI of Maison de l'Âne, Djemila, Algeria, late fourth or early fifth century AD. Fonds P. A. Fevrier, CNRS (Centre Camille Jullian), Aix en Provence.

65. Floor mosaic from a villa in Antioch, Syria, second quarter of the fourth century AD. Musée du Louvre, Paris/photo © Réunion des Musées Nationaux/Chuzeville.

66. Floor mosaic from Cherchel, Algeria, early third century AD. Musée Archéologique, Cherchel/photo T. W. Potter, London.

67. Detail of chariot racing in the Circus Maximus, floor mosaic from the Villa at Piazza Armerina, Sicily, first quarter of the fourth century AD. Whole mosaic 23.5 × 5.75 m. Azienda Autonoma di Soggiorno e Turismo, Piazza Armerina/from *Piazza Armerina: The Mosaics* (Bologna, 1989) © copyright 1989 La Fotometalgrafica Emiliana/ photos Ascanio Ascani and Ramondo Marino.

68. Tableware from the Mildenhall Treasure, found in Suffolk, fourth century AD. Silver. Copyright © The British Museum, London.

69. Tableware from the Sevso Treasure, provenance unknown, fourth century AD. Mainly silver. Property of the Trustee of the Marquess of Northampton, 1987 Settlement/ photo courtesy Sotheby's, London.

70. Cage-cup, fourth century AD. Glass. Civico Museo Archeologico, Milan/Foto Saporetti.

71. Lamp, Athens, first half of the third century AD. Terracotta. Agora Museum, Athens/photo The American School of Classical Studies (Agora Excavations).

72. Chiragan sculptures, fourth century AD. Marble. Musée Saint-Raymond, Toulouse/ photos Jacques Rougé.

73. Detail from a fragment of tapestry, Coptic Egypt, fourth century AD. Linen and wool.

Whole fragment, L. 7.3 × H. 2.2 m. Abegg-Stiftung, Riggisberg, Berne.

74. The Vatican Vergil, Rome, first half of the fifth century AD. Velum codex. Biblioteca Apostolica Vaticana, (Lat. 3223, fol. 39v), Vatican City.

75. Portrait originally attached to a mummy, Hawara, Fayum, Egypt, c.AD 110–30. Encaustic on wooden panel. Royal Museum of Scotland/photo © The Trustees of the National Museums of Scotland, 1998.

76. Funerary relief of Tibnan, Palmyra, Syria, second half of the second century AD. Painted white limestone. Musée du Louvre, Paris/ photo © Réunion des Musées Nationaux/ Hervé Lewandowski.

77. Colonnaded street, Timgad, Algeria. Photo Henri Stierlin, Geneva.

78. Aqueduct, Nimes (Pont du Gard). Photo Henri Stierlin, Geneva.

79. The remains of the temple of Olympic Zeus, dedicated in AD 132. Photo Michael Holford, Loughton.

80. Restored elevation of the Arch of Hadrian, Athens, erected AD 131. Diagram. Drawing after J. B. Ward-Perkins, *Roman Imperial Architecture* (New Haven, Conn., 1981), 269. Courtesy Yale University Press, Pelican History of Art.

81. Restored facade of the library of Celsus, Ephesus, c.AD 117–20. Photo Henri Stierlin, Geneva.

82. Dynastic relief from the Great Antonine Altar, Ephesus, after AD 169. Marble. Kunsthistorisches Museum, Vienna.

83. Restored elevation of Trajan's Victory Monument, Adamklissi, Romania, dedicated in AD 109. Diagram. Drawing after M. I. Finley (ed.), *Atlas of Ancient Archaeology* (London, 1977), 140 © Rainbird Publishers.

84. Metope xlii from Trajan's Victory Trophy, Adamklissi, Romania, AD 109. Photo Deutsches Archäologisches Institut, Rome.

85. Triumphal procession from the attic storey of the *quadrifonal* arch of Septimius Severus, Lepcis Magna, North Africa, AD 203. Marble. Photo Deutsches Archäologisches Institut, Rome.

86. Pilaster from basilica, Lepcis Magna, early 3rd century AD. Marble. Photo Stuart Laidlaw, Institute of Archaeology, University of London.

87. Sculpted relief from the south-west pillar of Galerius' *quadrifonal* arch, Salonica, c.AD 298–303. Marble. Photo Deutsches Archäologisches Institut, Rome.

88. The Basilica, Trier, interior view looking north, early fourth century AD. Brick, originally decorated with painted stucco on

the outside, and marble revetment and mosaic inside. 29 × 58 m. Photo Bildarchiv Foto Marburg.

89. The Porta Nigra, Trier, early fourth century AD. Photo Bildarchiv Foto Marburg.

90. Restored elevation of the exterior of the Basilica, Trier, seen from the north, early fourth century AD. Diagram. Drawing after J. B Ward-Perkins, *Roman Imperial Architecture* (New Haven, Conn., 1981), 445. Courtesy Yale University Press, Pelican History of Art.

91. Jewelled lady looking into a mirror, painted ceiling panel, Imperial Palace, Trier, early fourth century AD. Fresco on plaster. Photo Bischöfliches Dom- und Diözesanmuseum, Trier (R. Schneider).

92. The land walls of Constantinople, built under Theodosius II, AD 412–13. Photo Josephine Powell, Rome.

93. Trajanic relief, Mammisi, Denderah, Egypt. Photo Peter Clayton, Hemel Hempstead.

94. Bust of nude female figure, Cirencester, England, third century AD. Bronze with iron pin. Courtesy Corinium Museum, Cirencester/copyright Cotswold District Council.

95. Floor mosaic from a Roman villa, Lullingstone, Kent, England, fourth century AD. English Heritage Photo Library.

96. Map of the city of Rome in the reign of Constantine, *c.*AD 330. Drawing after R. Krautheimer, *Three Christian Capitals* (Berkeley and Los Angeles, 1983), 6. Courtesy University of California Press.

97. Map of Milan, *c.*AD 400. Drawing after R. Krautheimer, *Three Christian Capitals* (Berkeley and Los Angeles, 1983), 73. Courtesy University of California Press.

98. 'Battle' sarcophagus, Portonaccio, Via Tiburtina, *c.*AD 180–90. Marble. Museo Nazionale, Rome/photo Scala, Florence.

99. 'Biographical' sarcophagus, Catacomb of Praetextatus, fourth decade of the third century AD. Marble. Photo Deutsches Archäologisches Institut, Rome.

100. 'Mythological' sarcophagus, Rome, *c.*AD 200. Marble. The Walters Art Gallery, Baltimore.

101. 'Mythological' sarcophagus, Campania, mid to late third century AD. Marble. Copyright © The British Museum, London.

102. 'Frieze' sarcophagus, Rome, last quarter of the third century AD. Marble. Musei Vaticani/photo Monumenti Musei e Gallerie Pontificie, Rome.

103. Vault and walls of the *arcosolium* of cubiculum C, Via Latina Catacomb, Rome,

*c.*AD 320. Painted fresco. Photo Pontificia Commissione di Archeologia Sacra, Rome.

104. 'Cubiculum Leonis', Catacomb of Commodilla, late fourth century AD. Painted fresco. Photo Pontificia Commissione di Archeologia Sacra, Rome.

105. St Peter denies Christ while the cock crows, right-hand *arcosolium*, 'Cubiculum Leonis', Catacomb of Commodilla, late fourth century AD. Painted fresco. Photo Pontificia Commissione di Archeologia Sacra, Rome.

106. Sarcophagus from Sant'Ambrogio, Milan, late fourth century AD. Marble.

107. The mausoleum of Diocletian, Split, *c.*AD 300–6. Photo Zlatko Sunko, Split.

108. Hypothetical reconstruction of the mausoleum of Galerius, Romuliana. Photo Alinari, Florence. Drawing after D. Srejovic and C. Vasic, 'Emperor Galerius' Buildings in Romuliana' in *Antiquité Tardive* 2 (1994), 137, fig. 13b.

109. Plan and reconstruction of mausoleum of Helena and the adjacent basilica of Saints Peter and Marcellinus, *c.*AD 330. Drawing after Claude Abeille from R. Bianchi Bandinelli, *Rome: La Fin de l'Art Antique* (Paris, 1970), 400, fig. 424. Courtesy Editions Gallimard.

110. The mausoleum of Sta Costanza, Rome, *c.*AD 350. Exterior. Photo Alinari, Florence.

111. The mausoleum of Sta Costanza, Rome, *c.*AD 350. Interior. Canali Photobank, Capriolo (BS).

112. Sta Costanza, detail of mosaics, *c.*AD 350. Photo Scala, Florence.

113. Statue of Discobolus the Discus Thrower, Rome, first half of the second century AD. Marble. Museo Nazionale, Rome/photo Scala, Florence.

114. Statue of Hercules ('Farnese Hercules'), Baths of Caracalla, Rome, early third century AD. Marble. H. 3.17 m. Museo Archeologico Nazionale, Naples/photo Deutsches Archäologisches Institut, Rome.

115. Hadrian's Villa, Tivoli, between *c.*AD 118 and 134. Plan. Drawing after J. B. Ward-Perkins, *Roman Imperial Architecture* (New Haven, Conn., 1981), 205. Courtesy Yale University Press, Pelican History of Art.

116. Mosaic panel from Hadrian's Villa, Tivoli, third or fourth decade of the second century AD. Musei Vaticani/ photo Scala, Florence.

117. Statue of Aphrodite of Cnidos, Hadrian's Villa, Tivoli, third or fourth decade of the second century AD. Marble. Photo Deutsches Archäologisches Institut, Rome.

118. The Tyrannicides, perhaps from Hadrian's Villa, Tivoli, second century AD.

Marble. Museo Archeologico Nazionale, Naples/Canali Photobank, Capriolo (BS).

119. Canopus, Hadrian's Villa, Tivoli, first half of the second century AD. Photo Henri Stierlin, Geneva.

120. Plan of Baths of Caracalla. Drawing after J. B. Ward-Perkins, *Roman Imperial Architecture* (New Haven, Conn., 1981), 131. Courtesy Yale University Press, Pelican History of Art.

121. The Punishment of Dirce ('Farnese Bull'), Baths of Caracalla, Rome, late second or early third century AD. Marble. H. 3.7 m. Museo Archeologico Nazionale, Naples/photo Alinari, Florence.

122. Relief panel of Perseus and Andromeda, Rome, second century AD. Marble. Musei Capitolini, Rome/photo Deutsches Archäologisches Institut.

123. Statue of Antinous in Egyptian dress and posture, Hadrian's Villa, Tivoli, *c.*AD 130–38. Marble. Musei Vaticani/photo Alinari, Florence.

124. 'Mythological' sarcophagus, Rome, first half of the second century AD. Marble. Villa Albani, Rome/photo Deutsches Archäologisches Institut.

125. Relief portrait of man and woman as Venus and Mars, Rome, late second or early third century AD. Marble. Villa Albani, Rome/photo Deutsches Archäologisches Institut.

126. Schematic plan of the four faces of the Arch of Constantine, Rome, *c.*AD 312–15. Oxford University Press.

127. Leaf from a diptych issued in the names of the Symmachi/Nicomachi families, Rome, last or penultimate decade of the fourth century AD. Ivory. Victoria and Albert Museum, London/photo The Bridgeman Art Library.

128. The Corbridge Lanx, Northumberland, Great Britain, second half of the fourth century AD. Silver dish. The British Museum, London/photo Warburg Institute, University of London.

129. *Opus sectile* panels, basilica of Junius Bassus, Rome, mid-fourth century AD. Sawn marble, hard stones and glass paste. Museo Nazionale, Rome/photos Scala, Florence.

130. 'Columnar' sarcophagus of Junius Bassus, Rome, AD 359. Marble. Museo Storico del Tesoro della Basilica di San Pietro, Vatican City/photo Fabbrica di San Pietro in Vaticana.

131. Nude statue of Hadrian, imperial cult room, Asclepeion, Pergamon, *c.*AD 130. Marble. H. 2.3 m. Photo Warburg Institute, University of London.

132. Portrait of Commodus in the guise of Hercules, Esquiline Hill, Rome, *c.*AD 191–2.

Marble. Musei Capitolini, Rome/photo Scala, Florence.

133. Coin of Elagabalus (reverse), struck at Antioch, *c.*AD 218–19. Gold. The British Museum, London.

134. 'Beautiful Artemis' statue, Ephesus, first quarter of the second century AD. Marble. Ephesus Müzesi/photo The Ancient Art and Architecture Collection, Pinner.

135. Painted tauroctone, Marino, Mithraeum, *c.*AD 200. Fresco on plaster. Photo Carlo Pavia, Rome.

136. The Parabiago Plate, northern Italy, between the second century and the late fourth century AD. Silver with gilding. Diameter 0.31 m. Civico Museo Archeologico, Milan/Foto Saporetti.

137. Relief of L. Lartius Anthus as a priest of Ma-Bellona, Rome, early third century AD. Marble. Musei Capitolini, Rome/photo Deutsches Archäologisches Institut.

138. Map of Dura Europos, Syria. Drawing after M. I. Finley (ed.), *Atlas of Ancient Archaeology* (London, 1977), 239 © Rainbird Publishers.

139. Otes and Yahbishimshos making a sacrifice, temple of Bel, Dura Europos, Syria, third century AD. Fresco. From F. V. M. Cumont, *Fouilles de Doura-Europos, 1922–1923* (1926).

140. Cult niche, Mithraeum, Dura Europos, Syria, *c.*AD 168–71. Gypsum with traces of colour, and insets of glass and jewellery. Yale University Art Gallery, New Haven, Conn.

141. General view of the murals in the Synagogue, Dura Europos, Syria, *c.*AD 245. Frescos. Photo Percueron © Artephot, Paris.

142. Frescos in the Synagogue, Dura Europos, Syria *c.*AD 245. Detail. Photo André Held © Artephot, Paris.

143. London mithraeum objects: Tauroctone, H. 43.2 cm; head of Minerva, H. 25.3 cm; head of Serapis, H. 32.2 cm. Marble. Museum of London.

144. Hercules leads Alcestis back to Admetus, right hand *arcosolium*, Cubiculum N, Via Latina Catacomb, Rome, third quarter of the fourth century AD. Fresco on plaster. Photo Pontificia Commissione di Archeologia Sacra, Rome.

145. Sarcophagus, Ostia, second half of the third century AD. Strigilated marble. Photo Deutsches Archäologisches Institut, Rome

146. Floor mosaic from Nea Paphos, Cyprus, first half of the fourth century AD. Photo Department of Antiquities, Republic of Cyprus.

147. Statue of Isis giving the breast to the infant Horus ('Isis Lactans'), Antinoe, Egypt,

late fourth or early fifth century AD. Limestone. H. 1.0 m approx. Museum für Spätanike und Byzantinische Kunst, Berlin/ photo R. Friedrich © Bildarchiv Preussischer Kulturbesitz, Berlin 1997.

148. Isometric view and plan of St Peter's, Rome, AD 400. After R. Krautheimer, *Early Christian and Byzantine Architecture* (New Haven, Conn., 1975), 56, figs 21 and 22. Courtesy Yale University Press, Pelican History of Art.

149. The church of Santa Maria Maggiore, Rome, AD 432–40. View of the nave looking west. Canali Photobank, Capriolo (BS).

150. The church of Santa Sabina, Rome, AD 422–32. Exterior view. Photo Deutsches Archäologisches Institut, Rome.

151. The church of Santa Sabina, Rome, AD 422–32. View across the nave looking south-east. Canali Photobank, Capriolo (BS).

152. Panel from doors of church of Santa Sabina, Rome, second quarter of the fifth century AD. Cypress wood. Photo Deutsches Archäologisches Institut, Rome.

153. Mosaic from the triumphal arch, the church of Santa Maria Maggiore, Rome, second quarter of the fifth century AD. Canali Photobank, Capriolo (BS).

154. The 'Mausoleum of Galla Placidia', Ravenna, *c.*AD 450. Interior. Canali Photobank, Capriolo (BS).

155. The San Nazaro Reliquary, dedicated in AD 386, and interred beneath the main altar of St Ambrose's Basilica Apostolorum, Milan. Silver gilt casket. Tesoro del Duomo, Milan/ photo Hirmer Verlag GmbH, Munich.

156. The Trier Ivory, plaque depicting a translation of relics, possibly St Stephen's which were brought to Constantinople in AD 421. Domschatz, Trier/photo Ann Münchow.

157. Apse mosaic, church of Santa Pudenziana, Rome, *c.*AD 390. Photo Scala, Florence.

158. Engraved Christian gem, third or fourth century AD. Carnelian. Copyright © The British Museum, London.

159. Medallion from the bottom of a cup or bowl, Rome, fourth century AD. Gold-glass. Catacomb of San Pamfilo, Rome/photo Pontificia Commissione di Archeologia Sacra, Rome.

160. The 'Brescia Lipsanotheca', Italy (?), second half of the fourth century AD. Ivory casket. Civici Musei d'Arte e Storia, Brescia/ photo Alinari, Florence.

161. The Quedlinburg Itala, illuminated manuscript of the Books of Samuel and Kings, Rome (?), second quarter of the fifth century AD. Velum codex. Staatsbibliothek, Berlin (MS. Theol. Lat. fol. 485, fol. 2r)/Bildarchiv Preussischer Kulturbesitz, Berlin.

162. Papyrus Goleniscev, fol. 6v (fragment), Alexandria, early fifth century AD. Papyrus codex. From A. Bauer and J. Strzygowski, *Eine Alexandrinische Weltchronik* (1906).

163. Icon of St Peter, Monastery of St Catherine at Mount Sinai (original provenance unknown), second half of the sixth century AD. Encaustic on wooden panel. Metochio of the Monastery of St Catherine of Sinai.

The publisher and author apologize for any omissions in the above list. If contacted they will be pleased to rectify these at the earliest opportunity.

Bibliographic Essay

All chapters except the Introduction have notes which refer the reader to further bibliography (especially art-historical work) on specific issues or images discussed. In this bibliographic essay, I have tried not to repeat that material, but rather to give broader guidance on up-to-date thinking about the historical and cultural, as well as archaeological and art-historical, contexts related to specific chapters. In the interests of brevity, I have not referred to all important bibliographic items, but rather to where the interested reader can find a fuller bibliography. In general, I have always preferred English-language publications (except *in extremis* where no recent English discussion or translation exists) on the grounds that most readers of this book will be English-speaking and few will be as proficient in other languages as they are in English.

Chapter 1: Introduction

For general introductions to Roman culture and its heritage, see P. Jones and K. Sidwell, (eds), *The World of Rome* (Cambridge, 1997) and R. Jenkyns, *The Legacy of Rome* (Oxford, 1992).

For excellent general introductions to the complex history of late antiquity, see P. Brown, *The World of Late Antiquity* (London, 1971) and his essay in P. Veyne (ed.), *A History of Private Life: From Pagan Rome to Byzantium* (Cambridge, MA, 1987), 235–312; Averil Cameron, *The Later Roman Empire (AD 284–430)* (London, 1993) and *The Mediterranean World in Late Antiquity: AD 395–600* (London, 1993); also the collected essays in Averil Cameron and P. Garnsey (eds), *Cambridge Ancient History* (2nd edn, Cambridge, 1998), vol. 13 (AD 337–425). Still essential, though in some aspects outdated, is A. H. M. Jones *The Later Roman Empire* (Oxford, 1964).

On Augustus, see P. Zanker, *The Power of Images in the Age of Augustus* (Ann Arbor, 1988) and K. Galinsky, *Augustan Culture* (Princeton, 1996).

On Christianization, see P. Brown, *Authority and the Sacred: Aspects of the Christianization of the Roman World* (Cambridge, 1995); F. Trombley, *Hellenic Religion and Christianization c. 370–529*, 2 vols. (Leiden, 1993), 98–187; Averil Cameron, *Christianity and the Rhetoric of Empire* (Berkeley and Los Angeles, 1991); R. MacMullen, *Christianizing the Roman Empire* (New Haven, 1984).

On transformation of culture, see C. Webster and M. Brown (eds), *The Transformation of the Roman World* (London, 1997).

On the Second Sophistic, see G. Anderson, *The Second Sophistic: A Cultural Phenomenon in the Roman Empire* (London, 1993); S. Swain, *Hellenism and Empire: Language, Classicism and Power in the Greek World AD 50–250* (Oxford, 1996).

On the Barbarian invasions, see H. Wolfram, *History of the Goths* (Berkeley, 1988), E. Thompson (rev. edn P. Heather), *The Huns* (London, 1996), P. Heather, *The Goths* (London, 1996), and H. Wolfram, *The Roman Empire and its Germanic Peoples* (Berkeley, 1997).

On the late-antique ideals of womanhood, see K. Cooper, *The Virgin and the Bride* (Cambridge, MA, 1996).

For a one-volume account of Classical art (with sections devoted to our period by J. Pollitt and J. Huskinson) see J. Boardman (ed.), *The Oxford History of Classical Art* (Oxford, 1993).

For a broad overview of the historiography of Roman art, see O. Brendel, *Prolegomena to the Study of Roman Art* (New Haven, 1979), bearing in mind that this is not an objective account: it was written by one of those who helped to formulate the debates it describes. On the specific problems of late-Roman art, the key early historiographic contributions include A. Riegl, *Late Roman Art Industry* (Rome, 1985; first published in 1901); J. Strzygowski, *Orient oderRom: Beiträge zur geschichte der spätantiken und früchristlichen*

Kunst (Leipzig, 1901); G. Rodenwaldt, *Über der Stilwandel in der Antoninischen Kunst. Abhandlungen der Preussischen Akademie der Wissenschaften* 3 (Berlin, 1935); G. Rodenwaldt, 'The Transition to Late Classical Art' in *Cambridge Ancient History*, vol. 12 (first edn, Cambridge, 1939), 544–70; G. Rodenwaldt, 'Römische Reliefs vorstufen zur Spätantike' in *JDAI*, 55 (1940), 12–43.

Traditional accounts of Roman art from the Republic to Constantine include R. Brilliant, *Roman Art from the Republic to Constantine* (London, 1974); B. Andreae, *The Art of Rome* (London, 1978); D. Strong, *Roman Art* (rev. edn, J. M. C. Toynbee and R. J. Ling, New Haven and London 1988); N. H. Ramage and A. Ramage, *Roman Art* (London, 1995); R. Turcan, *L'art romain dans l'histoire* (Paris, 1995). Ending at the beginning of the third century is R. Bianchi Bandinelli, *Rome: The Centre of Power. Roman Art to AD 200* (London, 1970). An excellent resource on Roman sculpture, both visual and bibliographic, is D. E. E. Kleiner, *Roman Sculpture* (New Haven and London, 1992), which follows the traditional Republic to Constantine format and largely excludes Christian sculpture. Good recent collections of essays on an eclectic variety of themes within Roman art include E. Gazda (ed.), *Roman Art in the Private Sphere* (Ann Arbor, 1991); E. D'Ambra (ed.), *Roman Art in Context* (Englewood Cliffs, 1993); J. Elsner (ed.), *Art and Text in Roman Culture* (Cambridge, 1996); and N. B. Kampen (ed.), *Sexuality in Ancient Art* (Cambridge, 1996). Two helpful collections of ancient sources and documents on art in translation are J. J. Pollitt, *The Art of Rome c. BC 753–AD 337: Sources and Documents* (Cambridge, 1983), and *The Art of Ancient Greece: Sources and Documents* (Cambridge, 1990), but the reader should be aware that these are by no means comprehensive.

Accounts focusing specifically on late-antique art (which tend to underplay Christian art) include H. P. L'Orange, *Art Forms and Civic Life in the Later Roman Empire* (Princeton, 1965), and R. Bianchi Bandinelli, *Rome: The Late Empire AD 200–400* (London, 1971).

Accounts focusing specifically on the emergence of early Christian and Byzantine art (which tend to underplay the Graeco-Roman context) include A. Grabar, *The Beginnings of Christian Art, 200–395* (London, 1967), and A. Grabar *Christian Iconography: A Study of Its Origins* (London, 1968); I. Hutter, *Early Christian and Byzantine Art* (London, 1971); J. Beckwith, *Early Christian and Byzantine Art* (Harmondsworth, 1979, rev. edn); R. Milburn, *Early Christian Art and Architecture* (Berkeley, 1988); T. F. Mathews, *The Clash of Gods: A Reinterpretation of Early Christian Art* (Princeton, 1993); G. Koch, *Early Christian Art and Architecture* (London, 1996); J. Lowden, *Early Christian and Byzantine Art* (London, 1997). For a recent collection of essays on early Christian art, see P. C. Finney (ed.), *Art Archaeology, and Architecture of Early Christianity* (New York, 1993), vol. 18 of E. Ferguson (ed.) *Studies in Early Christianity*.

Chapter 2: A Visual Culture

On social ritual in Roman culture, see K. Hopkins, 'From Violence to Blessing: Symbols and Rituals in Ancient Rome', in A. Mohlo, K. Raaflaub, and J. Emlen (eds), *City States in Classical Antiquity and Medieval Italy* (Stuttgart, 1991)—a brilliant but eccentric paper: the presentation of Roman institutions and civic ceremonies as a culture of ritual is excellent, but the conclusion, which suggests that imperial Rome was a 'ritual vacuum', is certainly misguided (as G. Bowersock remarks in his critical comments in the same volume). See also J. P. Toner, *Leisure and Ancient Rome* (Oxford and Cambridge, 1995).

On visual display in the ritual of the games (focusing on cruelty), see K. Coleman, 'Fatal Charades: Roman Executions staged as Mythological Enactments', *JRS* 80 (1990), 44–73; C. Barton, *The Sorrows of the Ancient Romans* (Princeton, 1993); P. Plass, *The Game of Death in Ancient Rome* (Madison, 1995). For the impact of this kind of voyeurism on Roman imperial literature, see e.g. G. Most, '*Disiecti membra poetae*: The Rhetoric of Dismemberment in Neronian Poetry' in R. Hexter and D. Selden (eds), *Innovations of Antiquity* (London, 1992), 391–419; A. Richlin, 'Reading Ovid's Rapes', in A. Richlin (ed.), *Pornography and Representation in Greece and Rome* (Oxford, 1992), 158–79; H. Morales, 'The Torturer's Apprentice: Parrhasius and the Limits of Art', in J. Elsner (ed.), *Art and Text in Roman Culture* (Cambridge, 1996), 182–209; and on domestic art, see S. Brown, 'Death as Decoration: Scenes from the Arena on Roman Domestic Mosaics', in Richlin *Pornography and Representation*, 180–211.

On the theatrical and hence visual nature of Roman imperial culture, see K. Coleman, 'Launching into History: Aquatic Displays in the Early Empire', *JRS* 83 (1993), 48–74; C. Edwards, 'Beware of Imitations: Theatre and the Subversion of Imperial Identity',

in J. Elsner and J. Masters (eds), *Reflections of Nero: Culture, History, and Representation* (London, 1994); S. Bartsch, *Actors in the Audience* (Cambridge, MA, 1994).

On the gaze in some aspects of Roman imperial literature, see J. Henderson, 'Wrapping up the Case', *MD* 27 (1991), 37–88 and *MD* 28 (1992), 27–84; A. Walker, 'Eros and the Eye in the *Love-Letters* of Philostratus', *PCPS* 38 (1992), 132–48; B. Egger, 'Looking at Chariton's Callirhoe', in J. R. Morgan and R. Stoneman (eds), *Greek Fiction* (London, 1994); on viewing in Roman art, see P. Zanker, 'Nouvelle orientations de la recherche en iconographie: commanditaires et spectateurs', *RA* (1994), 281–91, and J. Elsner, *Art and the Roman Viewer: The Transformation of Art from the Pagan World to Christianity* (Cambridge, 1995), 15–155; P. Zanker, 'In Search of the Roman Viewer' in D. Buitron-Oliver (ed.), *The Interpretation of Architectural Sculpture in Greece and Rome, Studies in the History of Art* 49 (Washington, DC, 1997), 179–92.

Chapter 3: Art and Power
General accounts include N. Hannestad, *Roman Art and Imperial Policy* (Aarhus, 1986), and Kleiner, *Roman Sculpture*, which are both structured chronologically by imperial dynasties. For late antiquity, see S. Mac-Cormack, *Art and Ceremony in Late Antiquity* (Berkeley and Los Angeles, 1981).

For a sociological assessment of power in the Roman and early Byzantine worlds, see M. Mann, *The Sources of Social Power: Vol. 1: A History of Power from the Beginning to AD 1760* (Cambridge, 1986), 250–340. For a sociology of the power of images (not directly relevant to our period) see G. Fyfe and J. Law, (eds), *Picturing Power* (London, 1988).

A subtle account of power and art in the Roman world (but not specifically relevant to the period covered in this volume) is Zanker, *The Power of Images*.

Chapter 4: Art and Social Life
For a general introduction to daily life, see F. Dupont, *Daily Life in Ancient Rome* (Oxford, 1992).

On women see E. Fantham et al., *Women in the Classical World* (Oxford, 1994) and, specifically in relation to art, a number of essays in A. O. Koloski-Ostrow and Claire L. Lyons (eds), *Naked Truths* (London, 1997), as well as D. Kleiner and S. Matheson (eds), *I, Claudia* (Austin, Tex., 1996).

On the private sphere, see Veyne, *A History*

of Private Life, and (on art) see E. Gazda (ed.), *Art in the Private Sphere* (Ann Arbor, 1991).

On the house, see R. Lawrence and A. Wallace-Hadrill (eds), *Domestic Space in the Roman World: Pompeii and Beyond: JRA suppl. 22* (Portsmouth, RI, 1997).

On the family, see B. Rawson and P. Weaver (eds), *The Roman Family in Italy* (Oxford, 1997).

For community and society, see S. Dyson, *Community and Society in Roman Italy* (Baltimore, 1992).

On urbanism, see T. Cornell and K. Lomas (eds), *Urban Society in Roman Italy* (London, 1995).

Chapter 5: Centre and Periphery
An excellent and up-to-date introduction to the problems of Roman imperialism, acculturation and Romanization is D. Mattingly (ed.), *Dialogues in Roman Imperialism: JRA Supplement 23* (Portsmouth, RI, 1997). On the west see T. Blagg and M. Millet (eds), *The Early Roman Empire in the West* (Oxford, 1990); on the east, see S. E. Alcock (ed.), *The Early Roman Empire in the East* (Oxford, 1997).

For discussion of frontiers, see C. R. Whittaker, *Frontiers of the Roman Empire* (Baltimore, 1994).

On the problems of provincial identity, see F. Millar, *The Roman Near East 31 BC–AD 337* (Cambridge, MA, 1993), on the near east; and, on Greece, Swain, *Hellenism and Empire*; G. Woolf, 'Becoming Roman, Staying Greek: Culture, Identity, and the Civilizing Process in the Roman East', *PCPS* 40 (1994), 116–43; S. E. Alcock, *Graecia Capta: The Landscapes of Roman Greece* (Cambridge, 1993).

Chapter 6: Art and Death
A general introduction to death in the Roman world is J. M. C. Toynbee, *Death and Burial in the Roman World* (London, 1971) with the recent review and bibliographic overview by J. Rice, *Bryn Mawr Classical Review* 8 (1997), 583–94.

For some sociological reflections on the theme, see K. Hopkins, *Death and Renewal* (Cambridge, 1983), 1–30, 201–56.

Two useful collections of essays, mainly in French, are F. Hinard (ed.), *La mort: Les morts et l'au delà dans le monde romain* (Caen, 1987), and F. Hinard (ed.), *La mort au quotidien dans le monde romain* (Paris, 1995).

For some ramifications of death in early Christendom, see P. Brown, *The Cult of the Saints* (London, 1982).

Chapter 7: Art and the Past

Useful accounts of Second Sophistic antiquarianism include E. L. Bowie, 'Greeks and their Past in the Second Sophistic', in M. I. Finley (ed.), *Studies in Ancient Society* (London, 1974), 166–209; Swain, *Hellenism and Empire*; K. Arafat, *Pausanias' Greece* (Cambridge, 1996).

For Christianity and the past, see Cameron, *Christianity and the Rhetoric of Empire*, 120–54.

For late paganism and the past, see G. W. Bowersock, *Hellenism in Late Antiquity* (Cambridge, 1990).

On Byzantine and late-antique attitudes to the past, see G. Clarke (ed.), *Reading the Past in Late Antiquity* (Rushcutters Bay, 1990), and A. R. Littlewood (ed.), *Originality in Byzantine Literature, Art, and Music* (Oxford, 1995).

On Roman copying of earlier art, see M. Bieber, *Ancient Copies: Contributions to the History of Greek and Roman Art* (New York, 1977); B. Ridgway, *Roman Copies of Greek Sculpture: The Problem of the Originals* (Ann Arbor, 1984); C. C. Vermeule, *Greek Sculpture and Roman Taste* (Ann Arbor, 1977); E. Bartman, *Ancient Sculptural Copies in Miniature* (Leiden, 1992); L.-A. Touchette, *The Dancing Maenad Reliefs* (London, 1995); and M. Marvin, 'Roman Sculptural Reproductions or Polykleitos: The Sequel' in E. Ranfft and A. Hughes (eds), *Sculpture and its Reproductions* (London, 1997), 7–28.

Chapter 8: Art and Religion

An excellent introduction to (pre-Christian) Roman religion is D. Feeney, *Literature and Religion at Rome* (Cambridge, 1998). A long-awaited and authoritative discussion in two volumes will be M. Beard, J. North, and S. Price, *Religions of Rome* (Cambridge, forthcoming).

Useful accounts of the religions of the Roman world include M. Beard and J. North (eds), *Pagan Priests* (London, 1990); J. North, 'The Development of Religious Pluralism' in J. Lieu, J. North, and T. Rajak (eds), *The Jews among Pagans and Christians* (London, 1992), 174–93; R. Lane Fox, *Pagans and Christians* (London, 1986); R. Turcan, *The Cults of the Roman Empire* (Oxford, 1996).

On issues of belief, see P. Veyne, *Did the Greeks believe in their Myths?* (Chicago, 1988).

For a specialized study of ritual in relation to women, see A. Staples, *From Good Goddesses to Vestal Virgins* (London, 1988).

Specifically on art and religion, see R. Gordon, 'The Real and the Imaginary: Production and Religion in the Graeco-Roman World', *Art History* 2 (1979), 5–34.

On the rise of Christianity, see H. Chadwick, *The Early Church* (Harmondsworth, 1967); R. Markus, *Christianity in the Roman World* (London, 1974); W. H. C. Frend, *The Rise of Christianity* (London, 1984); P. Brown, *The Rise of Western Christendom* (Oxford, 1996).

Chapter 9: Art and Culture

For recent general accounts of *ekphrasis*, see M. Krieger, *Ekphrasis: The Illusion of the Natural Sign* (Baltimore, 1992); J. Heffernan, *Museum of Words* (Chicago, 1993); A. Becker, *The Shield of Achilles and the Poetics of Ekphrasis* (Lanham, Md., 1995).

On the place of *ekphrasis* in the Greek literary and visual tradition, see e.g. the essays by S. Goldhill, F. Zeitlin, and N. Bryson in S. Goldhill and R. Osborne (eds), *Art and Text in Ancient Greek Culture* (Cambridge, 1994), and Elsner *Art of the Roman Viewer*, 21–48, with further bibliography.

On *ekphrasis* in the Latin literary tradition, see the essays by D. Fowler and A. Laird in Elsner, *Art and Text in Roman Culture*, with further bibliography.

	AD 1	AD 110	AD 130		AD 150
Emperors	● 98 Accession of Trajan, adoptive heir of Nerva	● 117 Death of Trajan – Accession of Hadrian, his cousin and heir, ostensibly adopted on Trajan's deathbed	● 138 Death of Hadrian – Accession of Antoninus Pius, his adoptive heir		● 161 Death of Antoninus Pius – Joint accession of Marcus Aurelius and Lucius Verus, his adoptive heirs ● 169 Death of Lucius Verus – Marcus Aurelius sole emperor
Politics, history, and culture	● 101–6 Trajan's Dacian Wars	● c.110 Death of the sophist Dio Chrysostom (c.45–110) ● 114–17 Trajan's Parthian Wars ● 115–17 Jewish revolt ● c.120 Completion of Tacitus' Annals ● 122 Hadrian's voyage to Britain ● c.125 Death of Plutarch (c.50–c.125), priest at Delphi, biographer, and philosopher ● 128–32 Hadrian's journey to Greece, Asia Minor, and Egypt	● c.130 Death of Suetonius (c.70–c.130), author of the Lives of the Caesars ● 131–2 Inauguration by Hadrian of the Panhellenion, or league of Greek-speaking cities in Greece, North Africa, and Asia Minor ● 132–5 Bar Kochba's Jewish revolt, its defeat by Hadrian and the beginning of the diaspora	● c.145–c.75 Pausanias' travels in (and travel book about) Greece – Main works of Ptolemy of Alexandria, mathematician, geographer, and astronomer ● 147–8 Nine hundredth anniversary of the founding of Rome	● 161 Institutes of Gaius ● 162–6 Lucius Verus in the east: victories over the Parthians ● c.165 Apuleius (c.125–c.80), author of the Golden Ass, lecturing in Carthage ● 165–7 Major outbreak of plague in the Roman empire ● 168–75 Marcomannic Wars against the northern tribes
Monuments and art-historical events	● c.100 Trajan's Kiosk, Philae, Egypt ● 100–12 Trajan's Market, Rome ● 109 Trajan's Victory Trophy, Adamklissi	● 110–13 Forum and Column of Trajan, Rome ● 114–18 Trajan's Arch at Benvento ● 117–20 Library of Celsus, Ephesus ● 118–28 The Pantheon, Rome ● 118–38 Hadrian's Villa, Tivoli ● After c.120 Rise in the popularity and production of funerary sarcophagi ● 122–6 Hadrian's Wall in Britain	● 130–8 Conventional period for the portraiture of Antinous ● 130–40 Sanctuary of Asclepius, Pergamon ● 131–2 Hadrian's building programme in Greece, including the arch, stoa, and library, and the Olympeum at Athens ● 132–9 Hadrian's mausoleum, Rome	● 135 Temple of Venus and Rome consecrated, Rome ● 140–1 Antonine Wall in Britain (abandoned 163) ● 141 Inauguration of the temple of Antoninus and Faustina, Rome ● 145 Temple of the Divine Hadrian consecrated, Rome ● 149–53 Nymphaeum of Herodes Atticus, Olympia	● c.160 Odeum of Herodes Atticus begun, Athens ● 161 Column and base of Antoninus Pius, Rome ● ?c.169 Great Antonine Altar, Ephesus

● 180 Death of Marcus Aurelius
– Accession of his son, Commodus

● 192 Murder of Commodus
● 193 Accession and murder in swift succession of Pertinax and Didius Julianus
– Septimius Severus wins the empire in civil war
– His rival emperors (Pescennius Niger, 193–4, and Clodius Albinus, 193–7) gradually defeated

● 211 Death of Septimius Severus
– Joint accession of his sons, Caracalla and Geta
– Murder of Geta (by Caracalla) makes Caracalla sole emperor
● 217 Murder of Caracalla
● 217–18 Accession and murder in swift succession of Macrinus and Diadumenianus

● 218 Accession of Elagabalus, heir of the Severan house
● 222 Murder of Elagabalus
– Accession of Alexander Severus, his heir

● 235 Murder of Alexander Severus
– Accession of Maximinus Thrax
● 238 Murder of Maximinus Thrax
– Accession and murder in swift succession of Gordian I, Gordian II, Pupienus, Balbinus
● 239 Accession of Gordian III, heir of Gordian II
● 244 Murder of Gordian III

– Accession of Philip I (the Arab)
● 249 Death of Philip I in civil war
– Accession of Trajan Decius

● 177 Death of Herodes Atticus (c.103–77)
● c.185 Death of the orator and devotee of Asclepius, Aelius Aristides (117–c.185)

● c.190 Death of Lucian (c.120–c.90)
● c.200 Death of Galen (c.129–c.200), medical writer and court physician to Marcus Aurelius

● 212 Caracalla extends Roman citizenship to all free inhabitants of the empire (the *Constitutio Antoniniana*)
● 226 Ardashir the Sassanian crowned King of Kings in Iran
–The Sassanids replace the Parthians as the main empire in the East

● 232 The Sassanid Ardashir II defeated by Alexander Severus
● c.235 Philostratus (c.170–c.250?) publishes the *Lives of the Sophists*
– Death of the senator and historian, Cassius Dio (c.168–c.235, Consul, 229)
● 247–8 One thousandth anniversary of the founding of Rome

● c.176 Equestrian statue of Marcus Aurelius, Rome
● c.180–92 Column of Marcus, Rome

● c.200 First Christian images in Rome (Catacomb of Callistus)
● 203 Arch of Septimius Severus, Lepcis Magna
– Arch of Septimius Severus, Rome
● 204 Arch of the Argentarii, Rome

● 212–16 Baths of Caracalla, Rome
● 216 Severan Basilica completed, Lepcis Magna

	AD 250	AD 260	AD 270	AD 280	AD 290
Emperors	● 251 Death of Decius in battle against the Goths – Accession of Trebonianus Gallus ● 253 Death of Gallus in civil war – Accession and murder of Aemilianus – Accession of Valerian and his son Gallienus	● 260 Defeat, capture and subsequent execution of Valerian by the Sassanids – Gallienus sole emperor ● 268 Murder of Gallienus – Accession of Claudius II	● 270 Death from plague of Claudius II – Accession of Aurelian ● 275 Murder of Aurelian – Accession of Tacitus ● 276 Murder of Tacitus – Accession and murder of Florianus – Accession of Probus	● 282 Murder of Probus – Accession of Carus ● 283 Death of Carus – Joint accession of his sons, Numerian and Carinus ● 284 Murder of Numerian – Accession of Diocletian ● 285 Defeat and death of Carinus – Diocletian sole emperor ● 286 Diocletian adopts Maximian as emperor in the west	● 293 Diocletian and Maximian adopt Galerius and Constantius Chlorus as junior colleagues – The establishment of the Tetrarchy
Politics, history, and culture	● 250 Decius' persecution of the Christians ● c.250–73 Palmyrene kingdom of Odaenathus and Zenobia (after 267) ● 254 Death of the Christian theologian Origen (c.185–254) ● 257 Valentinian's persecution of the Christians	● 260–9 Postumus' Gallic empire ● 262 Last celebration of the 'Secular Games' ● 267 Heruls raid Athens ● 269 Death of the neo-Platonic philosopher, Plotinus (204–69)	● 271 The Romans evacuate Dacia ● 272 Aurelian defeats Zenobia and reconquers Palmyra ● c.277 Death of Mani (c.216–c.77), founder of Manichaeanism	● 285 St Antony (c.251–356) withdraws to Pispir in Egypt and founds Christian hermetic life ● 285–93 Carausius' British empire	● 296 Tetrarchic reform of the tax system
Monuments and art-historical events	● c.256 Destruction of Dura Europos	● c.262 Destruction of the Temple of Artemis of Ephesus by the Gauls	● 272–83 Aurelian's Walls, Rome ● 275–80 Aurelian's temple of Sol Invictus, Rome		● 293 Arcus Novus of Diocletian, Rome ● 297–305 Arch of Galerius, Salonica ● 298–306 Baths of Diocletian, Rome

● 305 Joint abdication of Diocletian and Maximian. Galerius and Constantius become senior emperors with Maximinus Dalia and Severus as junior colleagues (the 'Second Tetrarchy')
● 306 Death of Constantius
– His son Constantine proclaimed emperor at York

– Severus becomes senior emperor in the west, with Constantine his junior colleague
● 307 Severus overthrown by Maxentius, son of Maximian
● 308 Licinius adopted as emperor in the west in place of the usurper Maxentius, who nonetheless retains power in Italy

● 311 Death of Galerius
● 312 Constantine overthrows Maxentius and becomes sole emperor in the west
● 313 Licinius overthrows Maximinus Daia and becomes sole emperor in the east

● 324 Constantine defeats and executes Licinius and becomes sole emperor

● 337 Death of Constantine
– Joint accession of his sons Constantine II, Constans, and Constantius II

● 301 Diocletian's edict of maximum prices
● 303–5 The 'Great Persecution' of the Christians
● c.305 Death of the neo-Platonist philosopher, Porphyry (c.232–c.305)

● 311 Galerius' edict of toleration for Christianity
● 312 Battle of the Milvian Bridge: Constantine's victory over Maxentius
● 313 Edict of Milan: Constantine and Licinius affirm toleration for Christianity
● 314 Accession of Pope Silvester (to 335)

● 315 First monastery founded by Pachomius (c.292–346) in Tabenissi, Egypt
● 318–20 Donatist and Arian controversies in the Church

● 320 Sunday declared a public holiday
● 325 First Ecumenical Council of the Church, at Nicaea
● 326 Accession of Athanasius to the Patriarchate of Alexandria (to 373, with several periods of exile)
● 327–8 Helena's pilgrimage to Palestine

● 330 Inauguration of the new capital at Constantinople
– Death of the neo-Platonist philosopher, Iamblichus (c.260–c.330)

● c.300 The end of the making of marble 'copies' of ancient sculpture
● c.300–6 Diocletian's Palace, Split
● c.300–11 The Rotunda of Galerius, Thessalonica
● c.300–20 Basilica, Porta Nigra, imperial baths, Trier
● 303 Diocletian's Five-Column Monument, Rome

● 307–12 Maxentius' building programme in Rome: basilica, circus, and mausoleum

● c.313–20 Lateran Basilica (San Giovanni in Laterano), Rome
● 315 Arch of Constantine dedicated, Rome
● c.319–30 Constantine's building programme of churches in Rome, esp. St Peter's Basilica, on the Vatican Hill, Rome

● 320 Villa, Piazza Armerina
● c.320–30 Constantine's building programme of churches in the east, esp. The Holy Sepulchre, Jerusalem; The church of the Nativity, Bethlehem; The Octagon, Antioch

● c.330 Inauguration of building the main churches in Constantinople, esp. The Holy Apostles and St Sophia
● c.331 Basilica of Junius Bassus, Rome
● c.335 Mosaics of the Constantinian Villa, Antioch

	AD 340	AD 350	AD 360		AD 370
Emperors	● 340 Death of Constantine II (killed in civil war) – Constans emperor	● 350 Murder of Constans ● 351 Accession of Gallus as junior emperor to Constantius II ● 354 Execution of Gallus ● 355 Accession of Julian as junior emperor to Constantius II	● 361 Death of Constantius II – Julian (the Apostate) sole emperor ● 363 Death of Julian in battle against the Persians – Accession of Jovian ● 364 Death of Jovian – Joint accession of the brothers Valentinian I and Valens (in west and east)	● 367 Accession of Gratian, son of Valentinian I, as junior emperor in the west	● 375 Death of Valentinian I – Gratian senior emperor and his brother, Valentinian II, junior emperor in the west ● 378 Death of Valens at the battle of Adrianople – Adoption of Theodosius as emperor in the east
Politics, history, and culture		● 357 Battle of Strasbourg: The Romans defeat the Alamanni	● 366 Accession of Pope Damasus (to 385) ● 367 Accession of Epiphanius (c.313–403) to the bishopric of Salamis		● 370 The *Monastic Rule* of Basil (330–79): the promulgation of Christian Monasticism in the Greek east ● 374 Accession of Ambrose (340–97) to the bishopric of Milan ● 376 Visigoths allowed to settle in the confines of the empire ● 378 Battle of Adrianople, defeat and death of Valens by the Visigoths
Monuments and art-historical events		● *c.*350 The Mausoleum of Sta Constanza, Rome, and the Mausoleum at Centcelles near Tarragona ● *c.*352–75 The church of San Lorenzo, Milan ● 354 Codex calendar made by Philocalus the calligrapher, Rome ● 359 Sarcophagus of Junius Bassus, Rome			

● 383
Assassination of
Gratian
– Valentinian II sole
emperor in the west
– Arcadius, son of
Theodosius,
appointed junior
emperor in the east

● 392
Assassination (or
suicide) of
Valentinian II
–Theodosius I senior
emperor with his
sons Arcadius and
Honorius junior
emperors in east
and west
● 395 Death of
Theodosius I
– Partition of the
empire under
Arcadius in the east
and Honorius in the
west

● 408 Death of
Arcadius
– Accession of his
son Theodosius II in
the east

● 380 Edict of
Theodosius,
Gratian, and
Valentinian II
making Christianity
obligatory for
inhabitants of the
empire
● 381 Second
Ecumencial
Council, at
Constantinople
– Accession of
Gregory of
Nazianzus
(321–c.390) to the
Patriarchate of
Constantinople

● ?383 Abolition of
the office of Pontifex
Maximus
● 386 Edict order-
ing the destruction
of pagan temples

● 391 Edicts
prohibiting
paganism and
forbidding sacrifice
– Probable date of
the destruction of
the Great Library of
Alexandria
● 394 Last Olympic
Games and Olympic
festival suppressed
● 395 Accession of
Augustine
(354–430) to the
bishopric of Hippo
– Paulinus (353–
431) settles in Nola
as priest and sub-
sequently bishop

● 398 Accession of
John Chrysostom
(c.344–407) to the
Patriarchate of
Constantinople

● c.400 Text of the
Palestinian Talmud
finalized
● 401 Roman
troops withdraw
from the Rhine
● 402 Death of the
pagan aristocrat
Symmachus
(c.340–402,
Consul 391)
● 404 The western
imperial court
moves from Milan to
Ravenna
● c.404 Jerome
completes the
Vulgate translation
of the Bible into
Latin

● 405 Ban on
gladiatorial combat
● 406–9 Vandal
invasion of Gaul
and Spain
● 408 Murder of
Stilicho
(c.360–408),
regent of Honorius

● c.380 Church
of the Anastasis
begun, Jerusalem
● 382 Altar and
statue of Victory
removed from the
Senate House in
Rome
– Basilica
Apostolorum
begun, Milan
● 384–99 Sta
Pudenziana, Rome
● 385 The church
of St Paul outside
the Walls begun,
Rome

● 386–94 Column
of Theodosius,
Constantinople
● 388 Missorium of
Theodosius
– Destruction of the
Sanctuary of Zeus,
Apamea

● 390 Obelisk and
base of Theodosius,
Constantinople
● 391 Destruction
of the Serapeum,
Alexandria
● c.395 The first
ivory consular
diptychs

● c.400 The end of
Christian sarcophagi
production in Rome
– The beginning of
sarcophagi
manufacture in
Ravenna
– The Arcadian Way,
ceremonial street
with columns,
Ephesus
● c.400–25 The
first surviving
illuminated vellum
codices: the Vatican
Vergil and the
Quedlinburg Itala

● 402 Destruction
of pagan temples,
Gaza
● 402–21 Column
of Arcadius,
Constantinople

	AD 410	AD 420	AD 430	AD 440

Emperors

● 423 Death of Honorius
– Accession of his half-nephew, Valentinian III, in the West

Politics, history, and culture

● 410 Alaric the Goth sacks Rome
– The end of Roman rule in Britain
– The Franks occupy northern Gaul
– The Celts move into the Breton peninsula
● c.410 Death of the Christian poet, Prudentius (348–c.410)
● 412 Accession of Cyril (died 444), nephew of his predecessor Theophilus, to the Patriarchate of Alexandria

● 415 Murder in Alexandria of the pagan philosopher, Hypatia
● c.415 John Cassian (365–435) founds a monastery in Marseilles, bringing Egyptian Monasticism to the west

● 429–37 Compilation of the Theodosian Legal Code

● 430 The neo-Platonic philosopher, Proclus, begins teaching in Athens (till his death in 485)
● 430–1 Third Ecumenical Council of the Church, at Ephesus
● 438 Eudocia, empress of Theodosius II, visits Palestine

● 440 Accession of Pope Leo I (to 461)
● 443 Eudocia retires permanently to Palestine (dies there in 460)

Monuments and art-historical events

● c.410 Palace of Lausus, Constantinople
– Removal to Constantinople of canonical statues like Phidias' Zeus from Olympia and Praxiteles' Aphrodite of Cnidos
– The end of widespread use of Christian catacombs in Rome

● c.412 Church and pilgrimage centre of St Menas, near Alexandria, Egypt
● 412–40 The Theodosian Walls, Constantinople

● 422–32 Sta Sabina, Rome
● c.425–50 The first major churches of imperial Ravenna, esp. the 'Mausoleum of Galla Placidia' and the church of St John the Evangelist
● 426 Temple of Zeus at Olympia dismantled

● 432–40 Sta Maria Maggiore, Rome
– Lateran Baptistery, Rome

AD 450 AD 460 AD 470

● 450 Death of
Theodosius II
– Accession of
Marcian in the East
● 455 Death of
Valentinian III

● 476 Death
of Romulus
Augustulus, the
'last emperor of
the west'

● 451 Fourth
Ecumenical Council
of the Church, at
Chalcedon
● 452 Attila the
Hun invades Italy
● 455 The Vandals
pillage Rome

● 470 Sidonius
Apollinaris (c.430–
after 481) becomes
bishop of Clermont

● After c.450 The
demise (or at least
rapid decline) of
public honorific
statuary
● 450–2 Column
of Marcian,
Constantinople

● 475 Fire
destroys the Palace
of Lausus,
Constantinople,
and the antiquities
inside it

Index

The Oxford History of Art is an important new series of books that explore art within its social and cultural context using the most up-to-date scholarship. They are superbly illustrated and written by leading art historians in their field.

'Oxford University Press has succeeded in reinventing the survey ... I think they'll be wonderful for students and they'll also appeal greatly to members of the public ... these authors are extremely sensitive to works of art. The books are very very lavishly illustrated, and the illustrations are terribly carefully juxtaposed.'
Professor Marcia Pointon, Manchester University speaking on *Kaleidoscope*, BBC Radio 4.

'Fully and often surprisingly illustrated, carefully annotated and captioned, each combines a historical overview with a nicely opinionated individual approach.'
Independent on Sunday

'[A] highly collectable series ... beautifully illustrated ... written by the best new generation of authors, whose lively texts offer clear syntheses of current knowledge and new thinking.'
Christies International Magazine

'The new series of art histories launched by the Oxford University Press ... tries to balance innovatory intellectual pizzazz with solid informativeness and lucidity of presentation. On the latter points all five introductory volumes score extremely well. The design is beautifully clear, the text jargon-free, and never less than readable.'
The Guardian

'These five books succeed admirably in combining academic strength with wider popular appeal. Very well designed, with an attractive, clear layout and carefully-chosen illustrations, the books are accessible, informative and authoritative.'
The Good Book Guide

'A welcome introduction to art history for the twenty-first century. The series promises to offer the best of the past and the future, mixing older and younger authors, and balancing traditional and innovative topics.'
Professor Robert Rosenblum, New York University

The Photograph
Graham Clarke

How do we *read* a photograph?

In a series of brilliant discussions of major themes and genres, Graham
Clarke gives a clear and incisive account of the photograph's historical
development and elucidates the insights of the most interesting critics on
the subject. At the heart of the book is his innovative examination of the
main subject areas — landscape, the city, portraiture, the body, and
documentary reportage — and his detailed analysis of exemplary images
in terms of the cultural and ideological contexts.

'Graham Clarke's survey, *The Photograph*, argues elegantly while it informs.'
The Guardian

'entrancing . . . There was hardly an image new to me, hardly an image he
did not make new to me, reading its complicity . . . with the most sensitive
and perceptive eye.'
Sister Wendy Becket, *The Observer*

'Carefully selected images work with the text to illustrate the theme:
how the photograph is 'read'. Read this book and you will never look at
a photograph in the same way again.'
House & Garden

Art in China

Craig Clunas

China can boast a history of art lasting over 5,000 years and embracing a huge diversity of forms, but this rich tradition has not, until recently, been fully appreciated in the West where scholars have focused their attention on the European-style high arts (such as sculpture and painting), traditionally downplaying arts more highly prized by the Chinese themselves.

Art in China marks a breakthrough in the study of the subject. Drawing on recent innovative scholarship — and on newly accessible studies in China itself — Craig Clunas surveys the full spectrum of the visual arts in China. He examines art in a variety of contexts — as it has been designed for tombs, commissioned by rulers, displayed in temples, created by the men and women of the educated élite, and bought and sold in the marketplace.

'This reader was too lost in admiration . . . A triumphant success.'
Sister Wendy Becket, *The Observer*

'Since Thames & Hudson have just re-issued Mary Tregear's *World of Art* volume on *Chinese Art*, we can compare it head to head with Craig Clunas's *Art in China* for OUP. Clunas, I think, wins on nearly every count.'
The Independent

'a serious challenge to the conventional practice of art history . . . written with . . . lucidity, grace, and wit'
Professor Cao Yi Qiang, The National Academy of Art, China

Twentieth-Century Design

Jonathan M. Woodham

The most famous designs of the twentieth century are not those in
museums, but in the marketplace. The Coca-Cola bottle and the
McDonald's logo are known all over the world, and these tell us more about
our culture than a narrowly-defined canon of classics.

Professor Woodham takes a fresh look at the wider issues of design and
industrial culture throughout Europe, Scandinavia, North America, and the
Far East. In the history which emerges design is clearly seen for what it is:
the powerful and complex expression of aesthetic, social, economic,
political, and technological forces.

'a showcase for the virtues of the new series . . . deftly organized, extremely
cool-headed account . . . his range of reference and eye for detail are superb'
The Guardian

'[F]or a good general introduction to the subject you could not go very far
wrong Yet another example of the impressive new Oxford History
of Art series.'
The Bookseller

Oxford History of Art

Titles in the Oxford History of Art series are up-to-date, fully-illustrated introductions to a wide variety of subjects written by leading experts in their field. They will appear regularly, building into an interlocking and comprehensive series. Published titles are highlighted.